陳澄波全集
CHEN CHENG-PO CORPUS
第十六卷・修復報告（Ⅱ）
Volume 16・Selected Treatment Reports（Ⅱ）

策劃／財團法人陳澄波文化基金會
發行／財團法人陳澄波文化基金會
中央研究院臺灣史研究所
出版／藝術家出版社

感 謝
APPRECIATE

文化部 Ministry of Culture

嘉義市政府 Chiayi City Government

臺北市立美術館 Taipei Fine Arts Museum

高雄市立美術館 Kaohsiung Museum of Fine Arts

台灣創價學會 Taiwan Soka Association

尊彩藝術中心 Liang Gallery

吳慧姬女士 Ms. WU HUI-CHI

陳澄波全集
CHEN CHENG-PO CORPUS

第十六卷‧修復報告（Ⅱ）
Volume 16‧Selected Treatment Reports（Ⅱ）

藝術家

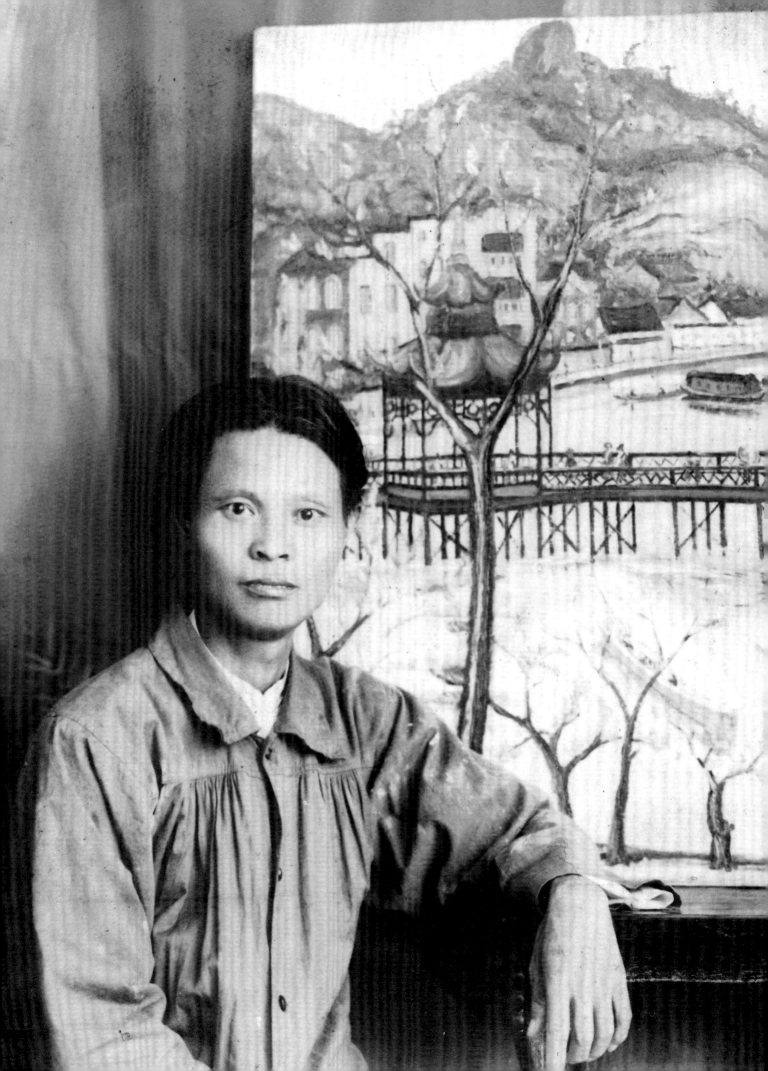

目 錄

Contents

榮譽董事長 序

家父陳澄波先生生於臺灣割讓給日本的乙未（1895）之年，罹難於戰後動亂的二二八事件（1947）之際。可以說：家父的生和死，都和歷史的事件有關；他本人也成了歷史的人物。

家父的不幸罹難，或許是一樁歷史的悲劇；但家父的一生，熱烈而精采，應該是一齣藝術的大戲。他是臺灣日治時期第一個油畫作品入選「帝展」的重要藝術家；他的一生，足跡跨越臺灣、日本、中國等地，居留上海期間，也榮膺多項要職與榮譽，可說是一位生活得極其精彩的成功藝術家。

個人幼年時期，曾和家母、家姊共赴上海，與父親團聚，度過一段相當愉快、難忘的時光。父親的榮光，對當時尚屬童稚的我，雖不能完全理解，但隨著年歲的增長，即使家父辭世多年，每每思及，仍覺益發同感驕傲。

父親的不幸罹難，伴隨而來的是政治的戒嚴與社會疑慮的眼光，但母親以她超凡的意志與勇氣，完好地保存了父親所有的文件、史料與畫作。即使隻紙片字，今日看來，都是如此地珍貴、難得。

感謝中央研究院翁啟惠院長和臺灣史研究所謝國興所長的應允共同出版，讓這些珍貴的史料、畫作，能夠從家族的手中，交付給社會，成為全民共有共享的資產；也感謝基金會所有董事的支持，尤其是總主編蕭瓊瑞教授和所有參與編輯撰文的學者們辛勞的付出。

期待家父的努力和家母的守成，都能夠透過這套《全集》的出版，讓社會大眾看到，給予他們應有的定位，也讓家父的成果成為下一代持續努力精進的基石。

我が父陳澄波は、台湾が日本に割譲された乙未（1895）の年に生まれ、戦後の騒乱の228事件（1947）の際に、乱に遭われて不審判で処刑されました。父の生と死は謂わば、歴史事件と関ったことだけではなく、その本人も歴史的な人物に成りました。

父の不幸な遭難は、一つの歴史の悲劇であるに違いません。だが、彼の生涯は、激しくて素晴らしいもので、一つの芸術の偉大なドラマであることとも言えよう。彼は、台湾の殖民時代に、初めで日本の「帝国美術展覧会」に入選した重要な芸術家です。彼の生涯のうちに、台湾は勿論、日本、中国各地を踏みました。上海に滞在していたうちに、要職と名誉が与えられました。それらの面から見れば、彼は、極めて成功した芸術家であるに違いません。

幼い時期、私は、家父との団欒のために、母と姉と一緒に上海に行き、すごく楽しくて忘れられない歳月を過ごしました。その時、尚幼い私にとって、父の輝き仕事が、完全に理解できなっかものです。だが、歳月の経つに連れて、父が亡くなった長い歳月を経たさえも、それらのことを思い出すと、彼の仕事が益々感心するようになりました。

父の政治上の不幸な非命の死のせいで、その後の戒厳令による厳しい状況と社会からの疑わしい眼差しの下で、母は非凡な意志と勇気をもって、父に関するあらゆる文献、資料と作品を完璧に保存しました。その中での僅かな資料であるさえも、今から見れば、貴重且大切なものになれるでしょう。

この度は、中央研究院長翁啟惠と台湾史研究所所長謝国興のお合意の上で、これらの貴重な文献、作品を共同に出版させました。終に、それらが家族の手から社会に渡され、我が文化の共同的な資源になりました。基金会の理事全員の支持を得ることを感謝するとともに、特に総編集者である蕭瓊瑞教授とあらゆる編輯作者たちのご苦労に心より謝意を申し上げます。

この《全集》の出版を通して、父の努力と母による父の遺物の守りということを皆さんに見せ、評価が下させられることを期待します。また、父の成果がその後の世代の精力的に努力し続ける基盤になれるものを深く望んでおります。

<div style="text-align: right">

財團法人陳澄波文化基金會
榮譽董事長　陳重光

</div>

Foreword from the Honorary Chairman

My father was born in the year Taiwan was ceded to Japan (1895) and died in the turbulent post-war period when the 228 Incident took place (1947). His life and death were closely related to historical events, and today, he himself has become a historical figure.

The death of my father may have been a part of a tragic event in history, but his life was a great repertoire in the world of art. One of his many oil paintings was the first by a Taiwanese artist featured in the Imperial Fine Arts Academy Exhibition. His life spanned Taiwan, Japan and China and during his residency in Shanghai, he held important positions in the art scene and obtained numerous honors. It can be said that he was a truly successful artist who lived an extremely colorful life.

When I was a child, I joined my father in Shanghai with my mother and elder sister where we spent some of the most pleasant and unforgettable days of our lives. Although I could not fully appreciate how venerated my father was at the time, as years passed and even after he left this world a long time ago, whenever I think of him, I am proud of him.

The unfortunate death of my father was followed by a period of martial law in Taiwan which led to suspicion and distrust by others towards our family. But with unrelenting will and courage, my mother managed to preserve my father's paintings, personal documents, and related historical references. Today, even a small piece of information has become a precious resource.

I would like to express gratitude to Wong Chi-huey, president of Academia Sinica, and Hsieh Kuo-hsing, director of the Institute of Taiwan History, for agreeing to publish the *Chen Cheng-po Corpus* together. It is through their effort that all the precious historical references and paintings are delivered from our hands to society and shared by all. I am also grateful for the generous support given by the Board of Directors of our foundation. Finally, I would like to give special thanks to Professor Hsiao Chong-ruy, our editor-in-chief, and all the scholars who participated in the editing and writing of the *Chen Cheng-po Corpus*.

Through the publication of the *Chen Cheng-po Corpus*, I hope the public will see how my father dedicated himself to painting, and how my mother protected his achievements. They deserve recognition from the society of Taiwan, and I believe my father's works can lay a solid foundation for the next generation of Taiwan artists.

Honorary Chairman, Chen Cheng-po Cultural Foundation
Chen Tsung-kuang

Chen, Tsung-kuang

9

院長 序

　　嘉義鄉賢陳澄波先生，是日治時期臺灣最具代表性的本土畫家之一，1926年他以西洋畫作〔嘉義街外〕入選日本畫壇最高榮譽的「日本帝國美術展覽會」，是當時臺灣籍畫家中的第一人；翌年再度以〔夏日街景〕入選「帝展」，奠定他在臺灣畫壇的先驅地位。1929年陳澄波完成在日本的專業繪畫教育，隨即應聘前往上海擔任新華藝術專校西畫教席，當時也是臺灣畫家第一人。然而陳澄波先生不僅僅是一位傑出的畫家而已，更重要的是他作為一個臺灣知識份子與文化人，在當時臺灣人面對中國、臺灣、日本之間複雜的民族、國家意識與文化認同問題上，反映在他的工作、經歷、思想等各方面的代表性，包括對傳統中華文化的繼承、臺灣地方文化與生活價值的重視（以及對臺灣土地與人民的熱愛）、日本近代性文化（以及透過日本而來的西方近代化）之吸收，加上戰後特殊時局下的不幸遭遇等，已使陳澄波先生成為近代臺灣史上的重要人物，我們今天要研究陳澄波，應該從臺灣歷史的整體宏觀角度切入，才能深入理解。

　　中央研究院臺灣史研究所此次受邀參與《陳澄波全集》的資料整輯與出版事宜，十分榮幸。臺史所近幾年在收集整理臺灣民間資料方面累積了不少成果，臺史所檔案館所收藏的臺灣各種官方與民間文書資料，包括實物與數位檔案，也相當具有特色，與各界合作將資料數位化整理保存的專業經驗十分豐富，在這個領域可說居於領導地位。我們相信臺灣歷史研究的深化需要多元的觀點與重層的探討，這一次臺史所有機會與財團法人陳澄波文化基金會合作共同出版陳澄波全集，以及後續協助建立數位資料庫，一方面有助於將陳澄波先生的相關資料以多元方式整體呈現，另一方面也代表在研究與建構臺灣歷史發展的主體性目標上，多了一項有力的材料與工具，值得大家珍惜善用。

臺北南港／中央研究院
院長
2012.3

Foreword from the President of the Academia Sinica

Mr. Chen Cheng-po, a notable citizen of Chiayi, was among the most representative painters of Taiwan during Japanese rule. In 1926, his oil painting *Outside Chiayi Street* was featured in Imperial Fine Arts Academy Exhibition. This made him the first Taiwanese painter to ever attend the top-honor painting event. In the next year, his work *Summer Street Scene* was selected again to the Imperial Exhibition, which secured a pioneering status for him in the local painting scene. In 1929, as soon as Chen completed his painting education in Japan, he headed for Shanghai under invitation to be an instructor of Western painting at Xinhua Art College. Such cordial treatment was unprecedented for Taiwanese painters. Chen was not just an excellent painter. As an intellectual his work, experience and thoughts in the face of the political turmoil in China, Taiwan and Japan, reflected the pivotal issues of national consciousness and cultural identification of all Taiwanese people. The issues included the passing on of Chinese cultural traditions, the respect for the local culture and values (and the love for the island and its people), and the acceptance of modern Japanese culture. Together with these elements and his unfortunate death in the post-war era, Chen became an important figure in the modern history of Taiwan. If we are to study the artist, we would definitely have to take a macroscopic view to fully understand him.

It is an honor for the Institute of Taiwan History of the Academia Sinica to participate in the editing and publishing of the *Chen Cheng-po Corpus*. The institute has achieved substantial results in collecting and archiving folk materials of Taiwan in recent years, the result an impressive archive of various official and folk documents, including objects and digital files. The institute has taken a pivotal role in digital archiving while working with professionals in different fields. We believe that varied views and multi-faceted discussion are needed to further the study of Taiwan history. By publishing the corpus with the Chen Cheng-po Cultural Foundation and providing assistance in building a digital database, the institute is given a wonderful chance to present the artist's literature in a diversified yet comprehensive way. In terms of developing and studying the subjectivity of Taiwan history, such a strong reference should always be cherished and utilized by all.

President of the Academia Sinica
Nangang, Taipei
Wong Chi-huey
2012.3

總主編 序

作為臺灣第一代西畫家，陳澄波幾乎可以和「臺灣美術」劃上等號。這原因，不僅僅因為他是臺灣畫家中入選「帝國美術展覽會」（簡稱「帝展」）的第一人，更由於他對藝術創作的投入與堅持，以及對臺灣美術運動的推進與貢獻。

出生於乙未割臺之年（1895）的陳澄波，父親陳守愚先生是一位精通漢學的清末秀才；儘管童年的生活，主要是由祖母照顧，但陳澄波仍從父親身上傳承了深厚的漢學基礎與強烈的祖國意識。這些養分，日後都成為他藝術生命重要的動力。

1917年臺灣總督府國語學校畢業，1918年陳澄波便與同鄉的張捷女士結縭，並分發母校嘉義公學校服務，後調往郊區的水崛頭公學校。未久，便因對藝術創作的強烈慾望，在夫人的全力支持下，於1924年，服完六年義務教學後，毅然辭去人人稱羨的安定教職，前往日本留學，考入東京美術學校圖畫師範科。

1926年，東京美校三年級，便以〔嘉義街外〕一作，入選第七回「帝展」，為臺灣油畫家入選之第一人，震動全島。1927年，又以〔夏日街景〕再度入選。同年，本科結業，再入研究科深造。

1928年，作品〔龍山寺〕也獲第二屆「臺灣美術展覽會」（簡稱「臺展」）「特選」。隔年，東美畢業，即前往上海任教，先後擔任「新華藝專」西畫科主任教授，及「昌明藝專」、「藝苑研究所」等校西畫教授及主任等職。此外，亦代表中華民國參加芝加哥世界博覽會，同時入選全國十二代表畫家。其間，作品持續多次入選「帝展」及「臺展」，並於1929年獲「臺展」無鑑查展出資格。

居滬期間，陳澄波教學相長、奮力創作，留下許多大幅力作，均呈現特殊的現代主義思維。同時，他也積極參與新派畫家活動，如「決瀾社」的多次籌備會議。他生性活潑、熱力四射，與傳統國畫家和新派畫家均有深厚交誼。

唯1932年，爆發「一二八」上海事件，中日衝突，這位熱愛祖國的臺灣畫家，竟被以「日僑」身份，遭受排擠，險遭不測，並被迫於1933年離滬返臺。

返臺後的陳澄波，將全生命奉獻給故鄉，邀集同好，組成「臺陽美術協會」，每年舉辦年展及全島巡迴展，全力推動美術提升及普及的工作，影響深遠。個人創作亦於此時邁入高峰，色彩濃郁活潑，充份展現臺灣林木翁鬱、地貌豐美、人群和善的特色。

1945年，二次大戰終了，臺灣重回中國統治，他以興奮的心情，號召眾人學說「國語」，並加入「三民主義青年團」，同時膺任第一屆嘉義市參議會議員。1947年年初，爆發「二二八事件」，他代表市民前往水上機場協商、慰問，卻遭扣留羈押；並於3月25日上午，被押往嘉義火車站前廣場，槍決示眾，熱血流入他日夜描繪的故鄉黃泥土地，留給後人無限懷思。

陳澄波的遇難，成為戰後臺灣歷史中的一項禁忌，有關他的生平、作品，也在許多後輩的心中逐漸模糊淡忘。儘管隨著政治的逐漸解嚴，部分作品開始重新出土，並在國際拍賣場上屢創新高；但學界對他的生平、創作之理解，仍停留在有限的資料及作品上，對其獨特的思維與風格，也難以一窺全貌，更遑論一般社會大眾。

以「政治受難者」的角色來認識陳澄波，對這位一生奉獻給藝術的畫家而言，顯然是不公平的。歷經三代人的含冤、忍辱、保存，陳澄波大量的資料、畫作，首次披露在社會大眾的面前，這當中還不包括那些因白蟻蛀蝕

而毀壞的許多作品。

　　個人有幸在1994年，陳澄波百年誕辰的「陳澄波‧嘉義人學術研討會」中，首次以「視覺恆常性」的角度，試圖詮釋陳氏那種極具個人獨特風格的作品；也得識陳澄波的長公子陳重光老師，得悉陳澄波的作品、資料，如何一路從夫人張捷女士的手中，交到重光老師的手上，那是一段滄桑而艱辛的歷史。大約兩年前（2010），重光老師的長子立栢先生，從職場退休，在東南亞成功的企業經營經驗，讓他面對祖父的這批文件、史料及作品時，迅速地知覺這是一批不僅屬於家族，也是臺灣社會，乃至近代歷史的珍貴文化資產，必須要有一些積極的作為，進行永久性的保存與安置。於是大規模作品修復的工作迅速展開；2011年至2012年之際，兩個大型的紀念展：「切切故鄉情」與「行過江南」，也在高雄市立美術館、臺北市立美術館先後且重疊地推出。眾人才驚訝這位生命不幸中斷的藝術家，竟然留下如此大批精采的畫作，顯然真正的「陳澄波研究」才剛要展開。

　　基於為藝術家留下儘可能完整的生命記錄，也基於為臺灣歷史文化保留一份長久被壓縮、忽略的珍貴資產，《陳澄波全集》在眾人的努力下，正式啟動。這套全集，合計十八卷，前十卷為大八開的巨型精裝圖版畫冊，分別為：第一卷的油畫，搜羅包括僅存黑白圖版的作品，約近300餘幅；第二卷為炭筆素描、水彩畫、膠彩畫、水墨畫及書法等，合計約241件；第三卷為淡彩速寫，約400餘件，其中淡彩裸女占最大部分，也是最具特色的精采力作；第四卷為速寫（I），包括單張速寫約1103件；第5卷為速寫（II），分別出自38本素描簿中約1200餘幅作品；第六、七卷為個人史料（I）、（II），分別包括陳氏家族照片、個人照片、書信、文書、史料等；第八、九卷為陳氏收藏，包括相當完整的「帝展」明信片，以及各式畫冊、圖書；第十卷為相關文獻資料，即他人對陳氏的研究、介紹、展覽及相關周邊產品。

　　至於第十一至十八卷，為十六開本的軟精裝，以文字為主，分別包括：第十一卷的陳氏文稿及筆記；第十二、十三卷的評論集，即歷來對陳氏作品研究的文章彙集；第十四卷的二二八相關史料，以和陳氏相關者為主；第十五至十七卷，為陳氏作品歷年來的修復報告及材料分析；第十八卷則為陳氏年譜，試圖立體化地呈現藝術家生命史。

　　對臺灣歷史而言，陳澄波不只是個傑出且重要的畫家，同時他也是一個影響臺灣深遠（不論他的生或他的死）的歷史人物。《陳澄波全集》由財團法人陳澄波文化基金會和中央研究院臺灣史研究所共同發行出版，正是名實合一地呈現了這樣的意義。

　　感謝為《全集》各冊盡心分勞的學界朋友們，也感謝執行編輯賴鈴如、何冠儀兩位小姐的辛勞；同時要謝謝藝術家出版社何政廣社長，尤其他的得力助手美編柯美麗小姐不厭其煩的付出。當然《全集》的出版，背後最重要的推手，還是陳重光老師和他的長公子立栢夫婦，以及整個家族的支持。這件歷史性的工程，將為臺灣歷史增添無限光采與榮耀。

<div align="right">
《陳澄波全集》總主編

國立成功大學歷史系所教授　蕭瓊瑞
</div>

Foreword from the Editor-in-Chief

As an important first-generation painter, the name Chen Cheng-po is virtually synonymous with Taiwan fine arts. Not only was Chen the first Taiwanese artist featured in the Imperial Fine Arts Academy Exhibition (called "Imperial Exhibition" hereafter), but he also dedicated his life toward artistic creation and the advocacy of art in Taiwan.

Chen Cheng-po was born in 1895, the year Qing Dynasty China ceded Taiwan to Imperial Japan. His father, Chen Shou-yu, was a Chinese imperial scholar proficient in Sinology. Although Chen's childhood years were spent mostly with his grandmother, a solid foundation of Sinology and a strong sense of patriotism were fostered by his father. Both became Chen's Office impetus for pursuing an artistic career later on.

In 1917, Chen Cheng-po graduated from the Taiwan Governor-General's Office National Language School. In 1918, he married his hometown sweetheart Chang Jie. He was assigned a teaching post at his alma mater, the Chiayi Public School and later transferred to the suburban Shuikutou Public School. Chen resigned from the much envied post in 1924 after six years of compulsory teaching service. With the full support of his wife, he began to explore his strong desire for artistic creation. He then travelled to Japan and was admitted into the Teacher Training Department of the Tokyo School of Fine Arts.

In 1926, during his junior year, Chen's oil painting *Outside Chiayi Street* was featured in the 7th Imperial Exhibition. His selection caused a sensation in Taiwan as it was the first time a local oil painter was included in the exhibition. Chen was featured at the exhibition again in 1927 with *Summer Street Scene*. That same year, he completed his undergraduate studies and entered the graduate program at Tokyo School of Fine Arts.

In 1928, Chen's painting *Longshan Temple* was awarded the Special Selection prize at the second Taiwan Fine Arts Exhibition (called "Taiwan Exhibition" hereafter). After he graduated the next year, Chen went straight to Shanghai to take up a teaching post. There, Chen taught as a Professor and Dean of the Western Painting Departments of the Xinhua Art College, Changming Art School, and Yiyuan Painting Research Institute. During this period, his painting represented the Republic of China at the Chicago World Fair, and he was selected to the list of Top Twelve National Painters. Chen's works also featured in the Imperial Exhibition and the Taiwan Exhibition many more times, and in 1929 he gained audit exemption from the Taiwan Exhibition.

During his residency in Shanghai, Chen Cheng-po spared no effort toward the creation of art, completing several large-sized paintings that manifested distinct modernist thinking of the time. He also actively participated in modernist painting events, such as the many preparatory meetings of the Dike-breaking Club. Chen's outgoing and enthusiastic personality helped him form deep bonds with both traditional and modernist Chinese painters.

Yet in 1932, with the outbreak of the 128 Incident in Shanghai, the local Chinese and Japanese communities clashed. Chen was outcast by locals because of his Japanese expatriate status and nearly lost his life amidst the chaos. Ultimately, he was forced to return to Taiwan in 1933.

On his return, Chen devoted himself to his homeland. He invited like-minded enthusiasts to found the Tai Yang Art Society, which held annual exhibitions and tours to promote art to the general public. The association was immensely successful and had a profound influence on the development and advocacy for fine arts in Taiwan. It was during this period that Chen's creative expression climaxed — his use of strong and lively colors fully expressed the verdant forests, breathtaking landscape and friendly people of Taiwan.

When the Second World War ended in 1945, Taiwan returned to Chinese control. Chen eagerly called on everyone around him to adopt the new national language, Mandarin. He also joined the Three Principles of the People Youth Corps, and served as a councilor of the Chiayi City Council in its first term. Not long after, the 228 Incident broke out in early 1947. On behalf of the Chiayi citizens, he went to the Shueishang Airport to negotiate with and appease Kuomintang troops, but instead was detained and imprisoned without trial. On the morning of March 25, he was publicly executed at the Chiayi Train Station Plaza. His warm blood flowed down onto the land which he had painted day and night, leaving only his works and memories for future generations.

The unjust execution of Chen Cheng-po became a taboo topic in postwar Taiwan's history. His life and works were gradually lost to the minds of the younger generation. It was not until martial law was lifted that some of Chen's works re-emerged and were sold at record-breaking prices at international auctions. Even so, the academia had little to go on about his life and works due to scarce resources. It was

a difficult task for most scholars to research and develop a comprehensive view of Chen's unique philosophy and style given the limited resources available, let alone for the general public.

Clearly, it is unjust to perceive Chen, a painter who dedicated his whole life to art, as a mere political victim. After three generations of suffering from injustice and humiliation, along with difficulties in the preservation of his works, the time has come for his descendants to finally reveal a large quantity of Chen's paintings and related materials to the public. Many other works have been damaged by termites.

I was honored to have participated in the "A Soul of Chiayi: A Centennial Exhibition of Chen Cheng-po" symposium in celebration of the artist's hundredth birthday in 1994. At that time, I analyzed Chen's unique style using the concept of visual constancy. It was also at the seminar that I met Chen Tsung-kuang, Chen Cheng-po's eldest son. I learned how the artist's works and documents had been painstakingly preserved by his wife Chang Jie before they were passed down to their son. About two years ago, in 2010, Chen Tsung-kuang's eldest son, Chen Li-po, retired. As a successful entrepreneur in Southeast Asia, he quickly realized that the paintings and documents were precious cultural assets not only to his own family, but also to Taiwan society and its modern history. Actions were soon taken for the permanent preservation of Chen Cheng-po's works, beginning with a massive restoration project. At the turn of 2011 and 2012, two large-scale commemorative exhibitions that featured Chen Cheng-po's works launched with overlapping exhibition periods "Nostalgia in the Vast Universe" at the Kaohsiung Museum of Fine Arts and "Journey through Jiangnan" at the Taipei Fine Arts Museum. Both exhibits surprised the general public with the sheer number of his works that had never seen the light of day. From the warm reception of viewers, it is fair to say that the Chen Cheng-po research effort has truly begun.

In order to keep a complete record of the artist's life, and to preserve these long-repressed cultural assets of Taiwan, we publish the *Chen Cheng-po Corpus* in joint effort with coworkers and friends. The works are presented in 18 volumes, the first 10 of which come in hardcover octavo deluxe form. The first volume features nearly 300 oil paintings, including those for which only black-and-white images exist. The second volume consists of 241 calligraphy, ink wash painting, glue color painting, charcoal sketch, watercolor, and other works. The third volume contains more than 400 watercolor sketches most powerfully delivered works that feature female nudes. The fourth volume includes 1,103 sketches. The fifth volume comprises 1,200 sketches selected from Chen's 38 sketchbooks. The artist's personal historic materials are included in the sixth and seventh volumes. The materials include his family photos, individual photo shots, letters, and paper documents. The eighth and ninth volumes contain a complete collection of Empire Art Exhibition postcards, relevant collections, literature, and resources. The tenth volume consists of research done on Chen Cheng-po, exhibition material, and other related information.

Volumes eleven to eighteen are paperback decimo-sexto copies mainly consisting of Chen's writings and notes. The eleventh volume comprises articles and notes written by Chen. The twelfth and thirteenth volumes contain studies on Chen. The historical materials on the 228 Incident included in the fourteenth volumes are mostly focused on Chen. The fifteen to seventeen volumes focus on restoration reports and materials analysis of Chen's artworks. The eighteenth volume features Chen's chronology, so as to more vividly present the artist's life.

Chen Cheng-po was more than a painting master to Taiwan — his life and death cast lasting influence on the Island's history. The *Chen Cheng-po Corpus*, jointly published by the Chen Cheng-po Cultural Foundation and the Institute of Taiwan History of Academia Sinica, manifests Chen's importance both in form and in content.

I am grateful to the scholar friends who went out of their way to share the burden of compiling the corpus; to executive editors Lai Ling-ju and Ho Kuan-yi for their great support; and Ho Cheng-kuang, president of Artist Publishing co. and his capable art editor Ke Mei-li for their patience and support. For sure, I owe the most gratitude to Chen Tsung-kuang; his eldest son Li-po and his wife Hui-ling; and the entire Chen family for their support and encouragement in the course of publication. This historic project will bring unlimited glamour and glory to the history of Taiwan.

Editor-in-Chief, *Chen Cheng-po Corpus*
Professor, Department of History, National Cheng Kung University
Hsiao Chong-ray

Chong-ray Hsiao

澄波重現——簡論陳澄波作品的保存與維護

一、前言

　　陳澄波是臺灣接受西方繪畫黎明期的代表，也是臺灣接收現代藝術教育的先驅者。在學院派的教育下，他跳脫出群體化的藝術教育系統，強烈而執著的特質展現了獨特的風格與情操，被稱為「學院中的素人畫家」。

　　2010年在大眾殷切的期盼下，陳澄波文化基金會（以下簡稱基金會）著手開始規畫2014年「陳澄波百二誕辰東亞巡迴大展」的一系列活動，目的是希望以陳澄波的各式作品來帶出他對於藝術的熱情與躍動的生命力，將這位自期如「油彩的化身」的藝術家創作的本質與態度如實呈現。規畫在此展中的作品也因為這個要素，包含了多種樣式的作品，跨含多類媒材，如西方的油畫、水彩、鉛筆、炭筆、鋼筆、粉彩、設計等，東方的膠彩、水墨、書法、底稿等。《陳澄波全集》第15-17卷都是以介紹修復為主的專文或作業內容集結而成，作品分別由三個修復單位主持，在15和16卷的前段是介紹國立臺灣師範大學藝術學院文物保存維護研究發展中心（以下簡稱師大文保中心）完成的修復作品內容，15卷是紙質類作品、16卷的前段則是介紹東京藝術大學與師大文保中心結盟合作修復的油畫作品和文物。16卷後段是由另一位修復師林煥盛先生的「臺北文化財保存研究所」所負責修復的相關生活史料與東方繪畫，第17卷則是由「私立正修科技大學文物修護中心」負責執筆。本文以下將逐一介紹第15-16卷各類型作品在各修復單位的作業過程紀錄與修復對策的專文，藉由這些作品、史料在展前的修復過程與展示中的呈現方式結合為一個完整、透明化的保存過程，將當時在藝術、教育、藝壇風潮與陳澄波心中的創作訊息等，更完整的從各角度詮釋他傳奇而短暫的一生。

二、師大文保中心

　　師大文保中心在此案中所負責的項目幾乎概括全部的類型，從油畫、東方繪畫（膠彩、水墨、書法）、水彩、鉛筆、炭筆、鋼筆、粉彩、設計等，以及底稿、遺書（共計1,012件、素描簿29本）面對如此完整、龐大的數量與緊迫的展示目標，保存修復的任務已不僅是單純修復技術的介入，而是必須在有限的時間內快速整合修復方針與研發適合的安全配套系統。修復目標除了著手修復各類文物長久以來的老化損弱狀況之外，亦需確保在日後與接下來的一連串展示、移動中保持最安全的狀況。除此之外，為了在多樣的作品中確保修復作業的完整性，並使修復效果能充分發揮作品價值（研究價值、展示價值、市場價值），師大文保中心將此案劃分為下述三種不同意義的修復方針：

　　1.「既定藝術形式」作品的修復方針：共計37件：油畫36件，膠彩1件。

　　2.「兼具史料意義」作品的修復方針：共計素描簿29本、963件作品（水彩71件、炭筆素描71件、鉛筆單頁速寫763件、素描簿附件6件、水墨7件、書法23件、設計底稿4件、剪紙4件、插畫4件、裸女淡彩9件、粉彩1件）。

　　3.「史料文物類」的修復方針：共計12件：遺書9件、受難著服2件、相片1件。

（一）修復專案設立

　　國立臺灣師範大學文保中心成立於2009年，是一個綜合教育、研究與執行修復任務的專業領域，成立之初是以維護師大的校藏品[1]為主要任務，同時也承接校外修復委託案。2011年中心承接基金會的託付，成立陳澄波作品修復團隊負責此案，團員中最大的特色就是歌田真介、木島隆康二位教授與他們的高徒鈴鴨富士子博士的加入，這三位來自於東京藝術大學也就是從前的東京美術學校、陳澄波的母校，主導此案中油畫作品的調查研究與修復。

　　日本東京藝術大學是一個非常重視校友情誼的學校，各種不同分野的學生常會在不同的課程、古美術研究旅行或是藝祭、各種競賽、展覽活動中交流。校內有一個奇怪的風氣，就是大家都很喜歡逗留在學校，窩在研究室裡不停的創作、摸索，休息的時候也喜歡到別人的研究室串串門子，甚至深夜也偷偷躲著校警繼續作業。這種彼此之間互相切磋、打氣、競爭的風氣，加上古老的校區也不是很大，所以師生之間也都不陌生，畢業後校友之間仍互相關心或是透過各種管道保持聯繫。此次修復計劃最早也是由於校友的串聯與母校的支持，如基金會董事長陳立栢先生在〈轉身，擁抱驕陽——陳立栢與阿公心底的約定〉中所述：「直到1997年，時任北美館館長林曼麗館長引介東京藝術大學修復師歌田真介，將作品送到東京修復。歌田真介為表達對校友的愛護，將〔岡〕與〔嘉義街景〕的修復轉作教學案，支付四成修復費，剩餘六成再由陳重光籌款。」[2]

　　歌田教授是日本西畫修復的先驅者，除了修復的技法與經驗一流之外，對於明治時期當時日本接收西方影響的歷史、傳承與繪畫材料技法等相關研究可謂是第一人，他自藝大「技法材料科」畢業之後致力於油畫保存修復技術，曾擔任創形美術學校修復研究所的所長、東京藝術大學教授，在校任職期開創油畫保存修復科兼任第一任藝大美術館長。他的重要著作《解剖油畫——從修復家的立場看日本西畫史》[3]一書，將幕府晚期到明治時期這一段受西方繪畫影響的「激動期」中的先驅者高橋由一、黑田清輝、岸田劉生等代表作家的特色，從修復現場、油畫創作技法、顏料畫布等材料技法開始，深入探討日本在接受西方思想影響後，對於繪畫空間、光線、描寫方式、畫面的切入手法等問題，是一部全面性探討繪畫材料技法與繪畫歷史變遷的重要書籍。歌田教授退休之後轉任榮譽教授，並薦舉他的得意門生木島教授接任藝大的研究室，持續進行多項重要的研究與修復計劃，是日本結合修復實務、教學研究、國際修復派遣隊的重要修復研究室。

　　木島教授繼1998年臺北市立美術館的七件（其中陳澄波二幅）重要藏品委託修復[4]之後，2007年又繼續承接基金會委託修復三幅，先後共完成五幅陳澄波的重要代表作品。2011年師大文保中心成立「陳澄波作品修復專案」之後，鈴鴨博士也隨後加入團隊，修復的陣地正式轉移地點至師大文保中心。這個決定除了作品得以在現地修復，隨時可以掌握與家屬們的訊息與意見之外，更直接地因為國外師資、技術的導入而培養了一批新生代的修復師。只是老師們三年間的辛勞幾乎每月一次的往返，其中甚至二次在中心度過他們的正月新年，走筆至此不禁再次要對他們的付出表達衷心的感激之意。藉由陳立栢先生所述：「師大的文保中心邀請歌田真介的學生木島隆康擔任基金會師大修復案的主持人，這兩年多來，他的行為令我非常感動：幾乎每個月都帶助手鈴鴨富士子來台，且依國科會計價標準，住師大宿舍、吃小吃，至今將近三年。這（收價）大概差了三到五倍。後來，木島把修復所有收入通通捐給文保中心，等於一塊錢都沒拿。我真的被感動了。是他推廣我，是他讓我知道『再不好好正確

17

地健康修復，那麼將失去所有日後要推廣的媒介』」[5]。

　　鈴鴨博士是木島教授的得意門生，秀外慧中的她在專業上的精優當然也毋庸置疑，是日本學院派新生代修復家的代表。特別的是鈴鴨博士原以優異的成績畢業於日本醫科大學之後又毅然決定轉入木島教授的研究室，投身於最愛的文物保存修復專業。除了精研一般修復技術之外，她之前的醫學專業也使得她不同於一般來自於藝術分野的修復師，對理化、科技、材料分析方面更是得心應手。在團隊中除了修復作業之外，鈴鴨老師還要負責日台雙方的聯繫、修復的進度規畫與整合。個性沈穩而待人誠懇親切的她，不論旅途多麼勞累，永遠面帶微笑的處理每一項繁雜瑣事，耐心的對年輕學子們不厭其煩地解說、細心確認每一步驟。看著文靜的她穿著白袍在充滿「患者」的修復室中穿梭，讓人不禁聯想到小時候常聽到南丁格爾的故事幾乎是一樣的情節，對「真誠的付出是一種幸福」是最好的詮釋。修復家是文物的醫療人員，能夠有這樣的人格修養與文保專業，同時又有熱愛藝術的情操，實在是不可多得的人才。

（二）師大專文簡介

　　此書是綜合此次修復專案的思維、技法、研究加以說明分類為11篇專文集結成冊，內容是以串聯、說明作品特色與修復技術為前提，然因排版編輯的原因，將專文分為紙質類修復（第15卷）與油畫修復（第16卷前段）二個區塊，雖然各文章之執筆者不同，但是實際操作時許多作業細節與分工都是經過討論後制定規範的修復方針再經整個團隊相互配合完成的，紙質方面的專文如下：

（1）紙質類修復專文

　　修復方針是為了輔助修復倫理原則[6]的方向性，它的作用是為了在龐大而繁複的修復作業中，建立一個共同指標，達到整合性的效果。除此之外，一件作品、文物的價值可分為研究價值、展示價值與市場價值，方針的制定也是為了防止在修復過程中忽略或扭曲作品、文物所涵蘊的價值性。接下來的論述是針對此案對象物（共計1,012件、素描簿29本）中扣除油畫36件之後的紙質類作品的修復作業，對象物如水墨、書法、水彩、素描（鉛筆、炭筆）、素描簿、遺書等各式修復技法的分類與運用介紹。

　　紙質文物類的修復作業在亞洲一直與傳統裝裱、東方書畫有著密切的關係，裝裱的技法從古代中國開始傳達至鄰近的韓、日、東南亞等地區影響深遠，近代在西方國家也開始認識、認同裝裱技術有助於修護專業的提升，並開始研究、應用。但是當文化上的習慣性處理變成過度依賴的手段時，有時需重新對「適切性」的拿捏再度評估。例如書籍、西方繪畫（水彩、版畫、素描、檔案等）、染織品、唐卡、拓片、照片等，常發生「西畫中裱」或是厚度重量改變過大、凹凸版被過度攤平、破壞質感等問題。

　　陳澄波的紙質作品對時代意義而言，代表著臺灣跳脫出傳統中國藝術樣式第一批接收西方美術教育洗禮的歷史背景，因此在大量的作品中看到素描、寫生、靜物等隨著他的生活腳步紀錄的作品。媒材與構圖形式上也受到西方的影響像炭筆、水彩、鉛筆、寫生簿、素描簿等，基底材亦有大量西方輸入或受西方影響而製作的紙張，因此在保留歷史特徵的思維上，西方紙質作品應該以西方修復的技法為主。然而受到當時世界潮流機械化大量造紙

的影響，即便如陳澄波這樣注重材料的藝術家也無法未卜先知的避開「酸性紙」[7]的後遺症──紙張因為製作、處理的流程造成酸性體質，日後容易出現黃化與脆化的問題。這不僅是陳澄波作品的問題，全世界的藝術作品、重要書籍、檔案、照片等幾乎都面臨著同樣的危機，甚至至今仍然持續製造、發生。如何將此類酸性紙張以適當的方式維護是後段逐篇探討的重點，先根據作業內容分類出以下5篇相關文章：

1. 張元鳳著〈技術、美學與文化性的探討──以陳澄波作品保存修復為例〉
2. 彭元興、徐建國著〈探微觀紙──紙張纖維玻片製作及種類判定〉
3. 丁婉仟著〈陳澄波書法及水墨作品修復〉
4. 陳詩薇著〈多樣性：中國、臺灣、日本紙張用於填補和補強的修復應用與思維〉
5. 李季衡著〈陳澄波紙質作品修復──多面向探討保存修復材料之應用〉

〈技術、美學與文化性的探討──以陳澄波作品保存修復為例〉此文的重點為如何設定修復方針與整合修復作業，內容中探討「托裱」技法的置入問題。雖然大家都認同作品經過中式小托的強化與攤平後，有利於後續管理的便利與安定性，但基於文化因素與文物的本質應該被尊重的原則，筆者將作業的步驟與處理重新調整與整合，特別是針對西式紙質作品的強化、保存、展示等規畫引用了一些新的理念，如材質上導入有「蜉蝣羽翅」之稱的「典具帖」[8]的應用設計、無酸裝框、夾裱與展示系統等以尊重作品的文化特色。分別針對「強化作品─典具帖的應用」與「保護作品─無酸夾裱應用」二個方向論述。

另外，修復師除了致力於科學、技術的進階之外，有鑒於此次修復計畫中已經有不久之前甫修復，但竟在短時間又面臨「重修」的案例出現，重修過程中除了警惕、告誡文物修復師的修復倫理原則之外，筆者基於教育者的立場，在文保的專業發展中初探「修復美學」的重要性，將藝術與技術之間、主觀與客觀之間保留適度的、可對話性的空間，以供未來規畫的可協調性。

〈探微觀紙──紙張纖維玻片製作及種類判定〉為彭元興老師與徐建國老師擔任紙張纖維鑑識的心得報告。兩位老師都是國內造紙業界的知名學者，而徐老師任職的林業試驗所更是人才濟濟，如之前的王國財先生與夏滄琪教授等，都是熱心致力於紙張研究與文保研發的名家。徐老師是臺灣手工紙研究先驅張豐吉教授與十餘年前活躍於國內的松雲山房岑德麟大師的門生，除了熟習各種紙質類文物的修復技法之外，對於紙張鑑識與製造不但累積了多年的實務經驗，更對於古代紙張的技術再現與客觀的科學辨識方法，分辨出各式各樣的纖維與紙張特質，在此也藉此文感謝兩位老師於百忙之中鼎力相助。陳澄波的紙質作品跨越東、西，有中式、日式與各種當時日本進口的西方紙張，這些紙張中所混合的纖維除了可代表當時藝術界常用紙張，也是修復作業開始的基本判斷，對於修復作業的進行是重要的明燈。

看過陳澄波的書法與水墨字跡嗎？如何在驚喜與戒慎恐懼的心情下完成陳澄波青春時期罕見的習作。丁婉仟這篇〈陳澄波書法及水墨作品修復〉雖然平靜地在有限的字數內介紹了書法與水墨的修復過程，但是對本人而言從接觸作品的瞬間震撼到點收、檢測、紀錄、規畫、執行、驗收、資料收集、運輸、掃描、點交，在一連串的緊湊節拍下結束，事後在報告撰寫時不由想起許多嘔心瀝血的夜晚，與許多意猶未盡、卻只能眼睜睜地看著作品被

專車運回基金會的不捨。「如果再給我多一點時間、請再讓我多看一眼！」這種感覺相信不僅是丁助理，接下來的二篇文章，甚至團隊的每一個成員都有相同的感覺。這樣大量的重要作品與資料在正常的情形下應該是一、二件，頂多也是以個位數的狀況下進入修復室，耗時數月以上的時間細細修復。此次的緊鑼密鼓之下，即便每位修復師都善盡心力、竭盡畢生所學使作品如其所願地安全交回基金會。但是即便驗收作業依序完成（數度提出延後交件的終於成果），三年間的朝夕相處仍然覺得時間太短（平均算起來一件作品只有一天左右），所以深怕有遺漏的地方卻來不及再多看一眼的心情至今依然難以平復。書法的字跡上看出陳澄波認真的學子之心，旁邊的朱批雖然已經由艷朱轉為暗赭，依然感受到指導老師諄諄教誨的愛惜與用心，也不禁聯想當時從日本全國各地精選入學的菁英份子皆被視為明日之星（将来の芸術家の玉子）的授課風景。因此這類典型的「兼具史料意義」作品，因為身兼歷史與作者風格，常會因為觀者的立場不同而對修復結果產生不同的見解。文中介紹陳澄波先生1924至1927年間未經托裱的23件書法與7件水墨共計30件紙本，並將變色與未變色朱墨以X射線螢光分析儀（XRF）非破壞檢測後與傳統鉛丹墨及朱砂墨比對後探討變色的原因，再將此類修復方針以東方裝裱的文化特質完成，包含使用修復專用的漿糊、小托命紙、加托強化、填補缺損、全色、鑲貼綾絹等步驟介紹。

與上篇論調接近但完全以西方文化元素為重點的是陳詩薇的〈多樣性：中國、臺灣、日本紙張用於填補和補強的修復應用與思維〉，此文敘述陳澄波的紙質作品中以素描、水彩、素描簿等西方形式的紙張的劣化處理過程。詩薇是受西方修復教育的碩士，畢業後來臺專攻跨東、西文化的修復策略與技術，此次修復重點是發揮西方強項的除酸作業，以確保作品脫離酸性體質，日後趨向穩定的中性體質。「除酸」—將作品的酸性體質在安全的範圍之內改變近趨中性，並且以中性的保護材質設計出防止作品繼續酸化的環境，是保存事項中最主要的安全重點。此技法在西方專業中已發展多年，但在處理不同對象物時如何適度調整則是各修復室的特色。除酸以外的技法策畫，例如紙板水彩是使用乾、濕式紙漿纖維兩階段式的填補破損技法，素描簿是綜合純紙纖維、宣紙、臺灣楮皮紙、典具帖、細川紙的廣泛應用，以及保護單線圈裝訂型式的素描簿而製作的複合式裝幀與加寬書背的介紹等，在材料技法使用上雖然涵括多樣式，但盡量將西方特質帶出的呈現方式是此文的特殊與有趣之處。

李季衡在團隊中是資歷較淺的修復助理，但是他對修復的熱忱與用心是大家公認的超級助理，此篇〈陳澄波紙質作品修復——多面向探討保存修復材料之應用〉便是以介紹基礎材料為主，分別說明修復專用材料的特質與使用方法。文章內用心撰寫此次紙質作品的保存修復材料的選擇及其特性，從無酸材料之化學性層面到文物修復倫理原則之哲學性層面探討材料選擇的重要性。作品從修復完成離開修復室開始，這些文物將持續經過運輸、展示、典藏、甚至百年之後的再次維修，強調文物保護材料的選擇與用心更是一門學問。結束此案後季衡亦負笈千里遠赴德國深造，謹藉此祝福將來立志要成為修復師一員的他一帆風順、學業有成。

（2）油畫修復專文
　　第16卷前半部是東京藝術大學的三位專家來臺與師大文保中心結盟合作修復的油畫作品專文，內容是以日本修復家的三篇專文、國內鑑識專家一篇與文保中心修復師二篇，共計六篇如下：
　　1. 歌田眞介著〈關於陳澄波的作品〉

2. 木島隆康著〈從修復作品看陳澄波的繪畫技法與作品再修復〉

3. 鈴鴨富士子著〈陳澄波的油畫——透過修復作品看繪畫材料〉

4. 黃曉雯、張維敦著〈陳澄波油畫打底材料與現代油畫材料中元素組成之比較〉

5. 王瓊霞著〈陳澄波的木板油畫調查研究與修復〉

6. 葉濱翰著〈文保中心油畫修復材料介紹與案例〉

前三篇分別針對歷史、風格、以及此案之修復技法、繪畫材料技法等詳述說明，是根據實務修復作業與研究而累積的經驗之談。三位日本專家將這些寶貴的經驗及技術無私地公開分享，不但是國內首次將日系油畫保存修復技術完整介紹的初例，更重要的是也藉由教學與實作，更縮短、加速了技術交流的腳步。

歌田教授的〈關於陳澄波的作品〉文中論及日本受到西方思想影響後繪畫的轉變過程，包含早期藝術家的源流、特徵、畫風、材料技法、日後發展脈絡等，從黎明期的西畫探討到學院派產生，最後站在一個制高點來探討日本畫壇以及以陳澄波為主的臺、日脈絡。這些早期的重要資料經過歌田教授言簡意賅的敘述下，清楚地看到早期日本在近代西化發展下的大環境中，針對亞洲油畫材料技法特別闢出的精彩評論。尤其文中花了相當的篇幅探討日本油畫變遷的過程，關於油畫的材料與體質方面，他認為「明治早期作品（脂派／紫派）的結構非常堅實且質感緻膩，到了明治後半期之後，隨著時代的潮流趨勢，油畫顏料層的耐溶性能也跟著逐漸低下，顏料層易溶解於水的作品也隨之增加」[9]。他與好友森田恒之[10]共同認為早期油畫之所以稱為「油」畫，就是因為混合在顏料中的油呈現出的油性光澤與黏稠感的特徵而命名，因此文中強調「然而在油畫東傳的演變過程中，亞洲的畫家所重視的是新潮流下自由放任的創作表現，畫家們無時無刻不專注、快速地捕捉歐洲藝壇傳來的新趨勢，相對之下反而將支持表現新手法的材料技法這麼重要的基礎忽略……在這樣的風氣下，畫家開始添加了不適切的揮發性溶劑作為稀釋劑或混合使用以求快速，這就是『亞洲化』油畫的材質特徵」。

然而，相較於上述日本在一味追求新趣的環境下，陳澄波卻依然專注於油畫的基本特質，加上素樸的風格與充滿熱情的作畫方式，當視點從材料技法回歸到論及陳澄波個人風格時他認為「這位畫家（的作品）是具有油畫體質的，他讓油畫顏料的特質充分地發揮，並以此貼切的描繪出臺灣故鄉的風土。以當時的社會氛圍下的東洋人而言，他的存在是非常特異的、是能夠符合我心目中理想的藝術家條件的少數者之一」[11]。歌田教授描述陳澄波並非一味追求梵谷、塞尚、雷諾瓦等人，而是自然釋放他心中既有的模式與理想，在當時就是一位獨特、自我風格獨特的畫家，是「有國際性、可以代表亞洲的畫家」。因此「陳澄波在日的學習過程中，到底內心真正的想法是什麼呢？」綜合歌田教授在文中對他作品的高度評價，不難看出這位學者從陳澄波身上影射出他對日本西畫發展過程的偏失與不足之外，也包含著檢討的深層意涵。這些建言相對地也警惕著現代藝術家，什麼樣的藝術作品是可以被國際認同甚至永恆流世。

其次是木島教授的〈從修復作品看陳澄波的繪畫技法與作品再修復〉，他與歌田教授一樣，都是可以同時以藝術家、修復家二者兼具的立場直接論述的學者。如同木島教授穩重而直爽的個性一樣，此文的一開始便單刀直入地點出陳澄波繪畫的風格與技法特徵，這是綜合了繪畫材料技法發展、修復材料技法發展以及科技檢測驗證等依據集結的經驗下，再以簡明客觀的方式說明。木島教授最擅長使用這種從結構解剖的方式將作品特質一一敘

述：眼光銳利如鷹的他，一眼便可以排除後加修復或是老化的因素，直接洞察作品的本質。因此這篇來自一位熱愛藝術、拯救過無數名作的專家所撰寫的文章，將此次修復現場的實務記錄與觀察集結、濃縮而成的心得以不同的角度切入，絕對兼具了高度的準確性與權威性。不論是在藝術、修復、鑑賞上，都讓人感受到他的修為之所以如此讓人敬服，原因不外乎在他敏銳的洞察力與細膩的表現功力這些專業能力之外，我個人認為最重要的關鍵是他「同理心」善良懇切的態度與不牽強、不做作與坦然面對的特質，不單在待人接物上同時也表現在修復專業上，難怪許多複雜的作品到了他手中後便在不知不覺中順利完成，不愧是一位成功而讓人尊敬的「大師級」修復家。

　　從1998年受臺北市立美術館的委託，對〔嘉義街景〕（1934）、〔夏日街景〕（1927）二幅油畫作品進行修復後，2007年木島教授再次受到家族的委託，修復〔嘉義街中心〕（1934）、〔岡〕（1936）、〔女人〕（1931）三幅重要作品。此案從2011年開始修復36幅作品，技法承續先前的技法，一改國內傳統油畫的「直接托黏式」[12]強化技法為「非黏合式加襯loose lining」[13]之外，更發現作者細心、謙和的說明比較二種技法的理念與步驟上的差異性。文中以近年被蠟托裱過的陳澄波作品進行再次修復為例展開說明，該作品的問題並非僅因蠟托裱處理的技術選擇問題，而絕大部分是因為人為處理不當與態度錯誤，造成畫布基底材空鼓、顏料層因加壓加熱過度變形、補彩覆蓋原彩等問題，也是因為修復家的職業道德的鬆弛。其實此文論述的這些想法與實際的做法，一直是國內文保界在授業時不斷重申的倫理原則，因此文中除了讓修復家們再次了解國際性共識之外，藝術愛好者與文資相關者也可以藉此理解修復家自我約束的重要性。歷史與事實顯示在修復專業裡，眾多的材料與技法隨著不同時代與理念輾轉演變或是進化，材料技法本身沒有對錯是非之分，修復成敗其實決定在「態度」，一個明睿的修復家遵循國際公認的原則，適時選擇適當的材料技法並且忠於原創者的理念完成現階段的任務，目的是安全的移轉給下一個世代。面對老化脆弱的文物，修復是不得已的手段，無法「點石成金、一勞永逸」，正確的修復規畫與長遠的保存維護策略，才是與文物恆久共處之道。

　　與保存修復專業相輔相成的另一個重點是—材料技法發展史，這是理解當下社會人文、科技發展與國際間交流的重要輔助資料，它需要大量研究成果的累積，配合科技化、系統化的記錄管理才能建立成為實用的資料庫。建立一個確實的資料庫可以幫助客觀的比對記錄，從單一作品發展到地域、甚至文化DNA的特質。日本對於繪畫材料技法的調查配合修復案的推動，相關的資料累積已經有相當的成果，國內在近十年也由於非破壞科技的進步，資料收集的制度與績效亦持續成長。然而關於日臺之間的銜接卻付之闕如。鈴鴨博士的〈陳澄波的油畫──透過修復作品看繪畫材料〉因可算是首篇將兩國銜接的發表，針對陳澄波在東京美術學校圖畫師範科的最重要指導教授─田邊至，從他的教學、繪畫材料技法的特徵開始說明他在校時的影響。而受老師影響很大的陳澄波從學習期的東美時期、畢業後的上海風格轉換時期與返臺後，各時期作品經過比對、修復與精細科技檢測推算，規畫出其作品的材料特徵，從顏料、畫布、木板、紙板等均在此文中說明。現今非破壞檢測的頻繁使用情形下，大量資料雖可以方便檢出，但若無精確的判斷，反而造成一些似是而非的錯誤資訊。此文給我們一條非常清晰的指引—非破壞檢測在推敲出結論前需要熟習繪畫媒材、技法、程序與材料史，才能從大量的檢測物質中精準的挑出可能性物質並排除干擾物質，經過交叉比對篩選出最有可能的訊息，而非將訊息全部接收造成誤判。

〈陳澄波油畫打底材料與現代油畫材料中元素組成之比較〉是由張維敦教授所指導的博士生黃曉雯所撰寫。張教授是中央警察大學的鑑識科學專業的著名教授、著名刑事鑑識專家李昌鈺博士的傳人，除了教職之外更身兼「臺灣鑑識科學學會」理事長要職，是深具學術與辦案實務經驗的資深學者。張教授在參與此計畫之前便多次協助文保中心從事微物鑑識的專業技術，完成數次文物修復檢測的任務。此文是針對畫布打底用的展色劑所做的分析，使用掃描式電子顯微鏡／X射線能譜分析儀（SEM/EDS）的串聯系統，除了可得知樣品的表面形貌影像外，又可得到化學成分或是微細組織之相關資訊，具有非破壞性檢測、樣品前處理簡單等優點，因此十分適合在微量檢體檢測上之應用，對陳澄波的繪畫資料中無機材質的分析是國內第一次的嘗試，也是對於非破壞檢視的系統之外的另一種驗證技法，日後對於此類研究進路與培育保存科學年輕學者的加入，都會是一個重要的訊息與資料。

文保中心的修復師王瓊霞、葉濱翰二位雖然之前一直是以東方繪畫、紙質文物為第一專長，二人以既備的專業知識與教養在師大文保中心成立之後，在木島、鈴鴨二位教授的指導下，執行師大典藏品油畫的修復案行之餘年。此次除了共同加入油畫修復作業之外，王瓊霞提出〈陳澄波的木板油畫調查研究與修復〉而葉濱翰則提出〈文保中心油畫修復材料介紹與案例〉，這二篇文章除了介紹一般畫布為基底的作品修復之外，還有木板、紙板等不同基底材的油畫作品。除了修復技法之外，亦針對特質、纖維鑑定、材料運用等，成為國內首次介紹日本東京藝術大學油畫修復技法，將日本的論述、授課、實際執行等內容，鉅細靡遺地完整紀錄。修復內容彼此交流與公開的事項，是一開始便在最早1931年的《雅典憲章》中被特別提出要求的世界公約，此案具體的透明化實務記載與成果發表成為成功的國際交流案例，必可以成為業界參考與認同的重要資料。

六篇專文之後接著是油畫的修復報告書，除了將不同基底材區分並過程記錄之外，最重要的是將油畫作品依照「初次修復」與「再修復」二種類型處理。修復作業主要的任務是解除因自然老化、環境因素造成的損傷加以整理、維護、強化以延長作品壽命是最大目標，通常在適當的修復後都希望作品能在百年之內平安度過（適宜的保存環境與制度規畫下）。但是此案中再修復的作品僅不過歷經三、四年左右便需重修，主因是前次修復技法措施應用不當，因此修復者對作品狀況錯誤的判斷與粗劣行為對作品所造成的二次傷害之大是難以想像的。

三、林煥盛「臺北文化財保存研究所」

第16卷後段是「臺北文化財保存研究所」的林煥盛先生所負責修復的作品修復過程介紹，林先生是一位傑出而自我要求甚高的修復師，在日本京都著名的宇佐美松鶴堂學習書畫修復開始，數十年來他對東方書畫的保存修復始終抱持著相當的熱忱與挑戰，除了設立「臺北文化財保存研究所」的工作室之外，現在亦擔任雲林科技大學文資所的教師。在此次修復案中，負責處理膠彩畫、淡彩、書畫掛軸類以及藏書、手稿、明信片、東京美術學校圖畫師範科畢業證書、美術圖片等生活資料等多項品目。從2010開始到2013年，三年中完成修復如此數量的效率與成績，南北的奔波勞累亦可想而知。一個有使命感的修復家如林煥盛先生所言「希望保存上能提供出最適宜的處置之外，也能透過修復，詮釋陳澄波的『再現』」，故特於16卷的後段集結了他精彩的努力與成果。

四、結語

　　此次修復的陳澄波作品除了配合大展的參展作品之外，修復計畫幾乎包含了基金會所有已知的作品與文獻類，參與的修復單位更網羅國內、外各大重要修復團隊。文保專業教育在國內已推動十數年，但是一個非政府單位的民間基金會能夠在臺灣的文化界刮起如此颶風，回想當時實在是從一個讓人又怕又期待的事件開始。如今此案得到圓滿的成果，甚至讓海外參與的人士、專業團隊也領會到臺灣社會人文如此高水準的表現，深感師大文保中心能參與此案實在是莫大的榮幸。三年的經歷中，上千件需要修復的龐大工作量與修復期間作品安全管理的壓力，雖曾經令人感覺沈重、焦慮與忐忑，但是如今回想起來，欣慰與肯定卻是記憶中的絕大部分。

　　修復計畫執行中，由於同時必須與其他項目緊密配合，負責聯繫與整合的基金會總是不辭辛勞地穿梭奔波在各單位之間，將必須同時進行的展覽規畫、出版文宣、佈展、運輸、典藏、學術研討、國際交流、教育推廣……等一一到位，並力求完善的如期完成。基金會對於每一個狀況、細節、整合都事必躬親、不辭辛苦的嘗試、挑戰、積極的態度，更是此項國際巡迴大展能夠圓滿達成的最主要因素。雖然執行中許多思維、做法、行程曾遇到過困難或不順利，但是最後總是能看見主事者能與時俱進的研擬出一個成熟、適切的模式，並且一直推動著整個團隊朝著一個不曾動搖的目標前進。

　　特別感謝東京藝術大學的三位教授在日本、臺灣間忙碌的奔波與細心的指導，三年緊湊的作業下，師大文保中心面對了極大的挑戰，但是全體修復人員因此得到寶貴的實務經驗，珍貴的國際交流機會教育更促成了在現今教育課程中最難能可貴的人才培育資源。感謝陳澄波文化基金會與策展團隊對修復團隊的信任與配合，此修復案可謂是國內民間委託案中規模最大、最完整的案例，從保存修復、記錄、管理、參展到教育推廣，許多修復相關的想法與規畫都是從策展團隊與基金會的建言下，才得到修正、反省與學習的機會。

【註釋】

* 張元鳳為國立臺灣師範大學藝術學院文物保存維護研究發展中心主任。

1. 師大美術系成立於1945年，是國內歷史最悠久的美術教育單位，歷屆優秀師生留校校藏作品計約三千餘件，是臺灣近代藝術創作發展過程中重要的代表系列。

2. 陳芳玲〈轉身，擁抱驕陽──陳立栢與阿公心底的約定〉《典藏投資》第87期，p.164-167，2015.1，臺北：典藏雜誌社。

3. 原日文書名《油絵を解剖する─修復から見た日本洋画史》。

4. 1930年代都曾留學日本的作家們如陳澄波、廖繼春、李石樵、劉啟祥、洪瑞麟、張義雄等作家的作品。

5. 同註2。

6. 國際公認規範概略：1.三大倫理：安全性（環境、技術材料、人員安全）、歷史性（原創性、歷史紀念性）、完整性（現狀完整、原狀真相完整）；2. 四項原則：預防性原則 Principle of Prevention、適宜性原則 Principle of Compatibility、相似性原則 Principle of Similarity、可逆性原則 Principle of Reversibility。

7. 參考第15卷專文〈技術、美學與文化性的探討──以陳澄波作品保存修復為例〉，p.42-63。

8. 同上註。

9. 日文原文：明治前期の作品は堅牢で緻密な絵肌を持っている。明治後半期以降、時代が降るに従って絵の具層の耐溶剤性能が落ちる。水に溶解する作品も多い。

10. 國立民族學博物館名譽教授、著名材料技法專家。

11. 日文原文：この画家は油絵の体質を持っている。油絵の具の性質を十分に生かしている。その上で故郷台湾の風土に寄り添って描いている。東洋人としては極めてと特異な存在である。ぼくが探し求めていた条件を満たす数少ない画家だ。

12. 國內又稱為「畫布移植」，泛指直接以各式黏著劑將新畫布以托或襯的方式在貼黏作品背面，用以強化作品基底材的修復技法。一般以「蠟托裱」、「大麵糊托裱」、「高分子黏著劑托裱」為代表。

13. 非黏合式加襯：詳見木島隆康著〈從修復作品看陳澄波的繪畫技法與作品再修復〉。

Chen Cheng-po Rediscovered: An Introduction to the Preservation and Conservation of His Works

I. Foreword

Chen Cheng-po was representative of Taiwan people when Western painting first gained acceptance in the island. As well, he was a pioneer in receiving education in Western painting in Taiwan. Though he was educated in academicism, he managed to free himself from an art education system that tended to produce people from the same mold. Because the intense and willful nature of his works fully displayed his unique style as well as his noble thoughts and feelings, he has been dubbed "a naive painter from academia".

In 2010, amid much earnest expectation, Chen Cheng-po Foundation ("the Foundation") embarked on planning a series of events for staging in 2014 under the theme "Chen Cheng-po's 120th Birthday Anniversary Touring Exhibition in East Asia" (the "Touring Exhibition"). The aim was to bring out through the artist's various works his passion towards art and his dynamic vitality so that the nature and attitude of the creation of an artist who aspired to be "oil paint incarnate" could be truthfully revealed. For this reason, curated in this exhibition were works spanning different media including Western oil paintings, watercolors, pencil sketches, charcoal sketches, ink pen sketches, pastel drawing, and designs; oriental artworks including glue color, ink-wash, and calligraphy; as well as daily correspondence and manuscripts. Volumes 15-17 of *Chen Cheng-po Corpus* are compilations of essays mainly on the conservation of the artist's works and details of the treatment procedures. The conservation work was carried out separately by three institutions: Volume 15 and the first part of Volume 16 are concerned with conservation works carried out by the Research Center for Conservation of Cultural Relics (RCCCR), National Taiwan Normal University. While Volume 15 deals with paper-based works, the first part of Volume 16 deals with conservation of oil paintings and cultural objects jointly carried out by RCCCR and the Tokyo University of the Arts. The second part of Volume 16 concerns with the conservation of daily life related historical materials and oriental paintings carried out by conservation expert Lin Huan-sheng's Taipei Conservation Center. Volume 17 is the responsibility of Cheng Shiu University Conservation Center. In this essay, we will introduce one by one the essays on treatment procedures and conservation approaches undertaken by the above conservation institutions in dealing with various types of artworks. Through the processes of treating artworks and historical materials as well as the presentation after treatment, a complete and transparent conservation process is formed. As a result, a comprehensive and multi-angle interpretation of the legendary but short life of Chen Cheng-po is given in terms of his art and his education, as well as the trends of the art world in his time and the messages of creation in his mind.

II. RCCCR

In the current project, the items treated by the RCCCR comprised almost all types of artworks attempted by Chen Cheng-po, ranging from oil paintings, oriental artworks (glue color, ink-wash, and calligraphy), watercolors, pencil sketches, charcoal sketches, ink pen sketches, pastel drawings and design drafts as well as the artist's daily correspondence, original of manuscripts, and his wills. In total, there were 1,012 items and 29 sketchbooks to be treated. In dealing with such a complete range and large quantity

of items as well as a tight exhibition target date, the task of conservation was no longer limited to the application of techniques, but had also required the quick consolidation of conservation guidelines and the development of a suitable safety support system in the limited time available. Apart from repairing the aging damages of the cultural objects, the goals of the conservation also included ensuring that these objects were in the safest conditions when being moved around from one exhibition to another later. In addition, in order to ensure the completeness of the conservation operations for the various types of artworks and that the values (study value, display value, and market value) of the artworks were fully revealed through the treatment process, RCCCR had laid down three conservation principles of different significances for this project:

1. Conservation principles for works of "established art forms":

 Total 37 items: including 36 oil paintings and one glue color painting

2. Conservation principles for works which "works of historic significance":

 Total 29 sketchbooks and 963 artworks: including 71 watercolors, 71 charcoal sketches, 763 single-sheet pencil sketches, 6 sketchbook enclosures, 7 ink paintings, 23 calligraphies, 4 design drafts, 4 paper cuts, 4 illustrations, 9 watercolor nude sketches, and 1 pastel.

3. Conservation principles for "historical materials and cultural relics":

 Total 12 items: including 9 wills, 2 final garments, and 1 photograph.

a. Establishment of conservation project

The RCCCR was founded in 2009 as a specialized domain for carrying out education and research in and execution of cultural object conservation. Initially, its mandate was mainly to treat the in-house collection[1] of the National Taiwan Normal University (NTNU) but it could also take on outside conservation projects. In 2011, on accepting a project from the Foundation, a team designated to treating Chen Cheng-po's work was established. The most distinctive feature of this team was the participation of Professors Utada Shinsuke and Kijima Takayasu and their favorite student Suzukamo Fujiko. They all came from Tokyo University of the Arts (TUA), which was formerly Tokyo School of Fine Arts or the alma mater of Chen Cheng-po, and led the investigation, research, and the conservation of oil paintings in the project.

TUA is a school where friendship among fellow students is given a high priority. There are frequent exchanges among students from different fields when they attend together various courses and ancient art studying trips, or when they participate in art festivals, competitions, and exhibitions. One unusual custom in the school is that students like to stay behind on campus. They may take refuge in study rooms to make artworks or explorations in art incessantly. In their break times, they like to go to the study rooms of other students to make small talks. In the middle of the night, some may dodge the campus police to continue producing artwork. This custom of carrying out discussions, cheering up and competing with each other, coupled with the facts that the age-old campus is not very large and that teachers and students are familiar with each other, has resulted in alumni continuing to take care of each other and staying in touch through various channels. Initially, this conservation project was also born out of

connections among alumni and support from the alma mater. Just as Chen Li-po, chairman of the Foundation said in the article "Turn Around and Embrace the Scorching Sun—The Unwritten Understanding between Chen Li-po and His Grandpa", "It was not until 1997 that the then director of Taipei Fine Arts Museum Dr. Lin Mun-lee introduced us to TUA master conservator Utada Shinsuke and asked us to send the works [of Grandpa] to Tokyo for treatment. To show his support toward an alumnus, Prof. Utada made the conservation of the paintings *Hill* and *Chiayi Street Scene* into lesson case studies so as to absorb 40% of the conservation fees. The remaining 60% of the fees would then be raised by Chen Tsung-kuang." [2]

Prof. Utada is a pioneer of Western painting conservation in Japan. Aside from his excellent skills and experience in conservation, he has unparalleled knowledge in Japan's history and legacy of receiving Western influence in the Meiji era and in related studies of painting materials and techniques. Upon his graduation from TUA's oil painting techniques and materials course, he has been dedicating to the conservation and treatment technologies in oil paintings. He has successively been director of the Institute of Conservation at the Sokei Academy of Fine Art & Design and professor of TUA. In the latter capacity, he has founded a course in oil painting conservation and treatment and has been concurrently the first director of the University Art Museum. His book *The Anatomy of Oil Paintings—The History of Western Painting in Japan from the Standpoint of a conservator* [3] is an important work in which he comprehensively discusses painting materials and techniques in relation to historical changes in painting. In the book, he cites the characteristics of the works of Japanese pioneers such as Takahashi Yuichi, Kuroda Seiki, and Kishida Ryusei who had been influenced by Western painting in the "agitated period" from the late shogunate period to the Meiji era. Starting with the places where conservation is carried out and the materials and techniques employed in painting such as the techniques in making oil paintings, pigments and painting canvas, he analyzes in depth the changes after Japan has been influenced by Western ideas in terms of the space, light, and methods of depiction in painting and approaches in introducing picture images. Upon his retirement, Prof. Utada has become a professor emeritus and recommended his favorite student Kijima Takayasu to succeed the directorship of the research laboratory at TUA. As it continuously conducts a number of important research and conservation projects, this research laboratory has become a prime conservation research laboratory in Japan in which work, teaching, and research related to conservation take place and from which international conservation teams are deployed.

In 2007, after he had finished treating seven important curated works [4] (two of which were paintings by Chen Cheng-po) commissioned by Taipei Fine Arts Museum in 1998, Prof. Kijima continued to take on the conservation of three paintings commissioned by the Foundation, so in all, he had treated five representative paintings by Chen. When the "Project for the Conservation of Chen Cheng-po's Works" was established by RCCCR of NTNU in 2011, Dr. Suzukamo also joined the conservation team and the base for carrying out conservation was formerly moved to RCCCR. This decision not only allowed the on-site conservation of the works and convenient access to information and opinions of Chen's family members, but also made it possible to directly nurture a batch of new-generation conservators through the bringing in of foreign teaching staff and techniques. The only drawback was that in the three years' time, the foreign teachers had to endure the hardship of traveling back and forth almost every month, and some of them even had to pass their New Year Days twice in RCCCR. At this juncture,

I cannot help but once again convey my heartfelt gratitude to their dedication. In the words of Chen Li-po, "NTNU's RCCCR had the fortune of inviting Utada Shinsuke's student Kijima Takayasu to head the Chen Cheng-po Foundation-NTNU conservation project. In the last two years, I was deeply moved by the way he conducted himself: almost every month he would come to Taiwan along with his assistant Suzukamo Fujiko. By sticking to the reckoning standards of NTNU, they put themselves up in one of NTNU's dormitories and always ate casual food for almost three years as of now. As a result, the room and board expenses they incurred were three to five times cheaper than would have been otherwise possible. Afterward, Kijima even donated all of his fees from the project to RCCCR, meaning that he had not taken even one dollar away. I was truly moved. Moreover, it was him who persuaded me and let me realize that 'if correct conservation work was still not properly carried out, all media for future promotion would have been lost.'"[5]

Clear-eyed and intelligent, Dr. Suzukamo is a favorite student of Prof. Kijima. As a representative of Japan's new generation of academia-trained conservators, her professional prowess has never been questioned. What is unusual is that she has graduated with honors from Nippon Medical School before courageously deciding to join Prof. Kijima's research laboratory and dedicate herself to the profession of conserving and treating cultural objects which she likes best. Not only is she knowledgeable in general conservation technologies, her former medical training has also set her apart from conservators with an arts background and makes her conversant with aspects of physical and chemical sciences, technology, and material analysis. In the conservation team, Dr. Suzukamo's duty was not confined to carrying out conservation; she was also responsible for communications between the Taiwan and Japan parties as well as the planning of the conservation schedule and the consolidation of conservation efforts. She has a stable and poised disposition, and she treats people with sincerity and cordiality. No matter how tired she is from traveling, she always wears a smile when dealing with complicated trivialities and would always be patient in explaining to young students and in meticulously confirming every step in a process. When one sees her in her white lab coat working ever so quietly around the conservation laboratory that is full of "patients", one cannot help associate her with the very similar story about Florence Nightingale one often heard about as a kid and conclude that she is the best demonstration of the saying that "earnest dedication is a blessing". Conservators are medical personnel for cultural objects; a person endowed with such a personality upbringing and professionalism in conservation while also having a passion for arts is truly a rare talent.

b. Synopses of NTNU essays

This volume brings together and explains the concepts, methods, and studies involved in the current conservation project. As a compilation of 11 essays, its contents are all based on the linking up and explanation of the features of the artworks and conservation technologies. Due to typesetting and editorial reasons, the essays are divided into sections, viz. conservation of paper-based works (Volume 15) and conservation of oil paintings (first part of Volume 16). Though the authors of these essays are different, in actual practice, the detailed conservation procedures and division of labor were carried out through the collaboration of all team members after standardized conservation principles were determined through discussions.

(i) Essays on the conservation of paper-based works

The conservation principles provide direction to the setting of ethical concerns[6] in conservation. Their roles are to establish a common benchmark and to achieve consolidation for the large number of complicated conservation procedures involved. Furthermore, as the value of an artwork or a cultural object can be broken down into study value, display value, and market value, the setting up of principles is also meant to prevent the ignoring or distortion of the value inherent in an artwork or cultural object during the conservation process. In the following discussion, the focus is on the conservation operations on the paper-based works of the current project (total 1,012 items and 29 sketchbooks minus 36 oil paintings). The paper-based items include ink paintings, calligraphies, watercolors, sketches (pencil and charcoal), sketchbooks, wills, etc. The categorization and use of various conservation methods will be discussed.

In Asia, the conservation procedures of paper-based cultural objects have always been closely related to traditional mounting methods and oriental painting and calligraphy. Since ancient times, the methods of mounting have been passed on from China to neighboring areas such as Korea, Japan, and Southeast Asia with profound effects. In modern times, Western countries have also begun to realize and agree that mounting technologies could help raise professionalism in conservation. Subsequently they have started studying and applying such technologies. But when a culturally habitual treatment becomes an over-relied-upon measure, sometimes it is necessary to re-assess how the line of "appropriateness" should be drawn. For example, when it comes to items such as books, Western paintings (including watercolors, engravings, drawings, and files), yarn-dyed fabrics, tankas, rubbings, and photos, various problems would often arise, including "using Chinese mounting on Western paintings", causing too much changes in thickness and weight, over-flattening of depressed and raised areas, damaging of textures, etc.

The epochal significance of Chen Cheng-po's paper-based works lies in the historical background that they are testimonies to Taiwan's liberation from traditional Chinese art forms to reception of Western art education for the first time. Consequently, among the large number of works, there are sketches, paintings from life, still lifes, etc—works that recorded his footprints in life. There is evidence of Western influence in Chen's choices of media and composition. For example, he employed the use of charcoal, watercolor, pencils, and sketchbooks among others. Among the substrate materials he used there were also a large quantity of paper imported from the West or produced under Western influence. For this reason, in terms of the logic in retaining historical characteristics, works using Western paper should be treated mainly by Western conservation methods. Yet, as a consequence of the then world trend of mechanical mass production of paper, even artists such as Chen Cheng-po who were particular about the materials they used could not foretell the after-effects of using "acidic paper"[7]—as paper was rendered acidic during production and treatment processes, problems of yellowing and brittleness tended to crop up later. This is not just a problem confined to Chen's works, but is a crisis affecting many of the world's artworks, great books, files, and photos. In fact, this type of paper is still being produced and the problem is still arising. What is the most appropriate method to conserve this type of acidic paper is a key discussion point for each paper in the following sections. The five related essays below are categorized according to the substance of the procedures:

1. Chang Yuan-feng, "Technique, Aesthetics, and Culture: Perspectives from the Conservation of Chen Cheng-po's Works of Art"

2. Perng Yuan-shing and Hsu Chien-kuo, "Microscopic Study of Paper: Preparation of Slides and Species Determination of Paper Fibers"

3. Ding Wen-chian, "Conservation Treatment of Chen Cheng-po's Calligraphy and Ink Paintings"

4. Melody Chen, "Versatility of Paper: Considerations and Applications of Chinese, Taiwanese, and Japanese Paper for Loss Infilling and Reinforcement"

5. Lee Chi-heng, "Conservation of Chen Cheng-po's Works on Paper: A Multi-perspective Study on the Use of Conservation Materials"

The focus of the essay "Technique, Aesthetics, and Culture: Perspectives from the Conservation of Chen Cheng-po's Works of Art" is on how to set conservation principles and integrate conservation operations. The question of when best to use the "lining" method is also discussed. It is commonly agreed that the use of Chinese style first lining on a piece of artwork for reinforcement and smoothing out will result in convenience in subsequent management and stabilization. But out of cultural considerations and a respect for the nature of cultural objects, the author has readjusted and integrated operational procedures and treatments. In particular, out of respect for the cultural characteristics of the works, he has introduced some new concepts in dealing with the reinforcement, preservation, and display of paper-based Western works. For example, he has introduced the application of tengujo[8], a kind of very thin and light-weight handmade Japanese paper; as well as the use of acid-free mounting frames, matting, and display systems. There are two main areas of discussion in this essay, namely, "Reinforcement of Artworks—Application of Tengujo" and "Protection of Artworks—Application of Acid-free Mattings".

The author has not limited himself to the advancement of science and technology because, in the current project, there are cases in which artworks that have undergone conservation just a short time ago are requiring conservation again. So during conservation, in addition to admonishing that conservators of cultural objects should bear in mind the ethical concerns of conservation, the author, from the standpoint of an educator, brings up the importance of "conservation aesthetics" in the professional development of conservators. He suggests leaving suitable space for carrying out dialogues between art and technology as well as between subjectivity and objectivity so that there will be flexibility in future planning.

The essay "Microscopic Study of Paper: Preparation of Slides and Species Determination of Paper Fibers" is a report by Perng Yuan-shing and Hsu Chien-kuo on their findings after carrying out identification of paper fibers. Both Mr. Perng and Mr. Hsu are famous scholars in the paper industry in Taiwan. Moreover, there is an abundance of talents in the (Taiwan) Forestry Research Institute where Mr. Hsu works, including, for instance, former staff Wang Kuo-tsai and Prof. Chia Tsang-chi, who are both passionate in studying paper and in R&D related to conservation of cultural objects. Mr. Hsu himself is a student of both Prof. Chang Feng-chi, a forerunner in the research of handmade paper in Taiwan; and Master Tsen Te-lin of Songyun Lodge

fame, who had been active in Taiwan more than a decade ago. Other than being well versed in conservation techniques for various types of paper-based cultural objects, Mr. Hsu also has considerable practical experience in the identification and production of paper and in reviving ancient paper-making technologies. By employing scientific methods, he can identify all types of paper fibers and paper characteristics. Here we would like to convey our gratitude for their sparing time in their busy schedules to lend us their expertise. Chen Cheng-po's paper-based works include both Western and oriental art forms drawn on Chinese paper, Japanese paper, or Western paper imported into Japan at that time. The fibers found in these types of paper are not only characteristics of paper often used in the art circle in his time, but are also a fundamental judgment before one embarks on treating his works. As such they are indispensable in guiding the conservation work.

Have you ever seen Chen Cheng-po's calligraphy and his handwritings in ink painting? It is hard to imagine how, under excitement and trepidation, one can treat those rare coursework he produced in his youth days. In her essay "Conservation Treatment of Chen Cheng-po's Calligraphy and Ink Paintings", Ding Wen-chian serenely describes in minimal words the processes of treating calligraphy and ink-wash paintings. To Ms. Ding herself, it was an experience in which she was momentarily stunned when she first came into contact with the works, followed by a quick succession of procedures including acknowledging receipt after checking, inspecting and testing, keeping records, planning, executing conservation, obtaining approval, collecting information, transporting, scanning, and submitting treated works. Afterward, when she was writing her paper, she could not help but think of the many nights in which she strained her heart and mind in the conservation, as well as her reluctance in seeing the treated works being sent back to the Foundation. "If I were given more time, I would like to take one more look!" she said. This is a sentiment shared also by the authors of the next two essays, and even by every member of the conservation team. Under normal circumstances, artworks and material of such importance would only be sent to the conservation lab one or two pieces, or at most in single digit quantities at any one time and meticulous conservation would take several months. Under the tight schedule of the current project, all conservators have done their best and contributed what they have learned in life in turning in the treated artworks to the Foundation on time. Though all treated works were completed and granted approval successively (after postponement in turning in has been requested and granted several times), a period of three years in dealing with all the items day and night is still considered too short (on average, only one day for each item), so until now, Ms. Ding is still wary that she has no time to give each item one last look to check for omitted areas. From Chen Cheng-po's handwriting in his calligraphy classwork, she discerns that he was a serious student. Though the teachers' comments in red ink on the edge of the pages have already turned from vermilion to sepia, the advising teachers' care and intent in providing untiring guidance can still be felt today. From this, one cannot help to have in mind a picture of the classroom [in the Tokyo School of Fine Art] where top students from all over Japan selected into attending were considered brilliant artists of the future. These are typical artworks which "also have significance as historical materials". Because they exhibit both a historical style and an artist's personal style, viewers with different standpoints may have very different opinions on what should be the results of conservation efforts. Discussed in Ms. Ding's essay are a total of 30 paper-based items, including 23 calligraphies and 7 ink-wash paintings. These are works made in the period from 1924 to 1927 and have not seen any lining. Red ink which have changed color and those that have not are

subjected to non-destructive examination by an X-ray fluorescence analyzer (XRF). The results have been compared with standard red lead and vermilion samples to find out the cause of color change. The conservation principles for these types of artwork are then complemented with the cultural characteristics of oriental mounting techniques. Therefore, in this essay, there are descriptions on the use of specific paste for conservation, applying first lining, applying second lining, infilling losses, inpainting, silk mounting, etc.

Having a similar line of thought is the essay "Versatility of Paper: Considerations and Applications of Chinese, Taiwanese, and Japanese Paper for Loss Infilling and Reinforcement" by Melody Chen. In this essay, the processes for treating deterioration of the type of paper used by Chen Cheng-po for various Western art forms including sketches, watercolors, and sketchbooks are described. Ms. Chen is trained in Western conservation methods and holds a Master's degree. Upon her graduation, she came to Taiwan to focus on conservation strategies and techniques that span across Eastern and Western cultures. In the current conservation project, the key is to make full use of a strong suit of Western conservation techniques—de-acidification—to ensure that the artworks in question will no longer be acidic and will gradually turn neutral and thus become more stable. As the most important safety issue in conservation, de-acidification consists of turning the acidity of an artwork into close to neutrality and using neutral protective materials to provide an environment that prevents further acidification. Though the technique of de-acidification has been developed long ago in the Western world, different conservation labs have different ways of adapting it for different treatment objects. Apart from de-acidification, other techniques have also been mentioned in this essay. For example, for watercolors on paperboards, a two-stage filling up of damages using dry and wet pulp fibers respectively can be applied. In the conservation of sketchbooks, a combination of pure pulp fibers, Xuan paper, Taiwan kozo paper, tengujo, and Hosokawa paper have been extensively used. For the protection of spiral binding sketchbooks, a compound binding and an increase in the width of the spine have been devised. In all, though a multitude of materials and methods are used, presentation methods that bring out Western characteristics as far as possible are a unique and interesting part of this essay.

Though Lee Chi-heng is a project technician with the least qualifications in the team, he is recognized by all as a super assistant because of his passion towards conservation and the concentrated efforts he has applied. In the essay "Conservation of Chen Cheng-po's Works on Paper: A Multi-perspective Study on the Use of Conservation Materials", he mainly talks about substrate materials and explains the characteristics and application methods of materials used specifically for conservation. In describing the details of the choices and properties of conservation materials used in the conservation of paper-based works in this project, he illustrates the importance of choosing the right materials by discussing the chemical properties of non-acidic materials and the ethical concerns in the conservation of cultural objects. He emphasizes that the choice of materials and the intents of their use is special knowledge by itself because, from the moment a piece of treated artwork leaves a conservation lab, it will constantly subject to transportation, exhibition, curation, and even conservation again after decades or centuries. Upon finishing the current conservation project, Mr. Lee has gone abroad to Germany to further his studies. I would like to take this opportunity to wish him good luck and every success in his pursuit to be a professional conservator.

(ii) Essays on the conservation of oil paintings

The first half of Volume 16 contains essays related to the three TUA experts who have come to Taiwan to cooperate with RCCCR in treating Chen Cheng-po's oil paintings. There are a total of six essays: one essay from each of the Japanese conservators, one from a domestic appraisal expert and two from in-house conservators from RCCCR. These are:

1. Utada Shinsuke, "A Discussion on Chen Cheng-po's Works of Art"

2. Kijima Takayasu, "On Chen Cheng-po's Painting Techniques and the Re-conservation of Artworks"

3. Suzukamo Fujiko, "The Oil Paintings of Chen Cheng-po: An Examination of Painting Materials through Treated Artworks"

4. Huang Hsiao-wen and Chang Wei-tun, "A Comparison between the Elemental Composition of Chen Cheng-po's Oil Paintings and Modern Oil Painting Materials"

5. Wang Chiung-hsia, "Analysis and Treatment of Chen Cheng-po's Oil Paintings on Wood Panel"

6. Yeh Pin-han, "Oil Paintings Conservation Materials at the Research Center for Conservation of Cultural Relics: An Introduction and Case Study"

The first three essays are detailed discussions borne out of much research and conservation practice and deal with aspects of history, style, the conservation methods used in this project as well as materials and techniques used in painting. The open sharing of invaluable experience and technology by the three Japanese experts is not only the first instance of a comprehensive explanation of Japanese oil painting conservation technology. What is more important is that it has stepped up the pace of technical exchange through tutoring and practical demonstrations.

In his essay "A Discussion on Chen Cheng-po's Works of Art", Professor Utada discusses the course of change in Japanese painting after the country had undergone Western influence. His discussions have touched on the origin and development of early period artists as well as their characteristics, painting styles, the materials and techniques they employed, and the thread of future development. After examining [Japan's] Western paintings at the nascent stage all the way to the rise of academicism, he discusses the Japanese painting circle from a commanding height and traces the thread of relationship between the Japan and Taiwan art circles by focusing on Chen Cheng-po. From Prof. Utada's concise and germane description of the key early stage information, we can clearly see the brilliant comments on the materials and techniques of Asian oil paintings at the early stage when Japan was under modern Westernization development. In particular, the essay has dealt at length with the course of changes in trend in Japanese painting. As regard the material and constitution of oil painting, he thinks "Artworks from the early Meiji era (Bitumen School/Violet School) are robust in structure and refined in texture. When it comes to the second half of the Meiji period, along with the trends of the time, the solvent resistibility of oil paint layers saw a gradual decrease and there was an increase in the number of works in which the paint layers dissolved easily in water."[9] He and his friend Morita Tsuneyuki[10] both agree that the reason why early oil paintings were called "oils" because the oil mixed in the paint displayed an oily luster and stickiness, so in the essay, Prof. Utada stresses that "As the concept of oil painting was passed to the East, what caught the

attention of Asian painters was the unrestrictive creative spirit under the then new movements, so much so that painters were always focused on quickly capturing the new trends passed on from European art circles. In contrast, they had ignored materials and techniques which were such important basics to support the new approach of presentation...Under such an ambiance, painters started to add inappropriate volatile solvents as thinner or simply used them in combination so that paints could be applied quicker. And this was a characteristic of 'Asianized' oil paintings."

Yet, at a time when Japan was engrossed solely in going after novelty, Chen Cheng-po was still focused on the basic nature of oil painting while maintaining an unembellished style and a passionate painting method. So when the spotlight returns from materials and techniques back to Chen's personal style, Prof. Utada thinks that "the works of this painter are replete with the constitution of oil paintings; he had allowed a full display of oil paint properties and used that to aptly depict the lands and customs of his Taiwan homeland. Among Japanese under the then prevailing ambiance, his existence was very special and he was one of the few people who can meet my standard of an ideal artist."[11]. In Prof. Utada's description, Chen Cheng-po was not unthinkingly imitating Western artists such as Van Gogh, Cézanne, and Renoir. Instead, he was naturally letting out his pre-existing pattern and ideal. As such he was at that time already an uncommon painter with his own unique style and an "international painter who can represent Asia". So "when Chen Cheng-po was studying abroad in Japan, what was he really thinking about?" Summing up Prof. Utada's high regards on Chen Cheng-po's works, it is not difficult to see that, through Chen, the scholar is expressing his view on the missteps and shortcomings in the course of development of Western painting in Japan, and this view may also include a deep sense of rethink. These suggestions serve also to forewarn modern artists what kind of artwork would be recognized internationally and be passed on to later generations.

The next essay is "On Chen Cheng-po's Painting Techniques and the Re-conservation of Artworks" by Prof. Kijima. Like Prof. Utada, he is also a scholar who is qualified to make direct comments from the standpoint of an artist and that of a conservator. Just like Prof. Kijima's steady and straightforward personality, right from the beginning, this essay points out Chen Cheng-po's painting style and technique characteristics. These are concisely and objectively expressed conclusions he draws from the combined knowledge of the development of painting materials and techniques, the development of conservation materials and methods, and scientific testing and verification methods. Prof. Kijima excels at using this type of deconstruction method in successively describing the characteristics of an artwork. With his keen perception, he can eliminate at a glance factors due to conservation or aging and directly discern the essential characters of an artwork. This essay is undoubtedly highly accurate and authoritative because it is written from a multitude of angles by an expert who is passionate about art and has treated countless masterpieces, and is a condensed summary of the operation records and observations at the conservation site. To me personally, the main reasons why Prof. Kijima's attainments in art, conservation, and appreciation have commanded so much respect are, besides his keen insight and refined presentation skills, his empathy, his kind and sincere attitude, and his unforced and uncontrived nature that deals with everything with calmness. This nature is demonstrated not only in the way he deals with people but also in his conservation practices. No wonder that when many complicated artworks land on his desk, they would be treated without

causing a fuss. That is why he is deservedly a successful and respected "conservator extraordinaire".

In 1998, Prof. Kijima was commissioned by Taipei Fine Arts Museum to treat the two oil paintings *Chiayi Street Scene* (1934) and *Summer Street Scene* (1927). On completion of the assignment, he was once again commissioned in 2007, this time by Chen's family members, to treat three important works, namely, *Downtown Chiayi* (1934), *Hill* (1936), and *Woman* (1931). In the current project in which he began treating 36 pieces of works in 2011, he has continued to use the conservation methods he used previously: instead of the "adhesive lining"[12] method of reinforcement traditionally used for oil paintings in Taiwan, he has switched to the use of a "loose lining"[13] method. In this essay, Prof. Kijima painstakingly and plainly lays out the conceptual and procedural differences between the two methods. An example given is a work which has undergone wax lining treatment in recent years but has to be treated again. Prof. Kijima points out that the problem in the previous conservation is not simply the choice of using wax lining. Rather, much of the problem concerns improper handling and misguided attitude. As a result, the canvas substrate material was separating, the paint layer was distorted from over-application of heat, and the paints applied during retouching were covering up the original paints. All these point to a lax in professional ethics on the part of the conservators concerned. In fact, the ideas and actual practice laid out in the essay have all along been the ethical concerns reiterated constantly by conservationists in cultural objects when they are teaching. Thus this essay once again allows conservators a chance to understand the international consensus involved. Furthermore, through this essay, art lovers and stakeholders in cultural assets can also understand the importance of self-restraint on the part of conservators. History and facts have shown that the myriad of materials and methods will change or evolve with time and prevailing concepts, so there are no definite rights and wrongs in the materials and methods themselves. Rather, what determines the success or failure of conservation is "attitude". An astute conservator will comply with internationally recognized principles, appropriately choose suitable conservation materials and methods, and accomplish his task at the present stage by remaining faithful to the ideas of the originating artist. His objective is to transfer the cultural object safely to the next generation. Given that a cultural object is aging and fragile, conservation is only a measure of last resort and there is no permanent or magical solution. Correct conservation planning and long-term conservation strategy are the only way to maintain everlasting co-existence with cultural objects.

Another key area that complements the conservation profession is the development history of conservation materials and methods, which can provide supplementary information on prevailing social and humanistic circumstances, technological development, and international exchanges. Knowledge on the development history of materials and methods requires the accumulation of a lot of research results and the support of scientific and systemic archive management before a database of practical value can be established. A well-established database can help the objective comparison of data so that records from a single piece of artwork to that of a region or even to the characteristics of cultural DNA. In Japan, as a result of surveys on painting materials and techniques and the driving needs of conservation projects, there is already a considerable cumulation of information. In Taiwan, due to advancement in non-destructive technologies in the last decade, the system and performance of information gathering are already quite mature. Yet there is still a lack of connection between Japan and Taiwan. Dr. Suzukamo's

essay "The Oil Paintings of Chen Cheng-po: An Examination of Painting Materials through Treated Artworks" is the first that links up the two places. It focuses on Tanabe Itaru, the most important advising professor of Chen Cheng-po when he was attending a course in art teaching at the Tokyo School of Fine Arts. Dr. Suzukamo begins by explaining Mr. Tanabe's influence in the school by examining his teaching and the characteristics of the painting materials and techniques he used. Then she summarizes the characteristics of the painting materials used by Chen Cheng-po from his studying period at the Tokyo School of Fine Arts to the period in which his style changed when he was in Shanghai upon graduation and the period after he returned to Taiwan. These characteristics are deduced from a comparison of his works, from various conservation operations, and from precise scientific examination. The materials described in this essay include paints, canvas, wooden boards and paperboards. Today, with the frequent use of non-destructive inspection technologies, a large quantity of information can be easily gleaned. Yet without accurate judgment, specious information may be obtained. This essay provides us with a very clear guideline: before conclusions can be drawn from results of non-destructive inspection, we have to be familiar with the media, techniques, and procedures of painting and also with the history of materials before we can pick out probable matters out from the large quantities of results from the inspection and eliminate interfering ones. We should sieve out the most probable messages through cross-comparisons instead of accepting all messages and make the wrong deduction.

The essay "A Comparison between the Elemental Composition of Chen Cheng-po's Oil Paintings and Modern Oil Painting Materials" is written by Prof. Chang Wei-tun's doctoral student Huang Hsiao-wen. Prof. Chang is a famous professor of forensic science at the Central Police University and a successor of renowned forensic scientist Dr. Henry Lee. Prof. Chang is a leading scholar with eminent academic credentials and abundant case handling experiences who is chairman of Taiwan Academy of Forensic Sciences in addition to his teaching post. Before participating in the current project, Prof. Chang has on numerous occasions helped the RCCCR in carrying out microscopic identification and has completed several assignments in the examination of treated cultural objects. This essay describes the analysis of material used in priming canvases. By using a serial system of a scanning electron microscope and an energy dispersion spectrometer (SEM/EDS), not only can we know the surface topographic image of a sample, but we can also get information related its chemical composition or microscopic structure. Such a system has the advantages of being non-destructive and requiring only simple pre-treatment of samples. As such, it is very suitable for use in trace specimen examination purposes. This is the first attempt in Taiwan at analyzing the inorganic materials in Chen Cheng-po's paintings. It also represents another verification technique outside of the non-destructive examination system. The analysis provides important messages and information to researchers who wants to adopt such an approach and to the nurture young conservation scientists.

For conservators Wang Chiung-hsia and Yeh Pin-han, the conservation of oriental paintings and paper-based cultural objects used to be their primary specialty before they joined RCCCR. After the establishment of RCCCR, with the professional knowledge and education they already possess and the guidance given by professors Kijima and Suzukamo, they have been carrying out conservation of NTNU's oil paintings for more than a year. In the current project, in addition to participating in the conservation

of oil paintings, Ms. Wang has proposed carrying out "Analysis and Treatment of Chen Cheng-po's Oil Paintings on Wood Panel" while Mr. Yeh has come up with "Oil Paintings Conservation Materials at the Research Center for Conservation of Cultural Relics: An Introduction and Case Study". The discussions of these two essays are not limited to conservation of artworks that have canvas as base material, but also ones drawn on wooden boards, paperboards, and other base materials. In addition to describing their conservation methods, they have also focused on the characteristics [of conservation materials], identification of fibers, and the use of materials. As such, these two essays are the first time that TUA's oil painting conservation methods are ever presented in Taiwan; they are also comprehensive records in which the discussions, lectures, and actual implementation of methods by the Japanese experts are all included without fail. It is noted that items arising from exchanges related to conservation projects should be disclosed has already been mentioned in the Athens Charter in 1931. The transparent recording of operations and the publishing of results of the current project are a successful case of international exchange and will definitely serve as important information for reference and for identifying with for the sectors involved.

Following the above six essays are the reports on the conservation of oil paintings. Apart from differentiating artworks based on different base materials and keeping records of the respective conservation processes, the most important approach is to divide the oil paintings into "first-time conservation" and "re-conservation" lots and deal with them accordingly. The main task of a conservation operation is to eliminate damages due to aging and environmental factors and to lengthen the life of the item concerned through tidying up, maintenance, and reinforcement. In general, the objective of appropriate conservation is to allow a piece of work to last for 100 years (under suitable preservation environment, system, and planning). In the current project, the works requiring re-conservation have only undergone conservation for three to four years. The main reason is that the methods and actions taken in the previous conservation are inappropriate. This shows that the wrong judgment of an item and poor actions on the part of a conservator would impart incalculable secondary damages to the item.

III. Lin Huan-sheng's Taipei Conservation Center

The second part of Volume 16 describes the processes of conservation of artworks under the responsibility of Lin Huan-sheng of Taipei Conservation Center. Mr. Lin is an outstanding and very self-demanding conservator. Since learning conservation of paintings and calligraphies at the renowned Usami Shokakudo in Kyoto, over the decades his zeal in the conservation of oriental paintings and calligraphies has remained high. In addition to the setting up of a studio at Taipei Conservation Center, he is also teaching at the Department of Cultural Heritage Conservation, National Yunlin University of Science and Technology. In the current project, he is responsible for the conservation of a large variety of items, ranging from glue-color paintings, watercolor sketches, and hanging scrolls of paintings and calligraphies to collection of books, manuscripts, and postcards, as well as lifetime mementos such as Chen Cheng-po's graduation certificate from the Art Teacher Training Department of the Tokyo School of Fine Arts and art pictures. From the large number of items he has treated within

the three years from 2010 to 2013, we can imagine the heavy traveling schedule and workload he has gone through. Since a conservator with a sense of mission like Mr. Lin has said that his "wish is to provide the best treatment in conservation and to be instrumental in the 'reemerging' of Chen Cheng-po through the conservation," we summarize his brilliant efforts and achievements in the second part of Volume 16.

IV. Conclusion

Apart from artworks meant for the Touring Exhibition, the current conservation project encompasses almost all artworks and documents known to the Foundation. Moreover, the institutions involved in the project include a number of major conservation teams both at home and abroad. Education in the conservation of cultural relics has been promoted in Taiwan for more than 10 years, but it is hard to imagine that a non-government, private foundation can create such an impact in Taiwan's cultural sector. Thinking back, this was then an incident that had people frightened and yet expectant. Now the project is so successful that even foreign participants and professional teams have come to appreciate the high social and humanistic performance of Taiwan, RCCCR is much honored to be involved. In the course of three years, the huge workload of having to treat over 1,000 items and the pressure from managing the safety of the artworks have invariably led to anxiety and apprehension, but now in hindsight, most of the memory is that of satisfaction and being recognized.

When the project was underway, because of the need to coordinate closely and simultaneously with other projects, the Foundation, which was responsible for liaison and consolidation, had to take up the trouble of going back and forth among different institutions for details in exhibition planning, publication and publicity, exhibition set up, shipping, curating, arranging seminars, fostering international exchanges, and carrying out education promotion so that every activity is completed successfully on time. The key to the success of running this international touring exhibition is the Foundation's hands-on handling of each situation, detail, and coordination while dealing with all sorts of challenges actively. Though difficulties and stumbling blocks were encountered in executing some concepts, practices, and itineraries, the persons-in-charge could always keep pace with the times and come up with well thought-out and appropriate solutions and led the whole team towards a goal that has never deviated.

We convey our special thanks to the three professors from TUA for their enduring the hardship of traveling back and forth between Japan and Taiwan throughout the project and for their giving us advice in matters large and small. Throughout the three years of tightly packed operations, the RCCCR has dealt with a lot of challenges. Nevertheless, all of its conservators have gained valuable practical experience, not least because the precious education opportunities arising from the international exchange have constituted exceptional personnel nurturing resources. We also thank Chen Cheng-po Cultural Foundation and their curatorial team for their confidence in and support given to the conservation team. This conservation project is one of the largest and most complete of its kind in Taiwan. Many ideas and planning of the conservation team, from treatment, record keeping and

management to exhibition participation, education, and promotion, have the chance of being revised and reviewed and turned into learning opportunities through the suggestions of the curatorial team and the Foundation.

＊Chang Yuan-feng: Director, Research Center for Conservation of Cultural Relics, College of Arts, National Taiwan Normal University.

1. Founded in 1945, the NTNU Department of Fine Arts was the oldest institution of art education in Taiwan. Its collection of more than 3,000 pieces of artworks left by outstanding teaching staff and students over the years is representative of the development of modern art in Taiwan.

2. Chen Fang-ling, "Turn Around and Embrace the Scorching Sun—The Unwritten Understanding between Chen Li-po and His Grandpa" in Volume 87, *ART INVESTMENT*, p.164-167, ART INVESTMENT Magazine, Taipei, January 2015.

3. The original name of the book in Japanese is 油絵を解剖する―修復から見た日本洋画史.

4. Works of artists who had studied abroad in Japan in the 1930s, including Chen Cheng-po, Liao Chi-chun, Li Shi-qiao, Liu Chi-hsiang, Hong Rui-lin, and Chang Yi-hsiung.

5. *Ibid*, footnote 2.

6. Summary of internationally recognized standards: 1. Three main ethical concerns: safety (environmental, technical material, personnel), history (originality, historical commemorative value), and completeness (completeness in current form, completeness in truth behind original form); 2. Four principles: principle of prevention, principle of compatibility, principle of similarity, and principle of reversibility.

7. Please refer to the essay titled "Technique, Aesthetics, and Culture: Perspectives from the Conservation of Chen Cheng-po's Works of Art" in Volume15, p.42-63.

8. *Ibid*, footnote 7.

9. The original Japanese is "明治前期の作品は堅牢で緻密な絵肌を持っている。明治後半期以降、時代が降るに従って絵の具層の耐溶剤性能が落ちる。水に溶解する作品も多い。"

10. Renowned expert in [painting] materials and techniques and emeritus professor of the National Museum of Ethnology, Japan.

11. The original Japanese is "この画家は油絵の体質を持っている。油絵の具の性質を十分に生かしている。その上で故郷台湾の風土に寄り添って描いている。東洋人としては極めてと特異な存在である。ぼくが探し求めていた条件を満たす数少ない画家だ。"

12. IIn Taiwan, this method is also called the "canvas transplanting" method. It generally refers to the conservation method of reinforcing primary support of an artwork by using various types of adhesives to stick a new piece of canvas as a lining or backing to the back of the artwork. The most common forms of direct adhesive lining are "wax lining", "barley paste lining", and "polymer adhesive lining".

13. For details of loose lining, please refer Kijima Takayasu's essay "On Chen Cheng-po's Painting Techniques and the Re-conservation of Artworks"

油畫作品
Oil Paintings

專文
Essays

國立臺灣師範大學文物保存維護研究發展中心
National Taiwan Normal University Research Center for Conservation of Cultural Relics

關於陳澄波的作品

歌田真介[1]

前言

　　東京美術學校於明治20年（1887年）創立，明治22年（1889年）正式開校。開始招生、創校當初設有繪畫（日本畫）、雕刻（木雕）、工藝（金工和漆藝）三個科目。是為了傳統美術的復興而設立的。西洋畫家們極力推動設置西洋畫科，但是沒有實現。西洋畫科是在之後的明治29年（1896年）才被設立。

　　它的時代背景可以歸納如下。因為明治維新而德川幕府倒臺，成立了新政府，設年號為明治（1861年開始）。在德川時代（江戶時代）的幕藩體制下，狩野派（日本室町後期至明治初期的日本畫一大流派）的畫家一直受到庇護。不過由於幕府的垮臺，失去庇護的畫家變得貧困衰敗。其他類似的，好比在德川時代的木雕工藝是以雕刻佛像為主，但是因為明治維新之後的廢佛毀釋運動，佛像製作師變得窮困潦倒。

　　受維新後文明開化風潮的影響，西方藝術得以普及並開始得到社會的認可。但是，明治10年（1877）在平息了西鄉隆盛叛亂之後，明治新政府開始穩定，社會開始變得保守了。於是，在明治10年代（1877-1887）的中期，開始有了傳統美術衰敗的危機意識。另外，由於歐美流行起了日本格調，日本工藝品開始對外出口，從而使人們意識到有必要提高工藝品花紋的繪製技術。明治10年代中期，在這種風潮中，西洋畫一直遭到排斥。以至於演變成禁止西洋畫參展博覽會的局勢。宣導傳統美術復興的是美國人芬諾洛薩（Ernest Francisco Fenollosa，1853-1908）和岡倉覺藏（1862-1913）。可以說日本畫與西洋畫的對立就是從這個時期開始的。下面論述日本的西洋畫情況。

一、日本西洋畫簡史

日本西洋畫的歷史，本文認為可以分為以下四個時期：

（一）第一期

16世紀，日本桃山時代（戰國時代）的1543年，葡萄牙人來到種子島並在島上傳售槍支。1549年聖方濟・沙勿略（San Francisco Javier，1506-1552）來到九州傳播基督教。基督教傳入的同時油畫及其他西洋畫技術被引進。之後由於德川時代的禁教，西洋畫沒能得以充分的落地生根。這個時代的作品被稱作「初期西洋畫」。（圖1）

（二）第二期

德川時代的鎖國政策，貿易往來僅限於在長崎與荷蘭及中國（明）之間展開。享保5年（1720年），第8代將軍德川吉宗允許輸入除基督教以外的書籍。此後，蘭學開始盛行。根據廣辭苑詞典的解釋蘭學是指「江戶中期以後，通過荷蘭語研究西方學術的學問。享保年間（1716-1786），從幕府的書籍奉行[2]青木昆陽譯讀荷蘭書籍開始，前野良澤、杉田玄白、大槻玄澤等多位蘭學者輩出。而且西博爾德（Philipp Franz Balthasar von Siebold，1796-1866）的貢獻是巨大的。普及到了從醫學到數學、軍事學、天文學、化學等學術。」不僅在學術方面，蘭學在繪畫方面也有著巨大的影響。荷蘭的博物書籍的插畫是銅版畫，採用明暗法、透視遠近法細緻的表現手法使人入迷。在那之前的日本繪畫不僅沒有透視遠近法，也沒有通過分開畫陰陽面來表現事物立體感的明暗法。代表人物有平賀源內（1728-1779）、小田野直武（1750-1780）、佐竹曙山（1748-1785）、司馬江漢（1747-1818）、亞歐堂田善（1748-1823）等。這一時期的作品被稱作「西洋繪畫」。展示日本最先創作銅版畫的司馬漢江的作品〔三圍之景〕。（圖2）

這些洋畫的研究都是畫家們出於個人好奇心而創作出來的。從19世紀開始幕府才組織研究機構有組織的展開研究。

（三）第三期

19世紀中期（幕府末期）到19世紀末前後（明治30年左右，即1897年）。

19世紀中期，幕府設立西洋學研究機構。機構名稱變為洋學所（1855）、蕃書調所（1857）、開成所（1863）等。成為明治維新後東京大學的一部分。廣辭苑詞典中開成所的解釋是「江戶幕府設立的教

圖1. 作者不詳　聖母子十五玄義圖（重要文化財產）　16世紀末-17世紀初

圖2. 司馬江漢　三圍之景　銅版畫　1783

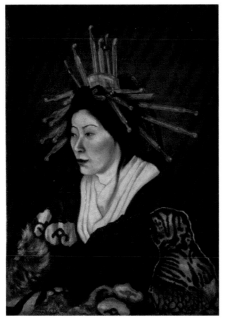

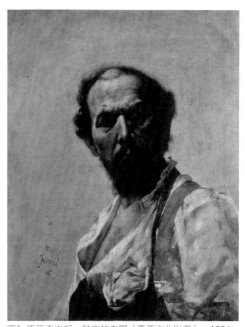

圖3. 高橋由一　花魁（重要文化財產）　1882　　　　圖4. 五姓田義松　自畫像　1877　　　　圖5. 原田直次郎　鞋店的老闆（重要文化財產）　1886

授荷蘭、英國、法國、德國、俄羅斯等西洋學的學校」。這其中便有教育研究西洋畫的畫學局。川上冬崖（1828-1881）擔任領導。明治前期的代表畫家高橋由一（1811-1894）也在35歲時入所開始研究西洋畫（圖3）。剛剛提過這一機關在明治時代成為東京大學的一部分。但是畫學局卻沒能夠被傳承下來。因此，明治時代初期是由私人畫塾支撐著西洋畫的研究和教育。比如川上冬崖的聽香讀畫館、高橋由一的天繪樓（後來的天繪舍、天繪學舍）、五姓田義松（1855-1915）私塾（圖4）、國澤新九郎（1847-1877）的彰技堂等。國澤新九郎是最早留學學生的一員，從英國帶回了很多技法書籍。國澤雖然英年早逝，但是畫塾的後繼人本多錦吉郎（1850-1921）翻譯了這些書籍。私塾學生們根據本多錦吉郎的翻譯各自做了筆記，分別創作了手稿本。因此彰技堂成為當時技術資訊最為豐富的私人畫塾。而英文原書於1970年代在國立國會圖書館被尾崎尚文氏再次發現。同時根據後來尾崎尚文氏和青木茂氏發現的私塾學生的手稿本弄清了當時大部分的情況。另外，通過調查和修復工作得以證實，明治前期的畫家是遵守歐洲的傳統方法來作畫的。他們的作品具有樸素的寫實的畫風，擁有細膩且完美的材料，可以說是與經歷了100年以上歷史的日本風土相吻合的。關於這一部分之後會再觸及。

明治9年（1876）工部省創辦工部大學校，其中設有工部美術學校。從義大利聘請豐塔奈西（Antonio Fontanesi，1818-1882）（油畫）、拉古薩（Vincenzo Ragusa，1841-1927）（雕刻）、卡貝萊緹（Giovanni Vincenzo Cappelletti，1843-1887）（預科）開始了正規的教育。豐塔奈西是位巴比松畫派的風景畫家，傳授印象派之前的畫風。淺井忠（1856-1907）受其很大的影響。工部美術學校在明治10年代的復古局勢中於明治16年（1883）廢校。

從那時起文部省開始構想創辦新的美術學校，以芬諾洛薩、岡倉覺藏為中心開始著手準備。芬諾洛薩到日本之後的初期，訪問了高橋由一的天繪樓（天繪舍、天繪學舍），在辦學方面給予由一很多協助。不久他便認識到日本傳統美術的卓越之處，傾注力量復興日本傳統美術。於是，明治22年東京美術學校開校。如同前言所述，以日本傳統美術工藝再興為目標。培養了初期的繪畫學科（日本畫）畢業生橫山大觀（1868-1958）、下村觀山（1873-1930）、菱田春草（1874-1911）等，可以說日本畫的改革、再興取得了成功。

高橋由一等西洋畫家極力推動在美術學校設置西洋畫科，但是沒有被接受。因此，西洋畫家們團結起來成立了明治美術會。有小山正太郎（1857-1916）、淺井忠（1856-1907）、川村清雄（1852-1934）、松岡壽（1862-1944）、原田直次郎（1863-1899）（圖5）、山本芳（1850-1906）、五姓田義松（1855-1915）

等核心成員。他們為了普及西洋畫，實施展開明治美術會展、演講會。此外，還積極培養具有創辦美術學校才能的後輩。經過努力，西洋畫開始再次得到了社會的認知。明治26年（1893）從法國留學歸國的黑田清輝（1866-1924）、久米桂一郎（1866-1934）加入。二人帶來了外光派的明亮清新的畫風。至此為止的畫家均是傾向於印象派以前的傳統方法。全部為褐色調的作品較多。由於黑田、久米的加入，引起了二人與老會員之間的不和。明治29年（1896）黑田等人退會結成了白馬會。這兩派的分裂引起了社會的重視，之前的畫家為舊派，也因為褐色調的畫作較多被稱為「脂派」。黑田一派則為新派，被稱為「紫派」等。從那時起，「新派」或者「新」這樣的詞語成為了西洋畫家的關鍵字。使用「新」一詞的例子比如有〈西洋畫問答〉，是明治32年（1899）大橋音羽採訪黑田的一篇報導。關於舊派和新派的差異、留學時代的回憶等等備受人們關注的話題，具體內容在這裡就不提及了。但是還是要描述一下該報導序言中的介紹文章：「黑田清輝在法國居住了大約十年，學習繪畫。然而油畫對他而言則是一個新的領域。他回到日本，和同伴結成白馬會，並在今年秋天在上野設立了油畫陳列展，博得了全東京的喝彩。」這裡的「新」一詞是體現截至1950年代前後為止的西洋畫家的價值標準之一。關於這個詞彙後面將會提及。

後來，在遲些的明治29年（1896），東京美術學校設置了西洋畫學科。黑田、久米擔任指導教師。在這之後被看做第四期。在第四個時期，西洋畫急遽地得到普及。但這一時期的畫家由於過於拘泥技法和材料近而忽視了表現形式。因此允許採用任何形式的繪畫素材，這種錯誤意識直到1950年仍被留下了濃厚的色彩。

（四）第四期

明治29年（1896）東京美術學校新設西洋畫學科，黑田清輝擔任指導教師。此外還有岡田三郎助（1869-1939）、藤島武二（1867-1943）、和田英作（1847-1959）、以及後來加上淺井忠、黑田留學時期的盟友久米桂一郎等人的支持。明亮清新的外光派畫風得到了社會的歡迎。黑田深知政府會將裸體畫和猥褻扯上關係而橫加干預，但這並沒有阻止黑田在國內推動裸體畫（圖6）這一全新的繪畫題材的努力步伐。

這也是經過了近20年與員警的干涉相抵抗，最終得以認可的偉大業績。在第一回的白馬會展（1896年）上發表了為了創作傑作〔昔語〕（圖7）而畫的多篇畫稿。第二年，發表了在此之上創作的油彩畫的傑作，展現了構想畫（群像表現）的手法。受此影響，誕生了許多諸如和田英作〔渡口的傍晚〕（圖8）、白瀧幾之助（1873-1960）〔練習〕、赤松麟

圖6. 黑田清輝　朝妝（第二次世界大戰的戰火中燒毀）　1893

圖7. 黑田清輝　昔語（第二次世界大戰的戰火中燒毀）　1898

圖8. 和田英作　渡口的傍晚　1897

圖9.赤松麟作　夜行火車　1901　　　　　　　　　　圖10.青木繁　海之幸（重要文化財產）　1904

作（1878-1953）〔夜行火車〕（圖9）、青木繁（1882-1911）〔海之幸〕（圖10）等等群像表現的傑作。也就是說，西洋畫家新舊兩派的不和的最盛時期，促成了美術學校西洋畫學科的設立。這一時期有一篇訪談報導〈美術學校與西洋畫〉（京都美術學會雜誌，明治29年），以此為線索，一起來看看有關黑田清輝的美術教育的想法和方法。記者寫下的序文如下所述：

「繪畫界東西洋兩派的反目嫉妒，使得繪畫之爭議性在畫壇已成為檯面上的嚴重問題。被推舉到世間的一個高度，而拒絕在美國哥倫布（芝加哥）世界博覽會上展覽事件，則將熱度提升到了一個白熱化的階段。自那之後，這兩派各持己見，繪畫界呈現出了針鋒相對的熱烈氛圍。此次，東京美術學校單獨設立了西洋畫學科，聘請黑田清輝、久米桂一郎兩位擔任教授，就是為了向世人展示東西混合的成果，給予繪畫界呈現一種新現象，為開拓一種進步奠定基礎。從右側所附的黑田清輝氏的一部分想法中可以得此結論。」

那時，除了西洋畫家間新舊派的對立，西洋畫界和日本畫界的對立也很激烈。因為芝加哥博覽會展覽而受到歧視的西洋畫家，拒絕在展覽會上展出作品。就是在上述的種種情況下，開始了西洋畫科的設置。接下來，一起來看下面的一部分內容：

「美術學校設置西洋畫學科，並由本人來擔任指導教師，是基於我會盡可能的提倡自由也就是沒有規則的束縛，因此可以有益於學生發揮自己的想法。」

「西洋畫學科共有4年的學期，第一年是石膏物的寫生，第二年是人物也就是裸體等的寫生，這第二年是用炭筆。到了第三年學習油畫，第四年則是用來作為畢業考試的。（中間省略）當然繪畫顏料的使用方法等學習油畫所需要的準備工作等知識在一年和二年中間的適宜時期教授。」

「雖然打算在一年和二年中間，讓學生們實地寫生學習風景等繪畫，……並不是一味地只給學生們圖畫範本來作畫。」

在明治前半期的私人畫塾和工部美術學校，入門課程是以臨摹開始的。而黑田認為臨摹只會把原畫的風格真實表現，這樣並不好。為此，非常重視寫生。採用繪畫人體素描以及裸體等劃時代的教育課程。

本人長期從事油畫的修復，會使用各種溶劑來移除畫面上的髒汙，因此在清洗前會對繪畫顏料進行溶劑的溶解性測試。結果顯示，明治前期作品的結構非常堅實且質感緻膩，到了明治後半期之後，隨著時代的潮流趨勢，油畫顏料層的耐溶性能也跟著逐漸低下，顏料層易溶解於水的作品也隨之增加。為此對於黑田「繪畫顏料的使用方法等在一年和二年中間的適宜時期教授」的這一說法是否真的被實施一直抱有懷疑的態度。

二十幾年前，有幸直接詢問到了在大正5年（1916）畢業的曾宮一念氏（1893-1994）。據曾宮氏說：「什麼也沒有。老師們每週兩次到畫室指導，對構圖、輪廓以及色彩給予建議指導，對於繪畫顏料、稀釋用油的性質以及處理方法等沒有任何建議指導。只能自己讀技法書來瞭解。」

黑田雖然引進了法國教育的新體系，但是好像並沒有充分地教給學生們繪畫是由材料和技法的支撐而構成的。藝術家不是工匠，所以釀成了無論怎樣處理繪畫素材都可以的這種潮流。

油畫原本的材料是什麼？這裡結合本人的過往經驗略作探討。

昭和27年（1952）普利司通美術館在東京開館。普利司通美術館是以印象派的作品和日本的西洋畫為中心的美術館。當時身為高中生的筆者經常去參觀。最初是喜歡西斯萊（Alfred Sisley，1839-1899）、畢沙羅（Camille Pissarro，1830-1903），日本西洋畫則是喜歡藤島武二、青木繁等。經過幾次的參觀，對塞尚（Paul Cézanne，1839-1906）、畢卡索（Picasso，1881-1973）產生了興趣。開始覺得美術館是可以反映自己變化的一面鏡子。之後便意識到法國作品和日本西洋畫比較之下，材料上存在著很大的差異。在認識到這一點之後，開始屬意柯洛（Jean-Baptiste Camille Corot，1796-1875）、庫爾貝（Gustave Courbet，1819-1877）的畫作。和在那之前的印象派的繪畫相比，雖然顯得樸素淡雅，不能引起人的興致，但是仔細觀看就會發現這些畫作有著像陶瓷器般細膩的肌理。因為非常想知道為什麼會有如此的肌理，便問了初中和高中的美術老師，但是並沒有得到答案。那時，筆者使用的稀釋用油是亞麻仁油和松節油的混合物，這是初中老師傳授的。但是用這種稀釋用油卻不能達到像陶瓷器般細膩的肌理。為解此困惑，筆者前往不同舊書店嘗試尋找繪畫技法書。下面羅列了一些筆者當年曾參考過的書籍。

《繪畫》（莫羅沃洽著，大森啟助翻譯，春鳥會，1942）。關於稀釋用油並沒有詳細記載。只是簡單說明了作為最後一道工序用以描畫用的是凡尼斯（Varnish），具體方法並沒有提及。

在《油畫的材料（油絵のマティエール）》（岡鹿之助著，美術出版社，1954）一書中寫了關於描畫用的凡尼斯。在紙上倒出油畫的顏料，紙吸去了油畫顏料的油。在除去油的油畫顏料中參入凡尼斯混合使用。這種情況下，由於凡尼斯的性質對油畫顏料產生了不好的影響，這種麻煩的方法並不實用。

《洋畫入門書（洋画手引草）》（森林太郎、久米桂一郎、岩村透、大村西崖共同編撰，畫報社，1898）沒有關於稀釋用油的詳細記載。

就像《畫的科學（畫の科学）》（石井柏亭、西村貞，中央美術社，1925）一書的序言中所說，莫羅沃洽的《繪畫》作為重要的技法書，卻沒有具體說明稀釋用油和凡尼斯。

《洋畫技巧技法全科的研究（洋画メチエー技法全科の研究）》（黑田重太郎、鍋井克之，文啟社書房，1928）一書，在眾多對稀釋用油進行解釋說明的內容中有這樣一段：

「既有只用松節油作畫的人，也有不用松節油而是僅使用少量的罌粟油作畫的人。也有人說根據特殊的範例，在新的畫布上，僅在作畫的第一天用筆尖沾上一點點的溶解油，之後不使用任何油類。」明明是技法書，卻沒有寫出任何的標準。

《油畫的科學（油絵の科学）》（山下新太郎，錦城出版，1942），沒有對稀釋用油的記載。

其他的技法書中，也沒有關於稀釋用油的使用標準。這對筆者沒有起到任何作用。曾宮氏是讀了什麼樣的技法書呢？有一次筆者從曾宮氏的一名學生畫家那裡打聽到可能是因為曾宮氏與中村彝（1887-1924）關係親密，從中村彝那裡得到的指導吧。中村彝是優秀的西洋畫家。翻譯有琴尼諾・琴尼尼（Cennino D' Andrea Cennini，1370-1440）的技法書。

在美術學校沒有關於油畫的技法、材料的課程。技法書很粗略，不能得以依賴。大正、昭和時代的大多數西洋畫家使用的油畫顏料都是由顏料製造商反覆研究來製作的。因此，畫家的想法就是無論怎樣處理都可以。油畫顏料黏性強，乾的也很慢。解決方法就是使用松節油等揮發性油，而且非常簡便。但是，松節油使用過多油畫原本細膩的肌理就沒有了。

至此，對於日本近代西洋畫來說，它的關鍵字可以認為是「新」。前面已經介紹了對黑田「以法國新資訊來做新的學問」的報導。的確，從明治前期的所謂舊派的畫風來看確實是新的，那也是以當時的信息量來說沒有辦法的事。明治40年（1907），文部省美術展覽會（文展）開設。國家建成美術學校、美術展成為近代國家體制的一部分。一方面，明治43年（1910）發行雜誌《白樺》，引進了法國的新資訊。介紹了梵谷（Vincent van Gogh，1853-1890）、塞尚、馬蒂斯（Henri Matisse，1869-1954）、羅丹（Auguste

Rodin，1840-1917）等，給青年畫家們帶來了很大的影響。年輕的畫家們對文展西洋畫的審查持有不信任的態度，引發了把文展二科（西洋畫部門）分成新舊兩科的運動。因為沒有能夠被接受，所以在大正3年（1914）創設了美術團體二科會。這裡所説的新舊的「舊」是指外光派。隨著之後的時代的變遷，野獸派、未來派、超現實主義等被年輕的畫家們所接受。他們認為比自己年長的一代為「舊的」。1910年代至1930年代的年輕西洋畫家在努力接受法國的最先端，這樣的氣氛一直持續到1950年仍殘留濃厚的色彩。遺憾的是，反抗文展的畫家們大部分都對油畫的材料和技法漠不關心。甚至可以用「隨波逐流」這句中國諺語來比喻。但是並不是所有畫家都是這樣的。

岸田劉生（1891-1929）（圖11）和他草土社的同伴們認為，大力發揮油畫顏料的材質特性能夠更有力地支撐表現出畫作深層次的美感。通過在修復畫作時候的調查，瞭解到他的畫作非常堅固，是僅用亞麻仁油和松節油所不能畫出的肌理。大概在三年前，再次讀了他的日記。逐一檢查關於繪畫的素材、技法等的記述。勤于記筆記的劉生對於繪畫素材幾乎沒有記錄。只是在1921年1月5日寫了一句「順道去了文房堂買了兩瓶罌粟油」，以及1922年4月2日寫有「在文房堂買了兩瓶peindre（描畫用的凡尼斯）」。從中可以推斷，草土社的畫家們是在稀釋用油中添加凡尼斯的。

圖11. 岸田劉生　公路和堤防和圍牆（通路寫生）（重要文化財產）
1915

且説在1970年代，據尾崎尚文氏的敘述，明治時期初國澤新九郎從英國帶回的，由國澤死後繼承畫塾彰技堂的本多錦吉郎贈與國會圖書館的技法書被再次發現。那時青木茂氏（明治美術學會會長）在舊書店買到了幾本彰技堂的私塾學生坂廣的手稿本，是手寫臨摹本多譯作的稿本。筆者回想起曾在坂廣的手稿本中看到過確切地寫著至今沒有看到關於溶解油的種類和特徵、處理方法等內容，並為此而感到驚歎。根據其中得到發表的作品〈油畫入門〉（《明治洋畫史料紀錄篇》，青木茂編，中央公論美術出版，1986）的記載，得知稀釋用油推薦用亞麻仁油和megilp（繪畫用調色油），大量使用松節油是不好的。而且當時的英國畫家是比較喜愛使用megilp（繪畫用調色油）的。Megilp是混合催乾劑的亞麻仁油與乳香凡尼斯（Mastic Varnish）調合而成。明治前期的作品是具有油畫顏料本來的細膩的材料、具有耐久性，符合日本風土的，這在前面已經做了闡述。它的秘密就是有稀釋用油，筆者認為這應該是描畫用凡尼斯起到的巨大的作用。但是，通過現在的分析機器並沒有檢測出樹脂，在那個時候這種參考文獻作為情況證據有著很大的意義。然而，並不知道明治10年（1877）前後，在日本是否輕易可以得到描畫用凡尼斯。關於這一點，青木氏發現了在那時的畫材店的商品目錄。根據商品目錄記載「瓶裝megilp（繪畫用調色油）20銅錢」，從而得知調色油已經被國產化。（〈油畫初學明治十年前後〉《近代畫説》20，明治美術學會，2011）

由此可見，不僅明治前半期的技術，連同黑田以後古風的作品風格也都遭到了後人的否定。這是非常遺憾的。

到了1970年代，一位1929年畢業於美術學校的畫家創作于1940年代的作品被修復，是在官展上十分活躍的畫家，但是其作品的一部分顏色遇水溶解了。這是遇到的最初的溶解於水的油畫。乾性油（亞麻仁油或罌粟油）是調製油畫顏料的主要成分，作為稀釋用油使用，乾性油可以通過氧化聚合再固化，變成不溶於溶劑的物質呈現在書本上，因此本以為油畫是不溶於水的，故而很震驚。關於這位畫家使用的稀釋用油，詢問了其遺屬：「父親討厭油畫的光澤，稀釋用油只是使用松節油而已。」這樣説到。僅是使用揮發性溶劑（松

節油或者揮發油）作畫，油畫顏料層缺乏耐溶性能，黏著力也很弱且易碎。當然，也不能形成油畫顏料獨特的細膩畫肌。下面是直接詢問了其他畫家的談話。

　　畫家A（美術學校1919年畢業）作為野獸主義的介紹人而活躍。學生時代開始僅使用松節油。

　　畫家B（美術學校1933年畢業）官展系畫家。學生時代開始僅使用松節油。

　　畫家C（美術學校1939年畢業）官展系畫家、藝術院會員。學生時代開始僅使用松節油。

　　畫家D（藝大1954年畢業）藝大名譽教授。松節油和亞麻仁油混合使用。作畫的開始多用松節油，臨近完成時多用亞麻仁油。這位畫家的畫作油畫顏料不會溶解於水。因為用了揮發油有一部分可溶的顏色。與明治前期的作品相比溶劑測試的成績稍微差了一些。從這個事例中本人認為明治初期的畫家在稀釋用油中加入描畫用凡尼斯的可能性很高。

　　如前文所述，在東京美術學校西洋畫學科是沒有油畫材料和技法的基礎教育的，是自由放任的。而且，大多數的青年畫家都忙於最快地捕捉法國最新的動態，並不在乎支撐繪畫表現的畫材和技法。這樣而成的西洋畫被尊敬的友人森田恒之氏（國立民族學博物館前名譽教授）稱為被亞洲化的油畫。回顧長久的日本西洋畫歷史，指出20世紀以後的日本油畫技法存在著問題是為了論述陳澄波。他在日本學習到了什麼呢？

二、陳澄波的油畫

　　與陳澄波的作品相遇是在1998年12月上旬。受陳景容氏的委託，與木島隆康氏訪問臺灣，對臺北市立美術館收藏的數件作品進行調查和修復評估，以及對一件油畫顏料層翹起的作品進行加固緊急處理和塗佈凡尼斯，召開了關於油畫修復的研討會。這期間，走訪了嘉義的陳重光先生的宅邸，在那裡初次看到了陳澄波的作品。因為在之後舉辦的《東亞—繪畫的近代—油畫的誕生和展開》展（靜岡縣立美術館等）上要展出陳澄波和其他畫家的作品，於是在東京修復這些作品。修復是由修復研究所21承擔，當時作為研究員的木島隆康氏（現東京藝大大學院教授）等負責。修復彙報《修復研究所報告》刊登在Vol.15，1999-2000（修復研究所21，2001）。

　　修復作品有以下7幅：

　　1.陳澄波〔夏日街景〕

　　2.陳澄波〔嘉義街景〕

　　3.廖繼春〔有椰子樹的風景〕

　　4.李石樵〔田園樂〕

　　5.劉啟祥〔桌下有貓的靜物〕

　　6.洪瑞麟〔日本貧民窟〕

　　7.張義雄〔吉他〕

之後，2002年木島氏轉調東京藝大。2007年受陳重光先生的委託，在東京藝大修復了3幅陳澄波作品：

　　1.〔嘉義街中心〕

　　2.〔岡〕

　　3.〔女人〕

　　最初見到陳澄波作品的印象是，保存狀態不是太好，也因此有一些受損傷的地方。但是，油畫的畫肌很細膩而富有魅力。這位畫家（的作品）是具有油畫體質的，他讓油畫顏料的特質充分地發揮，並以此貼切地描繪出臺灣故鄉的風土。以當時的社會氛圍下的東洋人而言，他的存在是非常特異的、是能夠符合我心目中理想的藝術家條件的少數者之一。

　　油畫顏料的黏性強、乾的慢，而且有光澤，這是其他人的油畫顏料不具備的特色，即使說西洋的名畫全

是充分發揮這種特質來畫的也不為過，但是，這正是美術學校出身的大多數畫家的缺點。當時的最簡單的不好的解決辦法就是僅是在稀釋用油中使用揮發性溶劑（松節油、Pétrole揮發性油）。就像前面所述那樣，美術學校出身的大多數畫家是在沒有關於材料和技法的基礎知識的情況下作畫的。畫是一種表現，可以說那是作為藝術家的畫家為了表現做什麼都被允許的時代。像這樣畫出來的容易壞掉、容易剝離、打破油畫顏料所具有的本來的性能美的作品群被森田恒之氏稱作亞洲化油畫。這一點在前面已經提到過。

在現在可以有這樣的批判，但是考慮時代狀況，當時的畫家也是很可憐的。19世紀末到20世紀初，西洋畫界的新舊兩派對立，新派勝利成為主流。因此，舊派優秀的一面，也就是材料技法正確的處理方法被摒棄，被植入了西洋畫家不能有陳舊的東西這種強迫性的觀念。那麼說到新的東西是什麼呢，那就是法國的新潮流。正如前面所述那樣，1910年代以後，塞尚、梵谷等被熟知，緊接著野獸主義、立體主義、未來派、超現實主義等等陸續的被人們所知。儘管這麼說，但是接觸到真正的作品是稀少的，只有從彩色印刷的畫集或者是雜誌上才能看到。在1930年的大原美術館建成以前是沒有專門的西洋畫美術館的。因此，從畫集或者美術雜誌的印刷品中，受到影響的是表面的色彩、輪廓、筆觸等，並不在乎支撐表現的畫布以及油畫顏料的處理方法。

在這種風潮中，陳澄波在日的學習過程中，到底內心真正的想法是什麼？東京美術學校入學時已經29歲，一定是積累了社會經驗，具有明確的目的意識來到日本的。他沒有在至今為止一直在闡述的安逸的潮流中隨波逐流，發揮油畫顏料的黏稠性，珍惜油畫顏料本來具有的細膩的肌理，而且還考慮到表現形式。嘉義近處的風景畫是樸素的、充滿對鄉土的愛，貼近故鄉的自然而作的畫作。是一幅將這種樸素和油畫本來的材質的美相輔相成的優秀作品，因此可以說具有國際性。樸素這個詞彙本人所表達的是好的意思，不是指以梵谷、塞尚、雷諾瓦等西歐畫家的畫風為基礎，而是說有他獨特的東西的意思。從他的畫風中並不能看出是受了誰的影響，只是，感受到他理解油畫顏料的性質，在此基礎上構成表現形式的堅強的意志。

在東京藝大修復的3幅作品〔嘉義街中心〕、〔岡〕、〔女人〕的報告書中，通過查看對溶劑測試表，顯示了其極高的耐溶性，比得上明治前期的作品。由此可以類推溶解油是在乾性油中添加凡尼斯的。正如至今為止所述那樣，那是缺乏材料技法的相關資訊的時代，他是如何掌握技術資訊的呢？這是本人非常感興趣的地方。包括日本畫家在內，陳澄波是走在油畫主道路上為數不多的畫家之一。如果他沒有被殺害，那麼臺灣的西洋畫界想必已得到了更加蓬勃的發展。這不禁讓人扼腕歎息。（2014.1.22）

【註釋】
1. 歌田真介：日本油畫修復專家、東京藝術大學名譽教授。
2. 譯註：官名，奉命處理書籍方面事務。

A Discussion on Chen Cheng-po's Works of Art

Utada Shinsuke[1]

Summary

Japan's adoption of oil painting techniques from modern Western paintings starting in the 19th century can be divided into two stages. In 1855, the Tokugawa shogunate set up the "Western Academy," a research institute focused on Western studies (Later renamed "Institute for Research of Foreign Documents," "Foreign Studies Center" and "Institute for Western Studies," after the Meiji Restoration this institute became known as the University of Tokyo). In 1856, the shogunate set up a "Division for Foreign Art Studies" (later renamed Painting Division) for Western painting studies within the Institute for Research of Foreign Documents. The period from 1856 to 1895 was the first stage. The second stage began in 1896, when a Western painting program was introduced in the Tokyo School of Fine Arts, and continued until 1950 when the Tokyo University of the Arts set up a research center for studying oil painting techniques and materials. The early stage was a period of introducing craftsmanship with a focus on teaching techniques for using tacky oil paints. Thus, during this period painting techniques were emphasized. We learn from a book titled *A Biography of Takahashi Yuichi* that this stage started with literature reviews in a serious attempt to obtain painting materials and learn painting skills. In 1868, the Tokugawa shogunate was replaced by the new Meiji government. The new government retained the Foreign Studies Center, but closed the Painting Division. Before the new government set up the Technical Fine Arts School under the Ministry of Industry, it was private painting studios owned by artists like Takahashi Yuichi that undertook the teaching and scholarship of Western painting. A national school of fine arts was finally founded in 1876. Nonetheless, after the crackdown of the Saigo Takamori Rebellion in 1877, the new Meiji government grew increasingly stable while society turned more traditional. This eventually led to the unfortunate rejection of Western paintings in the 1882 first National Painting Exhibition. Obliging to the social trends, the Technical Fine Arts School closed in 1883. In 1887, the Ministry of Education set up the Tokyo School of Fine Arts. Aiming to revive Japanese traditional art, the school offered three areas of study: painting (Japanese painting), sculpture (woodcarving) and art and crafts, while Western painting was excluded from the curriculum. Western painting artists pleaded and even launched a movement to have a Western painting program added, but to no avail. As a result, the Western painting artists formed Meiji Art Association. They not only held exhibitions and organized talks, but endeavored to popularize Western painting and nurture successors with the hope of establishing future art schools. Similar to the artists of the later denigrated Old School or Bitumen School, Western painters of this period adopted traditional European techniques, and their paintings were characterized by an overall brownish gloomy tone. Painters from that time period paid more attention to the durability of oil paints. As pointed out by Goseda Yoshimatsu in explaining the

artworks displayed in the First National Industrial Exhibition, "it was paramount to ensure that paintings remained the same" even after a long period of time. Takahashi Yuichi also proposed that oil painting copying or painting from real life was a very useful means of cultural heritage preservation. As will be discussed later, it can be seen that artworks in the first stage were durable and in line with Japanese customs.

The second stage started in 1896 when the Tokyo School of Fine Arts set up a Western painting program. Kuroda Seiki was appointed as an instructor in Western painting. Because he had studied in France, Kuroda was deeply influenced by the Impressionists, and so introduced the bright colored style of plein-air paintings. Known as the New School or Violet School, this style not only gained public acceptance, but was also particularly popular with young painters. This, in combination with the Ministry of Education running an annual art exhibition starting in 1907, the popularity of Western painting soared significantly. In "School of Fine Arts and Western Painting," Kuroda stated that copying artwork was not meant to simply copy model paintings, but rather, to teach that observation before painting was a necessary requirement. First and second year students would be taught how to properly use oil paints. He also mentioned that he would encourage students to freely paint and would respect their expression of personality and freedom of choice. Nevertheless, most paintings painted after Kuroda's era were not durable and easily deteriorated under natural conditions. They were supposed to be made with oil paints, but many of them dissolved on contact with water. It can be concluded that such an era came about because painters in those days neglected materials and techniques that were necessary for artists to express their styles. I had the chance to visit Somiya Ichinen before he passed away (graduated in 1916), who told me that he had not received any basic instruction on techniques and the handling of painting materials when he was a student.

I have been long engaged in the study of oil painting techniques and materials along with painting conservation. A few relevant accounts based on my experience are recorded as follows. Bridgestone Museum of Art opened when I was in high school. I visited often and became fascinated with the fine-grained texture of the works of Corot and Courbet. How could such a texture be achieved? I asked many teachers but received no answers. I could not get any clues from reading books on craftsmanship, nor could I obtain any information from the Tokyo University of Arts. In 1964, an exhibition of Takahashi Yuichi's works was held in Kanagawa Contemporary Arts Museum. I was commissioned along with several colleagues from the same laboratory to carry out minor cleaning on the paintings. From the beginning I had been taught that Takahashi Yuichi's works were obsolete, as they belonged to the Bitumen School or Old School, and I believed so. Surprisingly, the texture of Yuichi's paintings shared similarities with that of Corot and Courbet's works. Also, even after nearly one hundred years the paint layers remained robust. Since then, I have continued to study and research Yuichi's painting technique. However, it was not until recently, after half a century's research that I could clearly understand his techniques.

Before describing Takahashi's technique, let us first look at technical painting issues since the plein-air style of painting was introduced to Japan. In 1970 I treated a painting by Painter S, who graduated from the Tokyo School of Fine Arts in 1929. It was supposed to be an oil painting but dissolved on contact with water. Upon asking the painter's descendant I was told, "Father disliked lustrous textures so he only painted with turpentine." From this it can be further confirmed that mediums were used to dilute paints, and in contrast, that using volatile solvents like turpentine and petroleum spirits (petrol) would

increase the likelihood of cracking due to a lack of durability and the predilection of painting surfaces to dissolve on contact with water. Later, I successively heard that many painters who graduated after 1920 only used turpentine in their paintings. Due to the fact that the Tokyo School of Fine Arts did not stress the importance of painting mediums, most painters paid little attention to this. Painter T, a graduate in 1954, said that he used both linseed oil and turpentine in painting. When he started a painting, he used mostly turpentine, and upon finishing would use mostly linseed oil. About twenty years later, while surface cleaning his paintings I observed that the surface did not dissolve in water, but some colors dissolved on contact with oil paints. It can be seen that Takahashi Yuichi's works from one hundred years ago were much more robust. The secret to why Takahashi Yuichi's works stayed robust was the use of resins in the painting medium. Aoki Shigeru, chairman of Meiji Art Association, discovered a catalog of merchandise sold in a painting supplies shop around 1877. From one item "Bottled Megilp: 35 copper coins", we learn that domestically produced were already available. The reason why artworks from the first stage were so robust was that drying oils, such as linseed and poppy seed oil, were mixed with resins to act as mediums, and volatile solvents such as turpentine and petroleum spirits (petrol) were used for dilution.

The reason I describe in detail the technical problems of Western paintings from the second stage, especially the problem concerning painting mediums, is to explain why Chen Cheng-po's works are very robust with a perfect texture. His works were damaged due to storage in a poor environment, not because of incorrectly choosing materials and techniques. He was not confused by the misconception that most of his Japanese contemporaries had – that painting mediums were of little importance. Rather, he had his own understanding about the nature of oil paintings. Perhaps he deduced that painting mediums were mainly made of drying oils and resin oils and volatile solvents could be added to adjust tackiness, allowing Chen to create a perfect texture for his oil paintings. Where did Chen Cheng-po obtain this knowledge? I am also quite curious. Artists from the Sodosha Group, led by Kishida Ryusei, also produced works with a robust texture. Kishida recorded notes in his diary about buying a resin oil-based varnish. I think it was likely that Chen Cheng-po obtained his information from here.

1. Utada Shinsuke: Japanese oil painting conservator, emeritus professor of Tokyo University of the Arts.

從修復作品看陳澄波的繪畫技法與作品再修復

木島隆康[1]

前言

　　用強勁有力的筆法且充滿速度感的筆觸所描繪的彎曲的樹木，略顯有意圖的歪曲著的人物和建築物，不同色彩的原色搭配，對比度分外鮮明的充滿緊張感的色調，無論從哪一個角度看我們都能感受到這是一個有著堅強意志的作者所創作出的強而有力的作品。活用顏料的黏稠性，其強勁的色彩釋放出無法比喻的魅力，這就是筆者在陳重光先生家裡看到陳澄波作品時的第一印象。

　　筆者在修復調查陳澄波油畫作品的領域中已經經歷了數個年頭，最初的接觸始於1998年至1999年間，在創形美術學校修復研究所工作期間，受臺北市立美術館的委託對〔嘉義街景〕（1934年）、〔夏日街景〕（1927年）2幅油畫作品進行修復。之後，調轉工作到東京藝術大學，再一次受到陳重光先生於2007年對東京藝術大學的委託，參與修復〔嘉義街中心〕（1934年）、〔岡〕（1936年）、〔女人〕（1931年）3幅作品。此外，從2011年國立臺灣師範大學文物保存維護研究發展中心成立，油畫修復專案立案合作至今共參與36幅作品的修復工作，到現在仍在繼續陳澄波作品的修復專案。[2]

　　本文以這些作品為研究對象來探討陳澄波的繪畫技巧。筆者所負責的工作是考察文物保存維護研究發展中心所修復的36幅油畫作品中陳澄波使用過的創作技法。參考顏料分析結果和繪畫材料，以光學性調查、目測觀察以及可攜帶式X射線螢光分析儀（XRF）對作品展開非破壞性分析研究。有關顏料分析的部分，因鈴鴨富士子小姐已於下篇專文詳述，故請參照其分析結果。光學性調查是在對圖像進行正常光學拍攝的同時，另以紫外線螢光攝影、紅外線反射攝影捕捉那些用肉眼捕捉不到的圖像，參考Ｘ光（X-Ray）透射圖像找出作品特徵的手法。

　　36幅時間跨度頗大的作品，對研究陳澄波一生的繪畫技法而言有些管中窺豹。作品數目雖然有限，但在作品展開的修復過程中也累積了寶貴的光學性調查資料。我們會在本文透過這36幅作品，考察陳澄波作畫技法的特徵。

　　對象作品的36幅畫作，其年代介乎1925年至1941年之間（其中10幅年代不詳）。年代明確的26幅作品可以分為三類，分別為東京美術學校時期的作品7幅，上海時期的作品15幅，返回臺灣後的作品4幅來進行分類。另外，筆者在創形美術學校修復研究所工作時負責修復的2幅以及在東京藝術大學進行修復的3幅也作為本次研究的研究對象來考察。

　　此外，在進行36幅作品的修復專案過程中，還對已經被修復過的6幅作品進行再次修復的機會。其中包含了以蠟為黏著劑進行托裱的作品，本文以其中的一幅作品〔綠瓶花卉〕為例，對再次修復被蠟托裱處理過的作品進行報告說明。有關蠟托裱再修復（移除蠟托裱）的具體操作過程的相關研究是極少見的，因此，這次的報告定會成為寶貴的案例。

一、技法

（一）筆法

　　油畫的描繪方法有直接畫法（AllaPrima）、濕畫法（WetinWet），以及厚塗畫法（Impasto）等技法。直接畫法（AllaPrima）是在畫布上直接塗繪的方法，19世紀後半期開始得到廣泛使用。濕畫法（WetinWet）是在畫布上塗繪的顏料未乾期間再塗上一層顏料，使上層和下層的顏料顏色混合進行描繪的方法。厚塗畫法（Impasto）是將顏料厚厚的塗在畫布上，以調色刀的平坦塗痕以及畫筆的塗痕為筆觸強調表現效果的方法。厚塗畫法是17世紀中期開始使用的西方印象派畫家的特色性畫法。將其效果發揮極致的畫家是文森・梵谷（1853-1890）。值得一提的是，油畫的特徵性技法之一是古典西洋Glaze技法（透明畫法），但是陳澄波的特點是沒有使用這種方法。也就是說他並不採用以重疊具有透明感的顏料來製作多層次視覺色調的Glaze技法，而是採用在調色盤上或者畫布上將不透明的不同顏色顏料混合調色作出階調的描繪方法。陳澄波的這種將不透明顏料互相添加混合調色的描繪技法應該被歸為不透明繪畫一類，而他的大部分作品都使用了這種手法。

　　陳澄波以濕畫法在畫布上塗上用調色盤混合調色的顏料，並不過多的混合其他顏色，而是活用原色，一氣呵成地在固定的位置塗上顏料。他的很多作品都是以這種形式完成的。從其用筆動作可以看出作者被抑制的冷靜，加上他的速度感，動靜交織的那種筆觸，讓畫面呈現出緊張感與躍動感，形成了他獨特的畫風。除了大作之外，其創作時間較短也是他的特徵。觀察他簽在畫作上的簽名，可以看出，作品剛畫完在顏料還沒乾的狀態下就簽名的作品很多，是在簽名用的顏料與其下面一層的顏料混合狀態下寫成的。像這種在短時間完成的直接性畫法，與其說是在畫布上調色用濕畫法（WetinWet）作畫，倒不如說是在調色盤上混合調色顏料再直接塗在畫布上的這種直接畫法（AllaPrima）更合適吧。在中國的5年間，陳澄波都是有意識地使用這種畫法，而直接畫法其後也成為了他固定的畫法。概觀陳澄波的作品，會發現他是極少描完再描的畫家之一。如果先在畫布上構圖，就會反覆勾描力求找到理想的形體和色彩，陳澄波在對主題的形體和色彩處理上，並不是採用前面所提的這種方式，他的大部分作品都是一筆定型，使用最初的形體和色彩，幾乎不再做修正便完成畫作。這完全可以說就是直接畫法，也就是說，包括濕畫法（WetinWet）甚至厚塗畫法（Impasto）在內，如果需要用一句話來概括陳澄波的技法，可以說他最常採用的繪畫技法是直接畫法（AllaPrima）。

（二）畫筆和油畫刀的使用

　　畫筆和油畫刀是上述直接畫法必要的工具也是很重要的要素。可以確定陳澄波的36幅作品都使用了豬毛畫筆和油畫刀（以下簡稱畫刀）。他選用的畫筆主要以從中粗到極細的筆為主，為實現強有力的筆觸，在畫筆的硬度選擇上他選擇了中間硬、筆尖短的畫筆。畫刀的使用則大部分是在小畫作中，可以確定的有8幅。像〔綠蔭〕（1934年）這樣的大幅作品，只是在表現建築物的牆及招牌的時候部分使用。（圖1）。此外，還用於表現樹木的枝幹、電線杆、畫面中的小人等等的時候使用。陳澄波無論是畫筆還是畫刀都不過分依賴，而是根據需要適當使用。

圖1.〔綠蔭〕局部。

　　再進一步觀察畫刀的使用情況，發現作品群中有唯一的一幅只使用畫刀描繪的作品。是一幅名為〔古門

樓〕（年代不詳）的作品，是以建築物的牆壁和石階為主題的小幅作品。為求石壁和石階的堅硬質感利用畫刀作出堅硬質感的畫肌（圖2）。另外，還有一幅作品〔上海雪景〕（1931年），這是一幅混合使用畫筆和畫刀作畫的作品。右下角作為點綴的人物，只是在柔軟而黏稠的顏料上用刀尖省略細節的描寫扼要地表現。這種刀法的表現輕妙而又有躍動感（圖3）。

（三）顏料的黏稠性

　　陳澄波使用的顏料比一般的油畫顏料更柔軟並且具有能拉絲的黏稠性。其充分利用顏料黏稠性的筆觸，是他技法上的一大特點，也給他的畫風賦予了特色。想要讓顏料富有黏稠性，單是從管中擠出來是達不到的，得需要下一些功夫。畫家必須在顏料中混入某些具有黏性成分的乾性油以及樹脂成分。我們推測陳澄波應該是在顏料中混入這類成分才使顏料具有柔軟性和黏稠性。尤其是從〔少年像〕（年代不詳）中（圖4），可以看見人物的眼睛周圍散亂的絲狀顏料，他的這種從形體向外拉絲的處理手法讓人物的那種困惑的樣子躍然紙上非常有趣。另外，以微距近拍的照片來介紹幾幅顏料黏稠性顯著的作品。〔亭側眺望〕（1933年）中的樹木（如圖5），〔湖畔〕（1928年）中的樹木（圖6），〔塔峰下〕（1933年）中的母子（如圖7），都是畫家緊握著筆尖很短的豬毛畫筆，用筆尖淺淺地沾取調色板上的顏料，然後塗畫在畫布之上。用同一強度的筆壓，時慢時快地移動畫筆，塗畫顏料結束之後就會留下黏稠的筆觸。

　　值得一提的是，具有黏稠性的油畫的優點之一是結實、顏料牢固。在日本和臺灣很少有能夠這樣充分利用油畫顏料黏稠性的畫家。

圖2.〔古門樓〕。

圖3.〔上海雪景〕人物部分。

圖4.〔少年像〕的眼睛。

圖5.〔亭側眺望〕樹木部分。

圖6.〔湖畔〕中的樹木。

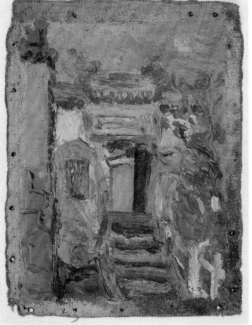
圖7.〔塔峰下〕中的母子。

二、通過X光照片看筆觸及顏料的特徵

此次調查,我們從X光照片中得到了讓人非常感興趣結果,這些研究結果能夠從側面了解出畫家的特徵。通過普通的照片圖像很難瞭解畫家的畫筆走向,以及瞭解畫家是如何利用顏料的黏稠性來繪畫的。而X光圖像所產生的黑白圖像卻能夠讓我們看到更多的資訊。X光圖像能夠不受色彩的迷惑明確地觀察到畫筆的走向和顏料黏稠性所產生的紋理。下面以3幅作品為例,嘗試將正常光與X光的圖像相互比對。

〔亭側眺望〕(1933年),沒有採用正確的遠近法,而是將描繪的主題各自做有意識的變形。用畫筆沾取足量的柔軟顏料,以強勁的筆壓一邊延展顏料一邊進行繪畫。作品中的黏稠性顏料完全看不到受磨損的跡象(圖8、9)。

圖8.〔亭側眺望〕正常光。

圖9.〔亭側眺望〕X光。

在〔女子像〕(年代不詳)中,可以觀察到畫家沒有特意的強化頭蓋骨的骨骼,而是將形體進行了變形並自由奔放的塗上柔軟的顏料。畫家的筆壓很強,可以說在塗過顏料的地方幾乎沒有反覆回筆的動作。換言之,畫家沒有重覆描繪而是一直向前完成了作品,最終創作一幅顏料黏稠性好,富有躍動感的作品。(如圖10、11)。

〔海灣〕(年代不詳)也是同上述2幅作品一樣,活用軟性顏料的黏稠性,畫筆自由的移動以表現天空和海邊的波浪。沒有重覆描繪,是短時間內一氣呵成完成的作品(圖12、13)。

對比正常光圖像,筆者認為X光圖像更能夠直接展示出顏料塗層的特點,也能更直觀的重現顏料的黏稠性和硬質豬毛筆所創作出的強有力的躍動感畫面。

此外,雖然隱藏於直接畫法富有躍動感的筆觸下,陳澄波的

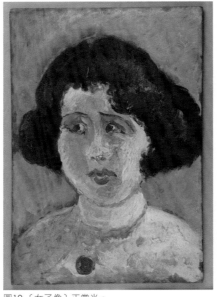

圖10.〔女子像〕正常光。

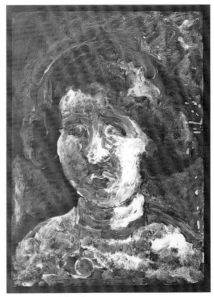

圖11.〔女子像〕X光。

畫作還存在著不容易為人所發現的漣漪狀的畫法。在〔普陀山群驢〕（1929年）的表面可以清楚的看到這種畫法（圖14、15），圖15是它的Ｘ光照片。〔綠蔭〕中天空的地方也是同樣（圖16）。對比油畫刀的硬質感，畫家極其自然地使用像這樣連續的漣漪，有區別的使用柔軟且有速度感的筆觸來創作。

其次，雖然與陳澄波的技法沒有直接聯繫，但是通過Ｘ光照片，筆者觀察到有4幅作品，在現有圖案的下層還有不同的圖案，所以在此介紹一下。不排除這些都是他在已經一次性完成的作品上，重新創作的作品，所以未必明確這一定是下層的圖案。

〔大白花〕（年代不詳）是橫幅畫面的風景畫（圖17、18）。雖然不是很明確，但是從〔新樓庭院〕

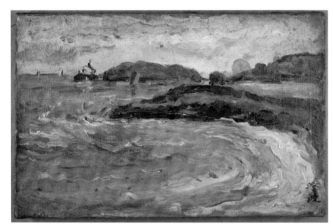
圖12.〔海灣〕正常光。

圖13.〔海灣〕Ｘ光。

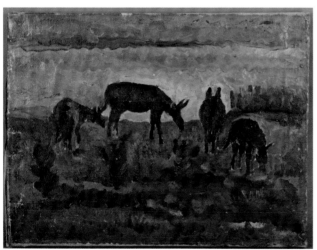
圖14.〔普陀山群驢〕正常光。

圖15.〔普陀山群驢〕Ｘ光。

圖16.〔綠蔭〕天空部分Ｘ光。

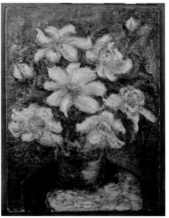
圖17.〔大白花〕正常光。

圖18.〔大白花〕Ｘ光。

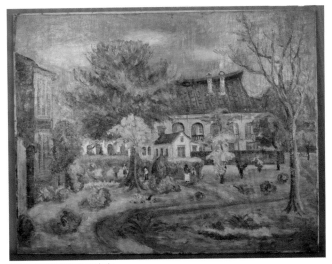

圖19.〔新樓庭院〕正常光。

圖20.〔新樓庭院〕X光。

（1941年）中可以看出不同的風景畫般的圖像（圖19、20）。〔陽台遙望裸女〕（1932年），可以確認是半身的女性，左手放在胸部，身體前傾的圖像（圖21、22）。〔綠蔭〕（1934年），圖像還不能確定，但是明確存在著不同的風景（圖23、24）。

理由暫且不做深究，通過X光照片筆者明確發現，陳澄波不僅在新的畫布上創作，還曾經在已經完成創作的畫作上進行全面再創作。

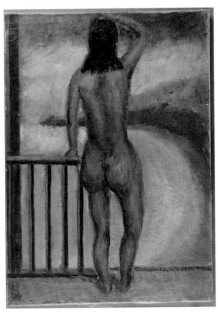

圖21.〔陽台遙望裸女〕正常光。

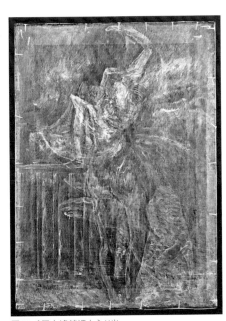

圖22.〔陽台遙望裸女〕X光。

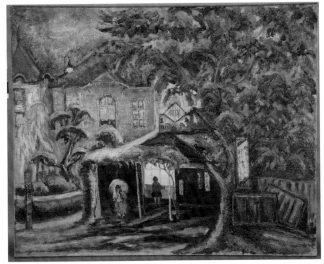

圖23.〔綠蔭〕正常光。

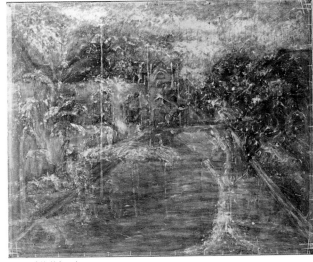

圖24.〔綠蔭〕X光。

三。關於顏料

（一）色彩

　　陳澄波經常以濃烈色調的對比度為軸進行色彩構成。綠色和紅褐色的對比是他的基礎用色，用這兩種顏色進行色彩搭配帶來變化進而增加色彩的種類。再加上隨處可見的色彩鮮豔的朱紅色進行有效的配色，給作品整體帶來一種色彩鮮明的感覺。綠色的範圍包括深綠色到淡青綠色，甚至擴展到黃綠色。紅褐色則是從紅土色到黑褐色，甚至擴展到帶有紫色的褐色。

（二）顏料分析

　　概觀陳澄波創作作品時使用的顏料以及畫布塗料的顏料分析結果，做如下總結。

　　陳澄波所使用的畫布，打底層被檢測出了鋅（Zn）和鋇（Ba），他使用塗有被稱為鋅鋇白（lithopone）的白色塗料的畫布居多。有時也選用單獨使用鉛白（Pb）以及用鉛白和鋅鋇白的混合塗布的畫布，這樣的畫布只在少數的幾幅作品中看到。

　　關於油畫顏料方面，筆者可以很肯定的推測陳澄波在東京美術學校學習油畫基礎時，應該受到田邊至（1886-1968年）的影響，他可能也同田邊一樣使用西方進口的高品質的油畫顏料。白色顏料是以鋅（Zn）為主要成分的鋅白為主色。綠色顏料被檢測出了鉻（Cr），我們認為是使用了氫氧化鉻和鉻系顏料。另外，有的綠色顏料中還檢測出了鈷（Co），可能是使用了鈷綠。除此之外，陳澄波的作品中還有被檢測出有銅（Cu）和砷（As）的綠色，以及使用了顏色鮮豔的祖母綠（emerald green）的綠色顏料。作品中的紅色則是以色彩鮮豔的朱紅色隨處可見的進行配色。從這些有紅色的地方還檢測出了汞（Hg），筆者猜測可能是朱砂（vermilion）。而被檢測出鎘（Cd）的作品是用了鎘紅，被檢測出鐵（Fe）的作品推測是用了氧化鐵系紅色顏料。從所有的褐色部分中檢測出的鐵（Fe）是氧化鐵系褐色顏料。關於黃色，陳澄波並不常用，黃色部分被檢測出的鎘（Cd）是鎘黃。各種顏色的色調濃淡大都是用白色的鋅白來混合調色的。

四、繪法技法的總結

　　從保存修復的角度概觀陳澄波從初期到後期的作品，坦率的說，技術性而言並沒有很大的變動。即便是1927年東京美術學校時期創作的〔日光華嚴瀑布〕，從樹木的黏稠性的筆觸就可以讓人預感到這已經成為他的畫風。也就是說，多年以後，他依然喜歡這種獨特的風格，利用顏料的黏稠性蜿蜒起伏地用筆。筆者認為這是他在不斷的創作中自覺地意識到的。而有關顏料黏稠性這項可謂是陳澄波魅力的原點，本文已透過觀察近攝照片和X光圖像明確地說明。他在東京美術學校師範師事田邊至，田邊豐富的油畫技法材料知識為陳澄波奠定了堅實的油畫基礎知識。筆者對於田邊的繪畫職業生涯並不是很了解，但是從東京藝術大學美術館收藏的〔放牛〕（1908年）中可以看到，田邊至使用厚塗顏料以活用油畫顏料的黏稠性進行創作。此外，整體的主色調是和諧多樣的綠色，單從這一點就可以看出田邊至對陳澄波的潛在的深遠影響。

　　陳澄波在基底材的使用上大多是以畫布為主體，此外也使用油畫木板（sketch板）和畫布板（canvasboard）。畫家們經常都是自己動手製作基底材，但是從陳澄波的作品中卻找不到手工製作的基底材，他使用的基底材全都是從市面上買來的商品。另外，在使用顏料方面，雖然使用量不是很多但是卻使用了當時價格很高的朱砂（vermilion）、鎘系顏料。陳澄波有好些作品都是在完成品上再加工的；由此看來，雖不能一概而論，但筆者猜測，陳澄波的一生，從沒窮困到要親手製作繪畫材料，而且在創作生涯中並未有面對太多來自經濟方面的壓力。

　　綜上所述從保存修復的角度概觀本專案所負責作品的繪畫技巧材料，陳澄波繪畫技法的明確手法是用直接畫法以及具有黏稠性的顏料表現他獨特的存在感。從畫作保存的角度來看，可以確定他的作品是保存性很

好、堅固的油彩畫。

五、蠟托裱後的陳澄波作品再修復

過去油畫修復時常會以蜜蠟、樹脂混合的黏著劑來小托畫布（waxlining，以下簡稱蠟托裱），就連損壞得不太嚴重的作品，也被施加了蠟托裱。但是近年來，油畫修復世界性的發展傾向就是盡可能的避免在作品背面小托畫布，更明確地說就是盡可能地不要讓托畫布的黏著劑附著在作品上。

以下介紹陳澄波作品〔綠瓶花卉〕被蠟托裱後的再次修復作業過程。

（一）蠟托裱的概要

畫在畫布上的油彩畫隨著時間消逝與劣化，修復一定會成為必然的作業。特別是當基底材的畫布強度劣化到已經無法成為支持體時，一般的做法就是在作品背面貼附一層新的布以達到強化的目的。

畫布托裱的種類有數種，根據使用的黏著劑種類而有不同的名稱。最具代表性的托裱有三種，分別是小麥澱粉和膠托裱、蜜蠟和樹脂托裱、合成樹脂托裱。但是，筆者想補充說一句的是，正如前面所述，近年來國際性的發展傾向就是盡可能避免使用黏著劑來托裱畫布。

此次，國立臺灣師範大學文物保存維護研究發展中心進行陳澄波油畫作品修復工作中，其中就有曾經被修復過的，其內亦含蠟托裱技法修復的作品。蠟托裱的技法始於19世紀中期，當時在比利時、荷蘭遠及法國都頻繁使用這種蠟托裱的方法修復了大量的作品。這種方法是從作品的背面加熱後，將熔化成液狀的蠟完全塗佈於作品背面，待冷卻硬化之後再將小托用的布加熱貼附在作品背面。蠟在當時而言算是穩定的材質，且不會急遽發生劣化現象，是一種理想的黏著劑，在世界上普遍被使用。在1980年左右蠟托裱傳入日本，許多日本的作品也是以此法修復。這種技術雖然看似理想，但是處理時修復者必須要有熟練的技術，否則稍有不慎就會對作品造成傷害。特別是加熱加壓不當時，會造成表面顏料層的筆觸扁平化而喪失原作應有的特質。筆者從事修復以來看到太多因為技術不成熟而造成作品莫大傷害的案例，深切地感受到蠟托裱技法的難度以及伴隨的高危險性。

以下，將以本次對已經被蠟托裱過的陳澄波作品進行再次修復的案子為例展開說明。該作品雖然被進行了蠟托裱處理，但是一看便可以判斷是沒有徹底的修復。畫布並沒有完全被蠟浸涵，無法完全將變形的畫布整平，甚至有多處空鼓並未與原作畫布密合。除上述現象之外，還可看出背面的蠟塗佈不均，許多地方尚有堆積未推平的蠟。由此可以判斷操作者對於蠟托裱的經驗不足、相關材料技法尚無法完全掌控。另外，補彩的色調沒有與周邊原作的色調與筆觸協調，使整體效果顯得粗糙不夠細膩。

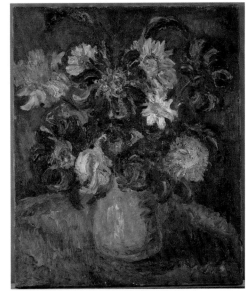

圖25.〔綠瓶花卉〕正面，修復前正光。

圖26.〔綠瓶花卉〕背面，修復前正光。

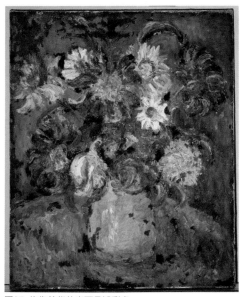

圖27. 修復前紫外光可見補彩處。

（二）〔綠瓶花卉〕的再次修復

1.修復前所見作品狀態和修復方針

本作品是在麻布上作畫的油彩畫（圖25）。背面可以看到曾經被蠟托裱處理過（圖26）。表面有一層凡尼斯光澤明顯可見，雖然是被修複過，但是顏料層仍然可見多處的空鼓與剝落，應該是處理時遺漏的部分。過去受損的大面積顏料層雖已被補上填充劑也在其上加上了補彩，但是仍有未完成處（圖27、28）。畫布在修復前判斷應有嚴重的劣化現象以致使用蠟托裱強化，但是背面卻可看出托裱的麻布並未與原作畫布密合。還可以看到尚有堆積未推平的蠟。內框是使用粗重結實的木材製造，是附有調節片的榫接木框（圖26）。

再次修復的方針是盡可能的將前次的修復材料去除，如凡尼斯、補彩、蠟托裱所使用的麻布、接著劑（蠟），僅保留少部分填補穩定的補彩區域，同時又將之前顏料層上未能完全清除的污垢再一次清理。為了移除小托畫布，不再進行新的托裱，而是使用先將托布繃在木框上再把畫作繃上的方法（這種方法暫譯為非黏合式加襯loose lining）。原來附屬的木框因為過粗，調節片的榫接安裝不適當，所以需要重新更換適當的木框。

進行再補彩則只限定於損傷部位，並且應盡可能的配合周邊的原創色調整合。最後塗佈上凡尼斯。凡尼斯塗佈時盡可能趨近顏料層原本的光澤，不可過強以避免不自然的反光。

2.再修復的作業程式

如下表所示，按照1-16的程式進行修復作業，操作內容説明如下。

1.	再修復前攝影
2.	現狀調查與修復計畫立案
3.	畫面清潔（凡尼斯、舊補彩、污垢等去除作業）
4.	用和紙暫時性正面封固
5.	拆解木框
6.	移除小托畫布
7.	去除托裱用黏著劑（蠟）
8.	去除暫時性正面封固的和紙
9.	畫布接邊條的補強（貼上麻布邊條加固）
10.	破損處修補
11.	新內框：非黏合式的加襯作業（loose lining）
12.	顏料層脫落處置入填充劑
13.	第一層凡尼斯塗佈
14.	補彩
15.	塗佈凡尼斯保護層
16.	再修復後攝影

（1）再修復前攝影

修復前先詳細地拍照記錄作品的狀態。攝影內容包含正常光、紫外光、X光等拍照。正常光攝影主要可以用照片的形式記錄修復前的各種現狀（圖25、26）。紫外光攝影可以明確凡尼斯的塗佈狀態與過去的修復跡象（圖27、28）。X光攝影則可以看到被掩蓋

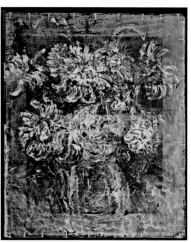

圖28. 補彩不完全。

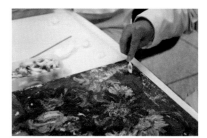

圖29. 修復前X光。

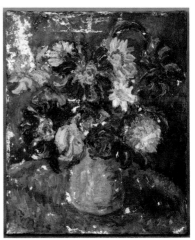

圖30. 去除凡尼斯及舊補彩。

圖31. 去除凡尼斯、舊補彩之後。

的損傷與修復區域，甚至有時可以看出畫家的技法特徵（圖29）。

（2）現狀調查與修復計畫立案

為了記錄作品的現狀，製作狀態調查書，進行直接觀察作品並詳細記錄的作業。參考此記錄成立修復案。以下是具體的作業順序。

（3）畫面清潔（凡尼斯、舊補彩、污垢等去除作業）

從紫外光拍攝的照片看出凡尼斯以及從前的補彩區域，以此做參考進行清理畫面。先將凡尼斯與補彩以棉花棒沾精製石油醚（petrol）小心清理去除（圖30、31）。最後再將前次修復時未能完全清理的污垢，以極低濃度的稀釋氨水再次將畫面做清潔處理。

（4）用和紙暫時性正面封固

在畫面清理過程中，有顏料層剝落的危險性。其對策就是事先在畫面上貼上日製和紙，這一步驟在保持作業安全上是至關重要的，在作業過程中可以保護顏料層。和紙要選用非常薄的紙，再將吟生麩糊為黏著劑塗佈貼上（圖32）。

（5）拆解木框

將固定作品的釘子拔除後，從木框上移出作品（圖33）。

（6）移除小托畫布

先以吹風機將被蠟固定的畫布加溫，使蠟先軟化，在畫布尚未變冷之前快速操作會比較容易將畫布剝離（圖34、35）。

（7）去除托裱用接著劑（蠟）

因蠟托裱而殘留在畫布背面的蠟要使用溶劑礦精和精製石油醚將其溶解並擦拭清理掉，但是儘管充分地進行了擦拭仍無法將大量的蠟清洗殆盡。本作品先後進行6次清理才明顯看見清理效果，恢復了畫布原來的狀態（圖36）。

（8）去除暫時性正面封固的和紙

因為在前面的步驟中暫時性正面封固的和紙已經完成了應有的保護作用，所以在進入下一個步驟之前要去除暫時性正面封固的和紙。移除方式是先將礦精塗佈於畫面上，在其揮發之前用富含水分的脫脂棉輕拭畫面，使水分滲入紙張，並在乾燥之前剝離和紙。要密切注意避免此作業傷到畫面的顏料層（圖37）。

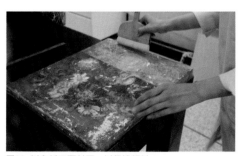
圖32. 以和紙正面封固，以保護顏料。

圖33. 拆解內框。

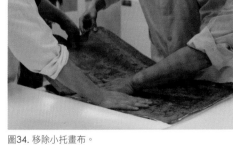
圖34. 移除小托畫布。

圖35. 小托畫布移除後。

圖36. 清洗殘留在畫布背面的蠟。

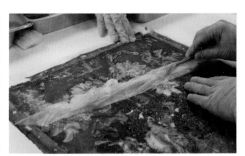
圖37. 去除暫時性正面封固和紙。

（9）畫布接邊條的補強（貼上麻布邊條加固）

去除小托畫布後，顯現出了劣化的原畫布。為了將原作繃在新內框上，要先將原畫布過短且老化的邊緣貼上新麻布邊條以達到補強的目的（圖38）。黏著劑是使用片狀的BEVA371。之後，將作品繃釘在一個較大的暫時性內框上，並整平畫布的變形（圖39）。

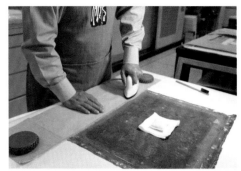

圖38. 原畫布的四周貼上麻布邊條強化。　圖39. 將作品繃釘在暫時性的內框上。　圖40. 破損處修補。

（10）破損處修補

在進行補強接邊條和暫時性繃固階段，發現了作品右下方有一個約2cm大小的破損。因此，把破損部位以很薄的和紙（4×2公分）填充、用片狀BEVA371黏接固定（圖40）。

（11）新內框非黏合式的加襯作業

將作品繃在新木框上。使用的方法是被稱為非黏合式加襯的方法。首先，在新內框上預先繃一層裡布，再將作品繃上與裡布形成重疊狀態。這種結構是以棉布支撐作品，避免晃動，增加作品的安定性（圖41）。

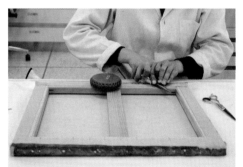 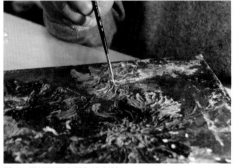 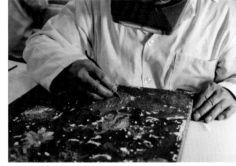

圖41. 將作品繃於新內框上。　圖42. 顏料剝落處置入填充劑。　圖43. 填充劑表面整形。

（12）顏料層剝落處置入填充劑

圖31是去除凡尼斯、補彩、污垢之後的照片。所看到的白色的地方是前次修復時的水性填充劑。還可以利用的地方將其保留不動，認為有必要修補地方則重新填入水性填充劑，將其與周邊原作的畫肌整合搭配（圖42、43）。填充劑是石膏與膠水混合製成的。

（13）第一層凡尼斯塗布

將顏料剝落的地方填充整合之後，先進行一次水彩顏料的底層補彩。為了便於最終的全色與保護原作，再將整個畫面塗上一層凡尼斯隔離。

（14）補彩

在底層的水彩顏料上使用溶劑型壓克力顏料配合原作的色調進行最終的色調整合。（圖44）。

（15）塗佈凡尼斯保護層

為了保護畫面以及使畫面光澤均勻和諧，再用空氣噴槍將凡尼斯噴塗在畫

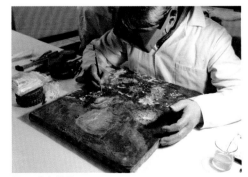

圖44. 全色補彩。

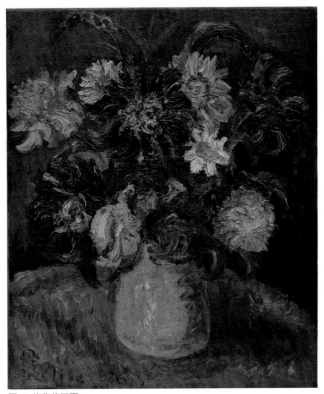

圖45. 修復後正面。

圖46. 修復後背面。

布上，完成修復作業（圖45、46）。

（16）再修復後攝影

完成修復後，將畫面正面、背面進行拍照，記錄完整圖像資料。

（三）再修復的總結

陳澄波作品修復專案共分兩次進行。進行第二次再修復的作品有6幅。其中4幅是被蠟托裱處理過的作品，皆進行了與本文報告的〔綠瓶花卉〕大致同樣的再修復處理。這4幅被蠟托裱處理過的作品分別是〔屏椅立姿裸女〕、〔右腕搭肩裸女〕、〔水畔臥姿裸女〕以及本文的〔綠瓶花卉〕。由於經過再次修復之後，4幅作品都恢復了陳澄波畫作原本的魅力，所以參與本次再修復的筆者感到過往修復時硬性進行蠟托裱處理是完全沒有必要的。蠟托裱已經成為一種修復過度的修復技術，根據世界性的趨勢，是不應該繼續使用蠟托裱技術給作品造成負擔。

本文能夠順利寫完，承蒙很多人的關照。特別是委託我們修復這些作品的陳重光先生和陳立栢先生。還有本修復專案的總負責人張元鳳老師，以及一起參與修復工作的王瓊霞、葉濱翰。此外還有日語非常流利的連絡人陳芳婷，以及文物保存維護研究發展中心友善的工作人員。在此，向各位表達深深地感謝。

【註釋】

1. 木島隆康：東京藝術大學大學院（研究所）文化財保存學保存修復（油畫研究室）教授。

2. 編按：本文完成時陳澄波作品修復案尚在進行，但在本書出版之前就已經結束。

On Chen Cheng-po's Painting Techniques and the Re-conservation of Artworks

Kijima Takayasu[1]

Summary

Foreword

This paper examines the unique artistic techniques used by Chen Cheng-po in thirty oil paintings treated by the National Taiwan Normal University Research Center for Conservation of Cultural Relics. Through optical examination, visual observations and the use of a portable X-ray fluorescence (XRF) spectrophotometer, non-destructive analyses have been carried out. Paint identification was also carried out and recorded. Optical study is a method of capturing images invisible to the naked eye through UV-induced visible fluorescence, infrared reflection reflectography, and X-radiography.

After completing the treatment of thirty paintings, we had the chance of re-treating six paintings that had been previous conserved, of which several had been lined with wax. In recent years, wax linings as a treatment has been considered problematic. We will take Nine Flowers in a Green Vase as an example to illustrate the re-treatment of this type of painting.

I. Painting Techniques

1. Painting Methods

Oil painting methods include, among others, alla prima, wet-in-wet, and impasto. Alla prima, also known as direct painting, is a method of applying paints directly onto the painting canvas. It has been used since the second half of the 19th century. Wet-in-wet is a technique of applying a second layer of paint when the first layer is still wet so that the paints of both layers can mix together. Impasto is a method in which thick paints are laid on the canvas and painting strokes are expressed through flat palette knife and brush marks. In Western paintings, the classic painting technique of glazing is one of the techniques that give the unique characteristic to oil paintings. One trait of Chen Cheng-po's artworks, however, lies in not using this method.

An overview of Chen Cheng-po's artworks reveals that most of his works appear to be completed in one painting session without further modification to the original forms and colors. Based on the above evidence, it can be said that Chen Cheng-po's paintings are characterized by the sole use of the direct painting method.

2. The Use of Paintbrushes and Palette Knives

Paintbrushes and palette knives are not only the necessary tools for, but also the major elements of direct painting. We can confirm that Chen Cheng-po used hog-hair brushes and palette knives (hereafter simply referred to as "knife" or "knives") to paint these thirty-six paintings. The brushes he used

were mainly those of medium to extra small size. In order to make strong and powerful brushstrokes, the brushes he chose all had stiff, short, and sharp tips. He employed knives mostly in his small-size works; this was observed in eight of his works. Even if a knife was used in large-format works such as *Foliage* (1934), it was used only to paint the walls of buildings and shop signs. Apart from this, he also employed knives to draw branches, poles, small figures, etc. Chen Cheng-po did not exclusively rely on either brushes or knives, but used them appropriately when necessary.

3. Viscosity of Paints

The paints used by Chen Cheng-po were softer than ordinary paints and were so viscous that threads could be drawn out of them. Brushstrokes that took full advantage of the paints' viscosity was a major characteristic of his technique, and also a unique feature of his style. In particular, from *Portrait of a Teenage Boy*, we can see thread-like paints scattered around the figure's eyes. The fine threads of the paints spread evenly out of the frame. From this example, we can see that handling of paints was a major concern for Chen Cheng-po.

II. Identifying Brushstroke and Paint Features with X-radiography

It is very difficult to distinguish brushstroke patterns and how paint viscosity was employed in Chen Cheng-po's paintings solely through normal photographs. X-radiographs are black and white, so brushstroke patterns and paint viscosity can be clearly observed without any color interference. In the following section, we will compare images of two paintings under normal illumination and X-radiography.

As can be seen *Distant View from Staircase of Pavilion* (1933), Chen Cheng-po did not paint in a realistic manner. Instead, he painted each image with déformer (the technique of deliberately editing and distorting a subject when it is visualized, rather than depicting it as it is). He used soft paints and pressed them hard on the painting surface to spread out the paints on the painting surface. This painting shows how paint viscosity was employed.

From *Portrait of a Female (date unknown)*, it can be seen that he did not intentionally accentuate the shape of the skull, but rather adopted déformer and freely applied soft paints to draw the shape of the body. His brushstrokes were very strong, and he never painted over the areas where paints had already been applied. In other words, he finished the whole painting without painting the same area twice. How he utilized the viscosity of paints in this very vibrant painting is fascinating.

III. Paints

1. Colors

Chen Cheng-po often used strong color contrasts in his paintings. The two contrasting colors green and red-brown were his basic choices. He then used various tones of these two colors to add to the variety of colors. The green colors he used covered a wide range from dark green, light sea green to yellow green. The scope of the red-brown colors was also broad, ranging from red earth, dark brown to purplish brown.

2. Paints Analysis

The results from the analyses of the paints and canvas coatings used in Chen Cheng-po's paintings

can be summarized as follows:

On the ground layer of Chen Cheng-po's paintings we identified zinc and barium, indicating that the canvases he used were mostly primed with a white paint called lithopone (a pigment made from zinc sulfate and barium sulfate).

As far as oil paints are concerned, we can discern the influence of Itaru Tanabe (1886-1968) on Chen Cheng-po when he was learning the basics of oil painting in the Tokyo School of Fine Arts. He probably used the same high quality oil paints imported from the West as the ones used by Tanabe. The major component of white paint was zinc white, whose main ingredient is zinc. In the green paints we found chromium, and believe that the paint used was chromium hydroxide. We have also identified cobalt, indicating the possible use of cobalt green. In addition, copper and arsenic have also been detected, suggesting the use of emerald green. The red that is found in many of Chen Cheng-po's paintings is a brilliant scarlet color. Among the red colors we identified mercury, identifying it as vermilion. We believe that where cadmium was detected, cadmium red must have been used; where iron was detected, an iron oxide red pigment was present. We found iron in the brown colors, so an iron oxide pigment must have been used.

IV. Summary of Painting Techniques

From a conservation perspective, there is not much change in Chen Cheng-po's painting techniques from his early to late works. The viscous brushstrokes used to paint trees in *Kegon Waterfall* (1927), dating to his student years at Tokyo Fine Arts School, belies hints of his mature style. His unique style of undulating brushstrokes as enabled by employing the viscosity of paints developed from a personal preference. It is believed that after having discovered this technique through repeated experimentation, he purposely chose to use it for his paintings. Itaru Tanabe was very knowledgeable about oil painting techniques and materials, and it was he from whom Chen Cheng-po acquired his basic knowledge of oil painting while studying at the Tokyo School of Fine Arts. As exemplified in *Letting off Cattle for Pasturing* (1908) in the Tokyo University of the Arts University Art Museum, Tanabe used thick paints and was versatile in manipulating paint viscosity. We can see that he had profound influence on Chen Cheng-po.

In conclusion, an overview of the techniques and materials used in Chen Cheng-po's works shows that he employed the direct method of painting. We are certain that he used the direct method in conjunction with viscous paints to express his unique style. We are also confident that his oil paintings are very robust.

V. Re-treatment of Wax Lined Paintings

Chen Cheng-po's painting *Flowers in a Green Vase* was previously wax lined. In the following sections, we will take the re-treatment of this painting as an example to describe the method and procedures of treating this type of painting.

1. Overview of Wax Lining

The National Taiwan Normal University Research Center for the Conservation of Cultural Relics is currently treating Chen Cheng-po's works, several of which have been previously treated and others

wax lined. The method of wax lining is to first to impregnate the back of a painting with melted wax. After the wax has cooled down and hardened, a lining cloth is adhered to the verso of the painting. Wax is a highly stable material that does not deteriorate over time, making it an ideal lining adhesive that has been widely used across the world. Wax lining was introduced to Japan around 1980 and was used in many oil painting treatments. This procedure must be carried out by highly skilled a conservator, because even small mistakes will lead to damage. Since the beginning of my career in conservation, I have seen many artworks damaged by unskilled hands, and therefore I fully understand its underlying difficulties and risks. It can be seen at first glance that the wax lining treatment of these paintings by Chen Cheng-po were carried out neither carefully nor thoroughly.

2. Re-treatment of *Nine Flowers in a Green Vase*

a. Before Treatment Condition Report and Treatment Proposal

This oil painting was painted on linen and varnished. The paint layer has suffered from a lot of delamination and flaking, areas that were not treated by the previous conservator. Although large paint losses have been filled and inpainted, the treatment was not thoroughly carried out. From the back, it can be seen that the lining cloth has detached from the original painting canvas.

The re-treatment proposal includes removing previous surface applications but retaining the infilling materials. The later applications to be removed are the varnish, inpainting, lining cloth, and wax lining. Instead of applying a new lining, we will add a loose lining and stretch the painting on a new, more appropriate stretcher.

Inpainting will only be added to damaged areas to blend in with the surrounding image area. A final varnish coating will be applied.

b. Re-treatment Procedure

The table below shows the re-treatment procedure.

1	Before treatment photographs	9	Adding strip linings
2	Condition examination and treatment proposal	10	Repair damaged areas
3	Surface cleaning (removal of varnish, inpainting, overpaint and surface dirt)	11	Adding a loose lining
4	Temporary facing with Japanese paper	12	Filling paint losses with gesso
5	Separating painting from wooden stretcher	13	Applying the first varnish coating
6	Removal of lining cloth	14	Inpainting
7	Removal of the wax lining	15	Applying the second varnish coating
8	Removal of the temporary paper facing	16	After treatment photographs

c. Summary of Re-treatment

Wax lining is an outdated conservation treatment, and there is an international trend to move away from wax lining in order to avoid damaging paintings.

The re-treatment of this painting has returned the work of art to its original condition.

1. Kijima Takayasu is a professor of Graduate Department of Conservation, Conservation Course Oil Painting Laboratory Tokyo University of the Arts.

陳澄波的油畫
——透過修復作品看繪畫材料

鈴鴨富士子[1]

前言

　　與畫家陳澄波（1895-1947）的作品相遇，是2007年（平成19年）在東京藝術大學保存修復油畫研究室參與修復陳澄波的3幅油畫作品〔嘉義街中心〕、〔岡〕、〔女人〕的時候。從那之後大概5年的光景，隨著國立臺灣師範大學文物保存維護研究發展中心的設立，2011年（平成23年）春，筆者與木島隆康教授共同參與油畫修復部門的指導工作。並於同年秋，開始合作修復陳澄波的油畫作品。2011年秋至2012年間修復了29幅作品，加上2013年修復的7幅，一共修復了36幅作品。此修復工作是為紀念陳澄波誕辰120周年而舉行的專案，為了修復作業，對相應的作品進行了詳細的調查及分析，並以技法材料為研究對象。而作家創作時所使用的材料，不僅是其技法的提示，更是瞭解創作當時社會、時代背景的線索。

　　本文將透過2011年秋至2012年間修復的29幅作品，來論證陳澄波在創作時使用的繪畫材料。這29幅作品，是於1925-1941年間（其中 9 幅作品創作時間不詳）創作的。陳澄波於1924年（大正13年）進入東京美術學校圖畫師範科就讀，1927年（昭和2年）3月畢業。之後就讀研究所，於1929年（昭和4年）結業，隨後不久便去了上海，在上海新華藝術專科學校、昌明藝術專科學校、藝苑繪畫研究會擔任了大約4年的指導教師後返回臺灣。創作時間明確的20幅作品中，有4幅是來自東京美術學校時期，12幅是上海時期，另4幅則是返臺後在臺灣創作的。本文將分別從日本留學時學會油畫基礎知識的東京美術學校求學時期、繪畫技術達到爐火純青的上海任教時期，以及返回臺灣後這三個時期的作品，來考究陳澄波使用的繪畫材料及其時代變遷。

一、東京美術學校時期 1924-1929年（大正13年-昭和4年）

　　陳澄波於1924年（大正13年）前往日本就讀東京美術學校圖畫師範科，並在1927年（昭和2年）3月畢業。之後於1929年（昭和4年）從研究所結業。在東京美術學校約莫5年間所受的教育，普遍認為是陳澄波奠定油畫繪畫基礎的重要時期。

　　在東京美術學校圖畫師範科，陳澄波跟隨田邊至（1886-1968）學習油畫。田邊至是畢業於東京美術學校後，主要活躍於官方美術展覽會的畫家，以色彩搭配調和、畫風溫雅安定的人物畫、風景畫聞名。此外，除了油畫，他還從很早的時期便開始親自動手製作蝕刻法版畫（Etching），還加入了日本蝕刻銅版畫作家協會、版畫奉公會。田邊在陳澄波入學東京美術學校的1924年結束歐洲留學生活返回日本，並成為東京美術學校的副教授，世人認為田邊或許有將他在留學時學到的知識導入東京美術學校的教學中。

　　當時專家們對繪畫材料認識較淺，顏料與畫布等是怎樣的材料，又是以怎樣的工序製作而成的？擁有這些相關知識的畫家非常稀少，而田邊更是這群少數人中尤為熱衷研究繪畫材料的一位。淺尾丁策的著書《谷中人物叢話金四郎三代記》中寫道：「……我是在美術學校遇到田邊老師的。老師在繪畫方面自不必説，在傾注於畫材研究的專家之中，也是和山下新太郎老師[2]齊名的。偶爾與老師談話提及畫材相關話題時，老師便説身為消費者一方的畫家如果有一定程度的知識，日本畫材就能進一步地提升。特別是在目前戰況不容樂觀的情況下，可想見進口畫材很難到手。真想藉這個時機集合同伴創立正規的研究組織，也正是以此為開端，1942年（昭和17年）初，成立了油彩材料研究會。」（圖1-2）

圖1. 油彩材料研究會的聯合簽名簿　　圖2. 油彩材料研究會發起人的親筆簽名和印章

※圖1、2轉載自淺尾丁策《谷中人物叢話　金四郎三代記》

　　關於油彩材料研究會的活動內容，書上記載著這樣一段話：「按照研究會的規定，為了瞭解顏料的性質和狀態，會員們要學習歐洲的典故，最好能自己試著研磨提煉顏料。研究會還製作附有桐木盒蓋的白色大理石研磨板及研磨棒分發給大家。另外，還把藉由請願而得到的顏料和油等材料分享給大家進行實驗，大家帶著自己的試驗品參加在美術學校會議室的研究討論月會。有時候研究會還聘請顏料製造商，向其詢問原料的性質、製作方法等等。時至今日，這些都成為了研究會成員對化學的神秘特質產生興趣的因素。除此之外，每一次的研究討論會，都會從多數的會員中邀請技術人員，特別是繪畫材料相關方面的技術人員，從他們那裡吸取各方面的知識。尤其是從瞭解畫布塗料的權威人士、麻布料方面的相關專家，以及製造西洋紙、日本和紙之技術人員等多方面的專業人士那裡學習到很多知識，得到了很多啟發。」但是，據説油彩材料研究會也在爆發戰爭的情況下，由於戰災及疏散等原因自然消失了[3]。

　　2005年，筆者在修復田邊至的油畫作品時，遇到了越智雄二氏，並得到了向他請教田邊至相關話題的機會。根據在東京美術學校學習時曾就學於田邊教室的學生越智雄二氏所述，田邊至非常努力地學習有關顏料的知識，還經常指導學生要使用最好的材料，他使用的顏料也幾乎都是國外進口的顏料[4]。我們認為田邊至深知「繪畫創作不僅需要技法，更需要以掌握畫材知識為前提進行創作」這點的重要性，而陳澄波也是從恩師田邊那裡學會了有關繪畫材料的知識。

二、關於創作時使用的繪畫材料

（一）油畫顏料

　　日本最初發售的油畫畫材主要都是國外進口的商品。日本開始進口油畫顏料是明治初期，據說最早是一家位於東京兩國地區且名叫「島屋」的西洋書店，在1871年（明治4年）進口英國製的油畫顏料。1897年（明治30年）以後油畫顏料的進口開始盛行，1898年（明治31年），東京神田地區的「丸善」、「文房堂」，大阪的「吉村商店」（現在的「Holbein工業株式会社」）等店鋪開始了進口貿易，市面上開始銷售英國製的Winsor & Newton、Cambridge，法國製的Lefranc & Bourgeois等品牌的油畫顏料（圖3）。有鑑於外國製造的油畫顏料不斷地被擴大進口之情況，日本國內也逐漸形成了生產油畫顏料的趨勢。大正初年「櫻木油畫顏料」誕生，隨後文房堂（1887年創業）在1920年（大正9年）開始銷售美術家專用的文房堂油畫顏料[5]。大正末期，像竹見屋、信畫堂、清泉堂、佛蘭西書院、美蘭堂、TSUKASA洋畫材料店、吉田芳文堂等經營進口和日本產油畫材料的商店逐漸增加[6]。但是由於第二次世界大戰導致一切物資短缺，繪畫材料也因為受到影響，使得劣質產品開始得以上市。從以上情況推斷，我們認為陳澄波在日本留學期間，主要是使用國外產的油畫顏料來創作油畫。在後來他移居上海之後，雖然很多詳細情況已經無法查證，但應該也是和在日本時一樣是使用進口產品。

文房堂商品目錄　　　Winsor & Newton油畫顏料（英國）　　　Winsor & Newton油畫顏料（英國）

Lefranc & Bourgeois油畫顏料（法國）　　　文房堂特製油畫顏料（日本）　　　Cambridge油畫顏料（英國）

圖3. 文房堂商品目錄（大正14年）中刊載的油畫顏料

（二）根據X射線螢光分析儀（XRF）分析顏料

　　根據X射線螢光分析[7]對陳澄波在創作時使用的繪畫顏料進行檢測，並透過東京美術學校時期、上海時期、返回臺灣後的13幅作品驗證陳澄波作品的繪畫技法及材料。

　　・使用機器：Thermo Fisher Scientific製　攜帶型成分分析計Thermo-Niton XL3t-900S-M
　　・條件：①Standard Soil Mode：測定時間80sec（Main Range 25sec,High Range 25sec, Low Range 30sec）
　　　　　　　X光照射直徑8mmφ
　　　　　　②Mining Mode：測定時間 80sec（Main Range 20sec, High Range 20sec, Lor Range 20sec, Light Range 20sec）
　　　　　　　X光照射直徑8mmφ

1. X射線螢光分析結果

　　東京美術學校時期　1924-1929年

　　・街道　1925　木板油彩

測定處	顏色	測出元素	推定出的主要顏料名稱
A	藍色	Pb, Zn, Co	鉛白（Silver white）、鈷綠（Cobalt green）、鈷藍（Cobalt blue）
B	黃色	Zn, Pb, Cr	鉛白（Silver white）、鋅白（Zinc white）、鉻黃（Chrome yellow）
C	綠色	Pb, Zn, Cr	鉛白（Silver white）、鋅白（Zinc white）、氧化鉻綠（Chromium oxide green）
D	褐色	Pb, Zn, Fe	鉛白（Silver white）、鋅白（Zinc white）、氧化鐵系褐色顏料（Iron(III) oxide or ferric oxide (Ferric oxide)）
E	紅褐色	Pb, Zn, Hg, Fe	鉛白（Silver white）、鋅白（Zinc white）、朱砂（Vermilion）、氧化鐵系褐色顏料（Iron(III) oxide or ferric oxide (Ferric oxide)）

　　【觀察結果】基底材為木板，從X光照片觀察到畫面的一部分曾被重新描繪過。天空的藍色部分已確認鋅的波峰很強，此外也檢測出鈷，故推論有可能使用以氧化鋅和氧化鈷製成的鈷綠；另外，雖檢測結果證實其中含有鉛的成分，但我們認為這是使用鉛白的緣故。黃色部分的鉻，推斷是以鉻酸鉛為主要成分的鉻黃，而樹木綠色部分的鉻則是以氧化鉻為主要成分的氧化鉻綠。褐色部分有觀測到鐵的波峰，普遍認定是使用了氧化鐵褐色顏料。而從檢測出鐵和汞的紅褐色可推論，應是使用了朱砂和氧化鐵系褐色顏料。

　　・日光華嚴瀑布　1927　畫布油彩

測定處	顏色	測出元素	推定出的主要顏料名稱
A	打底	Pb	鉛白（Silver white）
B	白色	Zn	鋅白（Zinc white）
C	藍色	Zn, Pb, Co	鋅白（Zinc white）、鉛白（Silver white）、鈷藍（Cobalt blue）、鈷綠（Cobalt green）
D	綠色	Zn, Pb, Cr, Cu	鋅白（Zinc white）、鉛白（Silver white）、氧化鉻綠（Chromium oxide green）、祖母綠（Emerald green）
E	紅褐色	Zn, Pb, Fe, Hg	鋅白（Zinc white）、鉛白（Silver white）、氧化鐵系褐色顏料（Iron(III) oxide or ferric oxide (Ferric oxide)）、朱砂（Vermilion）
F	黃色	Zn, Pb, Cr, Cu	鋅白（Zinc white）、鉛白（Silver white）、鉻黃（Chrome yellow）

【觀察結果】打底部分檢測出了鉛，應是使用了鉛白。從瀑布等描畫層的白色部分檢測出主要成分是鋅，推測是使用了鋅白。天空的淺藍色確認為鋅和鈷，推論是使用了鈷綠或鈷藍與鋅白的混合色。綠色部分的鉻普遍認為是氧化鉻綠，另外，也證實了檢測結果有銅的波峰，因此有使用祖母綠創作的可能。紅褐色部分被檢測出了鐵和汞，所以推測是使用了氧化鐵系褐色顏料和朱砂。黃色部分的鉛、鉻則認定為鉻黃。

· 湖畔　1928　畫布油彩

測定處	顏色	測出元素	推定出的主要顏料名稱
A	打底	Pb, Zn, Ba	鉛白（Silver white）、鋅白（Zinc white）、鋇系白色
B	白色	Zn, Pb	鋅白（Zinc white）
C	綠色	Zn, Pb, Cr, Cd	鋅白（Zinc white）、鉛白（Silver white）、氧化鉻綠（Chromium oxide green）、鎘藍（Cadmium green）
D	紅色	Zn, Hg, Pb	鋅白（Zinc white）、朱砂（Vermilion）、鉛白（Silver white）
E	黃色	Zn, Pb, Cd, Cr	鋅白（Zinc white）、鉛白（Silver white）、鎘黃（Cadmium yellow）
F	褐色	Zn, Fe, Pb, Hg	鋅白（Zinc white）、鉛白（Silver white）、氧化鐵系褐色料（Iron(III) oxide or ferric oxide (Ferric oxide)）、朱砂（Vermilion）
G	藍綠色	Zn, Pb, Cu	鋅白（Zinc white）、鉛白（Silver white）、祖母綠（Emerald green）

【觀察結果】打底層中檢測出鉛、鋅、鋇，普遍認為是使用了鉛白、鋅白和鋇系白色。而顏料層的白色部分中，出現較強的鋅波峰，因此推測有使用鋅白。綠色部分的鉻、鎘可能是氫氧化鉻和硫化鎘的混合物鎘綠色，或者是鎘黃色和氧化鉻綠的混合色。紅色部分經證實有較強的汞衍射峰，推斷是使用了朱砂。黃色部分則檢測出了鎘，研判是使用了鎘黃，另外雖然還有檢測出鉻的成分，但推測這應該是屬於下層的氧化鉻綠。褐色部分的鐵和汞則應為氧化鐵系褐色顏料和朱砂。天空的藍綠色部分的銅則研判是鋅白和祖母綠的混合色。

上海時期　1929-1933年

· 上海雪景　1931　畫布油彩

測定處	顏色	測出元素	推定出的主要顏料名稱
A	打底	Zn, Ba	鋅白（Zinc white）、鋇系白色
B	白色	Zn	鋅白（Zinc white）
C	綠色	Zn, Cu, As	鋅白（Zinc white）、祖母綠（Emerald green）
D	紅色	Zn, Hg, Pb, Fe	朱砂（Vermilion）、氧化鐵系褐色顏料（Iron(III) oxide or ferric oxide (Ferric oxide)）
E	褐色	Zn, Pb, Fe	氧化鐵系褐色顏料（Iron(III) oxide or ferric oxide (Ferric oxide)）
F	橙色	Zn, Pb, Hg, Cr	鋅白（Zinc white）、朱砂（Vermilion）、鉻黃（Chrome yellow）

【觀察結果】打底層中檢測出鋅和鋇，推斷是使用了鋅白和鋇系白色。白色部分的鋅應是鋅白。綠色部分經證實為銅和砷，故推測是祖母綠。紅色部分的汞普遍認定是朱砂。褐色部分的鐵可能是酸化鐵褐色顏料，橙色部分的汞則是朱砂，而鉛、鉻則可能是鉻黃。

・叉腰裸女　　1931　　畫布油彩

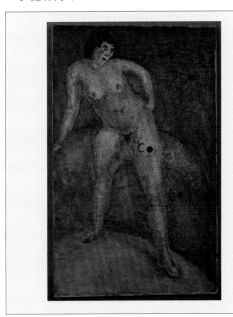

測定處	顏色	測出元素	推定出的主要顏料名稱
A	打底	Pb, Zn, Ba	鉛白（Silver white）、鋅白（Zinc white）、鋇系白色
B	綠色	Zn, Fe, Cu, Cr	鋅白（Zinc white）、祖母綠（Emerald green）
C	膚色	Zn, Fe, Hg	鋅白（Zinc white）、氧化鐵系褐色顏料（Iron(III) oxide or ferric oxide (Ferric oxide)）、朱砂（Vermilion）
D	紅褐色	Zn, Fe, Hg	氧化鐵系褐色料（Iron(III) oxide or ferric oxide (Ferric oxide)）、朱砂（Vermilion）
E	紅色（簽名）	Zn, Hg, Fe	朱砂（Vermilion）、氧化鐵系褐色顏料（Iron(III) oxide or ferric oxide (Ferric oxide)）

　　【觀察結果】打底層中檢測出鉛、鋅、鋇，推斷是使用了鉛白、鋅白、鋇系白色。綠色部分被檢測出鋅和銅，推測是使用了鋅白和祖母綠的混合色。肌色部分證實是鋅、鐵、汞，認為是使用了鋅白和氧化鐵系褐色顏料、朱砂。背景的紅褐色部分的鐵是氧化鐵系褐色顏料，而汞應是朱砂。簽名的紅色部分據觀察為汞的波峰最強，推斷是使用了朱砂，鐵則普遍認定為其下層的氧化鐵系褐色顏料。

・陽台遙望裸女　　1932　　畫布油彩

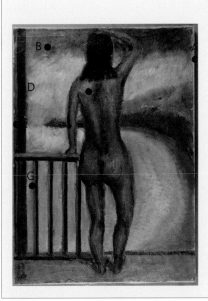

測定處	顏色	測出元素	推定出的主要顏料名稱
A	打底	Pb, Zn, Ba	鉛白（Silver white）、鋅白（Zinc white）、鋇系白色
B	淺藍色	Zn, Pb, Ba, Fe	鋅白（Zinc white）、普魯士藍（Prussian blue）
C	黑色	Pb, Zn, Fe	鉛白（Silver white）、鋅白（Zinc white）、氧化鐵系褐色顏料（Iron(III) oxide or ferric oxide (Ferric oxide)）
D	紅褐色	Pb, Zn, Fe	鉛白（Silver white）、鋅白（Zinc white）、氧化鐵系褐色顏料（Iron(III) oxide or ferric oxide (Ferric oxide)）
E	橙色	Pb, Zn, Fe	鉛白（Silver white）、鋅白（Zinc white）、氧化鐵系褐色顏料（Iron(III) oxide or ferric oxide (Ferric oxide)）
F	膚色	Pb, Zn, Fe	鋅白（Zinc white）、鉛白（Silver white）、氧化鐵系褐色顏料（Iron(III) oxide or ferric oxide (Ferric oxide)）
G	綠色	As, Cu, Fe	祖母綠（Emerald green）、氧化鐵系褐色顏料（Iron(III) oxide or ferric oxide (Ferric oxide)）

　　【觀察結果】打底層中檢測出鉛和鋅，可認為是使用了鋅白和鉛白。天空的灰暗的淺藍色部分經證實為鋅的波峰最強，我們認為是鋅白，鐵的成分推測是普魯士藍。人物的頭髮的黑色部分中檢測出鉛、鋅、鐵，

鉛和鋅則認為是打底層部分的成分，特定黑色的元素則尚未得到證實。紅褐色部分檢測出的鐵是氧化鐵系褐色顏料。橙色部分的鐵也研判是氧化鐵系褐色顏料。推測膚色部分是鋅的鋅白和鐵的氧化鐵系褐色顏料這兩色的混合色。綠色部分則證實檢測出砷和銅，推測應是祖母綠。而檢測出鐵的原因可能是綠色附近使用了褐色之故。

· 塔峰下　1933　畫布油彩

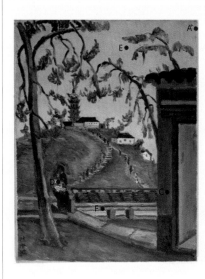

測定處	顏色	測出元素	推定出的主要顏料名稱
A	打底	Pb, Zn, Ba	鉛白（Silver white）、鋅白（Zinc white）、鋇系白色
B	綠色	Zn, Pb, Fe, Cu, Cd, Co, Cr	鋅白（Zinc white）、鉛白（Silver white）、綠土（Terre verte）、祖母綠（Emerald green）、鎘綠（Chrome green）、鈷綠（Cobalt green）
C	褐色	Zn, Pb, Fe	氧化鐵系褐色顏料（Iron(III) oxide or ferric oxide (Ferric oxide)）
D	黃色	Zn, Cd, Pb	鋅白（Zinc white）、鎘黃（Cadmium yellow）
E	藍綠色	Zn, Pb, Cu, Co	鋅白（Zinc white）、鉛白（Silver white）、祖母綠（Emerald green）、鈷藍（Cobalt blue）
F	粉紅色	Zn, Pb, Fe, Cu	鋅白（Zinc white）、鉛白（Silver white）、氧化鐵系褐色顏料（Iron(III) oxide or ferric oxide (Ferric oxide)）

【觀察結果】打底層中檢測出鉛、鋅、鋇，故認為是使用了鉛白、鋅白、鋇系白色。樹葉的綠色部分是用數種綠色描繪出來的，鐵可能是綠土，銅則是祖母綠，鎘、鉻是氫氧化鉻和硫化鎘的混合物鎘綠，鋅和鈷可能是鈷綠。褐色部分的鐵則認為是氧化鐵系褐色顏料。黃色部分的鎘推測是鎘黃。天空的淡藍綠色部分經證實為鎘、銅、鈷，而銅是祖母綠，鈷則可能是鈷藍。粉紅色部分的鋅、鐵應該是鋅白和氧化鐵褐色顏料的混合色。

· 戰災（商務印書館側）　1933　畫布油彩

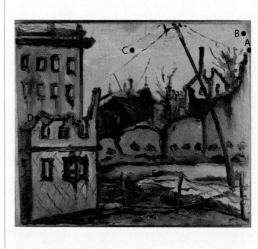

測定處	顏色	測出元素	推定出的主要顏料名稱
A	打底	Pb	鉛白（Silver white）
B	水藍色	Zn, Pb, Co	鋅白（Zinc white）、鈷藍（Cobalt blue）
C	白色	Zn	鋅白（Zinc white）
D	橙色	Zn, Pb, Cd, Se	鋅白（Zinc white）、鉛白（Silver white）、鎘紅（Cadmium red）
E	紅褐色	Zn, Pb, Fe	鋅白（Zinc white）、鉛白（Silver white）、氧化鐵系褐色顏料（Iron(III) oxide or ferric oxide (Ferric oxide)）
F	水藍色	Zn, Pb, Co, Fe	鋅白（Zinc white）、鉛白（Silver white）、鈷藍（Cobalt blue）

【觀察結果】打底層中檢測出鉛，證實使用了鉛白。天空的蔚藍色部分檢測出鋅、鉛、鈷。鉛的波峰很弱，我們認為是打底層部分的顏料，推測水藍色部分是使用了鋅白和鈷藍的混合色。白色部分經證實是鋅的最強峰，推斷是鋅白。建築物的橙色部分的鋅是鋅白、鎘和硒（Se）應該是以硫化鎘和硒化鎘為主要成分的

鎘紅的混合色。紅褐色部分所檢測出的鋅是鋅白，鉛則是鉛白，應該是打底層部分的顏料。鐵則是氧化鐵系褐色顏料。窗戶的水藍色部分則推測是鋅的鋅白和鈷的鈷藍這兩色的混合色。

・戰後（一）　1933　畫布油彩

測定處	顏色	測出元素	推定出的主要顏料名稱
A	打底	Pb, Zn, Ba	鉛白（Silver white）、鋅白（Zinc white）、鋇系白色
B	粉紅色	Zn, Pb, Cd	鋅白（Zinc white）、鉛白（Silver white）、鎘紅（Cadmium red）
C	水藍色	Zn, Pb, Cu, Co	鋅白（Zinc white）、鈷藍（Cobalt blue）
D	紅色	Zn, Pb, Cd	鋅白（Zinc white）、鉛白（Silver white）、鎘紅（Cadmium red）
E	褐色	Zn, Pb, Fe	鋅白（Zinc white）、鉛白（Silver white）、氧化鐵系褐色顏料（Iron(III) oxide or ferric oxide (Ferric oxide)）
F	黃色	Zn, Pb, Cr	鋅白（Zinc white）、鉻黃（Chrome yellow）
G	綠色	Zn, Pb, Co	鉛白（Silver white）、鋅白（Zinc white）、鈷綠（Cobalt green）

【觀察結果】打底層的鉛、鋅、鋇應該是鉛白、鋅白、鋇系白色。粉紅色部分經證實是鋅、鎘的波峰，可能是鋅白和鎘紅的混合色。天空的水藍色部分檢測出鋅、鈷，應該是鋅白和鈷藍混合色。紅色部分檢測出鎘的波峰很強，因而推斷為鎘紅。褐色部分的鐵是氧化鐵褐色顏料，黃色部分的鋅、鉻是鉻黃。推斷綠色部分的鋅、鈷是鈷綠。

臺灣　1934年以後

・綠蔭　1934　畫布油彩

測定處	顏色	測出元素	推定出的主要顏料名稱
A	打底	Zn, Pb, Ba	鋅白（Zinc white）、鉛白（Silver white）、鋇系白色
B	紅褐色	Zn, Hg, Fe	鋅白（Zinc white）、朱砂（Vermilion）、氧化鐵系褐色顏料（Iron(III) oxide or ferric oxide (Ferric oxide)）
C	黃綠色	Zn, Cr, Fe	鋅黃（Zinc yellow）、氧化鉻綠（Chromium oxide green）
D	綠色	Zn, Pb, Fe, Cr, Co	氫氧化鉻綠（Viridian）、氧化鉻綠（Chromium oxide green）、鈷綠（Cobalt green）
E	白色	Zn, Pb, Ba	鋅白（Zinc white）、鉛白（Silver white）、鋇系白色
F	赭色	Zn, Pb, Fe	鋅白（Zinc white）、黃土（Yellow Ocher）

【觀察結果】打底層中檢測出鋅、鉛、鋇，推斷是使用了鋅白、鉛白、鋇系白色。建築物屋頂的紅褐色部分檢測出的鋅應該是鋅白，汞是朱砂、鐵是氧化鐵系顏料。樹葉的黃綠色部分據觀察可見鋅的最強峰，也檢測出鈷，可能是以氧化鈷和氧化鋅為主要成分的鈷綠，或者是以氧化鉻為主要成分的氧化鉻綠。鐵的成分

應是描畫下層的樹枝所使用的氧化鐵系褐色顏料。另外，綠色部分中所確認含有的鉻，應是氫氧化鉻綠，或者是氧化鉻綠等等。鋅和鈷可能是鈷綠。推測鐵的成分是下層的氧化鐵系褐色顏料。建築物的白色部分經證實鋅的波峰最強，應該是鋅白。地面所檢測出的鐵可能是黃土。

· 大白花　年代不詳　畫布油彩

測定處	顏色	測出元素	推定出的主要顏料名稱
A	打底	Zn, Ba	鋅白（Zinc white）、鋇系白色
B	白色	Zn	鋅白（Zinc white）
C	淡紅色	Zn, Fe,	鋅白（Zinc white）、氧化鐵系褐色顏料（Iron(III) oxide or ferric oxide (Ferric oxide)）
D	綠色	Zn, Cr	鋅白（Zinc white）、氧化鉻綠（Chromium Oxide Green）、氫氧化鉻綠（Viridian）
E	褐色	Zn, Fe	鋅白（Zinc white）、氧化鐵系褐色顏料（Iron(III) oxide or ferric oxide (Ferric oxide)）
F	深褐色	Zn, Fe, Cr	鋅白（Zinc white）、氧化鐵系褐色顏料（Iron(III) oxide or ferric oxide (Ferric oxide)）
G	白色	Zn	鋅白（Zinc white）

【觀察結果】打底層中檢測出鋅和鋇，可能是鋅白和鋇系白色。花瓣的白色和放置花瓶的底座的白色都證實有鋅的最強峰，推斷可能是鋅白。花瓣的淡褐色部分檢測出鋅和鐵，應該是使用鋅白和褐色系顏料的混合色所繪製。葉子的綠色部分經確認有強烈的鉻波峰，應該是使用了氧化鉻綠和氫氧化鉻綠。背景的褐色部分中檢測出鐵和鋅，這種褐色應該是使用了氧化鐵系褐色顏料，據推測，鋅的成分應為下層所使用的鋅白。桌子的深褐色部分的鐵可能是氧化鐵系褐色顏料。

· 椰林　1938　畫布油彩

測定處	顏色	測出元素	推定出的主要顏料名稱
A	打底	Zn, Pb, Ba	鋅白（Zinc white）、鉛白（Silver white）、鋇系白色
B	淺藍色	Zn, Co	鋅白（Zinc white）、鈷綠（Cobalt green）、鈷藍（Cobalt blue）
C	黃色	Zn, Ba, Fe	鋅白（Zinc white）、鋇系白色、黃土（Yellow Ocher）
D	桃紅色	Zn, Pb, Ba, Fe	鋅白（Zinc white）、鉛白（Silver white）、氧化鐵系褐色顏料（Iron(III) oxide or ferric oxide (Ferric oxide））
E	白色	Zn, Pb, Ba	鋅白（Zinc white）、鉛白（Silver white）、鋇系白色
F	褐色	Zn, Ba, Fe	鋅白（Zinc white）、氧化鐵系褐色顏料（Iron(III) oxide or ferric oxide (Ferric oxide））
G	綠色	Zn, As, Co, Cu	鋅白（Zinc white）、祖母綠（Emerald green）、鈷綠（Cobalt green）

【觀察結果】打底層的鋅、鉛、銀依推測是使用了鋅白、鉛白、銀系白色。天空的藍色則檢測出鋅和鈷，應該是鈷綠、鈷藍。黃色部分經證實是鋅和鐵，故認為是鋅白和黃土的混合色。傘的淺桃紅色部分含有鋅、鉛、鐵，可能是使用鋅白和氧化鐵系褐色顏料的混合色。建築物的白色經證實為鋅的強峰，推斷是鋅白。地面的褐色被檢測出鋅和鐵，應該是氧化鐵系褐色顏料。樹的綠色部分中檢測出砷和銅，依推斷為祖母綠。鋅和鈷則應該是下層藍色部分的鈷綠。全畫各處皆檢測出了鉛和銀，應該是出自於打底層。

・新樓庭院　1941　畫布油彩

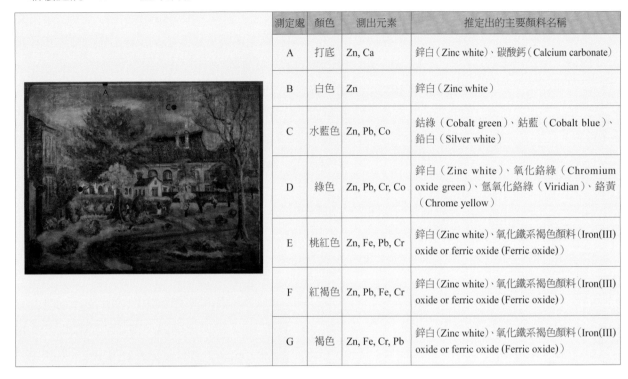

測定處	顏色	測出元素	推定出的主要顏料名稱
A	打底	Zn, Ca	鋅白（Zinc white）、碳酸鈣（Calcium carbonate）
B	白色	Zn	鋅白（Zinc white）
C	水藍色	Zn, Pb, Co	鈷綠（Cobalt green）、鈷藍（Cobalt blue）、鉛白（Silver white）
D	綠色	Zn, Pb, Cr, Co	鋅白（Zinc white）、氧化鉻綠（Chromium oxide green）、氫氧化鉻綠（Viridian）、鉻黃（Chrome yellow）
E	桃紅色	Zn, Fe, Pb, Cr	鋅白(Zinc white)、氧化鐵系褐色顏料(Iron(III) oxide or ferric oxide (Ferric oxide))
F	紅褐色	Zn, Pb, Fe, Cr	鋅白(Zinc white)、氧化鐵系褐色顏料(Iron(III) oxide or ferric oxide (Ferric oxide))
G	褐色	Zn, Fe, Cr, Pb	鋅白(Zinc white)、氧化鐵系褐色顏料(Iron(III) oxide or ferric oxide (Ferric oxide))

　　【觀察結果】打底層中檢測出鋅和鈣，應該是鋅白和碳酸鈣。白色部分可從鋅的強峰來推斷為鋅白。天空的水藍色部分是鋅波峰較強，還檢測出了鈷，應該是鈷綠和鉛的鉛白兩色的混合色。綠色部分經證實是鉻，應該是使用了氧化鉻綠或者氫氧化鉻綠。另外，推斷鉛和鉻是以鉻酸鉛為主成分的鉻黃。粉紅色部分中檢測出的鋅是鋅白，鐵是氧化鐵系褐色顏料，鉛和鉻可能是下層所使用的鉻黃。紅褐色以及褐色部分中檢測出的鐵，據推斷應是氧化鐵系褐色顏料。

2. 總結螢光X射線分析結果

　　進行分析的作品中，在畫布上描畫的作品都是使用了市售已塗好打底層的畫布。從這些打底層的分析結果來看，我們可以確定打底層有「只有鉛白」、「鉛白、鋅白、銀系白色」、「鋅白、銀系白色」、「鉛白、鋅白」以及「鋅白、碳酸鈣」等多種情況。證實了陳澄波在顏料的使用上，主要以鋅白作為描畫用的白色顏料，以及大量使用鈷綠作為藍綠色等的特殊用法。可證明在描繪紅色時，除了使用朱砂之外，還使用了鎘紅創作；描繪綠色時則使用了祖母綠、鎘綠、鉻綠；描繪黃色時是使用了鎘黃、鉻黃等數種同色系的顏料。如同我們從文房堂的畫材目錄中所瞭解（圖3），大正、昭和初期是日本進口油畫畫材普及的全盛時期，顏料的種類也是因應近代化學工業的發展，進而大量地生產鉻系及鎘系等顏料。從陳澄波的作品中，我們可以證實是使用了鎘系、鉻系的油畫顏料。在市面上以販售多種進口顏料為大宗的環境下，陳澄波卻能找到他獨特的色彩風格。

（三）基底材

　　進行修復的29幅作品，共使用了3種基底材。基底材使用畫布的有21幅，使用板材的有7幅（寫生板6幅、三合板1幅），使用畫布板的有1幅。

・畫布

　　修復的29幅作品中，有21幅是在畫布上繪製而成的，其中有19幅是畫布則是已繃在內框上。陳澄波在東京美術學校學習的時候，日本市面上出售的畫布除了進口產品外，還有日本國內自行生產及銷售的產品。進口產品有Branche（法國）、Winsor & Newton（英國）、Claessens（比利時）等品牌。但由於第一次世界大戰，從歐洲進口商品中斷，導致貨源不足，於是日本國產畫布逐漸得以銷售。日本開始販售國產畫布的起源，是大正7年（1918年）日本畫材工業股份有限公司生產販售的產品。當時市售的畫布種類有極細紋、細紋、粗細適中紋、粗紋、absorbant（吸收性的畫布）等等（圖4）。筆者參與修復的作品中，21幅作品的基底材使用了畫布，並且全部是市售已塗好打底層的畫布。畫布的紋路上，可以確定除了有像如同圖5所示的〔古門樓〕那樣比較粗糙的、有紋路粗細適中的，還有像〔戰災（商務印書館側）〕那樣縝密的多樣種類（圖6）。

・寫生板

　　29幅作品中，有7幅是使用板材描畫的作品。其中又有6幅是在寫生板上繪製而成，而另1幅則是在三合板上。

　　寫生板主要是在描繪風景時使用，市面上銷售的寫生板厚度約為5mm、長寬有從33×24cm到

圖4. 文房堂商品目錄（1908年）

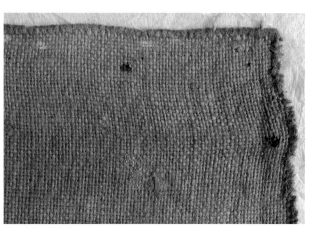

圖5.〔古門樓〕背面 部分

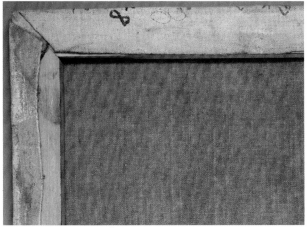

圖6.〔戰災（商務印書館側）〕背面部分

37×27cm等多種尺寸。使用的木材種類有樸樹（日本厚朴）、桂樹（連香樹）、白楊等，其特徵是在背面的兩邊或者四邊斜切（圖7-8）。國內畫材店「文房堂」的商品目錄中（圖9-11），對寫生板的最早記錄是1905年（明治38年），最後的一次記載則是1928年（昭和3年），應該是隨著寫生板的需求減少，其生產也逐漸中止[8]。另外，在東京藝術大學大學美術館所收藏的作品中，也包含這一時期用寫生板所創作的作品。從大多數的作品都是學生作品這一點來看，可想知寫生板是在寫生課等時機所使用的。

圖7.〔少年〕1929年／背面 部分　　　　　　　　　　　　圖8.〔街道〕1925年／背面

圖9. 文房堂商品目錄（1908年）

圖10. 文房堂商品目錄（1925年）

圖11. 文房堂商品目錄（1925年）

・畫布板

　　修復的作品中有一幅作品〔帆船〕，是在一種稱為「紙板（board）」的厚紙上作畫的。這種紙板的一面黏貼著塗有打底層的畫布。此類基底材有著「紙板（board）」、「畫布板（canvas board）」、「畫布板（board canvas）」、「畫紙（academy board）」等各式各樣的稱呼。所有把繩、線以及其他纖維緊壓後固定，具有結實且有柔韌性的一種厚紙，都通稱為「紙板」，推測是C. Roberson公司在18世紀末所研發。「畫紙」也是紙板的一種，通常會在其表面用描畫用（特別是油畫用）的鉛白以及油、白堊等

混合成的白色顏料塗上一層打底層，而倫敦的Reeves and Newton公司在1850年在其商品目錄上第一次登載了這種「畫紙」。「畫布板」則是1878年George Lowe公司發售的，是一種將塗有打底層的畫布黏貼在紙板其中一面上的基底材。〔帆船〕的基底材便是使用這種「畫布板」（圖12-13）。George Lowe公司是在1887年開始銷售這種紙板，其表面會貼著一種名為「拉什莫爾板（Rushmore boards）」的類畫布布紋[9]。在1908年的文房堂商品目錄中（圖14）也有「畫布板」的記載。因此我們可以確定當時國產與進口的畫布板都有在市面上販售。因為畫布板較輕且攜帶方便，非常適合寫生等時機使用。因此陳澄波的〔帆船〕應該是在野外寫生時使用畫布板所繪製的。

圖12.〔帆船〕年代不詳／側面

圖13.〔帆船〕年代不詳／背面

圖14. 文房堂商品目錄（1908年）

三、總結

　　透過本修復專案，再次確認了陳澄波油畫作品的魅力，而其作品的損傷主要是因為保存環境等外在因素所導致。從這些顏料層幾近牢固、筆觸果敢有力的作品中，可以看出畫家是熟知油畫顏料的特質並作畫的。由於近代工業的發展，油畫顏料的顏色數量也逐漸增加，他卻可以從中活用各種顏色、選擇顏料，表現其獨特的畫風。此外，在基底材的使用上，除了使用畫布，也搭配使用了寫生板等板材、畫布板等各種材料作畫。經由研究本專案所修復之作品在創作時所使用的材料，我們得以證實當時畫材進口比較盛行，而且由於近代工業的發展，市面上也大量販售了多種顏料以及其他各種材料。在東京美術學校時期，陳澄波學會了油畫技法材料的基礎知識，移居上海之後更是積極地進行創作，開拓其獨有的一片天；而透過修復畫作，我們可以感受到上述歷程的變遷。完成修復的作品得以復甦，筆者認為對於臺灣油畫影響深遠的陳澄波油畫，今後也將會永遠地傳承下去。經歷120年的漫長歲月而愈發能夠傳遞強烈躍動感的作品，可謂是充分展現畫家掌握了扎實的油畫技法、材料知識來進行創作的豐富技術吧。

【註釋】

1. 鈴鴨富士子曾任東京藝術大學大學院（研究所）文化財保存學保存修復（油畫研究室）非常勤講師，現為日本內閣府迎賓館上席政策調查員。

2. 山下新太郎（1881（明治 14 年）- 1966（昭和 41 年））是東京下穀根岸町的裝裱師山下七兵衛的長子。1901 年（明治 34 年）入學東京美術學校西洋畫科。與他同期的有青木繁、熊穀守一等。1904 年（明治 37 年）於東京美術學校畢業，隔年赴巴黎留學。在 1910 年前後得到了修復中國古畫的機會，從那之後對修復繪畫產生了興趣，利用西洋畫知識進行修復油畫的研究。留存有作為有關油畫的保存修復的重要資料《油畫修繕方法記錄》，可以說是日本真正進行繪畫修復的先驅者。

3. 淺尾丁策《谷中人物叢話　金四郎三代記》1986 年，p.217-225，株式會社藝術新聞社。

4. 鈴鴨富士子《東京藝術大學 平成 16 年（2004 年）碩士論文 田邊至〔放牛〕調查‧修復報告》。

5. 株式會社櫻花彩色筆 櫻花專欄《日本油畫顏料發達史（前篇）》http://www.craypas.com/target/senior/colum/index.php

6. 種倉紀昭〈關於對大正‧昭和初期（1912-1930）我國油畫材料的考察—萬鐵五郎的油畫顏料相關〉《岩手大學教育學部年報》第46卷第2號，1987年，p.15-37。

7. X射線螢光分析：當用X光照射物質時，該物質構成元素會相應地發生特有波長的二次X光。這種二次X光就是螢光X光。通過分析這種X光，進行物質所含元素的定性和定量。攜帶型螢光X光裝置因為可以進行非破壞性的試樣分析，所以被廣泛應用於文化財產的調查研究。

8. 李涯利《關於對明治時期油畫所使用的寫生板的考察》東京藝術大學平成 23 年（2011 年）碩士論文。

9. 蓋頓斯（R.J.Gettens）、斯托特（G.L.Stout）著、森田恒之譯《繪畫材料事典》1999年，p.223，美術出版社。

The Oil Paintings of Chen Cheng-po:

An Examination of Painting Materials through Treated Artworks

Suzukamo Fujiko[1]

Summary

Foreword

My first encounter with the artworks of Chen Cheng-po (1895-1947) dates back to 2007. At that time, I was involved with the conservation treatment of three of his paintings, *Chiayi Street Center, Hill* and *Woman* at the Tokyo University of the Arts Conservation Course Oil Painting Laboratory. Five years later, with the establishment of the National Taiwan Normal University Research Center for Conservation of Cultural Relics, Professor Takayasu Kijima and I worked as oil painting conservation advisors, working together on the treatment of Chen Cheng-po's paintings. Altogether we treated 36 of his oil paintings – 29 from 2011 to 2012, and 7 in 2013.

This article aims to study the painting materials used by Chen Cheng-po and how his artistic style had changed with the passage of time through a study of 29 paintings treated between 2011 and 2012. These paintings include the ones he made when he was studying at the Tokyo School of Fine Arts where he acquired basic painting knowledge; ones he made during his teaching period in Shanghai when his skills were well honored and refined; and ones he made on returning to Taiwan.

I. Tokyo School of Fine Arts Period 1924-1929

Chen Cheng-po entered the Tokyo School of Fine Arts in 1924 and graduated in March 1927. He then continued on as a graduate student, eventually completing his studies in 1929. The five years

Fig.1: Signature book of the Oil Painting Materials Research Society

Fig.2: The Oil Painting Materials Research Society sponsors autograph and seal

Fig.1 &2 were reproduced in Kinshiro Sandaiki: Yanaka Jinbutsu Sōwa, Teisaku Asao

Bumpodo's catalog

Winsor & Newton (England)

Winsor & Newton (England)

Lefranc & Bourgeois (France)

Bumpodo's finely prepared oil paints（Japan）

Cambridge (England)

Fig.3: Bumpodo's catalog, 1925.

during which he studied at the Tokyo School of Fine Arts were generally regarded as an important period in which the foundation of his oil painting skills was laid.

At the Tokyo School of Fine Arts, Chen studied oil painting under Itaru Tanabe (1886-1968), who was a graduate of the same school. Tanabe was active in official art exhibitions and enthusiastic in the study of painting materials. In his book, Kinshiro Sandaiki: Yanaka Jinbutsu Sōwa, Teisaku Asao wrote: "...ever since the beginning of his life as a painter, my teacher studied of painting materials and applied all his knowledge to study. Even among experts, my teacher rivalled in reputation was as reputable as Yamashita Shintaro[2]... Because he wanted to gather fellow artists together to establish a formal research organization, under his initiative, in 1942 the Oil Painting Materials Research Society was set up." (Fig. 1-2)[3] According to Yuji Ochi, who studied under Tanabe while at the Tokyo School of Fine Arts, Tanabe often advised his students to use the best painting materials.[4] Therefore it is likely that Chen Cheng-po obtained his knowledge about painting materials from his revered teacher, Tanabe.

II. Painting Materials

1. Oil Paints

Early oil paints sold in Japan were mostly imported; importation began in the early Meiji period. Takashimaya, a bookstore selling Western books, was said to have imported English oil paints as early as 1871. After 1897, imported oil paints became popular and paint from Winsor and Newton (England), Cambridge (England), and Lefranc & Brourgeois (France) also began to be sold (Fig. 3). Eventually, Japan began to domestically produce oil paints. In the early Taisho years, the company Sakuragi Oil Paints was formed. Subsequently, Bumpodo, established in 1887, also began selling oil paints

in 1920.[5] By the end of the Taisho period, there was a steady growth in the number of stores selling imported and domestic oil paints.[6] It is in my opinion that when Chen Cheng-po was studying in Japan, he was using imported oil paints.

2. X-ray Fluorescence for Paint Analysis

X-ray fluorescence (XRF) spectrophotometry[7] was used for paint identification and to examine painting techniques and materials.

a. Results of XRF analysis

Tokyo School of Fine Arts Period, 1924-1929

· *Kegon Waterfall*, 1927, oil on canvas

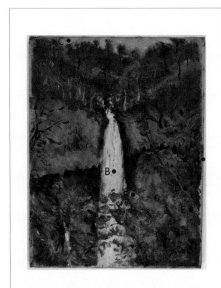

Test Points	Color	Elements Found	Names of major pigments determined
A	Ground	Pb	Silver white
B	White	Zn	Zinc white
C	Blue	Zn, Pb, Co	Zinc white, Silver white, Cobalt blue, Cobalt green
D	Green	Zn, Pb, Cr, Cu	Zinc white, Silver white, Chromium oxide green, Emerald green
E	Mahogany	Zn, Pb, Fe, Hg	Zinc white, Silver white, Iron(III) oxide or ferric oxide (Ferric oxide), Vermilion
F	Yellow	Zn, Pb, Cr, Cu	Zinc white, Silver white, Chrome yellow

Shanghai Period, 1929-1933

· *At the Foot of Pagoda Hill*, 1933, oil on canvas

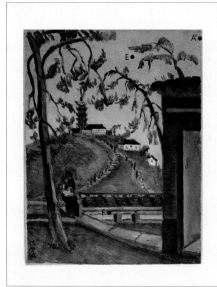

Test Points	Colors	Elements Found	Names of major pigments determined
A	Ground	Pb, Zn, Ba	Silver white, Zinc white, Barium sulfate
B	Green	Zn, Pb, Fe, Cu, Cd, Co, Cr	Zinc white, Silver white, Terre verte, Emerald green, Cadmium green, Cobalt green
C	Brown	Zn, Pb, Fe	Iron(III) oxide or ferric oxide (Ferric oxide)
D	Yellow	Zn, Cd, Pb	Zinc white, Cadmium yellow
E	Blue-green	Zn, Pb, Cu, Co	Zinc white, Silver white, Emerald green, Cobalt blue
F	Pink	Zn, Pb, Fe, Cu	Zinc white, Silver white, Iron(III) oxide or ferric oxide (Ferric oxide)

· *Courtyard in Sin-Lau*, 1941, oil on canvas

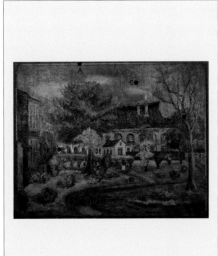

Test Points	Colors	Elements Found	Names of major pigments determined
A	Ground	Zn, Ca	Zinc white, Calcium carbonate
B	White	Zn	Zinc white
C	Cerulean	Zn, Pb, Co	Cobalt green, Cobalt blue, Silver white
D	Green	Zn, Pb, Cr, Co	Zinc white, Chromium oxide green, Viridian, Cadmium yellow
E	Fuchsia	Zn, Fe, Pb, Cr	Zinc white, Iron(III) oxide or ferric oxide (Ferric oxide)
F	Mahogany	Zn, Pb, Fe, Cr	Zinc white, Iron(III) oxide or ferric oxide (Ferric oxide)
G	Brown	Zn, Fe, Cr, Pb	Zinc white, Iron(III) oxide or ferric oxide (Ferric oxide)

b. Summary of XRF results

Analytical results showed that other than lead white, pigments used for the ground layer also included zinc white, barium sulfate and calcium carbonate. We also identified several unique painting characteristics of Chen Cheng-po's works. For instance, he primarily used zinc white; for blue-green areas, cobalt green was used most often. For red areas, he used both vermillion and cadmium. Similarly, emerald green, cadmium green and cobalt green were found in green areas while cadmium yellow and chrome yellow were found in yellow areas. This showed that Chen Cheng-po tended to use colors belonging to the same genre. Imported painting materials were popular during the early years of the Taisho and Showa periods, which were the Japan's most prosperous periods. With the development of the modern chemical industry, chrome and cadmium paints began to be manufactured in large quantities. At that time, all kinds of paints, mostly imported, were being sold in the market. We believe that it was under such circumstances that Chen Cheng-po was able to find paints that helped express his unique style.

3. Supports

Among the 29 paintings treated, 3 kinds of supports had been identified: 21 canvas, 7 panels (6 on wood panel and 1 on plywood) and 1 canvas board.

a. Canvas

When Chen Cheng-po was studying at the Tokyo School of Fine Arts, both imported and domestically produced canvases were available. Imported canvases included Blanche (France), Winsor & Newton (England) and Claessens (Belgium), among others. Unfortunately, import trade with Europe was disrupted with the outbreak of World War I, leading to a shortage of supply. As a result, the market turned to domestically produced canvases. Japan Art Materials Industry Limited first sold canvases in Japan in 1918. Among the oil paintings I helped treat, 21 used canvas as a support. All the canvases used were commercially available and pre-primed. As for the canvas weaves, it can be confirmed that other than rough-weave canvases such as the one used for painting *Ancient Gate*

Tower, there were canvases of average weave and fine-weave canvases like the one used for *War Devastation (Beside the Commercial Press Building)*.

b. Wood panel

Among the seven paintings on panels, six were painted on wood panels while one was on plywood. Wood panels were usually used for painting landscapes. Commercially available wood

Fig.4: Portrait of a Teenage Boy 1929/Verso part

Fig.5: Country Road 1925/ Verso

panels came in different sizes: all were 5mm in thickness, but dimensions ranged from 33x24cm to 37x27cm. They were commonly made from magnolia, osmanthus and poplar wood, and were characterized by beveled edges on two or four sides of the panel verso (Fig. 4-5). With the gradual decrease in demand for wood panels, their production gradually came to a halt.[8]

c. Canvas board

Among the treated paintings is one titled *Sailboat*, painted on a piece of primed canvas backed with a thick laminated paper. This kind of thick paper is called paper board, and is called by various names including "board," "canvas board," "board canvas" and "academy board." A canvas board is a support made by gluing a primed canvas to a paper board. In 1878, canvas boards were sold by a company called George Lowe. The support of *Sailboat* was precisely this kind of canvas board[9]. By virtue of their lightness and convenience to carry around, canvas boards are ideal for outdoor sketching. Therefore, it is reasonable to believe that *Sailboat* was a sketch done on canvas board when Chen went on an outdoor sketching excursion.

III. Conclusions

Through this conservation project, we are drawn once again to the charm of Chen Cheng-po's oil paintings. The paintings' damages were largely caused by external factors including poor environment, but the paint layers have remained quite sturdy and the brushstrokes intentional and powerful. From Chen Cheng-po's works, we can see that he was well versed in the properties of oil paints. With modern industrialization, oil paints were produced in a greater range of colors. Chen Cheng-po had chosen a variety of colors to paint with, was versatile in their use, and gradually developed a unique

artistic style. In addition, he used wood panels and canvas boards as supports when fitting for the purposes of his paintings. By examining the painting materials used in the works treated in this project, we can confirm that the there were many imported art materials available during that time period, and industrial advancement led to the commercial availability of many kinds of oil paints and other painting materials. Chen Cheng-po learned the basic techniques of oil painting when he was studying at the Tokyo School of Fine Arts. Afterwards, he moved to Shanghai and completely devoted himself to painting, setting out to create a new artistic world of his own. Through the study of his paintings, we can observe the changes that took place along his journey. Chen Cheng-po's paintings have been fully restored after conservation treatment. Considering the profound impact of his work on oil painting in Taiwan, we believe that the legacy of his oil paintings will be passed on in posterity. Even though one hundred and twenty long years have now passed since his birth, the vigor that he sought to convey in his artwork has nonetheless grown in strength. Chen Cheng-po had a solid foundation of oil painting technique and deep understanding of painting materials. His paintings are faithful testaments to the multifaceted skills he possessed as an artist.

1. Suzukamo Fujiko was Adjunct Lecturer of Graduate Deparment of Conservation, Conservation Course Oil Painting Laboratory Tokyo University of the Arts. Now she is the Senior Researcher of state Guest House of Cabinet Office.

2. Yamashita Shintaro (1881-1966) was a pioneer of Japanese oil painting conservation.

3. Teisaku Asao, Kinshiro Sandaiki: Yanaka Jinbutsu Sōwa (Geijutsu Shinbunsha, 1986), p.217-225.

4. Suzukamo Fujiko, Tokyo National University of Fine Arts and Music, Master's Dissertation, 2004: Study and Conservation Report on Itaru Tanabe's Grazing Cattle.

5. Sakura Color Products Corporation, The History of Oil Color Development in Japan (Prequel), Sakura Column. http://www.craypas.com/target/senior/colum/index.php.

6. Noriak Tanekurai, "Study on Painting Materials in Japan during the Early Years of Taisho and Showa – Oil Colors Used by Yorozu Tetsugoro," (Iwate University Education Journal, Vol. 46 No.2, 1987), p.15-37.

7. X-ray fluorescence: When an object is exposed to x-raays, its component elements correspondingly emit secondary x-rays of specific wavelengths. This secondary x-ray is x-ray fluorescence. Analysis of this type of x-ray fluorescence allows one to carry out qualitative and quantitative determination of the elements of the object.

8. Lee Ya-li, Tokyo University of the Arts, Master's dissertation, 2011: A Study on the Use of Wood Panels in the Meiji Period.

9. R. J. Gettens and G. L. Stout, Painting Materials: A Short Encyclopedia, tr. Morita Tsuneyuki (Art Publishing Co. Ltd. [Bijutshu Shuppan-sha Co. Ltd.], 1999), p.223.

陳澄波油畫打底材料與現代油畫材料中元素組成之比較

黃曉雯[1]、張維敦[2]

前言

　　本文一方面為提供修復陳澄波油畫作品所需之材料參考資料，特別是為解釋當使用X射線螢光分析法測定油畫材料時，必須進行塗層間元素種類重疊之解析，另一方面為建立陳澄波油畫作品打底材料之無機元素組成特徵，以提供偽畫鑑識所需之參考數據。實驗樣品蒐集範圍第一部份為陳澄波油畫框邊上取得之微量白色打底材料，第二部份為現代油畫打底材料，包括日本、韓國、英國、荷蘭、法國、巴西等國之市售商品，現代油畫打底材料樣品塗裝在載玻片上經乾燥後，取微量進行掃描式電子顯微鏡/X射線能譜法之分析與比較。結果發現幾乎陳澄波所有檢體均含有鉛元素，而卻均未測得鈦元素，而現代油畫打底材料均含有鈦元素，卻較少用鉛元素。顯見在陳澄波年代之油畫打底材料中含鉛元素應相當普遍，而鈦元素成為現代油畫打底材料的指標元素。

一、研究動機與構想

（一）動機與目的

　　為達到能長期保存、活用與傳承珍貴歷史文化資產的目的，文物資產修復作業對如何擬定一套較理想完備的計畫，理論上均必須跨領域地從技術、科學與歷史等三個專業角度進行構思，同時必需遵循安全性、歷史性與完整性的三大維護倫理，並依據預防性原則、適宜性原則、相似性原則與可逆性原則等四大原則綜合考量後才加以建置。國立臺灣師範大學於2011年10月22日正式落成啟用「文物保存維護研究發展中心暨美術學系藝術文物修復室」（簡稱文保中心），該中心自喻為一所文物與珍貴藝術品的修復醫院，而延續文物藝術生命，發揚社會教育功能成為該中心成立的最重要使命。文保中心多年來已積極成立跨領域修復團隊，致力於藝術、修復技法、人文、現代科技的跨域結合，試圖打造成為一流的現代化專業修復室，特別著眼於藝術品與文物修復相關科技與應用發展，例如光學檢測儀器之運用、修護專用材料之研發、藝術品之鑑定等範疇，建構成為亞洲文保專業交流的重要平台[3]。

　　陳澄波先生是一位受過嚴格正統學院訓練且飽經戰亂洗禮的台灣早期畫家，其畫作當年在日本、上海、台灣等地均成為美術界眾所矚目的焦點，但卻在1947年二二八事件中不幸捐軀。這位熱愛土地、熱愛國家、熱愛藝術的偉大畫家，內在所具足恢宏胸襟與偉大人格，外在展現出真正藝術家的堅持，創造出一幅幅曠世經典作品，穿過時間與空間的歷史長廊。臺師大文保中心開始運作以後，即承接了各名畫大師作品的修

復案件，其中陳澄波先生畢生作品的修復顯得格外慎重，不但獲得財團法人陳澄波文化基金會的全力支持，也邀請日本修復專家團隊的奧援協助。

本研究係配合臺師大文保中心陳澄波油畫的整體修復計畫，希望能從陳澄波先生所用的油畫材料進一步作科學性分析，一方面為修復一位偉大畫家的一系列作品，提供擬定修復計畫所需的參考資料，同時展開台灣早期油畫材料特性的基礎研究，特別是為解釋當使用X射線螢光分析法（X-ray fluorescence spectrometry；XRF）測定油畫材料時，必須進行元素種類重疊的解析之所需。另一方面，面對當前嚴重的偽畫鑑識難題[4]，本研究分析之結果盼可作為探討陳澄波偽畫鑑識所需的部份研判特徵。

（二）研究構想

從偽畫鑑識所需的完整分析內容而言，至少必需包括畫家技法分析（Stylistic Analysis 或稱為 Morellian Analysis）與鑑識科學分析（Forensic Science Analysis）兩部份，技法分析方法主要是從畫家作品中的獨特形式（Idiosyncrasies）或慣性風格細節作為鑑別畫家或創作方法，其理論基礎在於認定一位畫家當達到純熟的技術巧時必然已發展出特有的慣性技法（Formulas），而且將終身維持一致性的技法風格。即便該作家的風格有所進化，其慣性技法依然呈現。透過這些重複呈現的慣性風格細節特徵的嚴密分析鑑定，讓觀察者能以如指紋般的特徵加以鑑別，這些個化性（Individualization）的特徵存在於作品中之大小繪畫技巧，例如一位畫家如何繪製像眼睛、衣領、植物等等之技巧與材料習慣，這些技法分析與比對類似文書鑑定中的筆跡鑑定，證據的證據能力與證明力在法庭上完全是可被接受的[5]。至於鑑識科學的分析部分則大致分為三個方向，第一是光學結合攝影技術的應用，包括：側光檢驗、近距離與顯微攝影、紫外光攝影、紅外光攝影、X光攝影等；第二是化學成分與年代分析，1.元素成分分析，包括：掃描式電子顯微鏡/X射線能譜分析法、原子吸收光譜法、感應耦合電漿原子發射光譜分析法、X射線螢光光譜分析法，2.分子組成與結構分析，包括：顯微紅外光譜法、拉曼光譜法、氣相或液相層析質譜法、熱解氣相層析質譜法，3.年代分析，包括：顏料年代學鑑定法、放射性碳-14元素定年法；第三是筆跡鑑定。

另外從修復陳澄波先生作品必需在保護原作的完整性前提下，微量取樣與微量分析成為本研究必需遵行的準則。在微量取樣方面，本研究僅採取修復畫作前遺留在包裝紙上自然掉落之部份樣品，另在畫框角落布結內側取下少量打底材，試圖獲取足以顯示陳澄波油畫中代表性之材料特性。微量檢體經以掃描式電子顯微鏡／X射線能譜法進行微量檢體之無機元素成分分析。為兼顧偽畫鑑識之比對需求，本研究將取自日本、韓國、英國、荷蘭、法國等國之現代油畫材料作為比較分析，探討過去打底材料與現代材料之差異。

（三）掃描式電子顯微鏡／X射線能譜分析法概述

掃描式電子顯微鏡（Scanning Electron Microscopy；SEM）可說是鑑識科學實驗室分析微量證物（Trace Evidence）最需仰賴的顯微鏡，一般光學顯微鏡之最高放大倍率約僅達1500X，解析度最小約為0.3μm，而SEM放大倍率可達300,000X，解析度約在3.5至10nm之間。此外，SEM可搭配能量散射光譜儀（Energy Dispersive Spectrometer；EDS）後，形成掃描式電子顯微鏡／X射線能譜分析儀（SEM/EDS）的串聯系統，除了可得知樣品的表面形貌影像外，又可得到化學成分或是微細組織之相關資訊，具有非破壞性檢測、樣品前處理簡單等優點，因此十分適合在微量檢體檢測上之應用。

SEM之基本原理是將電子源所發射出之電子束，經高電位之電場加速後，再利用2至3個電磁透鏡所組成的電子光學系統進行聚焦，形成一直徑約2至10nm之高能電子束。利用此電子束對樣品固體表面進行掃描，進而獲得樣品的表面資訊。樣品表面被入射電子束轟擊後，會產生彈性與非彈性碰撞。所謂彈性碰撞指的是入射電子束與樣品表面碰撞後，幾乎沒有損失能量，僅造成行進方向之改變；而非彈性碰撞則是入射電子束在與樣品表面碰撞後會失去部分能量，因此釋放多種電子訊號與電磁波，例如二次電子（secondary

electrons；SE）、歐傑電子（Auger electron；AE）及X光等，如圖1所示。

　　大部分SE主要來自樣品表面約2至5nm的深度範圍，其能量約小於50eV，約90%之二次電子能量小於10eV。SE對檢體之表面情況相當敏感，因此可用來顯現檢體之表面形貌。而背向散射電子（Backscattered Electron；BSE）則是入射電子反彈所形成，屬於彈性碰撞所產生之訊號，因此能量約略小於入射電子能量（~50eV）。BSE之產生與物質之原子序有關，檢體表面材料之原子序越大，可獲得較多的BSE訊號，因此可獲得較明亮的影像。由於BSE之強度主要受檢體之原子序影響，因此適用於説明物質的元素組成及分布情形。利用電子束撞離原子內層電子形成受激離子，高能階外層電子經一系列的向內層軌域補位回到基態而發射一系列X光之特性， SEM可因此搭配能量散佈分析儀進行元素分析，形成一套可一面觀察並鎖定特定區域一面偵測其元素資訊的系統，是化學鑑識領域應用最廣的分析儀器。

　　以材料分析角度而言，常見的油畫材料中，顏料大致上有無機及有機材料之分別。無機顏料主要來自礦石，不同種類及氧化態的無機金屬化合物或鹽類造就不同顏色礦石，也是人類早期使用較多的繪畫材料。而有機顏料則多來自於動植物。兩種類型顏料相較之下，有機顏料之著色力與顏色鮮豔度通常較高，而無機顏料的遮蓋力與耐光性較佳。近年來無論有機或無機顏料均有人工合成材料出現。由於SEM/EDS可針對固態材料的無機元素分析，且較不易受檢體中之有機成分干擾，因此十分適合作油畫無機顏料檢體之分析，惟SEM/EDS所分析的結果屬於定性或半定量分析，並無法進行定量分析之解釋。

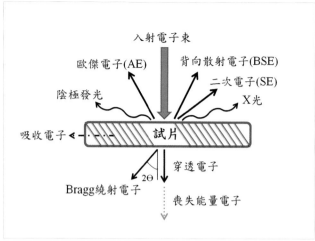
圖1. 入射電子在試片裡經彈性和非彈性碰撞後所放出之電子和電磁波。[6]

編號	作品名稱	檢體標示
1	屏椅立姿裸女	CU1
2	和服男子	CU2
3	仰臥枕掌裸女	CU3
4	搭肩裸女	CU4
5	綠瓶花卉	CU5
6	水畔臥姿裸女	CU6
7	戰災（商務印書館正面）	CU12
8	椰林	CUA
9	新樓庭院	CUB
10	綠蔭	CUC

表1. 陳澄波畫作檢體清單與標示。

二、實驗材料與方法

（一）實驗材料

1. 陳澄波油畫畫作檢體與採樣

　　本次實驗檢體係取自臺灣師範大學文保中心待修復之陳澄波油畫畫作，共採取十幅畫作之打底層塗料，樣品編號與畫作名稱如表1所示。為避免破壞作品畫面，每幅畫作均僅自畫框角落布結內側，如圖2所示，採取極微量之樣品進行SEM/EDS分析。

圖2. 檢體採樣地點如紅色圓圈所示。

2. 現代油畫材料

　　為與陳澄波油畫打底材進行比較分析，現代油畫檢體分別購自臺北市八大美術社及高雄市松林美術器材社，以白色打底用顏料為主，總計十五支樣品。樣品類屬廠牌共含八家廠商製造（來自七個國家），分別為Winsor & Newton（England）、Royal Talens（Netherlands）、Lefranc & Bourgeois（France）、Holbein（Japan）、KUSAKABE（Japan）、Shield（Korea）、JHON SONE（America）及ALPHA

編號	廠牌	品名	品項編號	製造地	檢體標示
1	Winsor & Newton	Under-painting White	674	England	WN674-1
2	Winsor & Newton	Under-painting White	674	England	WN674-2
3	Winsor & Newton	Under-painting White	674	England	WN674-3
4	Winsor & Newton	WHITE GESSO		France	WN-GE
5	Holbein	Foundation White	631	Japan	H631-1
6	Holbein	Foundation White	631	Japan	H631-2
7	Holbein	Foundation White	631	Japan	H631-3
8	Shield	Foundation White	411	Korea	SH411-1
9	Shield	Foundation White	411	Korea	SH411-2
10	Shield	Foundation White	411	Korea	SH411-3
11	JHON SONE	GESSO		America	JS-GE
12	Lefranc & Bourgeois	GESSO		France	LB-GE
13	ALPHA	GESSO		Brazil	AP-GE
14	Royal Talens	GESSO Primer	1001	Netherlands	TA-GE
15	KUSAKABE	GESSO		Japan	KU-GE

表2. 現代油畫打底材料檢體清單與標示一覽表。

（Brazil）。檢體清單、產地與標示詳如表2所示。

（二）實驗方法

1. 樣品前處理

　　檢體以11號手術刀片或泰爾茂塑膠注射針於實體顯微鏡觀測下取樣，各檢體取下三個微量樣品轉移至雙面碳膠圓柱形鋁座上，所有樣品於分析前均進行鍍碳表面處理後備用。現代油畫打底材料檢體則先進行塗裝在載玻片上乾燥，經完全乾燥後的檢體再以11號手術刀片取樣，置於雙面碳膠圓柱形鋁座上鍍碳備用。

2. SEM/EDS之測定

　　掃描式電子顯微鏡/X射線能譜測定之儀器與條件：

　　（1）SEM/EDS系統：Jeol JSM-5410LV SEM/Oxford Link ISIS X-ray EDS

　　（2）測定條件：加速電壓為20KV，工作距離為15mm，傾斜角（Tilt Angle）為0°，收集時間為200sec。

三、結果與討論

（一）陳澄波油畫打底材料之元素組成特徵

　　陳澄波檢體經SEM/EDS分析結果之元素含量圖譜，詳如表3所示。依其主要元素強度所形成之能譜型態特徵加以分類發現，十個陳澄波油畫打底材料之SEM/EDS檢測結果，大致可分為四類。第一類是以鋅（Zn）為主要成分元素之材料，其他次要成分元素尚包括：鈣（Ca）、鉀（K）、氯（Cl）、硫（S）、磷（P）、鋁（Al）等，第二類是以鋅（Zn）為主要成分元素之材料，其他次要成分元素尚包括：鉛（Pb）、鈣（Ca）、鉀（K）、矽（Si），鋁（Al）、鎂（Mg）、鈉（Na）等，第三類是以鉛（Pb）為主成分元素之材料，其他次要成分元素僅包括：鈣（Ca）、鋁（Al）等，第四類是以鋇（Ba）、硫（S）、鋅（Zn）

為主要成份元素，其他次要成分元素尚包括：鉛（Pb）、鈣（Ca）、鉀（K）、矽（Si），鋁（Al）、鈉（Na）等。

分類編號	元素特徵	檢體標示	含不同成份元素組成特徵之代表性X射線能譜圖
1	鋅為主要成份元素	CU4	
2	鋅為主要成份元素/鉛為次要成份元素	CU2、CU3、CUB	
3	鉛為主成份元素	CU1、CU5、CU12、CUC	
4	鋇、硫、鋅為主要成份元素/鉛為次要成份元素	CU6、CUA	

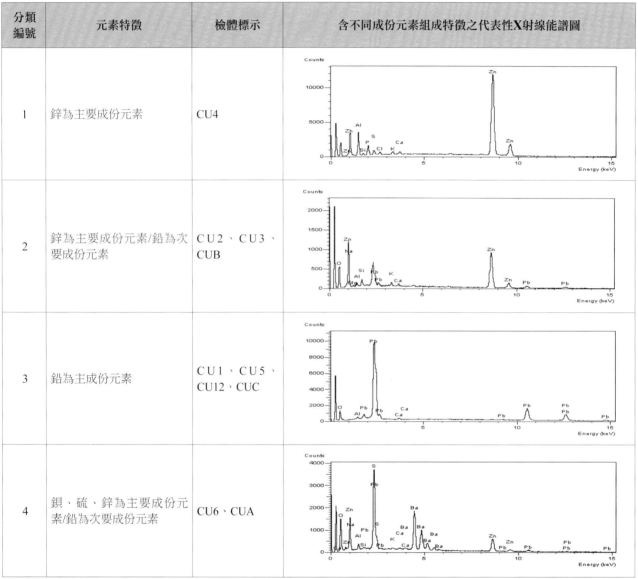

表3. 陳澄波油畫打底材料之掃描式電子顯微鏡／X射線能譜分析結果

　　在所有檢體當中，僅有一個標示CU4檢體不含鉛元素外，其他九個檢體均可測得鉛元素，顯示在陳澄波作畫年代使用含鉛元素之油畫打底材料應該相當普遍，各檢體的主要成份元素與其他次要元素含量相比，主要成份元素所佔比例較次要成份明顯為多，顯示材料製造時使用的原料應較為簡單。

（二）現代油畫打底材料之元素組成特徵

　　現代打底材料之成份元素分析結果可大致成四類，詳如表4所示。第一類是以鈦（Ti）為主要成分元素之材料，其他次要成分元素尚包括：鋅（Zn）、鉀（K）、矽（Si）、鋁（Al）、鎂（Mg）、鈉（Na）等，第二類是以鈦（Ti）、鈣（ca）、矽（Si）為主要成分元素之材料，其他次要成分元素尚包括：硫（S）、磷（P）、鋁（Al）、鎂（Mg）、鈉（Na）等，第三類是以鉛（Pb）、鈦（Ti）、鈣（Ca）為主要成分元素之材料，其他次要成分元素僅包括鋁（Al）等，第四類是以鈦（Ti）、矽（Si）為主要成分元素之材料，其他次要成分元素尚包括：硫（S）、鋁（Al）、鎂（Mg）、鈉（Na）等。

　　由八家廠商製造的十五種現代油畫打底材料的成份元素比較發現，所有樣品不例外地均含有鈦元素，顯

分類編號	元素特徵	檢體標示	含不同成份元素組成特徵之代表性X射線能譜圖
1	鈦為主要成份元素	WN674、AP-GE	
2	鈦、鈣、矽為主要成份元素	WN-GE、SH411、JS-GE、LB-GE、TA-GE	
3	鉛、鈦、鈣為主要成份元素	H631	
4	鈦、矽為主要成份元素	KU-GE	

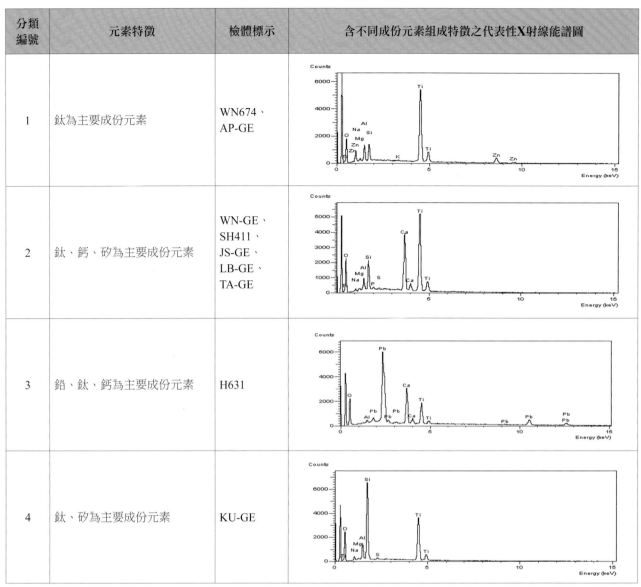

表4. 現代油畫打底材料之掃描式電子顯微鏡／X射線能譜分析結果

示現代油畫白色打底材料使用二氧化鈦的普遍化。又現代油畫白色打底材料當使用含矽（Si）或鈣（Ca）元素成份時，其使用含量的比例明顯較多，除了日製Holbein產品標示H631之Foundation White打底材獨含鉛元素成份外，其餘均呈現無使用含鉛元素成份之情形。

四、結論

本實驗之陳澄波油畫打底材料與現代油畫打底材料中所含元素結果比較，明顯發現幾乎所有陳澄波畫作檢體均含有鉛元素，而均未測得鈦元素。現代油畫打底材料則均含有鈦元素，卻較少用鉛元素。換言之，在陳澄波年代之油畫打底材料中含鉛元素應相當普遍，而鈦元素成為現代油畫打底材料的指標元素。

【註釋】
1. 中央警察大學鑑識科學研究所博士生。
2. 中央警察大學鑑識科學研究所教授。
3. 國立臺灣師範大學文物保存維護研究發展中心，請參閱："http://rcccr.ntnu.edu.tw/target.php (瀏覽日期：2014年2月28日)。
4. 李嘉興《偽造油畫犯罪之鑑定方法、法律責任及偵查作為之研究》，中央警察大學刑事警察研究所碩士論文，2009年6月。
5. Hans H. Buhr, Forensic Analysis，請參閱：http://archive.is/SjhxS（瀏覽日期：2014年3月1日 ）。
6. 陳力俊等著《材料電子顯微鏡學》，行政院國家科學委員會精密儀器發展中心出版，1990年7月。

A Comparison Between the Elemental Composition of Chen Cheng-po's Oil Paintings and Modern Oil Painting Materials

Huang Hsiao-wen[1] and Chang Wei-tun[2]

Summary

This study complements the National Taiwan Normal University Research Center for Conservation of Cultural Relics' project to treat Chen Cheng-po's oil paintings. It aims to, through an in-depth scientific analysis of the oil painting materials used by the artist, provide necessary reference information for establishing a conservation methodology for the works of a great painter, and in addition, in light of the difficulties in identifying forgeries, to elucidate unique characteristics to authenticate Chen Cheng-po's paintings.

The authentication of a work of art consists of two aspects: stylistic analysis (also called Morellian analysis) and forensic science analysis. Stylistic analysis deals with the authentication of a painter or the painter's creative method through an analysis of idiosyncrasies or signature style. Its theoretical basis lies in the assumption that when a painter's skills have reached a high level of proficiency, they have developed signature techniques or unique stylistic formulas, and are likely to maintain a consistent technical style throughout their life. Even if the painter's style evolves, their formulas may still appear. Stylistic analysis is analogous to handwriting identification in the authentication of documents. Forensic science analysis can be divided into three parts. The first is the application of various photographic techniques including macrophotography, microphotography, UV photography, IR photography and X-radiography. The second is chemical composition and dating analysis that includes: (1) elemental composition analysis using scanning electron microscopic/energy dispersive spectrometric analysis, atomic absorption spectroscopy, inductively coupled plasma atomic emission spectroscopy and X-ray fluorescence spectrometry and (2) molecular composition and structural analysis using micro infrared spectroscopy, Raman spectroscopy, gas chromatography, liquid chromatography, pyrolysis gas chromatography-mass spectrometry; (3) dating analysis, including paint dating and carbon-14 dating. The third involves signature authentication.

When a scanning electron microscope (SEM) is used in conjunction with an energy dispersion spectrometer (EDS), a serial SEM/EDS system is formed. When used with micro sampling pre-treatment, it not only reveals the surface topographic image of a sample, but also information related to its chemical composition or microscopic structure. This system has the advantages of being non-destructive and requiring simple pre-treatment, and is therefore most suitable for trace specimen detection. Since SEM/EDS can be used for inorganic elemental analysis of solid materials and is not easily interfered by the organic composition of the object under examination, it is most suitable for

the analysis of inorganic paint samples from oil paintings. However, since the analysis of SEM/EDS is qualitative or semi-quantitative, it cannot provide quantitative data. In order to provide a basis of comparison against forgeries, this study employs SEM/EDS to compare traces of white priming materials near the edges of Chen Cheng-po's oil paintings against modern painting materials from Japan, Korea, England, Holland and France in order to better understand the differences between priming materials of the past and modern painting materials.

The results show that nearly all samples from Chen Cheng-po's paintings contain lead but no titanium, whereas priming materials of modern oil paintings invariably contain titanium but rarely lead. This indicates that during the period in which Chen Cheng-po's was painting, it was quite common to find lead-based priming materials for oil paintings, whereas titanium is indicative of priming materials for modern paintings.

1. Huang Hsiao-wen is PhD student of Graduate School of Forensic Science, Central Police University.
2. Chang Wei-tun is professor of Graduate School of Forensic Science, Central Police University.

陳澄波的木板油畫調查研究與修復

王瓊霞[1]

前言

　　陳澄波文化基金會從2012年至2013年間委託國立臺灣師範大學文物保存維護研究發展中心執行陳澄波（1895-1947）紙質及油畫文物修復作業。油畫媒材作品由東京藝術大學保存油畫修復木島隆康教授、鈴鴨富士子講師主持修復畫布29件、木板型式的材質7件，作品總數計36幅。油畫木板型式極為特殊，整體為長方形面板、背面兩側短邊經斜面處理、大小尺寸皆已製式化可存放畫板攜帶箱內，單件畫箱容量可放置6片。作品中僅〔俯瞰西湖（一）〕此件製作年為1930年代於畫面上落款，為陳澄波從東京美術學校畢業離開日本後所創作。現今臺灣市面並無販售此類型的繪畫材料，相關資料十分稀少，不過調查發現1921年來臺任教的日籍畫家鹽月桃甫（1886-1954）描繪臺灣紅磚綠樹的南國風情〔大成門〕（1934年作）、1925-1930年留日畫家陳植棋〔睡蓮〕（1927年作）、〔野薑花〕、〔淡水風景〕（1925-1930年作）等、東京藝術大學美術館於2001年解讀分析館藏明治時期（從高橋由一至黑田清輝時代）58幅油畫名品一書中，中村勝治郎（1866-1922）〔洗い場〕（明治後期作）、山本森之助（1877-1928）〔琉球の燈台〕（1902年作）　油畫木板作品同樣使用此種形制的畫板，因此可推論是陳澄波1924-1929年間赴日求學時購置且當時頗為流行。造型與現今大不相，同極簡約古著的畫板攜帶箱和油畫木板經考證屬19-20世紀在日本販售流通的油畫材料。這有著不同於畫布材質異趣的油畫木板直到1947年陳澄波的最後之作〔玉山積雪〕仍使用創作。

　　木材樹種經非破壞性檢測後為5件為連香樹（*Cercidphyllum japonicum*，俗稱桂樹）、1件屬於臺灣特產紅檜（*Chamaecyparis formosensis Matsum.*）及1件三合板作品（表1、3）。本文藉由上述物件之研究探知陳澄波承續於日本繪畫技法且體現當時環境的材料與技法。

編號	作品名稱	尺寸（cm）	年代	落款
1	街道	23×33	1925	左下 / 符號CTH
2	林中廊沿	24×33	不詳	無
3	女子像	33×24	不詳	無
4	少年像	33×24	不詳	無
5	俯瞰西湖（一）	24×33	1930年代	右下 / 澄波
6	女孩	22.5×15	不詳	右下 / 澄波
7	船屋	12.5×17.5	不詳	無

表1. 7件木板油畫的基本資料

一、亞洲美學的潮流中心

日本留學時期（1924-1929），是陳澄波繪畫過程中最重要的成長與蛻變階段，受到家人的支持，1924年至亞洲藝術潮流的中心東京美術學校（現為東京藝術大學），成為臺灣最早留學日本的藝術先驅。

陳澄波出生於1895年，這年中、日簽訂馬關條約，臺灣、澎湖割讓給日本，進入日治時代。明治維新後的「和洋折衷」的近代化教育思維與完整的美術啟蒙課程，在歷史流轉年代間進入臺灣時期。陳澄波對於西洋藝術啟蒙認知是就讀臺灣總督府國語學校時，受日籍水彩畫家石川欽一郎（1871-1945）指導。1924年便考進日本東京美術學校圖畫師範科，於田邊至門下學習，後來進入岡田三郎助設立的「本鄉繪畫研究所」鑽研素描，展開西洋繪畫的正式養成教育訓練。

日本的西洋繪畫最初在江戶末期（16世紀）藉由基督教傳入被引進，幕府時代便有西洋畫的活躍跡象但僅限某部分畫家，其中代表性人物為現今被譽為近代洋畫的開拓者高橋由一（1828-1894）。經明治維新後的藝術教育政策設立，公部美術學校、西洋學研究等培育藝術人才的機構相繼計畫成立，高橋由一、淺井忠爾後積極於國內推動西洋畫的普及性等學術活動。直至因受到法國印象畫派啟發影響[3]的黑田清輝（1866-1924）、久米桂一郎（1866-1934），承襲拉法葉‧柯朗（Louis Joseph Raphael Collin，1850-1916）外光派繪畫技法，1893年從法國返回日本後，因與高橋由一的傳統畫派技法主張歧異，日後逐漸形成分野與派爭[4]。1887年，日本國內最高的藝術學府東京美術學校正式創立，當時尚未有西洋畫科直到1896年黑田清輝進入學校執教後開設，並聘請同為外光畫派的久米桂一郎、藤島武二、岡田三郎助等。著重人體素描、強調戶外寫生，感受自然光對於物體的微妙變化等深深引領著亞洲繪畫的潮流，這即是陳澄波所處亞洲藝術新浪潮的環境。

二、油畫起源

回溯歷史西洋繪畫可説是技法與材料長時間交織演變下的發展，木板（Panels）和畫布（Canvas）是主要使用的基底材質，另有紙、羊皮紙、金屬、玻璃、石等材質。在畫布尚未使用前，大自然原生木材是繪畫的最主要的使用材料。原木為繪畫基底材（支持體）大約從13世紀義大利使用，特別是文藝復興時期後300-400年間逐漸發展到歐洲各地。但隨著原生木種橡木（Oak）、白楊木（Poplar）、白樺木（Birch）等品質優良的木材日漸短缺，畫家更傾向輕便、易攜帶性的材料如棉、麻等布料且約15世紀時油彩技法逐漸確立與成熟因此在這雙重因素下，油彩繪於畫布上的技法廣為畫家所用，16世紀後畫布發展成為最主要的基底材料（表2）。隨著高度文明經濟發展，以往繪畫的用具材料、顏料等由畫家自製，18世紀即有廠商專門製造販售。

坦培拉（tempera） ⇨	複合技法（mixed technique） ⇨	油畫（oil painting）
水性顏料：蛋與顏料色粉調合	水性、油性混合顏料	油性顏料：用油研磨顏料並調和
【繪畫特性】 1.線條勾勒技法 2.柔合的表面光澤呈現 缺點： 1.保鮮期短：因蛋屬有機材質，不易保存 2.氧化易乾：蛋彩顏料接觸空氣後容易乾燥，以點、線為表現技法 3.無法混色、厚塗：固體的顏料色粉不溶於水。於是，像蛋此類水溶性的載色劑無法有效將顏料相互結合。	1.蛋彩顏料混合其他 2.油性坦培拉（oil tempera） 【目地】 1.延緩顏料氧化乾燥的速度 2.最初油畫雛形	逐漸發展出三種打底層型式： 1.水性吸收底（動物膠） 2.半吸收底（動物膠、少量乾性油） 3.非吸收底（乾性油）

表2. 西洋繪畫的技法演變

三、油畫木板與攜帶箱

針對風景、人物題材進行描寫，做為繪畫的基本習作訓練所需的戶外寫生用具。此種木板主要有兩側為斜邊、長形面板的明顯特徵。兩側斜邊是為可推置進攜帶箱的凹槽軌道（圖1-2）收納攜帶的設計用意。單個畫板攜帶箱一次可收納6片木板。這種形制的木板與木箱是否確切源於歐洲並無相關史料回溯，僅可確認20世紀在日本已有印製於繪畫材料的商品目錄並載明有舶來品進口提供選購（圖3）。

在本書東京藝術大學鈴鴨富士子〈陳澄波的油畫—透過修復作品看繪畫材料〉專文中史料知（參見本卷81頁），油畫木板（日文為スケッチ板，スケッチ為外來語sketch）與畫板攜帶箱（日文為スケッチ板携帶箱）為使用組件。攜帶箱有大、中、小三種尺寸，木板分日本國產與國外製、無打底的生木板與已打底木板，在日本當時是非常普遍且西洋畫學習必需的用具，只是日後在需求量的減少下而式微。另，昭和9年（1934年）北原義雄編撰《油繪科2 技法・材料論》一書中，在〈材料用具知識及初步實技〉章節中便介紹了油畫箱、畫布、木板攜帶箱等戶外寫生用具（圖4-5），本文研究整理歸納以下：

（一）畫板與畫布相同根據既有號數，普遍從2號起算到8號左右，偶爾也有更大畫板。

（二）就初學者所持有的油畫顏料箱大小容量，是剛好可放置2-3張4號的畫板。因此4號畫板對速寫而言是較為方便使用的。

（三）畫板的材料以最上等是櫻木，普通的則是桂木、日本厚朴、楊屬（ポプラ）等，經充分乾燥過後的硬木可減少木板變形問題。

（四）因偏好習慣有些人直接就使用畫板，但建議先上一層白色打底層。

陳澄波慣用的木板多為22.5×15cm與33×24cm左右的尺寸，攜帶箱共有兩種35×25.7×6.7cm、24.6×18.8×7.7cm。兩攜帶箱造型設計不盡相同，現今看來是十分的精緻小巧的簡潔設計造型（圖6-7）。

圖1. 側邊斜角

圖2. 油畫木板放置攜帶箱內狀況

圖3. 商品標籤紙

材料用具一式
A スケッチ箱內部
B 畫架床几スケッチ箱
C 材料用具一式

圖4. 油畫箱、畫架（圖片來源：國立臺灣圖書館）

と枠スパンカ（4）椽額（3）箱帶携板チツケス（2）スパンカ（1）
及フイナトツレバ（7）顏油解（6）器戔枠スパンカ（5）具金止枠
洗筆（8）フイナグンイテンイべ

圖5. 材料用具組：（1）畫布（2）油畫木板攜帶箱（3）畫框（4）木榫內框與金屬配件（5）畫布鉗（6）溶劑（7）調色刀與畫刀（8）筆洗（圖片來源：國立臺灣圖書館）

收納尺寸為33×24cm、厚度約0.5cm的木板，整體木箱的接合處皆使用金屬薄片強化結構。

1. 箱蓋上提把，提把環已劣化損失，現僅存金屬扣鈕。

2. 聯接箱體與箱蓋的扣環已遺失。

3. 箱體凹槽有等距間隔圓釘：推測防止木板因磨損。後有尺寸差，脫離凹槽造成木板互疊的保護設計。

圖6. 油畫木板攜帶箱35×25.7×6.7cm

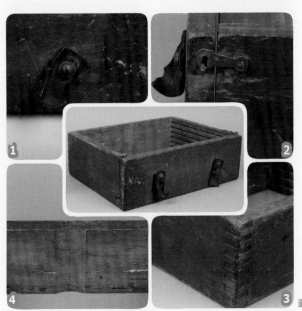

收納尺寸為22.5×15cm、厚度約0.3cm的木板。

1. 皮革提把：已老化斷裂。

2. 金屬扣環：設計於箱體兩側，另一側扣環已遺失。

3. 整體結構：採用「方榫指接」工法。

4. 底部有半圓溝槽：可將木板從底部推出的設計。

圖7. 油畫木板攜帶箱24.6×18.8×7.7cm

四、油畫木板的材料特性

　　繪畫基底材的安定攸關承載畫作的穩定性。繪畫使用的木板與畫布（主要為麻布），材質若屬天然有機物質有保存上考量，經仔細探究繪畫材的選擇與製作後，便知隱藏其後的無形材料技法學問。7件委託作品以不從文物作品上採樣，針對木材橫切面（圖8）的組織進行樣本比對[5]，分析結果如表3。另發現木材部位為選用徑切面（日文稱為柾目面radial section）特徵為平行紋路且靠近「心材」部位（圖9）。從物理性言，木材的徑切面比起弦切面（日文稱為板目面tangential section）特徵為V或U紋路有較好的強度且不易變形或開裂（圖9-10）。

圖8. 先以酒精清潔木材橫切面區域

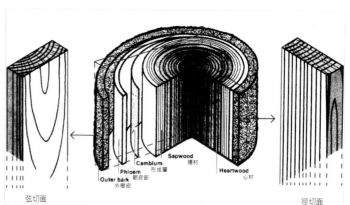

弦切面　　　　　　　　　　　　　　　　　　　　　　　徑切面

圖9. 木材之「弦切面、徑切面」示意說明圖[6]

油畫木板（五）		街道	
弦切面（數位影像處理）	弦切面紋理	徑切面紋理	徑切面（數位影像處理）

圖10. 弦切面、徑切面與油畫木板紋理對照圖

編號	作品名稱	尺寸（cm）	木材種類	切面
1	街道	23×33	臺灣紅檜（臺灣特產木材）	徑切面
2	林中廊沿	24×33	連香樹（桂樹）	弦切面
3	女子像	33×24	連香樹（桂樹）	徑切面
4	少年像	33×24	連香樹（桂樹）	徑切面
5	俯瞰西湖（一）	24×33	連香樹（桂樹）	徑切面
6	女孩	22.5×15	連香樹（桂樹）	徑切面
7	船屋	12.5×17.5	三合板	無

表3. 油畫木板材質鑑定結果

　　綜合上述研究，陳澄波對於木板油畫技法歸納如下：

（一）使用日本國產製且無打底畫板

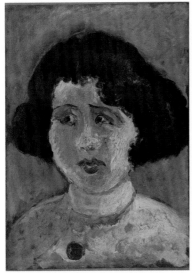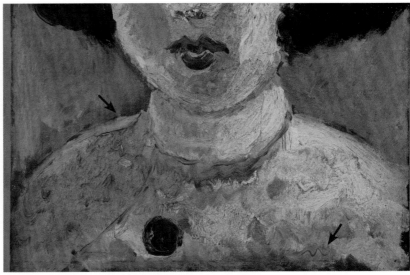

圖11.〔女子像〕顏料餘白處可清楚看見鉛筆打稿痕（見右圖箭頭所示）、直接使用無打底木板上色

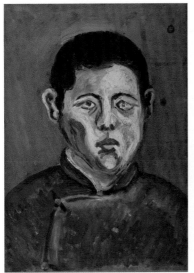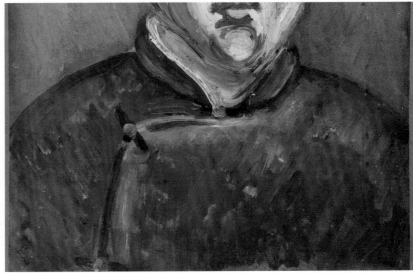

圖12.〔少年像〕顏料餘白處可清楚看出直接使用無打底木板上色

（二）素描線稿構圖

直接使用未打底木板，以鉛筆線描打稿並對形體特徵、比例、形體皆已大致底定後上色。

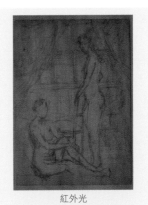

| 正光 | 紅外光 | 正光 | 紅外光 |

圖13. 陳澄波文化基金會提供僅有底稿的畫板參考

（三）重複繪製習慣

請詳閱第105頁說明。

五、7件木板油畫現況檢視調查與劣化狀況

　　是為作品修復前的整體狀況紀錄及調查。於是在修復前進行可見光（正光、側光）、非可見光（紅外光與紫外光）攝影作業、X光與非破壞性X螢光（X-Ray Fluorescence）光譜儀器的運用可輔助並全面性了解畫作材質及損傷的狀態。針對7件修復作品檢視調查後，有以下分析結果：

（一）全數為初次修復

　　經肉眼與可見光攝影初步判斷，後以紫外光輔助有無後加補彩或其他修復的處理痕跡。諸

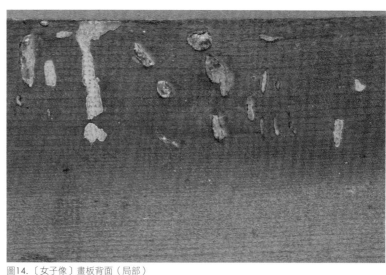

圖14.〔女子像〕畫板背面（局部）

多主要作品現狀是經長年時間累積下產生，畫面多有全面性髒污、顏料層剝落起翹、顏料層缺損、昆蟲排遺、異物附著、水害漬痕、基底材裂開及破損。背面也多有歷經時間下的灰塵污垢、刮痕、磨損、水損漬痕、顏料沾黏等現象（圖14），顏料沾黏多為濃厚的顏料附著，應該是因顏料未乾之際而相互堆疊導致沾黏，〔俯瞰西湖（一）〕顏料層就因沾黏有多處缺損而露出木板（圖15）。

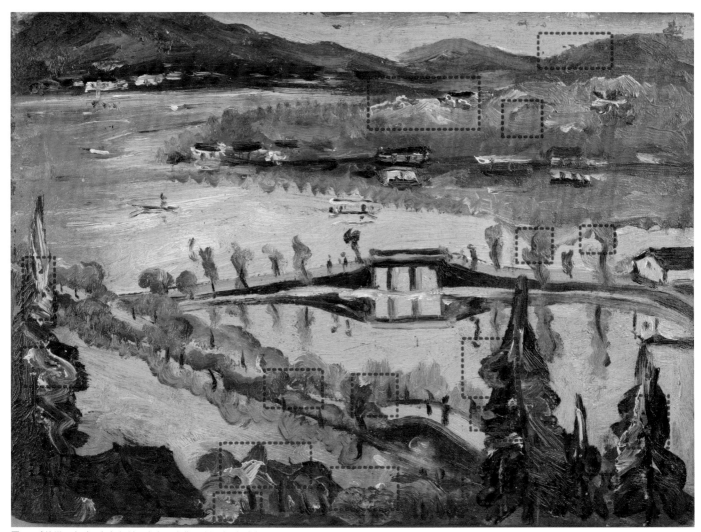

圖15.〔俯瞰西湖（一）〕顏料層多處因沾黏而缺損（紅框處）

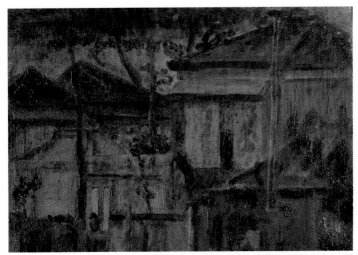

圖16.〔郊區風景〕局部：於正光（左圖）與紫外光（右圖）檢視凡尼斯嚴重黃化且塗刷不均

（二）有後加凡尼斯層跡象

多數作品未經專業性修復，經檢視後發現部分作品有被薄塗上凡尼斯，因此髒污灰塵被包覆於凡尼斯層下，也間接造成灰塵污垢長久時間深陷顏料層肌理內而不易移除。至於判斷有無凡尼斯層可憑專業修復經驗初步以肉眼檢視（凡尼斯黃化的光澤與塗佈的均勻度），其次以紫外光源輔助提供確認判斷（圖16），但因此批部分畫板的凡尼斯保護層為薄塗手法不易以上述兩種方式檢驗，最後選擇於角落邊緣做表面顏料層的溶劑測試（圖17）。測試後，7件作品中有5件有凡尼斯，〔少年像〕、〔船屋〕則無。

圖17.〔俯瞰西湖（一）〕溶劑經測試後小心移除表面薄層的凡尼斯

（三）〔街道〕有重覆繪製過程

主要是運用顏料層對於紅外線的吸吸反射特性。若顏料層過於厚重，有時則需再以高穿透性的X光進一步確認。藉由醫療用具高穿透力X光判斷顏料缺損處及底層圖稿，此作品底層構圖仍是以風景為主題（圖18）。

正光　　　　　　　　　　紅外線光　　　　　　　　　　X光

圖18.〔街道〕於三種光學檢測下之照片

以下就〔街道〕、〔女孩〕、〔俯瞰西湖（一）〕三件作品為代表案例解說修復前狀況：

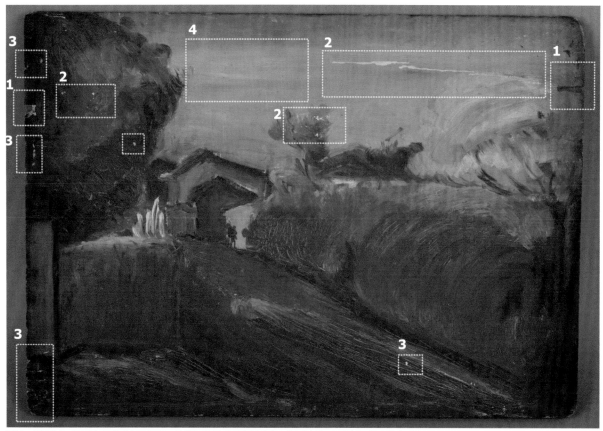

圖19.〔街道〕（正面）修復前狀況說明：整體性狀況-凡尼斯層老化、全面性髒污、木板四邊磨損與刮傷。
1木板裂開缺損；2顏料層起翹；3顏料層剝落露出底板；4昆蟲排泄

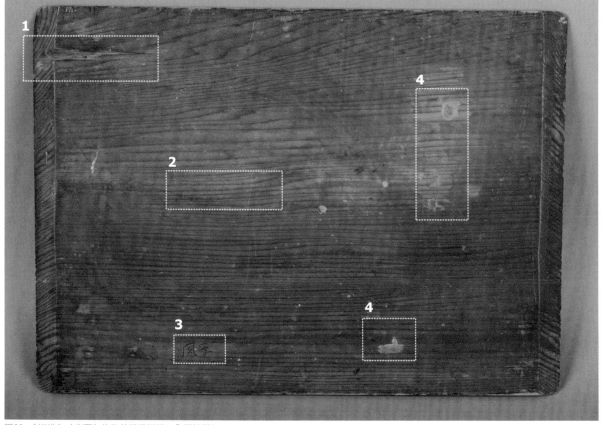

圖20.〔街道〕（背面）修復前狀況說明：全面性髒污。
1木板裂開缺損；2鉛筆字跡；3藍色原子筆字跡；4不明附著物（殘紙）

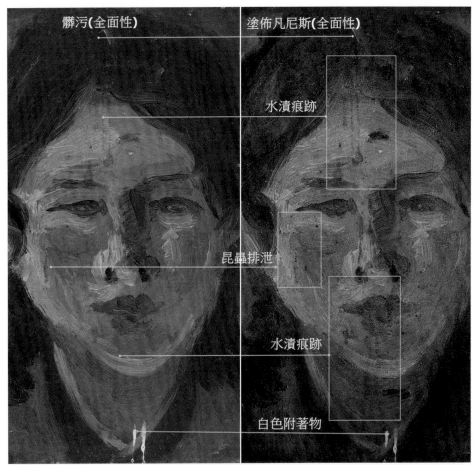

髒污(全面性)　　　　塗佈凡尼斯(全面性)

水漬痕跡

昆蟲排泄

水漬痕跡

白色附著物

圖21.〔女孩〕修復前狀況
說明：正光與紫外光對照分
析。

髒污(全面性)

圖22.〔俯瞰西湖（一）〕
修復前狀況說明：全面性凡
尼斯黃化、髒污包覆於凡尼
斯層下、不明漬痕、多處顏
料層因沾黏而缺損。

根據上述通盤性的檢測與調查後，擬定以下全面性的修復方針與作業內容：

1.修復前攝影與檢視登錄調查

作品修復前的整體狀況紀錄及調查。狀況紀錄是指修復前的現狀使用攝影儀器進行可見光（正光、側光）、紅外線、紫外線、X光檢視作業。

2.顏料層加固

顏料空鼓、起翹剝落等顏料脆弱部分，須使用動物膠（兔膠）滲透顏料層間，再以可控溫小頭熨斗加溫加壓方式讓顏料層間相互結合緊密。

3.表面清潔

畫作因長年累積灰塵污垢及昆蟲排遺等附著物，先使用手術刀小心移除，再謹慎控制水分慢慢清潔畫面，木板的背面則初步以修復用海綿乾式清潔後，再以淨水清潔。

4.畫面清潔（凡尼斯移除、附著物）

表面髒污與凡尼斯的移除作業。透過棉棒沾取稀釋阿摩尼亞水溶液輕移擦拭洗淨表面髒污後，經溶劑測試後選擇使用以乙醇（Ethanol）與礦精（Mineral Spirit）的混合溶劑移舊有凡尼斯保護層。

5.填充整形

於顏料缺損處填入動物膠調和補土（Gesso）的混合材料，再按畫面肌里筆觸進行破損處的表面形體塑造。

6.全色補彩

於白色補土處使用可逆性修復專用溶劑型壓克力顏料。以視覺美感立場下使全色處達成接近周圍色域為準則，於紫外光下檢視可分辨出後加補彩區域。

7.凡尼斯保護漆

畫面修復完成後，塗佈凡尼斯保護層，藉由保護層整合畫面全體光澤達均勻一致，亦隔絕日後空氣中灰塵污垢等外來傷害。

8.裝框保存

修復後作品以裝框保存。〔街道〕、〔林中廊沿〕為此次修復完成後選配新框；〔女子像〕、〔少年像〕、〔俯瞰西湖（一）〕、〔女孩〕、〔船屋〕已有原本外框，因框體結構等狀況良好經清潔整理後將作品裝回。

六、結論

為數眾多的文物與作品不僅可見東京美術學校的美學教育的脈絡，更是陳澄波個人藝術特質的完整呈現。經家屬世代精心保護與開放性觀念，將這些文物與作品分類整理、建檔、修復及典藏保存，提供藝術史學者研究、文化藝術的推廣等。陳澄波的文物與作品已超越展示單一目的性而是轉換為更實質意義面相，成為世代共有共享的教育資產。

【註釋】

1. 王瓊霞國立臺灣師範大學文物保存維護研究發展中心專案修復師。

2. 歌田真介《油画を読む 解剖された明治の名品たち》，p.74、122。

3. 在19世紀，經過法國大革命的洗禮及工業革命帶來的經濟繁盛，法國成為西方思想、文學及藝術的新薈萃之地，巴黎在此環境下吸引世界各地藝文人士聚集，此時倡導走出戶外與強調光與色彩的印象畫派衍生而出。

4. 明治前期以高橋由一、淺井忠為舊派（脂派）代表性人物，承襲著傳統的古典技法，於畫室內進行創作以褐色為陰影背景色；明治後期黑田青輝、藤島武二稱呼新派（紫派）。（歌田真介《油絵を解剖する—修復から見た日本洋画史》p.85，2002，日本放送出版協　）。

5. 由國立臺南藝術大學古物維護研究所林仁政兼任助理教授協助比對分析。

6. 資料引用後經編輯。

【參考文獻】

中文

1. 林曼麗〈臺灣「新美術」的萌芽及其發展」〉《東亞油畫的誕生與開展》2000年，臺北：臺北市立美術館。

2. 王勝《西方傳統油畫三大技法》2000年，臺北：國立歷史博物館。

3. 羅淑慧《日治時期的臺灣留日美術家-以東京美術學校為研究中心》2009年，桃園：國立中央大學歷史研究所碩士論文。

4. 台北市立美術館《臺灣東洋畫探源》2000年，臺北：臺北市立美術館。

5. 林仁政《木材鑑定報告書》。

外文

1. 歌田真介《油絵を解剖する—修復から見た日本洋画史》2002年，日本放送出版協会。

2. 歌田真介《油画を読む—解剖された明治の名品たち》2002年，東京藝術大學大學美術館協力会。

3. 北原義雄編《油繪科2 技法・材料論》1934年，東京：アトリヱ社。

4. Tiarna Doherty and Anne T. Woollett, *Looking at paintings: a guide to technical terms*, 2009, published by the J. Paul Getty Museum.

5. *Painting Materials: A Short Encyclopaedia*, published 1966 by Dover Publications Inc.

6. *The Restoration of Paintings*.

網頁資料

1. 東京藝術大學大學美術館http://www.geidai.ac.jp/museum/collection/collection_ja.htm

2. 行政院農委會林務局 臺灣山林悠遊網http://recreation.forest.gov.tw/epaper/2011/ePaper_10032-1.html

Analysis and Treatment of Chen Cheng-po's Oil Paintings on Wood Panel

Wang Chiung-hsia[1]

Summary

From 2012 to 2013, the Judicial Person Cheng Cheng-po Cultural Foundation commissioned the National Taiwan Normal University Research Center for Conservation of Cultural Relics (RCCCR) to treat Chen Cheng-po's (1895-1947) works on paper and oil paintings. The conservation treatment of oil paintings was supervised by Professor Kijima Takayasu and Suzukamo Fujiko. The oil paintings were painted on different supports including 29 works on canvas and 7 on wood panels, for a total of 36. The cross-section of each wooden panel was examined with non-destructive methods and compared with known samples. It was concluded that five panels were made from the katsura tree (mostly found in China and Japan); one was Taiwan red cypress while the other was composite board (commonly called plywood). With the exception of the composite board, a modern synthetic wood product, the wood panels were unusually shaped – rectangular with two bevels on the verso shorter edges. Wood art panels and carrying cases were made in sets, and the sizes of the panels were standardized to fit into their corresponding carrying cases. A single case was big enough to fit six panels. Their design was minimalist and classic in style, vastly different from what we find today. During the study, it was found that this kind of panel was used by the Japanese painter Shiotsuki Toho (1886-1954), who came to teach in Taiwan in 1921 and painted *Confucian Temple*, depicting the red bricks and green trees of northern Taiwan. Another graduate of the Tokyo School of Fine Arts, Chen Chih-chi, painted *Camellia* (1925-1930) and *Lotus* (1927) on similar panels. A preliminary assumption was that the panels were purchased while Chen Cheng-po was studying at the Tokyo School of Fine Arts from 1924 to 1929. In 2001, during a study to analyze Meiji art collections (from Takahashi Yuichi to Kuroda Seiki) at the Tokyo University of the Arts's University Art Museum, it was found in the description notes of 58 oil paintings that Nakamura Katujiro's (1866-1922) *Public Bath* and Yamamoto Morinosuke's (1877-1928) *Lighthouse at Ryukyu* (1902) were painted on the same type of panel. This finding provided evidence for an even earlier use of wood panels for painting.

In a related study conducted by Suzukamo Fujiko of the Tokyo University of the Arts, "The Oil Paintings of Chen Cheng-po: An Examination of Painting Materials through Restored Artworks" (also included in this compilation), the author references Kitahara Yoshio's book, *Oil Painting Volume 2 - Skills and Materials* (1934). In the chapter "Knowledge and Preliminary Skills in Materials and Tools," he introduced the materials and skills related to contemporary Japanese oil painting. The Japanese word for oil painting panel "スケッチ板, スケッチ" is borrowed from the English word "sketch." A wood panel carrying case was called "スケッチ板携帯箱." This panel and carrying case set was a painting tool to be used for outdoor sketching of scenery and people as a basic training exercise. The carrying

cases came in three sizes: large, medium and small. Panels were made both in Japan and overseas, and came either plain or pre-primed. At that time, wood panels were very common and essential tools for learning Western art. However, as demand dropped, they gradually became obsolete. The best material for panels was top quality cherrywood. More common materials were katsura, Japanese bigleaf magnolia and poplar. Thorough drying hardened the wood, making it less pervious to warping. These facts matched the results of wood identification from these treated oil paintings on panel. Chen Cheng-po's wood panels were made from katsura and were not primed. They came in two sizes: 22.5x15cm and 33x24cm. This explains why there was a carrying box that could accommodate panels of these two sizes. The paintings were painted directly onto the unprimed boards, first with a pencil outline, followed by the addition of color. The panels were quartersawn and close to the heartwood. Quartersawn wood is generally stronger and more humidity resistant, hence reducing the probability of warping and splitting due to humidity.

There is no historical evidence to prove whether the wood panels and carrying cases originated in Europe and were then introduced to Japan. It can only be confirmed that in the 20th century, there were product catalogs for Japanese painting materials advertising imported products. Over time, the popularity of wood panels declined as fewer people used them. Its decline might be related to the growing prevalence of canvas, which was light and convenient, and therefore much preferred. The uniqueness of a painting on wood panel can be seen in Chen Cheng-po's last work *Accumulated Snow on Jade Mountain* (1947).

Examination of paintings on wood panel, their deterioration, and conservation treatment

The before treatment condition of the seven oil paintings was examined and documented, and included photo documentation with visible illumination (normal, raking) and non-visible illumination (infrared and UV radiation). The use of x-ray and non-destructive x-ray fluorescence spectrometers helped provide a comprehensive understanding of the painting materials and their state of damage. After inspection and analysis, the following findings were reported:

1. None of the paintings were previously treated: The paintings were first examined by visual observation under normal illumination for an initial assessment. With the assistance of ultraviolet radiation, the paintings were checked for inpainting and other traces of treatment. Major physical problems included long-term overall surface dirt accumulation, flaking or lifting paint, paint layer

damage, insect accretion, tidelines, and warping of the primary support.

2. Varnish application: Most of the paintings had not been professionally treated. A thin layer of varnish was applied to most paintings, trapping surface dirt and dust underneath this varnish layer.

3. *Street* was repainted: High penetration x-rays were used to examine damaged areas and the underdrawing, revealing a different landscape composition underneath.

After a thorough examination, a complete treatment proposal was prepared as follows:

1. Before treatment examination and documentation
2. Solvent tests (including varnish and paint solubility tests)
3. Paint consolidation
4. Cleaning of recto and verso
5. Varnish removal
6. Surface cleaning, removal of surface accretions
7. Filling
8. Inpainting
9. Applying protective varnish
10. After treatment photographs
11. Framing and storage

1. Wang Chiung-hsia is a conservator at the National Taiwan Normal University Research Center for Conservation of Cultural Relics.

文保中心油畫修復材料介紹與案例

葉濱翰[1]

前言

　　師大文保中心自2011年起與財團法人陳澄波文化基金會建立產學合作關係，修復陳澄波大量的繪畫作品，油畫部分由日本東京藝術大學油畫保存修復研究所歌田教授、木島教授、鈴鴨博士與文保中心成員共同負責修復。木島教授與鈴鴨博士在臺期間，有幸擔任他們的助手，學習油畫修復的處理方式。他們帶來日本油畫修復的技法與經驗，依每幅油畫發生的劣化狀況，診斷問題並提出修復方針與步驟，讓受損的油畫趨以穩定。本文藉由參與修復實務，彙整修復案期間常用材料資訊與各界交流。

一、修復材料介紹

　　依序將相關材料概分為基底材、媒材、畫用油、凡尼斯、加固材料、修復用框等數類分項介紹。

（一）基底材

畫布（Canvas）

　　畫布為油畫中最常見的基底材，文保中心修復的36件陳澄波油畫作品中，繪製在油畫布上的有28件，木板7件，紙板1件。早期油畫布多以麻質為主，如亞麻、大麻、黃麻等。麻布強韌、彈性低不易變形，加上品質好的麻布可存放很久，故成為油畫非常好的支持體。大約18世紀以後發展出棉料的畫布種類，提供畫家另一選擇，棉質畫布有較經濟的價格及平整均勻的紋路，並在壓克力顏料問世後更提升了棉料畫布的普及和使用率（圖1）。

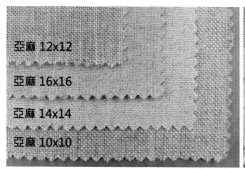

圖1. 市售各類畫布樣品[2]

· 亞麻畫布（Linen）

　　取自亞麻（Flax，Linum usitatissimum）莖部韌皮纖維所紡製而成，外觀呈褐色，纖維粗細均勻，有清晰、規律的竹狀橫節，柔細卻堅韌耐磨不易斷裂，遇水也不易腐爛，低燃性且耐高溫，強度是棉纖維的1.5倍、絹絲的1.6倍。其纖維可純紡也可混紡，18世紀至19世紀初斜紋織成的亞麻畫布較為流行，而現在經線與緯線長度相等的平織紋布是被認為質地較佳且穩定性高的，亞麻是油畫麻質基底材中，保存性與操作上屬較好的材料，也是修復常選用的材料之一。陳澄波的畫作如〔郊區風景〕、〔戰災（商務印書館正面）〕使用的基底材即為亞麻。

· 大麻畫布（Hamp canvas）

　　大麻（Cannabis sativa）的韌皮纖維可用於紡織、製造繩索麻線，也可用於造紙。大麻的纖維韌性比亞麻強，但相較之下較為粗糙，纖維粗細稍不均勻，編織出的布料紋理起伏大。

· 棉質畫布（Cotton canvas、Cotton duck）

　　相較於亞麻畫布，棉布具有低廉的價格，有各種不同的等級與重量，棉布沒有麻質畫布醒目織紋，紡織出的畫布紋理粗細均勻，纖維韌性較麻纖維弱，使用重量較高較厚的棉質畫布可彌補其強度不足，增加耐久性。棉布的彈性較大，對水份較敏感，易導致變形、縮水。

（二）顏料

　　在修復油畫時，為了讓補彩前後具有可辨識性，通常會使用油畫顏料以外的媒材來執行補彩作業。在畫作缺損處補土後，先採用水性顏料將補土處繪上底色，塗刷上隔離層後，再使用專為油畫補彩所調製的顏料，此顏料可溶於松節油、石油精、礦物油精中，須在使用前先針對不同的基底材、媒材，作溶劑測試，確認安全無虞後選出適合的溶劑來使用，其優點為可輕易的移除，在紫外線下的辨識性佳（圖2）。

圖2. 補彩專用壓克力顏料

（三）打底材料

　　石膏（gypsum），一般而言泛指不同型態的硫酸鈣（$CaSO_4$），包括含水與無水的成分。天然採集到的石膏稱為生石膏（Gypsum，二水石膏、軟石膏，$CaSO_4·2H_2O$），經過約200℃加熱，水分蒸發後成為熟石膏（Plaster of Paris，半水石膏、$CaSO_4·1/2H_2O$）。義大利古典技法中，繪畫打底用的石膏可分為兩層，第一層為粗口石膏（Gesso Grosso，雪花石膏），第二層為細口石膏（Gesso sotile），使用石膏與動物膠調合成的打底劑孔隙率較小較密實，相較於白堊土調製成的打底劑吸油性較弱，較適合厚塗[3]（圖3-1）。

　　白堊土（Chalk）是一種碳酸鈣（$CaCO_3$）的沉積物，主要是由單細胞浮游生物圓石藻（Gephyrocapsa oceanica）的遺骸所累積構成。根據顏色和膠結程度，可分為白色白堊（$CaCO_3$含量達到99%）、泥灰白堊、似白堊石灰岩、海綠石白堊四種。把白堊土碾磨成粉末，經過漂洗與過濾後，稱為白堊粉（Whiting chalk），而人造的碳酸鈣則稱為沉澱白堊粉（Percipitated chalk）。適合用於打底的白堊土是開採後經人工去除黏土質再加以精製的，以白堊土為打底層的吸油性較弱。

圖3-1. 石膏

圖3-2. 調和兔膠過程

修復畫作媒材缺損處多使用石膏為打底與補土材料。調製步驟如下：於容器中依需求調製合適的兔膠溶液，再均勻將石膏粉慢慢加入（圖3-2），未完全溶解均勻前不可搖晃與攪拌。

（四）畫用油

繪畫使用的油品大致可分為乾性油及揮發性油兩類，作為色粉的黏著劑與展色劑，或是用來稀釋顏料，可增加流動性並加速乾燥，調配凡尼斯的溶媒也是使用畫用油，採用的溶媒、稀釋劑也多屬這兩類，以下介紹幾種畫用油（圖4）。

圖4. 市售各類畫用油

1.乾性油

定義為碘價在130以上，含有少量的油酸、固體脂肪酸、多量的亞麻仁油酸及次亞麻仁油酸等高級不飽和脂肪酸之甘油酯。乾性油之所以會逐漸乾燥是因為其在雙鍵結合之處如果加上一個氧原子，便會轉換成為氧化物，經過氧化結合作用之後，逐漸形成為固化物，稱為氧化亞麻仁油（Linoxyn）。包括亞麻仁油（Linseed Oil）、罌粟油（Poppy Oil）、胡桃油（Nut Oil）都屬於乾性油。於特殊情況下有時調和顏料會使用到亞麻仁油，但多使用揮發性油類為主。

亞麻仁油是將亞麻種子壓榨後精製純化的油，呈淺黃色，乾燥速度比罌粟油快，置於暗處易黃化，其乾燥後的油膜強韌。亞麻仁油乾燥速度相較於揮發性油慢，會有畫家因畫作特殊需求作為顏料的稀釋劑。

2.揮發性油

揮發性油的油質輕，具有揮發性，乾燥速度比乾性油快且富流動性，可用來稀釋乾性油，使顏料的稠度降低，更容易拖動，但因不具有黏著力，較少單獨用來調合顏料。質純的揮發性油外觀呈現無色透明，揮發之後不會在畫面上殘留油漬，但是過量使用揮發性油會降低畫面顏料的固著力。揮發性油除了可以用來稀釋乾性油外，還可以在製作凡尼斯時，作為溶解樹脂的溶媒，在清洗蠟托裱時也常使用揮發性油。

松節油（Turpentine）是透過蒸餾松科植物的樹脂（松香）並純化後得到的透明揮發性液體。具有優

良的溶解能力，可溶解天然樹脂。松節油易吸收空氣中的氧而逐漸成為黃色的樹脂化黏稠物，含水分的松節油於調製凡尼斯時也容易導致變質，於保存上需要遮光並且密封確實。依照原料和製造的方式不同，大致可分為純樹膠松節油（脂松節油，Pure gum spirits of turpentine）、木松節油（Wood turpentine）。繪畫使用的是經過二次蒸餾後更為精純的畫用松節油，質量輕，透明無色，乾燥後在

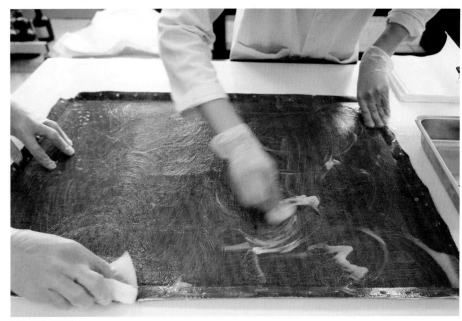

圖5. 清除蠟托裱

畫面上不留下漬痕，因其揮發速度合宜，富有流動性，可作為油畫顏料的稀釋劑及溶解樹脂製作凡尼斯。

礦物油精（Mineral spirits），又稱礦油精、白酒精（White spirits），為石油餾出物，通常做為油漆的稀釋劑或衣物乾洗劑，也可做為松節油的替代品，用於調和乾性油或作為輔助劑。經安全測試後有時可用於清除舊凡尼斯層。其揮發速度較松節油慢，不具黏性、無色、低氣味、低毒性、不易變質，現今有無味的產品出現，精製後的礦物油精不含硫，可減少與顏料發生反應的可能性，避免顏料變色。

石油精（Petrol、Essence de petrole）同為石油分餾精製後的揮發性溶劑，不含有樹脂類物質，對於油脂與樹脂的溶解力較松節油弱，可用於清洗畫筆或去除凡尼斯層，亦可作為乾性油的稀釋劑，調和後可增加顏料的滲透力，但調和過多可能會使顏料減少光澤與彩度，其本身能完全的揮發，不會留下筆觸或漬痕。

陳澄波油畫作品中有幾件曾使用蠟托裱的方式處裡，經顏料安全性測試後，以石油精（Petrol）及礦物油精多次清洗，儘可能降低蠟於作品上的殘留（圖5）。更詳細修復研究內容請參閱本卷木島隆康教授專文（第54-65頁）。

（五）凡尼斯

油畫使用的凡尼斯（Varnish）依其功用可分為：1.繪畫用凡尼斯（Mixing Varnish），與顏料或畫用油調和使用，可增加顏料的黏著力與彩度；2.補筆凡尼斯（Retouch Varnish），當油畫顏料多層堆疊時，於上層與下層顏料間塗刷補筆用凡尼斯，可減少下層顏料的吸油性並增加顏料的光澤度；3.保護用凡尼斯（Picture Varnish），於油畫繪製完成後，塗刷保護凡尼斯可隔絕空氣，減少顏料變色的可能，也可用於調整畫面的光澤度[3]。凡尼斯的製作方式早期傳統上是以加熱法將樹脂溶解，現在多以溶劑來溶解樹脂調配而成。利用溶劑溶解的凡尼斯顏色較淺、清澈且不易氧化，流動性也較好[4]，修復的過程中使用這類的凡尼斯較不會影響畫作的原始樣貌，例如以松節油或石油精溶解達瑪樹脂（Dammar）、柯巴脂（Copal）、乳香脂（Mastic）等。油畫修復的程序中，塗布凡尼斯層的主要目的是為了保護顏料層，避免顏料直接的接觸到空氣與濕氣導致氧化變色，讓畫作顏料所呈現的層次與色澤更能表現出來。本次修復案中有許多油畫修復前顏料呈色黯淡，經過清除氧化的凡尼斯層後，原始鮮麗的色彩便顯露出來（圖6）。另一目的是用來作為全色前的隔離層，避免後加的補彩直接覆塗在舊有的媒材上，往後如需移除補彩或凡尼斯，只要使用適當的溶劑即可安全的清除。本案陳澄波油畫修復則使用達瑪脂調配石油精所製成的凡尼斯，作為補彩的隔離層與最

後畫面的保護層。

達瑪樹脂（Dammar）生產於東南亞，為龍腦香料植物（Dipterocarpaceae）的分泌物，為軟質樹脂，外觀呈現透明淡黃色至琥珀色的粒狀物（圖7-1），顏色愈淺品質愈佳，軟化點約在65-70℃左右，溶點介於100-150℃之間，可完全溶解於松節油、石油精之中（圖7-2）。製作達瑪凡尼斯的方式如下：

1.依照作品所需調配達瑪樹脂與石油精，不同的濃度比例會影響噴塗後的光澤、凡尼斯層厚度、呈色效果等。

2.利用雙層紗布包住達瑪樹脂並將開口綁緊，放置或懸掛於透明玻璃容器中。

3.將適量的石油精倒入，待樹脂完全溶解後取走紗布，如果有雜質或懸浮物，可用紗布過濾。

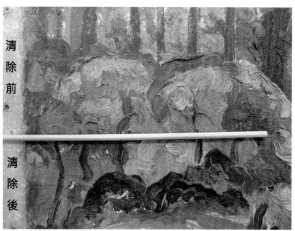

（六）黏著劑

修復油畫作品時，針對不同的用途可選擇適用的黏著劑，需符合安全、可逆性且易清除的原則。在顏料層、打底層較脆弱或容易剝落、產生空鼓時可將黏著劑填入，將狀況不穩定的顏料層加固，當畫布上出現裂縫、缺損、破洞時，視作品損傷現況有兔膠、魚膠、BEVA等諸多加固材料使用。畫面執行暫時性的表面加固時，可運用動物膠或稀釋的修復用漿糊等，搭配典具帖、縲縈紙、楮紙等各式的加固材料來保護顏料層。

BEVA®於1970年由美國紐約的Gustav A. Berger所研發，分為溶劑型、薄膜型、不織布載體型以及水溶性型等不同型號，廣泛應用於油畫、物件表面熱封黏合、製作玻璃纖維層板等黏著使用。BEVA®不含水分，不會溶解於非極性的石油溶劑（如甲苯、二甲苯、正己烷等）之中，對於大多數的顏料來說是無害的。BEVA藉由熨斗加熱可以很容易的移除，當溫度到達65-70℃時，BEVA會活化產生黏性並具有熱塑性，，。

薄膜型的BEVA（圖8-1）於現今繪畫修復廣為使用，利用透明聚酯片（Mylar）與矽膜防黏紙（silicone coated paper）上下夾住BEVA薄膜，優點是可以依據需求精確地切割或利用拼貼的方式組合成任何形狀，再放置於所需黏合的位置。在不損害文物的前提之下，BEVA薄膜可使用己烷或丙酮等溶劑使其吸收膨脹後移除。

畫布四周摺邊處如有劣化狀況，可藉由加上條狀的襯裡布（strip or edge lining）增加強度，將布條與黏著劑黏貼在畫布的折邊處，加強畫布的結構力，也可加固破損處。加拿大國家美術館修復實驗室於1976年測試了許多用於黏貼襯裡的黏著劑，如PVA、PVAc、Parafilm M、臘及BEVA等，BEVA具有移除性與可塑性佳等優點，成為常使用的黏著劑。木島教授針對不同畫布的材質特性，選擇適合的襯裡材料，依需要的

圖6.〔亭側眺望〕凡尼斯去除前後比較。

圖7-1. 達瑪樹脂

圖7-2. 浸泡於石油精中的達瑪樹脂

圖8-1. 薄膜型BEVA

圖8-2. 以日本和紙與BEVA加固

圖9. 片狀的魚膠

圖10. 兔膠顆粒

尺寸剪裁後，將條狀的襯裡黏貼處修剪整齊，利用手工削邊處理，使黏貼面呈現整齊的毛絨斜口，再以BEVA固定於畫布的摺邊處。木島教授也曾使用日本和紙與BEVA加固〔綠瓶花卉〕的破損處（圖8-2）。

魚膠取自魚的皮膚、骨骼（Isinglass）或魚鰾的膜（鱘魚膠，Sturgeon glue），魚膠的用途廣泛且年代久遠，西元8世紀歐洲的盧卡大教堂（Cathedral of Lucca）即有手稿記錄了魚膠被用於繪畫上。另中世紀的歐洲也使用在羊皮書的裝飾技法中，如燙金、施膠等，也用於修補畫作、書頁的缺損。中國唐代從魚的生皮提煉魚膠，與顏料調和使用。魚膠表面張力較弱，單獨塗佈乾燥後會形成質脆的薄膜，再次遇水可溶解並具黏性。在特定的修復條件下可將其溶於乙醇中，以減少水分的使用（圖9）。

兔膠作為黏著劑已經有數百年的歷史，常與石膏、白色顏料調和成為西方貼金工藝的打底層。兔膠取自兔子的皮膚，利用水與加熱提煉，將膠質萃取出來後乾燥成粒狀、立方狀或片狀物質，具有高內聚性，外觀呈黃至褐色，有獨特的氣味（圖10）。兔膠為水溶性且具有彈性，與白土或石膏混合乾燥後，相較其他動物膠有更好的韌性，在貼金工藝的施作過程與拋光時，對產生的下壓力有較好的受壓能力，比較不會有凹陷嚴重或產生裂痕的問題。以石膏作為打底材料時，石膏必須要能承載木材、畫布等材質屬性，在溫濕度變異時有脹縮空間，減少與載體分離剝落和龜裂的可能性，適當的兔膠與石膏調配比例可達到此目的。兔膠是一種有機物質，需適當的冷藏保存與加熱使用，放置過久或加熱溫度過高，在與石膏、白土調配製作打底劑時容易產生氣泡，乾燥後表面會產生較多的細孔，會削弱兔膠的黏合力，導致粉化脆裂。

（七）內框

以畫布為基底材的繪畫作品，除特殊的情況外，修復時仍會使用內框作為畫布的支撐體。將畫布釘在木框上繃平，可減少因溫溼度變化而導致的變形與皺褶，變形的畫布輕者導致畫面凹凸不平，較嚴重可能導致打底層或顏料產生裂痕甚而剝離。油畫修復過程中，會利用木製的內框將畫作繃平，包括常見的木頭內框、含木楔的內框以及有調整功能的擴撐式內框，各有其用途。

圖11-1. 可調式擴撐框

圖11-2. 依畫作尺寸組裝

可調式擴撐框是在修復作業中暫時性矯正畫作變形所用的臨時用內框。使用輕質鋁管與松木作為支架，共有五種不同長度的支架供各種尺寸畫作調配組合，四個角內部有螺牙，利用專用的調整工具可將四個角朝八個方向伸展最大約5公分。因應部分較大的畫作的需求，避免支架組合過長而導致支架內凹變形，可於擴撐框的中心處加裝伸縮的輔助支架增強結構力，輔助支撐架最長可以伸展至250公分（圖11-1、11-2）。有些油畫作品因材質、保存環境、時間等因素導致皺縮、變形，遇到這些狀況，可利用調整式擴撐框緩慢的向外撐大，將收縮變形的畫布撐開拉平，恢復原本畫布的平整度，此擴撐工具是在修復作業中以安全且緩慢方式逐漸矯正畫面的凹凸變形。使用時要不斷的觀察注意畫布與顏料層、打底層狀態，循序而緩慢的微調，再置放一段時間使畫作趨於穩定。

木框（Stretcher）或稱內框，具有支撐及繃平畫布的功能，讓畫家於作畫時畫布仍可保持平整並具有適當的緊實度，搬運畫作較安全方便，展覽陳列時也能有理想的視覺感受。繪在畫布上的油畫作品隨著時間的推移和環境的影響，畫布可能會逐漸變得鬆弛，因此含有楔孔的接榫式內框（Keyed stretcher）（圖12-1、12-2）便出現於18世紀中的法國，當時為一種新的發明，到了18世紀末才較為普及，這種木框經由小鎚輕輕地敲擊四個角落的三角形木楔（Keys，wedges）（圖12-3），使之插緊於木框上的楔孔，並輕微的撐開畫框，讓畫布再度被拉緊。畫布繃在內框上後，為避免與內框表面觸碰到，因此內框的表面會被製成斜切面，有些內框會在四周做凸起的邊緣。經過不斷的修改與創新，時至今日，具有可微調功能的木框形式多樣，材質也有許多種類可選擇。

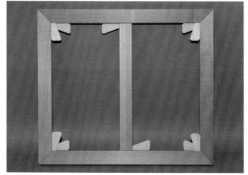

圖12-1. 接榫式內框的外觀

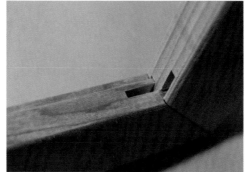

圖12-2. 四角的楔孔

圖12-3. 木楔

（八）典具帖紙

典具帖（Tengujo）於修復上用途廣泛，陳澄波修復案的油畫類作品多用於表面顏料層的暫時性加固（圖13-1、13-2）。依照畫作表面肌理來選擇適合的厚度，如遇到肌理凹凸明顯者，使用5~8g/m²的典具帖來施

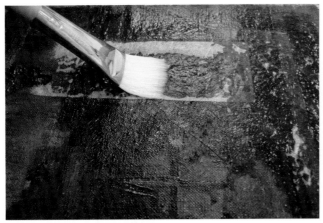

圖13-1.〔郊區風景〕表面暫時性加固　　　　　　　　　　圖13-2. 四邊脆弱處以典具帖加固

行加固，其柔軟度較佳，能服貼在凹凸面上，而較厚的典具帖因紙質相對堅韌，多用於筆觸肌理較平緩的畫作上。

二、參考案例：〔帆船〕

　　本修復案中油畫共有36件，當中僅一件是繪製於紙板上，根據木島教授的檢視紀錄，本件作品為繪製於紙板上的油畫，作品的正反面沒有標註年代，也沒有簽名落款，畫板上無任何商號、標記，僅根據正面的肌理紋路與四周的斷面來判斷此畫作的基底材應為畫布板，詳細的修復程序請參閱修復報告（頁174-179），以下僅就油畫用的紙板歷史作簡述：

　　油畫紙板因具有質輕、價格便宜、攜帶方便等特點，為藝術家所採用。略可分為學院油畫板（Academy boards）及畫布板（Canvas boards），這類的繪畫材料多是讓畫家們速寫或外出寫生時使用，也供業餘愛好者及學生使用[5]。學院油畫板出現於19世紀初的英國，很快地就流傳到歐洲其他國家[6]，多為學校繪畫課程或藝術學院的學生所使用，使用滑面的厚卡紙板製成，表面有打底或是特殊的壓印痕跡，也有處理成粗糙的表面利於油彩塗覆，學院油畫板的尺寸是經過特別設計的，可放進速寫箱內，外光派的畫家外出寫生時也常使用這種攜帶方便的紙板[7]。學院油畫板與繃在木框上的畫布或是木板相比，除了價格經濟外，在學習油畫時具有更多的揮發空間。之後衍生出了書皮用的厚紙板（麻絲板，Mill board），這是一種高磅、質地強韌的紙板，原料多為繩子、棉紗或其他便宜的纖維，也可與木漿板（Pulp board）結合，並在表面覆上一層粗厚的塗料，通常為灰白色或是白色的含鉛顏料，讓較薄的紙板更為堅硬。木漿板使用較低廉的纖維如麥稈、木漿纖維、甜菜根纖維、鋸木廠的廢料等，再將所有的纖維

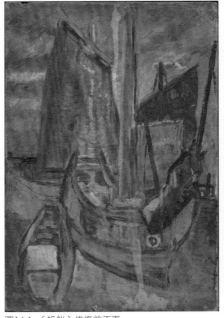

圖14-1.〔帆船〕修復前正面　　　　　　　　　　圖14-2.〔帆船〕修復前背面

輾軋攪拌在一起壓製而成[8]。學院油畫板、書皮用的厚紙板及木漿板皆非無酸材料，屬於較不穩定的材質。在紙版的尺寸上，當時如需較大的特定尺寸須向店家下單才能購得，一般的尺寸為27"×30"、22"×27"、24"×19"、9.5"×12"，陳澄波油畫作品〔帆船〕與9.5"×12"（24×30 cm）這個尺寸較接近。油畫紙板在19世紀至20世紀初甚為普及，但19世紀中時則有畫家提出其缺點出來，如油畫紙板在保存上容易變形彎曲，在打底或塗敷油彩時容易吸收水氣與油料，重壓與碰撞也容易導致基底材與媒材破損裂開。基於上述的原因，到了19世紀末就逐漸地被較為堅固的畫布板（Canvas boards）所取代。

　　1878年倫敦的George rowney油畫材料公司將紙板的單面黏貼油畫布，稱為畫布板，始販售於市面上。1895年美國、法國的畫材商店目錄中也可看到這項商品，畫布板提供了畫家一種堅固且方便的油畫載體。為了解決畫布板容易扭曲變形、破裂或起皺等缺點，經過不斷的研發，各個公司皆有獨門的畫布板製造專利技術，如畫布與紙板使用獨特的黏合劑配方，不同的加壓乾燥方式及多樣的基底色調、特殊表面紋理等，今日美術用品社仍可購買到許多品牌的畫布板[9]。

圖15. 厚紙板與紙張脫開的地方用甲基纖維素加漿糊作為黏著劑貼合

圖16. 購於舊書攤的精裝書籍，作為後續填補缺損處的材料[10]

圖17. 取書背的寒冷紗和封面內厚紙

圖18. 以甲基纖維素潤濕封面的厚紙

圖19. 將厚紙攪成泥狀後覆滿缺損處[11]

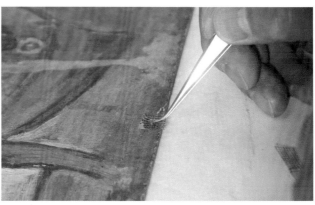

圖20. 將寒冷紗剪適合形狀補缺損處

【註釋】

1. 葉濱翰：國立臺灣師範大學文物保存維護研究發展中心專案修復師。

2. 圖片內的標示為纖維名稱與編織密度，編織密度為1平方公分內的經線X緯線。

3. 陳景容《油畫的材料研究與實際應用》p.112-116，1970，臺北：天同出版社。

4. 陳淑華《油畫材料學》p.219-228，1998，臺北：紅葉文化。

5. Ralph Mayer《藝術名詞與技法辭典》p.7，2005，臺北：貓頭鷹出版社。

6. 大約在1830年代時，學院油畫板可在英國倫敦的Winsor & Newton店中購得，之後廣為流傳，在巴黎、紐約、日本也可買得到這類的紙板。

7. Rutherford J. Gettens & George L. Stout, Painting Materials: A Short Encyclopedia, 1996, p.235-238, Dover Publications.

8. Joyce Hill Stoner & Rebecca Rushfield, Conservation of Easel Paintings, p.113-117, 2013, Routledge.

9. http://www.warrensestateservice.com/stk/apsfW.htm ,http://en.wikipedia.org/wiki/Frost_%26_Adams

10. 於舊書攤尋找與畫作年代接近的書籍，因已天然老化，其紙纖維的紙力較弱，作為填補材料時可將影響的程度降到最少。

11. 填補的厚度僅需讓缺損處的基底材足夠支撐媒材即可，填補過多反而會讓水氣乾燥緩慢，甚至會影響到作品的安全。使用的黏著劑為甲基纖維素與少量日式漿糊調製，增加可逆性與移除性，並有適度的黏著力。

【參考資料】

專書

1. 久米康生《和紙の見わけ方》p.46-47，2003，東京美術出版。

2. 陳冠瑜《塗白底的材料》2014。

3. 陳景容《油畫的材料研究與實際應用》p.112-116，1970，臺北：天同出版社。

4. 陳淑華《油畫材料學》p.219-228，1988，臺北：紅葉文化。

5. Ralph Mayer《藝術名詞與技法辭典》p.7，2005，臺北：貓頭鷹出版社。

6. Rutherford J. Gettens & George L.Stout, Painting Materials: A Short Encyclopedia, p.235-238, Dover Publications, 1966.

7. Joyce Hill Stoner & Rebecca Rushfield, "Conservation of Easel Paintings, p113-117, 2013, Routledge.

8. Knut Nicolaus, The Restoration of Paintings, p.78, 1999, KONEMANN.

期刊

1.陳進來〈聚酯纖維於絲織業的應用情形〉《絲織園地》第77期，p.66-76，2011，臺北：臺灣區絲織工業同業公會。

規格書

Conservation support systems, "Instructions for use of BEVA ® 371 Film", General information about BEVA ® 371 Film, 1982.

網路資料

1. Mark Golden, Painting supports: Cotton Canvas, Volume 28, p.1-3, 2013, Just Paint.

2. Sarah Sands with Amy McKinnon, Preparing a Canvas for Oil Painting, p.4-7, Volume 28, 2013, Just Paint.

3.〈第1章土佐典具帖紙等の特性調查研究〉《和紙の研究—歷史、製法、用具、文化財修復—財団法人ポーラ美術振興財団助成事業研究報告書》（PDF）P.1-6、28-31，高知縣廳出版物。

4. http://www.prtdyeing.org.tw/tech/index.php?parent_id=108

5. http://www.ntcri.gov.tw/zh-tw/Home.aspx

6. http://www.claessenscanvas.com/en

7. http://www.talens.com/en-gb/

8. http://www.holbein-works.co.jp/static/chart_mamual/oil02.htm

9. http://www.sennelier.fr/

10. http://www.arte.gov.tw/

11. http://www.conservators-products.com/

12. http://cool.conservation-us.org/coolaic/sg/bpg/annual/v19/bp19-29.html

13. http://lowyonline.com/wp-content/uploads/WHAT-IS-RABBIT-SKIN-GLUE.pdf

14. http://lascaux.ch/en/index.php

15. http://www.si.edu/mci/downloads/topics/Tsang-etal.pdf

16. http://www.warrensestateservice.com/stk/apsfW.htm

Oil Paintings Conservation Materials at the Research Center for Conservation of Cultural Relics: An Introduction and Case Study

Yeh Pin-han[1]

Summary

In October 2011, the National Taiwan Normal University Research Center for Conservation of Cultural Relics (RCCCR) was commissioned by the Judicial Person Chen Cheng-po Cultural Foundation in October 2011 to treat a large number of Chen's sketches, watercolors, ink paintings, oil paintings, among others. The treatment of oil paintings was undertaken by a team of conservators led by Professor Utada Shinsuke, Professor Kijima Takayasu and Dr. Suzukamo Fujiko of the Tokyo University of the Arts Conservation Course Oil Painting Laboratory, as well as members of the RCCCR. Professor Kijima and Dr. Suzukamo brought their skills and experience in oil painting conservation from Japan. According to the physical condition of each oil painting, they diagnosed problems, proposed treatment methodologies, and proceeded to carry out conservation to stabilize the physical condition of these severely damaged paintings.

Under a collaborative education curriculum, this author was fortunate to have worked as an assistant under these Japanese conservators, from whom he learnt the techniques of oil painting conservation. Prof. Kijima and Dr. Suzukamo always expected the highest caliber workmanship, even for the most minute of details. They were most fastidious with the use of conservation materials. Through their mentorship and guidance in treating these oil paintings, they brought the knowledge and materials of oil painting conservation from the Tokyo University of the Arts Conservation Course Oil Painting Laboratory to the RCCCR. This article will discuss the materials commonly used by the RCCCR for the conservation treatment of Chen Cheng-po's paintings, categorizing them into supports (linen and cotton canvas), media (paint and priming materials), oils (drying oils, volatile oils), varnishes and reinforcing materials (BEVA, fish glue, rabbit-skin glue, tengujo paper), inner frames (strainers, stretchers) etc. These materials will be introduced through text descriptions and images.

Of the 36 oil paintings in this conservation project undertaken by the RCCCR, only one of them, *Sailboat*, was painted on paper board. This painting was in poor condition, including a warped support, support delamination along the four edges, surface dirt and stains, particularly along the four edges, and darkening of paints. There were also tidelines and discoloration. The paint layer was in good condition with the exception of localized flaking and losses. There was severe mold damage at the bottom left and right edge. After examination and solubility tests

were completed, a treatment methodology was proposed. Under the supervision of Prof. Kijima and Dr. Suzukamo, the present author carried out the conservation treatment of this painting, documenting and photographing each step. According to Prof. Kijima's initial examination, this oil painting was painted on a paper board, and was neither dated nor signed, and did not have any other inscriptions. Based upon an examination of the surface texture and four edges, it was determined that the painting was painted on a canvas support. These canvas boards are a type of painting support that is unique in that it is light, inexpensive, and portable, and are therefore favorable among artists. These types of boards may be divided into academy boards and canvas boards. They can be used for sketches or outdoor painting from life, and are also used by amateur painters and students. Academy boards first appeared in 19th century Europe, and were used in many painting classes and art academies. Paintings are painted on the glossy side of the board, that is made by applying a primer or other imprinting material. Some boards are intentionally made with a coarse surface for easy application of oil paint. Canvas boards provide artists with a convenient and resilient support for the painting canvas.

1. Yeh Pin-han is a conservator at the National Taiwan Normal University Research Center for Conservation of Cultural Relics.

油畫作品
Oil Paintings

修復報告
Selected Treatment Reports

國立臺灣師範大學文物保存維護研究發展中心
National Taiwan Normal University Research Center for Conservation of Cultural Relics

前言
Introduction

　　國立臺灣師範大學藝術學院文物保存維護研究發展中心（以下簡稱文保中心）於2011年起接受財團法人陳澄波文化基金會委託，執行為期三年36件油畫作品的修復計畫，本計畫由東京藝術大學文化財保存學專攻保存修復研究室主任木島隆康教授與鈴鴨富士子博士跨國主持。36件作品年代橫跨陳澄波日本東京求學、上海與返臺定居三個階段，基底材類型不僅包含麻布，另有描繪於木板、紙板等多樣性且具歷史性材質（詳如表1）。從作品修復前至修復執行，按表2流程並最終確立具體的修復內容與順序。本次修復委託以基底材的不同（畫布與其他材質）、有無經專業修復歸納出如表3的修復類型，再從中挑選代表作品介紹完整的修復過程。

　　In 2011, the National Taiwan Normal University Research Center for Conservation of Cultural Relics (RCCCR) was commissioned by the Judicial Person Chen Cheng-po Cultural Foundation for a three year project to treat a total of thirty-six oil paintings. This project was led by Tokyo University of the Arts, Graduate Department of Conservation, Conservation Course Oil Painting Laboratory Professor Kijima Takayasu and Dr. Suzukamo Fujiko.The thirty-six oil paintings treated date to Chen's three major artistic periods: his student years in Japan, Shanghai and his return to Taiwan. The primary supports of these paintings are not only limited to canvas, but also include wood and paper board for sketches and other diverse historical materials (see Table 1).The oil paintings were treated according to an established conservation procedure as Table 2. This conservation

計畫主持人木島隆康教授向陳澄波文化基金會人員解說油畫作品修復前的狀態
Project director Kijima Takayasu discusses the oil paintings' before treatment condition with Chen Cheng-po Cultural Foundation

project was divided into different categories based on primary support (canvas and others), and whether they had been previously treated or not (see Table 3). One representative work from each category was selected to describe the overall treatment methodology.

表1. 油畫作品年代與基底材類型
Table 1: Division of time periods and primary supports

種類 Type \ 年代 Date		1924前	1924-1929.3	1929.4-1933	1934-1947	年代不詳 Date unknown	總數 Total
基底材類型 Primary support	畫布（麻布）Canvas	0	5	14	4	5	28
	木板（スケッチ板）* Wood (sketch) panel*	0	2	1	0	3	6
	三合板 Plywood panel	0	0	0	0	1	1
	紙板（紙板＋麻布）Paper board (paper and canvas)	0	0	0	0	1	1
總數Total		0	7	15	4	10	36

*為陳澄波於東京美術學校時期所用的油畫木板。スケッチ為外來語sketch之意，材質有桂、朴樹等。
The wood panels that Chen used at the Tokyo Fine Arts School were made from laurel and elm wood.

表 2. 修復作業流程
Table 2: Conservation procedure

| 修復前攝影與檢視調查 Before treatment examination and documentation | → | 作品現況紀錄與表面溶劑溶解性測試 Condition report and treatment proposal | → | 判斷有無凡尼斯層、舊補彩 Identification of varnish and overpaint | → | 測試移除凡尼斯層及舊補彩的溶劑 Testing solubility of varnish and inpainting | → | 確立修復作業內容 Establish conservation protocol | → | 修復執行 Conservation treatment |

表3. 作品修復類型
Table 3: Treatment category

基底材 Primary support	畫布 Canvas	
修復類型 Treatment category	第一類型修復：初次修復 Treatment category 1: First time treatment	
	無凡尼斯層 No varnish	後加凡尼斯或補彩 Varnish or inpainting
作品名稱 Title	1. 日光華嚴瀑布 Kegon Waterfall 1927 2. 湖畔 Lakeside 1928 3. 朝陽洞 Chaoyang Cave 1929 4. 上海雪景 Shanghai in Snow 1931 5. 亭側眺望 Distant View from Side of Pavilion 1933 6. 戰災（商務印書館側） War Devastation (Beside the Commercial Press Building) 1933 7. 戰後（一） After a War (1) 1933 8. 綠蔭 Foliage 1934 9. 古門樓 Ancient Gate Tower 年代不詳 Date unknown 10. 海灣 Bayside 年代不詳 Date unknown	1. 普陀山群驢 Donkeys at Putuo Mountain 1929 2. 陽台遙望裸女 Nude Female Looking Out 1932 3. 戰災（商務印書館正面） War Devastation (Front of the Commercial Press Building) 1933 4. 塔峰下 At the Foot of Pagoda Hill 1933 5. 河岸 Riverside 1934 6. 椰林 Coconut Grove 1938 7. 新樓庭院 Courtyard in Sin-Lau 1941 8. 郊區風景 Rural Scene 年代不詳 Date unknown 9. 大白花 Big White Flowers 年代不詳 Date unknown

	畫布 Csnvas		木板 Wood panels	三合板 Plywood panels	紙板 Paper board
第二類型修復：再修復 Treatment category 2: Previously treated			第三類型修復：木板與紙板 Treatment category 3: Oil paintings on wood panel and paper board		
2010年曾修復 Treated in 2010	2011年曾修復 Treated in 2011				
1. 半身裸女 Half-length Portrait of Nude Femaile 1931	1. 屏椅立姿裸女* Standing Nude Female Leaning Against a Chair* 1925 2. 搭肩裸女* Nude Female with Hand on Shoulder* 1926 3. 和服男子 Man in Kimono 1928 4. 綠瓶花卉* Flowers in a Green Vase* 1930 5. 叉腰裸女 Nude Female with One Hand in Akimbo 1931 6. 水畔臥姿裸女* Nude Female Lying on Waterside* 1932 7. 上海江南製船所 Shanghai Jiangnan Shipyard 1933 8. 仰臥枕掌裸女 Supine Nude Female Pillowing Head on Palms 年代不詳 Date unknown		1. 街道 Street 1925 2. 少年像 Portrait of a Teenage Boy 1929 3. 俯瞰西湖（一） Overlooking the West Lake (1) 1930s 4. 林中廊沿 Next to a Forest Corridor 年代不詳 Date unknown 5. 女孩 Girl 年代不詳 Date unknown 6. 女子像 Portrait of a Female 年代不詳 Date unknown	1. 船屋 Boat Houses 年代不詳 Date unknown	1. 帆船 A Sailboat 年代不詳 Date unknown

*在2011年修復時曾使用蜜蠟、樹脂混為黏著劑將新畫布貼黏於作品背面藉以補強原有劣化畫布與穩定顏料層，但成效不佳，評估後將移除蠟托裱後進行再次修復。

The previous treatment in 2011 included the addition of a wax and canvas lining on the verso of the painting to strengthen the deteriorated canvas and pigment layer. However, because the treatment was ineffective, a decision was made to remove the wax lining and re-treat the painting.

第一類型修復：初次修復
Treatment category 1: First time treatment

· 海灣 Bayside

I. 修復前狀態 Before treatment condition

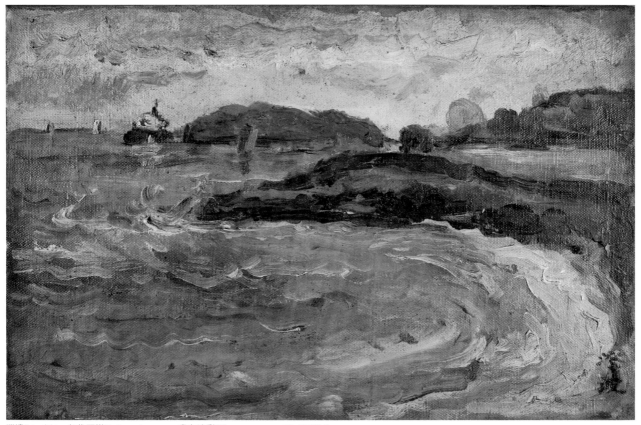

灣邊Bayside　年代不詳Date unknown　畫布油彩Oil on canvas　21.5×33.8cm

修復紀錄 Conservation history

　　■未曾修復Not treated □曾修復Previously treated

凡尼斯層 Varnish （■無None □有Yes）

　　□黃化Yellowing □黴害Mold damage □塗佈不均Uneven □其他Other

繪畫層 Paint layer

　　■灰塵髒污Surface dirt □黴害Mold damage □水害Water damage

　　■蟲害Insect damage （昆蟲排遺accretion、啃蝕破損loss）

　　■龜裂Craquelure（乾燥drying cracks、經年age cracks、損傷damage）■起翹Lifting ■剝落Flaking □粉化Friable

　　□擦傷Abrasion □撞傷Compression damage □燒傷Fire damage □割傷Cuts

　　□缺損Loss □舊補彩Inpaint □畫布變形Canvas distortion □附著物Foreign accretion

　　■其他Other：畫作背面疑似有水害漬痕現象 The back of painting shows evidence of water damage (tidelines)

打底層 Canvas

■既成畫布Commercial canvas □自製畫布Self-prepared canvas（□無None □有Yes）

基底材 Primary support

□木板Wood panel ■畫布Canvas（麻布、平織Plain weave linen）□其他Other

內框 Inner frame

□無None ■固定式內框Strainer □可調整式卡榫內框Stretcher（□楔子Keys）

1. 此作品為初次修復。畫作完成後並無凡尼斯層保護，致使表面繪畫層因長期累積灰塵污垢且深入顏料肌理內、多處昆蟲排泄物附著、畫作四邊繪畫層已局部顏料磨損脫落。

This work of art has not been previously treated. After the painting was completed, a protective varnish layer was not applied, resulting in the long-term accumulation of dust and accretions within the paint layer, overall insect accretion, and paint loss and damage along the four edges of the painting.

2. 畫作背面發現有疑似水害後的漬痕現象，肉眼檢視判斷並無黴菌滋生。

Tidelines on the verso of the painting indicate possible water damage, but visual observation does not reveal the presence of mold.

3. 整體畫面側邊的畫布釘因長時間的氧化生鏽腐蝕，造成畫布邊緣嚴重破損。

Nails on the four canvas edges have rusted, causing severe canvas deterioration.

II. 修復作業內容 Conservation treatments

1. 修復前攝影 Before treatment examination and documentation

作品修復前的整體狀況紀錄及調查。修復前進行可見光（正光、側光）、非可見光（紅外光與紫外光）、X光攝影作業與非破壞性X螢光光譜儀（XRF）輔助分析顏料成份。透過上述不同特殊光源的檢測技術交互比對下，全面性了解畫作材質及損傷的狀態。此件作品於紅外光與X光檢視下並無底稿構圖的變動。

Before treatment examination and documentation of the work of art was carried out and included visible illumination (normal, raking illumination) and non-visible radiation (infrared and UV radiation) photography, x-radiography, and x-ray fluorescence spectroscopy for the pigment identification. Comparison of these photographic and analytical results allowed the conservators to understand the work's materials and physical condition. Under infrared radiation and x-radiography it was determined that these paintings did not have underdrawings.

正光（正面）Normal illumination (Recto)

正光（背面）Normal illumination (Verso)

紫外光（正面）UV radiation (Recto)
檢視後無凡尼斯層No varnish layer is visible

紫外光（背面）UV radiation (Verso)
反白圈形處疑似水害後的漬痕現象
Whiter areas are tidelines indicative of water damage

長年堆積的塵垢Long-term grime accumulation

嚴重灰塵附著Thick layer of dust accretion

畫作四邊的顏料層磨損脫落（白色框處）
Paint abrasion and loss along the four edges of the painting (Outlined by the white box)

昆蟲排泄物Insect accretion

2. 狀況檢視登錄與修復計畫擬定 Condition report and treatment proposal

作品基本資料調查（尺寸、畫布經緯與損傷現狀等）、表面顏料溶劑測試。以此為基礎，對作品現有損傷狀況提出合適的修復處理內容。

The work of art's basic information (dimensions, weft and weave of canvas support, damage) was recorded, and the paint layer underwent solvent testing. Based upon this information and the work's present condition, an appropriate treatment methodology was proposed.

3. 拆框解體與暫時性顏料封固 Separation of painting from inner frame and temporary facing of paint layer

移除氧化生鏽的畫布釘使畫面與內框安全分離後，使用典具帖封固保護脆弱的顏料層，以避免於畫作正、反面清潔時致顏料層脫落受損。

After rusted nails were removed and the painting was separated from its stretcher, tengujo paper strips were adhered as a temporary facing on weakened paint areas to avoid paint loss during surface cleaning.

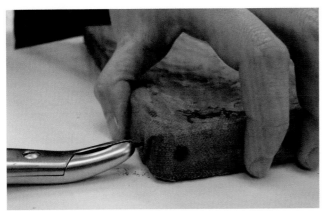

移除生鏽的畫布釘
Removing rusted nails

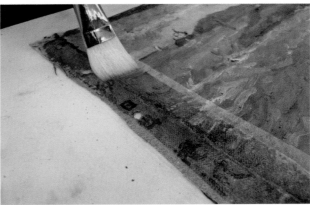

暫時性的封固保護畫布四邊的脆弱顏料層
Temporary facing is applied to weakened paint areas along four edges of canvas

4. 表面清潔與除塵 Surface cleaning

依序進行畫作背面與正面的清潔，以移除長年累積的灰塵污垢、外來附著物等。若有黴菌滋生問題則以酒精全面性消毒殺菌處理。

The painting recto and verso were surface clean to remove long-term accumulation of dust and accretions. If there was active mold growth, the painting was disinfected by spraying the entire surface with alcohol.

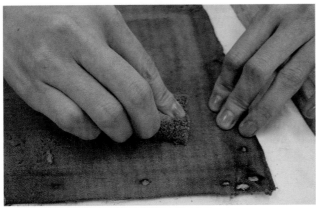

以修復用海綿深層清潔麻布纖維內藏垢
Conservation-use sponges were used to remove dirt within the canvas

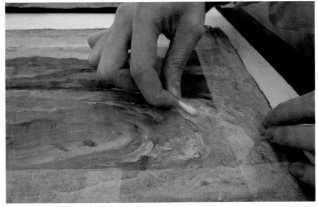

使用淨水及低濃度稀氨水多次清潔
Water and dilute ammonia were used to clean the painting surface

5. 畫布接邊與補強 Applying strip linings and reinforcement

將畫布邊緣因鐵鏽腐蝕劣化部分強化處理，以修復用可逆性熱熔片（BEVA 371）黏著劑與天然亞麻畫布補強畫布四邊後，暫時固定於臨時木框上以整平畫作。確認畫面顏料層已穩定狀態下即移除顏料暫時性保護紙。

Because the original tacking edge had deteriorated due to rust, new linen strip linings were adhered to the four edges with BEVA 371. The painting was then temporarily stretched onto a strainer to maintain planarity. Once the paint layer was stabilized, the temporary paper facings were removed.

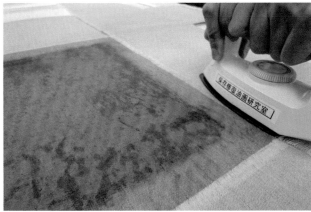

畫布邊緣的補強
Reinforcing the tacking edges

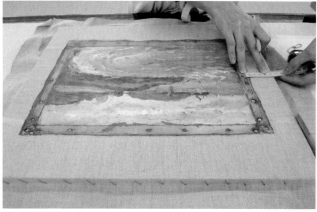

畫布全面性撐平作業
Ensuring planarity of the painting surface

移除保護紙
Removing the temporary facings

清潔前後對照
Before and after cleaning

重新繃於新的可調整式新卡榫內框
Stretching onto a new stretcher

背面畫布收邊完成
Verso of finished stretcher

6. 填充整形與全色補彩 Filling losses and inpainting

　　於顏料層剝落處填入水溶性補土（動物膠調和Gesso石膏），再按畫面肌里筆觸進行破損處表面的形體塑造。然後以水彩進行補彩作業，之後將畫面全面性塗刷凡尼斯做為補彩前的隔離層。待乾燥後以溶劑型的壓克力顏料進行色調整合。

　　Areas of paint loss were filled with a water-soluble material (animal glue and gesso) and textured. After a base tone was applied to the filled areas with watercolors, an overall varnish coating was applied. After the varnish fully dried, acrylic paints were used to complete the inpainting.

補土後，全色補彩前
After filling, before inpainting

全面均勻噴塗達瑪凡尼斯
Evenly spraying a layer of damar onto the painting

7. 凡尼斯保護層 Protective varnish layer

畫面修復完成後，再次噴塗達瑪凡尼斯保護層，全面性的整合畫面光澤以達均勻一致。

After the painting has completed treatment, a protective layer of damar varnish was sprayed on the painting for an even surface luster.

III. 修復前後對照 Before and after treatment

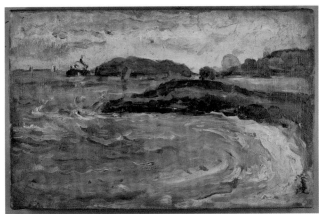
修復前Before treatment

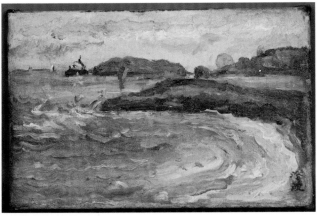
修復後After treatment

・戰災（商務印書館正面）

War Devastation (Front of the Commercial Press Building)

I. 修復前狀態 Before treatment condition

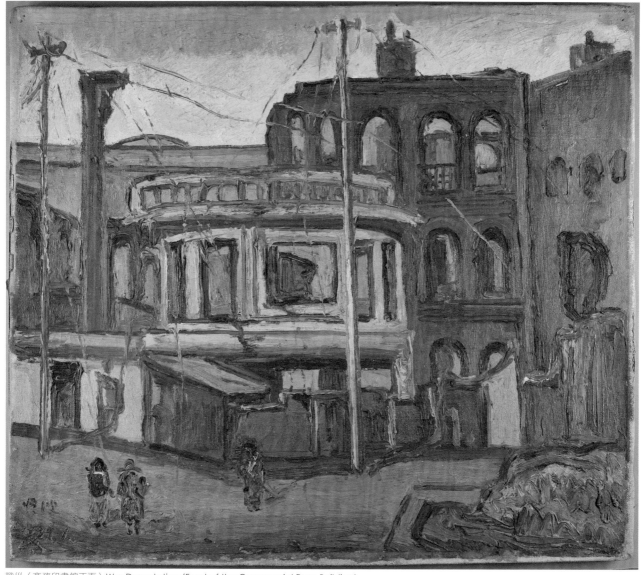

戰災（商務印書館正面）War Devastation (Front of the Commercial Press Building)
1933　油彩畫布Oil on canvas　45×52cm

修復紀錄 Conservation history

　　■未曾修復Not treated □曾修復Previously treated

凡尼斯層 Varnish（□無None ■有Yes）

　　■黃化Yellowing ■黴害Mold damage ■塗佈不均Uneven ■其他Other：髒污Surface dirt

繪畫層 Paint layer

　　■灰塵髒污Surface dirt ■黴害Mold damage □水害Water damage

　　■蟲害Insect damage（昆蟲排遺accretion、啃蝕破損loss）

　　■龜裂Craquelure（乾燥drying cracks、經年age cracks、損傷damage）

■起翹Lifting ■剝落Flaking □粉化Friable □擦傷Abrasion □撞傷Compression damage □燒傷Fire damage □割傷Cuts ■缺損Loss ■舊補彩Inpaint ■畫布變形Canvas distortion ■附著物Foreign accretion ■其他Other：補彩溢塗與變色 Overpaint had discolored

打底層 Canvas

■既成畫布Commercial canvas □自製畫布Self-prepared canvas（□無None □有Yes）

基底材 Primary support

□木板Wood panel ■畫布Canvas（麻布、平織Plain weave linen）□其他Other

內框 Inner frame

□無None ■固定式內框Strainer □可調整式卡榫內框Stretcher（□楔子Keys）

1. 此作品為初次修復。經修復前檢視發現有非專業性與不當的後加凡尼斯層與補彩。

This painting has not been treated before. Visual examination reveals non-professional and inappropriate varnish application and overpaint.

2. 因未經專業修復程序全面清潔狀態下即塗佈凡尼斯保護層，致使長年累積下的灰塵髒污被深埋於筆觸肌理內。另外，明顯可見天空處有大面積的後加補彩，不僅變色甚至溢塗覆蓋畫作原彩。

The varnish was applied prior to thorough surface cleaning, resulting in a long-term accumulation of dust and accretion within the paint layer. In addition, visual observation reveals a large section of the sky suffers from discolored overpaint, obscuring the original paint layer below.

3. 透過側光檢視畫布有局部凹凸變形，木框也略彎曲，導致畫布四角內縮。顏料層極為脆弱，有龜裂、翹起剝落現象。

Visual examination reveals that the canvas support has localized deformations, the wooden stretcher has warped, and the four corners of the canvas support have shrunk inwards. The paint layer is extremely fragile, and suffers from cracking and flaking.

4. 於左右兩側畫作邊緣處，因畫布纖維老化狀態下已脆弱裂開，並用釘書針固定。

The left and right edges are weakened and torn, and have been supported with staples.

5. 木框背面以簽字筆寫上「00〈24〉10F 1933 戰後」。

On the back of the stretcher is written [00〈24〉10F 1933 戰後].

II. 修復作業內容 Conservation treatments

1. 修復前攝影 Before treatment examination and documentation

作品修復前的整體狀況紀錄及調查。修復前進行可見光（正光、側光）、非可見光（紅外光與紫外光）、X光攝影作業與非破壞性X螢光光譜儀（XRF）輔助分析顏料成份。透過上述不同特殊光源的攝影技術交互比對下，全面性了解畫作材質及損傷的狀態。

Before treatment examination and documentation of the work of art was carried out and included visible illumination (normal, raking illumination) and non-visible radiation (infrared and UV radiation) photography, x-radiography, and x-ray fluorescence spectroscopy for the pigment identification. Comparison of these photographic and analytical results allowed the conservators to understand the work's materials and physical condition.

正光（背面）Normal illumination (Verso)

側光（背面）Raking illumination (Verso)
畫布龜裂、變形Canvas cracks and distortions

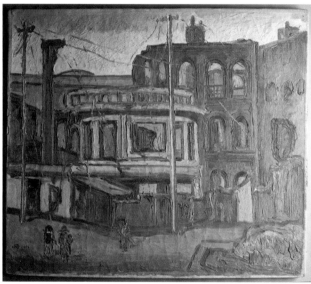

側光Raking illumination
顏料層嚴重龜裂與變形Severe paint layer cracking and distortions

X光X-radiography
底層構圖無變動，顏料缺損多發生於畫作四邊
The original composition is the same as the final composition. Paint damage occurs mostly along the four edges of the painting.

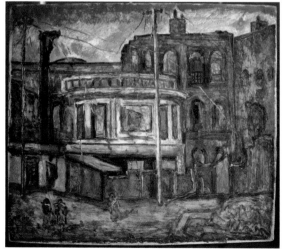

紫外光UV radiation
判斷有尼斯層與舊補彩溢塗
Evidence of varnish layer and overpaint

紫外光（局部）UV radiation (Detail)

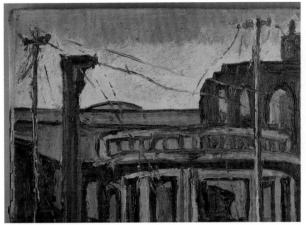

天空上方補彩變色（局部）
Discolored overpaint in the sky (Detail)

補彩溢塗覆蓋原彩（局部）
Overpaint covering original paint (Detail)

2. 狀況檢視登錄與修復計畫擬定 Condition report and treatment proposal

作品基本資料調查（尺寸、畫布經緯、凡尼斯保護層與損傷現狀等）、表面顏料溶劑測試。以此為基礎，對作品現有損傷狀況提出合適的修復處理內容。

The work of art's basic information (dimensions, weft and weave of canvas support, damage) was recorded, and the paint layer underwent solvent testing. Based upon this information and the work's present condition, an appropriate treatment methodology was proposed.

3. 拆框解體與畫布攤平 Separation of painting from inner frame and flattening of canvas support

將畫布從內框移除下後，再以熨斗適當的加溫加溼整平畫布四邊。

After the painting was separated from the inner frame, the four canvas edges were flattened with gentle heat and humidity.

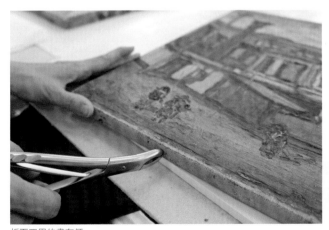

拆下四周的畫布釘
Removing old nails

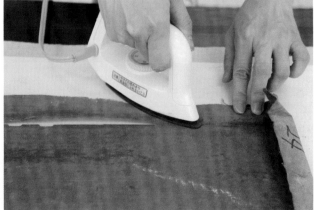

整平畫布四邊翻摺處
Flattening four canvas edges

4. 裂痕補強與變形修正 Crack reinforcement and flattening of canvas distortions

先以動物膠加固裂痕處的顏料層使之密合後，選用天然麻布纖維做為支撐補強。

Animal glue is applied to the tears to ensure proper adhesion. Linen threads were used to mend and reinforce the tears.

將動物膠填入畫布裂痕內層
Animal glue is applied to the canvas tears

以麻布纖維於背面補強斷裂痕
Linen threads are used to mend the tears

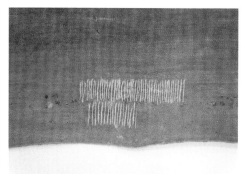
裂痕加固補強後
After the tears are fully reinforced

5. 顏料層加固與裂痕整平 Paint consolidation and flattening of cracks

利用加溫加壓方式處理畫作正、背面的每道龜裂痕與畫布變形處，透過使用輕薄的不織布保護紙塗刷動物膠使之滲入裂痕層間達到顏料層密合與平整的目的。

Heat and pressure are used to reduce distortions in the canvas support. With a thin layer of rayon paper as a facing support, animal glue was applied to the cracks to ensure planarity and adhesion of the paint layer.

以可溫控小頭熨斗撫平龜裂痕
A small iron was used to flatten distortions

加固與封固保護顏料層
Consolidation of and applying facing to the paint layer

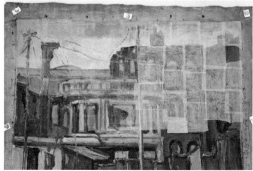
針對裂痕與脆弱顏料層以保護紙封固
Facing of cracks and weakened paint layer

6. 移除舊補彩、黃化凡尼斯層 Removing old overpaint and varnish

用淨水潤濕顏料保護紙後，邊揭除保護紙邊清潔畫面。經顏料溶劑測試後，以合適的溶劑清除變色的補彩與黃化凡尼斯層。

Water was used to soften and remove the facing and clean the painting surface. After solvent testing, an appropriate solvent was selected to remove discolored overpaint and yellowed varnish.

使用淨水潤濕後移除顏料保護紙
Water was used to soften and remove the facing

以溶劑清除舊補彩
Solvent was used to remove old overpaint

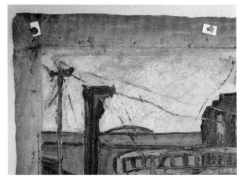
移除變色與溢塗的補彩後
After removal of discolored overpaint

7. 畫布變形修正 Reducing canvas support distortions

使用修復用可逆性熱熔片（BEVA 371）黏著劑於畫布邊緣搭貼天然亞麻布以達補強目的。再將作品暫時性固定於臨時木框上調整全面性的變形。

Reversible, conservation-use BEVA 371 adhesive strips were used to apply linen reinforcement strip linings to the painting edges. The painting was then stretched onto a temporary stretcher to reduce distortions.

固定畫作於臨時木框上調整變形
Painting was stretched onto a temporary stretcher to reduce distortions

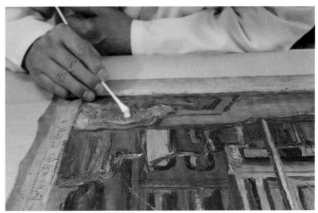

以低濃度的稀釋氨水再次清潔畫面
Dilute ammonia was used to clean the painting surface

8. 新內框與非黏合式的加襯作業 Stretching onto new stretcher and adding loose lining

經全面修復後考量此幅作品畫布已老化極為脆弱，決定以loose lining加襯修復技法。先在新的可調整式卡榫內框繃上一層棉布後，再將之加襯於畫作背面以支撐作品，可因應原畫布因氣候收縮鬆動且達到作品穩固。

Because the painting's canvas support has severely deteriorated, the decision was made to add a loose lining. A cotton sheet was stretched onto the stretcher to act as a secondary support for the painting and provide stability against climate-induced shrinkage or warping.

測量尺寸後，裁切搭邊的畫布
Cutting the edges of the painting after measuring the appropriate width

將畫作與加襯棉布的內框固定
After stretching cotton lining and painting on stretcher

9. 全色補彩 Inpainting

待上述基底材與顏料層穩定後進行全色補彩。先以水彩進行補彩底色後，再將畫面全面性塗刷凡尼斯做為補彩前的隔離層。待乾燥後再以溶劑型的壓克力顏料進行色調整合。

After the primary support and paint layer have been stabilized, the next conservation treatment steps can be carried

out. First, watercolors are used to inpaint the fills, followed by applying the first varnish layer. After fully dried, acrylic paints are used to complete inpainting.

10. 凡尼斯保護層 Protective varnish layer

畫面修復完成後,再次噴塗達瑪凡尼斯保護層,全面性的整合畫面光澤以達均勻一致。

After the painting has completed treatment, a protective layer of damar varnish was sprayed on the painting for an even surface luster.

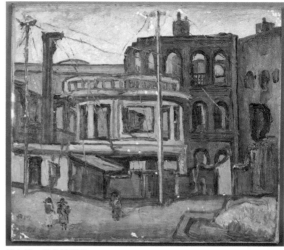

補土後,全色補彩前
After filling, before inpainting

III. 修復前後對照 Before and after treatment

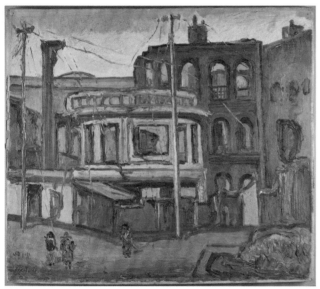

修復前Before treatment

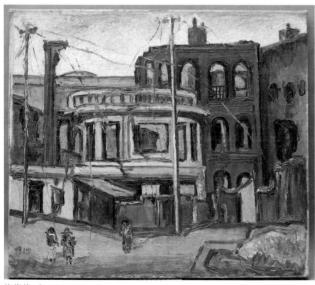

修復後After treatment

· 新樓庭院 Courtyard in Sin-Lau

I. 修復前狀態 Before treatment condition

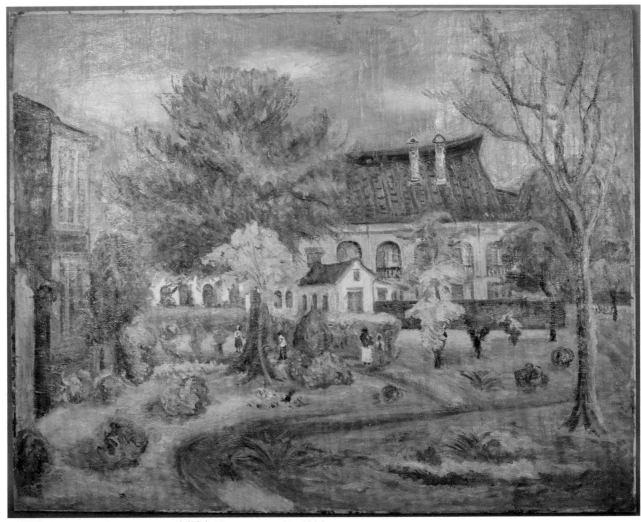

新樓庭院 Courtyard in Sin-Lau　1941　油彩畫布Oil on canvas　91×116.5cm

修復紀錄 Conservation history

　　　■未曾修復Not treated □曾修復Previously treated

凡尼斯層 Varnish（□無None ■有Yes）

　　　■黃化Yellowing □黴害Mold damage ■塗佈不均Uneven □其他Other

繪畫層 Paint layer

　　　■灰塵髒污Surface dirt □黴害Mold damage □水害Water damage

　　　□蟲害Insect damage（昆蟲排遺accretion、啃蝕破損loss）

　　　■龜裂Craquelure（乾燥drying cracks、經年age cracks、損傷damage）■起翹Lifting ■剝落Flaking □粉化Friable

　　　■擦傷Abrasion □撞傷Compression damage □燒傷Fire damage □割傷Cuts

　　　■缺損Loss ■舊補彩Inpaint ■畫布變形Canvas distortion □附著物Foreign accretion

　　　□其他Other

打底層 Canvas

　　　■既成畫布Commercial canvas □自製畫布Self-prepared canvas（□無None □有Yes）

基底材 Primary support

　　□木板Wood panel ■畫布Canvas（麻布、平織Plain weave linen）□其他Other

內框 Inner frame

　　□無None ■固定式內框Strainer □可調整式卡榫內框Stretcher（□楔子Keys）

　　1. 此作品為初次修復。經修復前檢視發現有非專業性與不當的後加凡尼斯層與補彩。

This painting has not been treated before. Visual examination reveals non-professional and inappropriate varnish application and overpaint.

　　2. 因凡尼斯塗佈不均造成兩側的光澤感較亮。

Because the varnish was unevenly applied, two edges appear brighter.

　　3. 顏料層有多處舊補彩，直接以油彩顏料覆蓋溢塗顏料缺損處。

There is a lot of overpaint that used regular oil paint to cover damaged areas.

　　4. 畫作遍布垂直方向的龜裂痕與畫布凹凸變形，於嚴重龜裂處有顏料起翹後剝落狀態。

There are cracks running perpendicular to the painting's four edges, canvas deformations, and severe paint cleavage and flaking along cracks.

II. 修復作業內容 Conservation treatments

1. 修復前攝影 Before treatment examination and documentation

　　作品修復前的整體狀況紀錄及調查。修復前進行可見光（正光、側光）、非可見光（紅外光與紫外光）、X光攝影作業與非破壞性X螢光光譜儀（XRF）輔助分析顏料成份。透過上述不同特殊光源的攝影技術交互比對下，全面性了解畫作材質及損傷的狀態。

Before treatment examination and documentation of the work of art was carried out and included visible illumination (normal, raking illumination) and non-visible radiation (infrared and UV radiation) photography, x-radiography, and x-ray fluorescence spectroscopy for the pigment identification. Comparison of these photographic and analytical results allowed the conservators to understand the work's materials and physical condition.

正光（正面）Normal illumination (Recto)

正光（背面）Normal illumination (Verso)

側光Raking illumination
顏料層嚴重龜裂Severe cracking of the paint layer

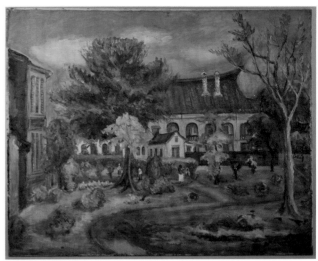
紫外光UV radiation
判斷有凡尼斯層與舊補彩
Evidence of varnish layer and overpaint

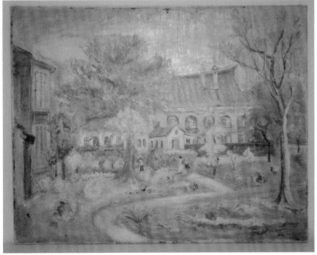
紅外光Infrared radiation
顏料層厚重無法初步檢視畫作底稿
Because of the thick paint layer, the underdrawing is unable to be seen

X光X-radiography
底層構圖有些微變動;顏料缺損嚴重
Slight changes were made to the underlying composition; severe paint damage

畫面遍布龜裂痕、畫布變形
Cracks running perpendicular from painting edge and canvas distortions

畫布多處凹凸變形
Canvas distortions

深層的裂痕
Cracks in thick paint layer

於顏料缺損處直接補彩覆蓋，明顯可見顏料厚度落差
Overpaint is directly applied to areas of paint loss. There is a distinct difference in paint thickness

2. 狀況檢視登錄與修復計畫擬定 Condition report and treatment proposal

作品基本資料調查（尺寸、畫布經緯、凡尼斯保護層與損傷現狀等）、表面顏料溶劑測試。以此為基礎，對作品現有損傷狀況提出合適的修復處理內容。

The work of art's basic information (dimensions, weft and weave of canvas support, damage) was recorded, and the paint layer underwent solvent testing. Based upon this information and the work's present condition, an appropriate treatment methodology was proposed.

3. 拆框解體與清潔除塵 Separation of painting from inner frame and surface cleaning

將四周的釘子拔除後與木框分離，以修復用吸塵器與海綿清潔畫布背面的髒污灰塵。

After old nails were removed, the painting was separated from the stretcher, and surface dirt and accretions were cleaned from the painting verso using gentle vacuuming and sponges.

拔除四邊的畫布釘（鐵釘）
Removing iron nails

以海綿清除背面灰塵
Using a sponge to remove surface dirt from the painting verso

4. 畫布邊緣補強 Applying strip linings and reinforcment

將畫布邊緣因鐵鏽腐蝕劣化部分補強處理，以修復用可逆性熱熔片（BEVA 371）黏著劑於畫布邊緣搭貼天然亞麻畫布強化。再將作品暫時性固定於擴撐器上慢慢攤平畫布。

Because the original tacking edges had deteriorated due to rust, new linen strip linings were adhered to the four edges with BEVA 371. The painting was then temporarily stretched onto a strainer and slowly flattened.

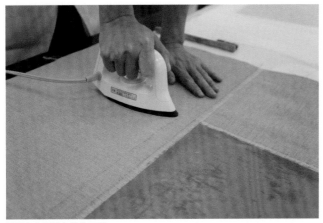
將亞麻布搭貼在畫作四周
Linen canvas is adhered to the four edges of the painting

將畫作固定於擴撐器上矯正變形
Painting is secured onto a expandable stretcher to reduce deformations

5. 顏料加固與裂痕整平 Paint consolidation and flattening of cracks

　　利用加溫加壓方式處理畫作正、背面的龜裂痕與畫布變形處，透過使用輕薄的不織布保護紙塗刷動物膠使之滲入裂痕層間達到顏料層密合與平整的目的。

　　Heat and pressure are used to reduce distortions in the canvas support. With a thin layer of rayon paper as a facing support, animal glue was applied to the cracks to ensure planarity and adhesion of the paint layer.

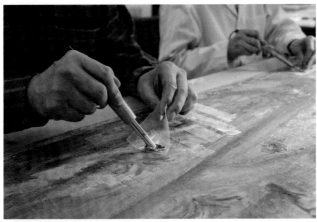
加溫加壓整平裂痕
Applying heat and pressure to flatten creases

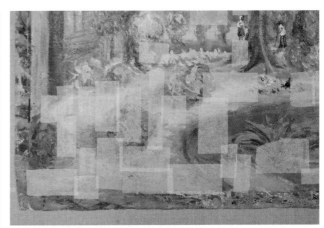
裂痕、缺損處加固後
After consolidation of cracks and damaged areas

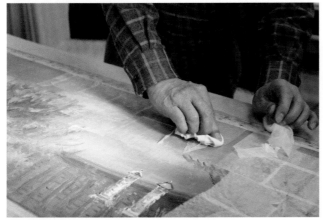
以水潤濕後移除保護紙
Using water to remove the temporary facing

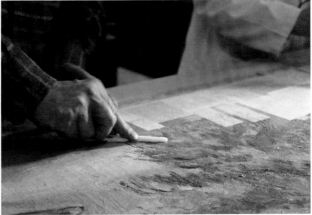
以棉棒沾水清除殘留的動物膠
A cotton swab moistened with water is used to remove excess animal glue

6. 移除舊補彩與凡尼斯層 Removing old overpaint and varnish

此作品之舊補彩使用與原彩同屬性之油畫顏料，在紫外光下無法做區別，但因直接於顏料缺損處覆蓋溢塗，仍可藉由顏料的厚度與色系的落差判斷。經顏料層溶劑測試後，選用適合移除舊補彩與凡尼斯層的清洗溶劑。

Because the overpaint was applied with regular oil paint, it was indistinguishable from the original paint layer under UV radiation. However, because the overpaint covered the original paint layer, the conservators were able to use differences in paint layer thickness and color to differentiate between original paint and overpaint. Solvent tests were carried out to select an appropriate solvent for the removal of overpaint and varnish.

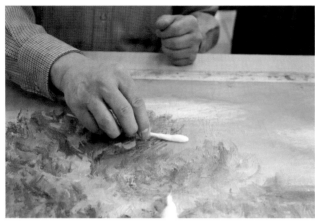
以溶劑清除凡尼斯層
Solvent removal of varnish layer

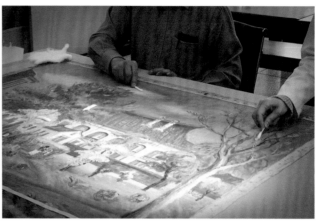
利用側光源輔助確認凡尼斯的移除
Raking illumination is used to confirm removal of varnish

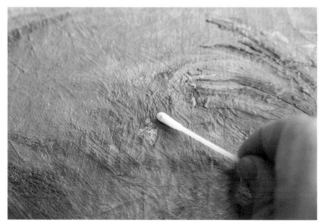
以溶劑方式清除變色的舊補彩
Solvent removal of discolored overpaint

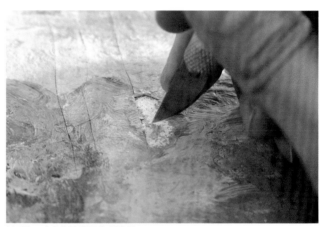
以手術刀小心剃除溢塗的舊補彩
Using a scalpel to removal overpaint

舊補彩去除前
Before overpaint removal

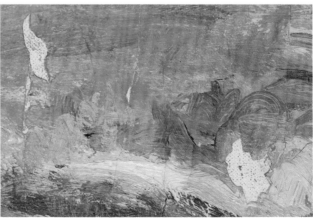
舊補彩與凡尼斯移除除後
After overpaint and varnish removal

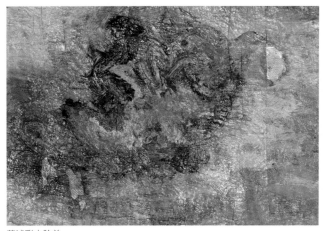

舊補彩去除前
Before overpaint removal

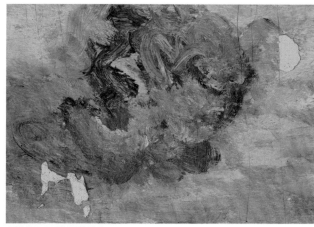

舊補彩與凡尼斯移除除後
After overpaint and varnish removal

7. 畫布變形修正 Restoring planarity to canvas support

　　畫布的整體變形須透過擴撐器逐步調整矯正，同時以加溫加壓方式處理畫作正、背面的龜裂痕與凹凸變形。先於畫作下置入支撐物，再使用吹風機加溫變形處後重壓整平。後將畫作背面朝上，下襯羊毛墊並以控溫熨斗整平變形處。整平後將畫作固定於可調整式卡榫內框上。

　　Restoring planarity to the canvas support requires not only stretching the painting on an expandable stretcher, but at the same time also apply heat and pressure to reduce the distortions caused by cracking and deformation. After the

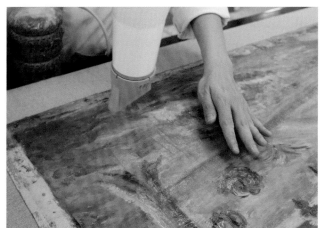

加熱加溫慢慢軟化畫布
Adding heat to slowly soften the canvas support

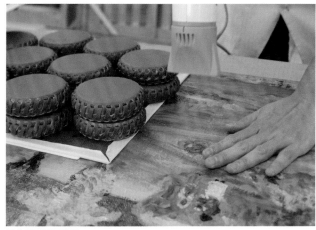

紙鎮重壓整平變形
Weights are used to reduce distortions

由背面加溫整平裂痕與變形
Heat is applied from the verso to flatten creases and distortions

將畫作固定於可調整式卡榫內框上
The painting is stretched onto a new stretcher

painting is secured on the stretcher, a blow dryer is used to apply heat to deformed areas, and then the area is pressed under weights. The painting is then flipped over, placed on a felt blanket, and ironed in these same deformed areas. After the painting is fully flattened the painting is transferred onto a new stretcher.

8. 填充整形與補彩 Filling losses and inpainting

於顏料層剝落處填入水溶性補土（動物膠調和Gesso石膏）並進行表面形體塑造，再以水彩填補底色後，再將畫面全面性塗刷凡尼斯做為補彩前的隔離層。待乾燥後再以溶劑型的壓克力顏料進行色調整合。

Areas of paint loss were filled with a water-soluble material (animal glue and gesso) and textured. After a base tone was applied to the filled areas with watercolors, an overall varnish coating was applied. After the varnish fully dried, acrylic paints were used to complete the inpainting.

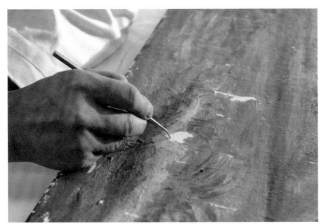

補土表面肌理塑造Texturing the fills

補彩中Inpainting

9. 凡尼斯保護層 Protective varnish layer

畫面修復完成後，再次噴塗達瑪凡尼斯保護層，全面性的整合畫面光澤以達均勻一致。

After the painting has completed treatment, a protective layer of damar varnish was sprayed on the painting for an even surface luster.

III. 修復前後對照 Before and after treatment

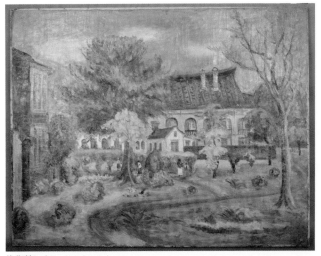

修復前Before treatment

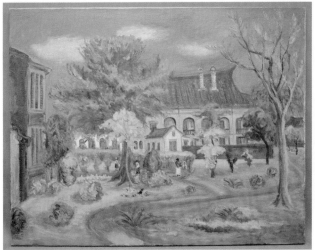

修復後After treatment

第二類型修復：再修復案
Treatment category 2: Previously treated

・水畔臥姿裸女 Nude Female Lying on Waterside

I. 修復前狀態 Before treatment condition

水畔臥姿裸女Nude Female Lying on Waterside　1932　油彩畫布Oil on canvas　53×79cm

修復紀錄 Conservation history

　　□未曾修復Not treated ■曾修復Previously treated：2011年，蠟托裱Wax lining

凡尼斯層 Varnish（□無None ■有Yes）

　　■黃化Yellowing □黴害Mold damage □塗佈不均Uneven □其他Other

繪畫層 Paint layer

- ■灰塵髒污Surface dirt □黴害Mold damage □水害Water damage
- □蟲害Insect damage（昆蟲排遺accretion、啃蝕破損loss）
- ■龜裂Craquelure（乾燥drying cracks、經年age cracks、損傷damage）■起翹Lifting ■剝落Flaking □粉化Friable
- □擦傷Abrasion □撞傷Compression damage □燒傷Fire damage □割傷Cuts
- □破洞Loss ■舊補彩Inpaint ■畫布變形Canvas distortion □附著物Foreign accretion
- ■其他Other：蠟滲透The wax had penetrated through the canvas support

打底層 Canvas

- ■既成畫布Commercial canvas □自製畫布Self-prepared canvas（□無None □有Yes）

基底材 Primary support

- □木板Wood panel■畫布Canvas（麻布、平織Plain weave linen）□其他Other

內框 Inner frame

- □無None □固定式內框Strainer ■可調整式卡榫內框Stretcher（■楔子Keys）

1. 針對曾經修復過並以蠟托裱處理的畫作，如今再次修復處理。

This category of paintings that have been previously treated (including wax linings) is undergoing a second conservation treatment.

2. 此作品曾於2011年修復過，當時以蜜蠟為黏著劑於畫布背面結合新麻布，欲改善顏料層脆弱不穩的現狀但成效不彰，蠟經熱而溶解滲透不均、畫布與顏料層無法有效緊密結合反加重畫作整體性負擔。

This painting was treated in 2011, and, in an effort to reinforce the fragile paint layer, it was given an ineffective treatment of applying a wax and canvas lining. The wax was applied unevenly and does not dissolve with heat, and instead of effectively consolidating the paint layer, becomes an additional burden on the painting.

3. 經修復前攝影檢視後，有蜜蠟嚴重滲透至畫布纖維內和顏料表層、顏料層嚴重龜裂、缺損處的舊補彩溢塗覆蓋到周圍原彩、凡尼斯層黃化等問題。

Before treatment examination revealed several physical and structural problems. The wax had penetrated through the canvas support and into the paint layer, the paint layer had severe cracking, overpaint on areas of paint loss covered and obscured original paint, and the varnish had already begun to yellow.

II. 修復作業內容 Conservation treatments

1. 修復前攝影 Before treatment examination and documentation

作品修復前的整體狀況紀錄及調查。修復前進行可見光（正光、側光）、非可見光（紅外光與紫外光）、X光攝影作業與非破壞性X螢光光譜儀（XRF）輔助分析顏料成份。透過上述不同特殊光源的攝影技術交互比對下，全面性了解畫作材質及損傷的狀態。

Before treatment examination and documentation of the work of art was carried out and included visible illumination (normal, raking illumination) and non-visible radiation (infrared and UV radiation) photography, x-radiography, and x-ray fluorescence spectroscopy for the pigment identification. Comparison of these photographic and analytical results allowed the conservators to understand the work's materials and physical condition.

正光（背面）Normal illumination (Verso)

實體顯微照（8X）蠟滲透至背面
Photomicrograph (Mag. 8x) of wax penetrating the verso

側光Raking illumination
顏料層嚴重龜裂Severe cracking of the paint layer

紫外光UV radiation
判斷有凡尼斯層與舊補彩Evidence of varnish layer and inpaint

紅外光Infrared radiation
顏料層厚重無法初步檢視畫作底稿
Because of the thick paint layer, the underdrawing is unable to be seen

X光X-radiography
底層構圖已變動Underlying composition is different

2. 狀況檢視登錄與修復計畫擬定 Condition report and treatment proposal

　　作品基本資料調查（尺寸、畫布經緯、凡尼斯保護層與損傷現狀等）、表面顏料溶劑測試。以此為基礎，對作品現有損傷狀況提出合適的修復處理內容。

　　The work of art's basic information (dimensions, weft and weave of canvas support, damage) was recorded, and the paint layer underwent solvent testing. Based upon this information and the work's present condition, an appropriate treatment methodology was proposed.

3. 移除舊補彩、黃化凡尼斯層 Removing inpaint and yellowed varnish

經表面顏料的溶劑測試後，決定移除凡尼斯層與舊補彩的清洗溶劑。

After solvent testing, an appropriate solvent is selected to remove varnish and old inpaint.

以石油醚移除表面黃化凡尼斯層與舊補彩
Petroleum spirits (petrol) are used to remove yellowed varnish and old overpaint

將黃化發黏的封邊紙膠清除
Removing yellowed paper tapes

4. 暫時性顏料封固與拆框解體 Temporary facing of paint layer and separation of painting from inner frame

使用典具帖封固保護脆弱的顏料層，以避免拆除框體及移除蠟托裱作業時顏料層受損脫落。

A tengujo paper facing was used to protect the fragile paint layer to ensure that there would be no damage or loss to the paint layer during the painting's separation from its inner frame and subsequent removal of the wax lining.

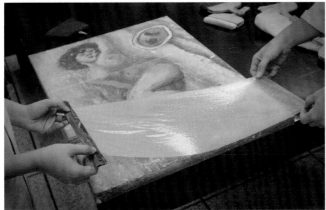

全面性的封固保護顏料層
Applying an overall facing to protect the paint layer

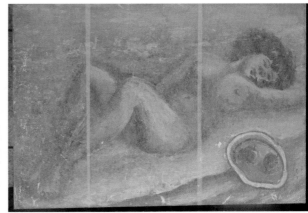

自然乾燥使保護紙與顏料層緊密黏合
Air-drying allowed the facing to securely adhere to the paint layer

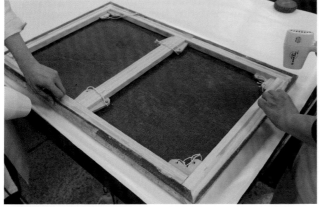

拔除畫布釘後加熱軟化畫布四邊
After nails were removed, heat was applied to soften the four tacking edges

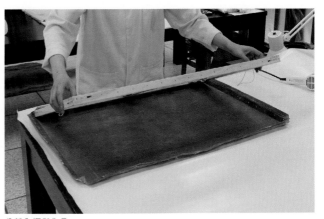

分離內框與作品
Separating the painting from inner frame

5. 移除蠟托裱 Removing the wax lining

以間接性加熱使蠟液化而分離，慢慢移除蠟的殘留。

Indirect heat softened the wax and allowed the lining to be slowly removed.

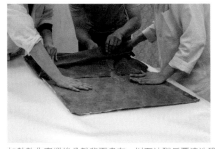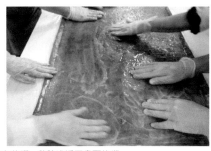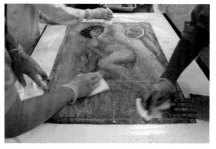

加熱軟化蜜蠟後分離背面畫布，以石油醚反覆清洗殘留的蠟，移除滲透至畫面的蠟
After an application of heat softened the wax and allowed removal of the lining, petroleum spirits (petrol) were used to remove residual wax that had penetrated to the painting recto

清洗前Before cleaning 清洗後After cleaning

6. 畫布邊緣補強 Applying strip linings and reinforcement

將畫布邊緣因鐵鏽腐蝕劣化的部分強化處理，以修復用可逆性熱熔黏著劑（BEVA 371）搭貼覆天然亞麻布強化並固定在擴撐器上。確認畫面顏料層已穩定後，即可移除保護紙。

Because the original tacking edges had deteriorated due to rust, new linen strip linings were adhered to the four edges with BEVA 371. The painting was then temporarily stretched onto a strainer to maintain planarity. Once the paint layer was stabilized, the temporary paper facings were removed.

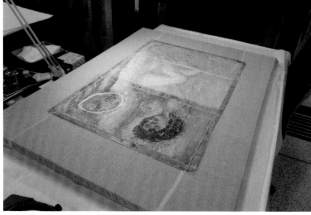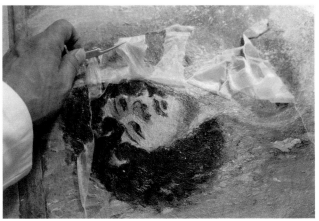

固定於擴撐器上全面性地調整變形
Painting is temporarily stretched onto an expandable stretcher and flattened

使用淨水濕潤保護紙後移除
Water was used to soften and remove the facing

7. 畫布變形修正 Reducing canvas support distortions

畫布變形須透過擴撐器調整矯正，同時以加溫加壓方式處理畫作正、背面的每道龜裂痕。

Reducing canvas support distortions requires not only adjusting the painting on an expandable stretcher, but also requires adding heat and pressure to treat crack distortions on the painting recto and verso.

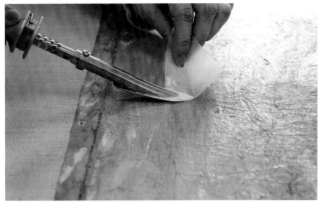

以可溫控小頭熨斗撫平龜裂背面
A small iron was used to flatten distortions

畫布嚴重龜裂
Severe cracking in the canvas support

慢慢潮濕軟化龜裂痕
Slowly humidifying and softening cracks

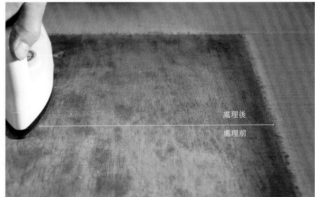

處理後
處理前

加溫加壓下安全地整平畫布與龜裂
Adding heat and pressure to carefully flatten canvas and cracks

8. 新內框與非黏合式的加襯作業 Applying new inner frame and loose lining

先在新的可調整式卡榫內框繃上一層裡布後再將之加襯於畫作背面以支撐作品，可因應原畫布因氣候收縮鬆動且達到作品穩固。

A cotton sheet was stretched onto the inner frame to act as a secondary support for the painting and provide stability against climate-induced shrinkage or warping.

測量尺寸後，裁切搭邊的畫布
Cutting the edges of the painting after measuring the appropriate width

將畫作與加襯裡布的內框結合固定
After stretching cotton lining and painting on inner frame

9. 填充整形 Filling losses

於顏料層剝落處填入水溶性補土（動物膠調和Gesso石膏），再按畫面肌里筆觸進行破損處的表面形體塑造。

Areas of paint loss were filled with a water-soluble material (animal glue and gesso) and textured.

於顏料缺損處補土
Filling areas of paint loss

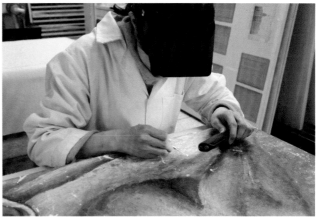

以側面光源輔助補土的表面肌理塑造
Using raking illumination to help texture the fill

10. 全色補彩 Inpainting

先以水彩進行補彩作業後，再將畫面全面性塗刷凡尼斯做為補彩前的隔離層。待乾燥後再以溶劑型的壓克力顏料進行色調整合。

First, watercolors are used to inpaint the fills, followed by applying the first varnish coating. After fully dried, acrylic paints are used to complete inpainting.

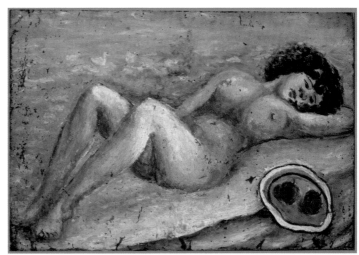

全色補彩後（全幅 | 紫外光）
After inpainting (Overall | UV radiation)

前次補彩，嚴重溢塗覆蓋原彩（局部 | 紫外光）
Previously applied overpaint severely obscuring original paint (Detail | UV radiation)

本次全色補彩（局部 | 紫外光）
Current inpainting (Detail | UV radiation)

11. 凡尼斯保護層 Protective varnish layer

畫面修復完成後，再次噴塗達瑪凡尼斯保護層，全面性的整合畫面光澤以達均勻一致。

After the painting completed treatment, a protective layer of damar varnish was sprayed on the painting for an even surface luster.

III. 修復前後對照 Before and after treatment

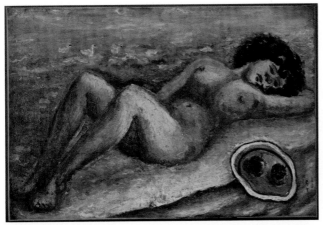

修復前Before treatment

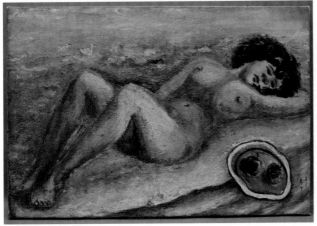

修復後After treatment

· 上海江南製船所 Shanghai Jiangnan Shipyard

I. 修復前狀態 Before treatment condition

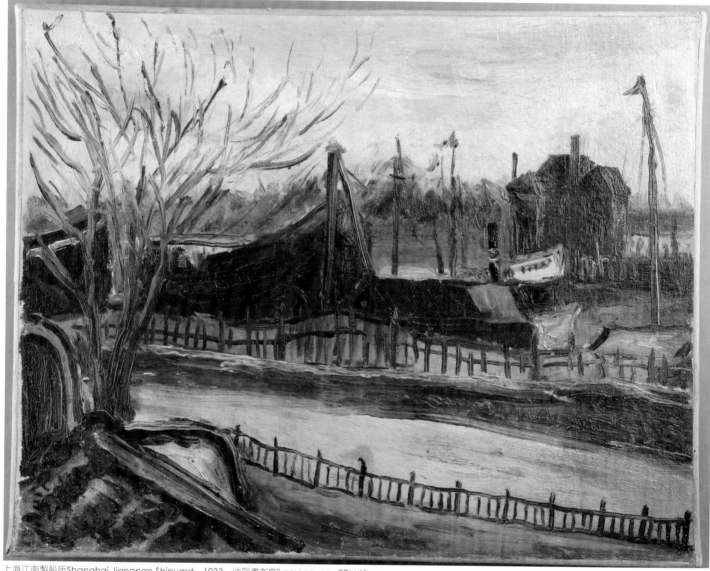

上海江南製船所Shanghai Jiangnan Shipyard　1933　油彩畫布Oil on canvas　32×41cm

修復紀錄 Conservation history

　　□未曾修復Not treated ■曾修復Previously treated：2011年

凡尼斯層 Varnish（□無None ■有Yes）

　　■黃化Yellowing □黴害Mold damage ■塗佈不均Uneven □其他Other

繪畫層 Paint layer

　　■灰塵髒污Surface dirt □黴害Mold damage □水害Water damage

　　□蟲害Insect damage（昆蟲排遺accretion、啃蝕破損loss）

　　■龜裂Craquelure（乾燥drying cracks、經年age cracks、損傷damage）■起翹Lifting ■剝落Flaking □粉化Friable

　　□擦傷Abrasion □撞傷Compression damage □燒傷Fire damage □割傷Cuts

　　□破洞Loss ■舊補彩Inpaint ■畫布變形Canvas distortion □附著物Foreign accretion

　　■其他Other：畫布四邊封固紙膠發黃滲膠Four tacking edges are sealed with yellowed paper tape

打底層 Canvas

　　■既成畫布Commercial canvas □自製畫布Self-prepared canvas（□無None □有Yes）

基底材 Primary support

　　□木板Wood panel■畫布Canvas（麻布、平織Plain weave linen）□其他Other

內框 Inner frame

　　□無None □固定式內框Strainer ■可調整式卡榫內框Stretcher（■楔子Keys）

　　1. 此作品2011年修復過，修復完成後塗佈凡尼斯保護層，並於畫布四邊以紙膠貼覆封固。紙膠已經發黃明顯滲出嚴重膠漬，致使因紙膠保護的畫作四邊（白色打底層）反被沾黏受損。

This painting was treated in 2011, during which a varnish layer was applied and the four tacking edges were sealed with paper tape. The tape has yellowed and caused severe staining, and because remained very tacky, during removal it also removed some of the original white ground layer.

　　2. 凡尼斯層已有黃化光澤與塗佈不均等問題、缺損處的舊補彩多數溢塗覆蓋到周圍原彩。

The unevenly applied varnish layer has yellowed, and old overpaint from areas of paint loss covered original paint.

II. 修復作業內容 Conservation treatments

1. 修復前攝影 Before treatment examination and documentation

　　作品修復前的整體狀況紀錄及調查。修復前進行可見光（正光、側光）、非可見光（紅外光與紫外光）、X光攝影作業與非破壞性X螢光光譜儀（XRF）輔助分析顏料成份。透過上述不同特殊光源的攝影技術交互比對下，全面性了解畫作材質及損傷的狀態。

Before treatment examination and documentation of the work of art was carried out and included visible illumination (normal, raking illumination) and non-visible radiation (infrared and UV radiation) photography, x-radiography, and x-ray fluorescence spectroscopy for the pigment identification. Comparison of these photographic and analytical results allowed the conservators to understand the work's materials and physical condition.

正光（背面）Normal illumination (Verso)
紙膠發黃滲膠 Yellowed tapes

紅外光Infrared radiation
鉛筆字跡「上海江南製船所」Pencil inscription "Shanghai Jiangnan Shipyard"

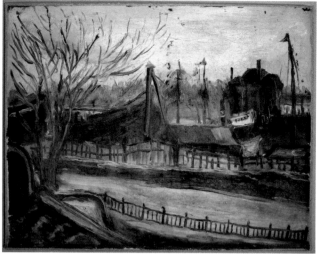

X光 X-radiography
底稿構圖無變動，顏料缺損多發生於四周
The original composition is the same as the final composition. Paint damage occurs mostly along the four edges of the painting.

紫外光 UV radiation
判斷有凡尼斯層與補彩
Evidence of varnish layer and inpaint

紫外光下呈現霧白的凡尼斯層
Varnish fluoresces white under UV radiation

凡尼斯塗佈不均
Uneven varnish application

補彩處的辨別
Inpaint is discernable from original paint

2. 狀況檢視登錄與修復計畫擬定 Condition report and treatment proposal

作品基本資料調查（尺寸、畫布經緯、凡尼斯保護層與損傷現狀等）、表面顏料溶劑測試。以此為基礎，對作品現有損傷狀況提出合適的修復處理內容。

The work of art's basic information (dimensions, weft and weave of canvas support, damage) was recorded, and the paint layer underwent solvent testing. Based upon this information and the work's present condition, an appropriate treatment methodology was proposed.

3. 移除劣化的封邊紙膠 Removing deteriorated paper tapes

將黃化發黏的紙膠以水潤濕
Softening the yellowed paper tapes with water

輕慢地移除紙膠
Slowly removing the paper tapes

局部性的封固保護顏料層
Localized facing

拔除繃釘分離畫布與內框
Removing nails to separate painting from inner frame

搭邊的黏著劑沾黏內框
Excess adhesive from the added edge lining adhered onto the inner frame

4. 暫時性顏料封固與拆框解體 Temporary facing of paint layer and separation of painting from inner frame

使用典具帖封固保護脆弱的顏料層，以確保拆除框體及作業時避免顏料層脫落受損。在拆除內框作業時發現前次修復者對於材料使用未能以穩定的技術掌控，導致高濃度且過量的液態黏著劑溢出沾黏內框與畫布。

A tengujo paper facing was used to protect the fragile paint layer to ensure that there would be no damage or loss to the paint layer during the painting's separation from its inner frame. During the separation from the inner frame it was found that the previous conservator did not have control over the materials used, resulting in overly thick and excess adhesive accumulation on the inner frame and canvas.

移除前次不當的畫布搭邊：先刮除表面過量的溢膠並以溶劑輔助清洗殘留膠漬
Removing inappropriately applied strip linings: after excess adhesive is scraped off, the remaining residues are cleaned with solvents

5. 畫布邊緣補強 Applying strip linings and reinforcement

將脆弱的畫布邊緣強化處理，以修復用可逆性熱熔片（BEVA 371）黏著劑於畫布邊緣搭貼天然亞麻畫布以達補強目的後，再暫時固定於木框撐平畫作，並確認畫面顏料層已穩定狀態下移除暫時性保護紙。

In order to strengthen the weakened canvas tacking edges, new linen strip linings were adhered to the four edges

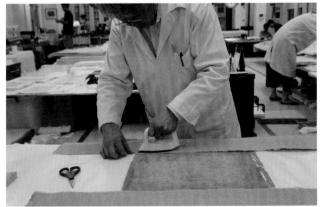

搭接畫布邊條Adhering strip linings

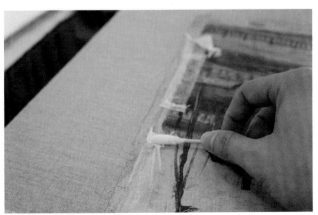

移除顏料上保護紙Removing temporary facing

with BEVA 371. The painting was then temporarily stretched onto a strainer and slowly flattened. After the paint layer was stabilized, the temporary facing was removed.

6. 移除舊補彩、黃化凡尼斯層 Removing old overpaint and yellowed varnish

經表面顏料的溶劑測試後，決定移除凡尼斯層與舊補彩的清洗溶劑。之後以低濃度的稀釋氨水全面清潔畫面的灰塵污垢。

After solvent testing, an appropriate solvent was selected to remove varnish and old overpaint. Dilute ammonia was then used to remove surface dirt and accretions.

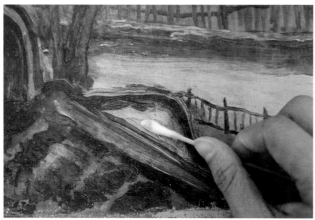

移除黃化的凡尼斯層Removing yellowed varnish

清潔前後對照Before and after cleaning

7. 重新繃於新內框 Stretching onto a new inner frame

將作品重新繃於新的可調整式卡榫內框上。

The painting was stretched onto a new wooden stretcher.

8. 填充整形與全色補彩 Filling losses and inpainting

於顏料層剝落處填入水溶性補土（動物膠調和Gesso石膏），再按畫面肌里筆觸進行破損處的表面形體塑造。以水彩進行補彩底色作業，再將畫面全面性塗刷凡尼斯做為補彩前的隔離層。待乾燥後以溶劑型的壓克力顏料進行色調整合。

Areas of paint loss were filled with a water-soluble material (animal glue and gesso) and textured. After a base tone

加熱軟化畫布四邊Using heat to soften the tacking edges

繃框作業Stretching onto the stretcher

was applied to the filled areas with watercolors, an overall varnish coating was applied. After the varnish fully dried, acrylic paints were used to complete the inpainting.

9. 凡尼斯保護層 Protective varnish layer

畫面修復完成後，再次噴塗達瑪凡尼斯保護層，全面性的整合畫面光澤以達均勻一致。

After the painting completed treatment, a protective layer of damar varnish was sprayed on the painting for an even surface luster.

補土作業中 Filling losses

III. 修復前後對照 Before and after treatment

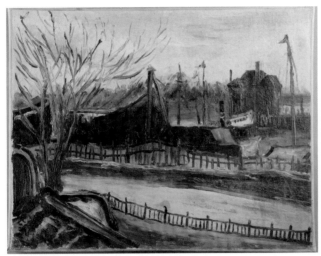

修復前Before treatment

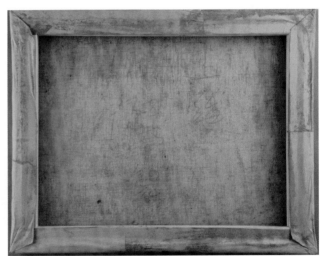

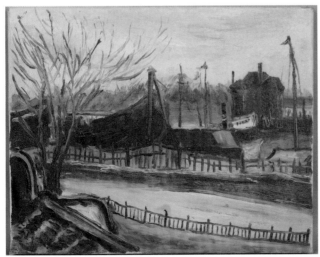

修復後After treatment

167

第三類型修復：木板與紙板
Treatment category 3: Oil paintings on wood panel and paper board

· 街道 Street

I. 修復前狀態 Before treatment condition

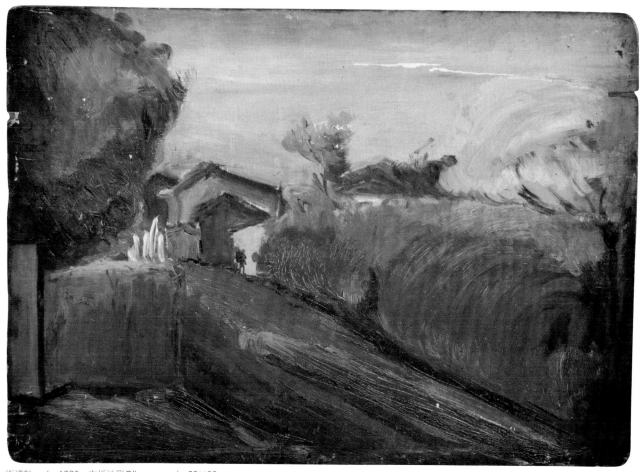

街道Street　1925　木板油彩Oil on wood　23×33cm

修復紀錄 Conservation history

　　■未曾修復Not treated □曾修復Previously treated

凡尼斯層 Varnish（□無None ■有Yes）

　　■黃化Yellowing □黴害Mold damage □塗佈不均Uneven □其他Other

繪畫層 Paint layer

■灰塵髒污Surface dirt ■黴害Mold damage □水害Water damage

■蟲害Insect damage（昆蟲排遺accretion、啃蝕破損loss）

■龜裂Craquelure（乾燥drying cracks、經年age cracks、損傷damage）■起翹Lifting ■剝落Flaking □粉化Friable

■擦傷Abrasion ■撞傷Compression damage □燒傷Fire damage □割傷Cuts

■破洞Loss □舊補彩Inpaint □變形Distortion ■附著物Foreign accretion □其他Other

打底層 Canvas

□既成畫布Commercial canvas □自製畫布Self-prepared canvas（□無None □有Yes）

基底材 Primary support

■木板Wood panel□畫布Canvas（麻布、平織Plain weave linen）□其他Other

內框 Inner frame

■無None □固定式內框Strainer □可調整式卡榫內框Stretcher（□楔子Keys）

1. 此作以油彩繪製於木板上，背面有以鉛筆寫「1925.3.作」，和藍色原子筆寫「風景」兩字。

Th is oil painting is painted on wood panel. On the back of the panel is a pencil inscription [1925.3], and a blue ink inscription [Landscape 風景].

2. 木板形製特殊厚度約0.5cm，長方形面板、背面兩側短邊經斜面處理。油畫木板與攜帶箱為相互搭配使用的組件，為陳澄波於東京美術學校時期購置使用。經採取非破壞性鑑定方式針對木材橫切面組織調查與比對，鑑定為徑切面的臺灣特有「紅檜」樹種。

The uniquely shaped rectangular wood panel is approximately 0.5cm thick, with bevels on the verso s hort edges. The wood panel and its carrying case are a matching set, and were used by Chen Cheng-po while he was a student at the Tokyo Fine Arts School. Non-destructive analysis of the wood panel's cross section identified it as Taiwanese cypress, a tree unique to Taiwan.

3. 作品的基底材些許變形、邊緣缺損與裂痕；背面沾黏不明碎紙與髒污，左方有道較大的缺損處。顏料層有全面性髒污、昆蟲排遺與黴斑，另有起翹剝落的情形且遍布細小的龜裂痕。

The wood support suffers from warping, cracks, and losses along its edges. There are small paper remnants and accretions adhered to the panel verso, and a large loss at the verso left side. There is overall surface dirt, insect accretions, mold foxing spots, as well as paint cleavage and small cracks along the panel edge.

4. 經紅外光初步檢視發覺底層構圖有變動，透過X光明顯可見不同的底層構圖。

Infrared radiation reveals that the original composition was changed, which was confirmed with x-radiography.

II. 修復作業內容 Conservation treatments

1. 修復前攝影 Before treatment examination and documentation

作品修復前的整體狀況紀錄及調查。修復前進行可見光（正光、側光）、非可見光（紅外光與紫外光）、X光攝影作業與非破壞性X螢光光譜儀（XRF）輔助分析顏料成份。透過上述不同特殊光源的攝影技術交互比對下，全面性了解畫作材質及損傷的狀態。

Before treatment examination and documentation of the work of art was carried out and included visible illumination

正光（背面）Normal illumination (Verso)

斜邊Beveled edge

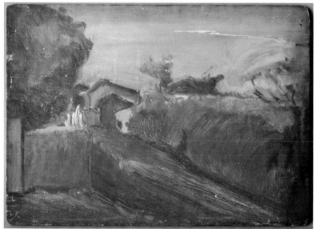

側光Raking illumination
顏料層嚴重龜裂Severe cracking in paint layer

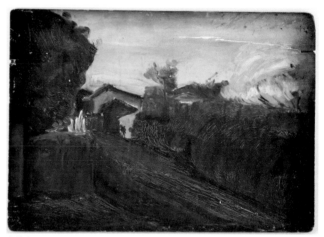

紫外光UV radiation
判斷後有後加凡尼斯層Evidence of varnish layer

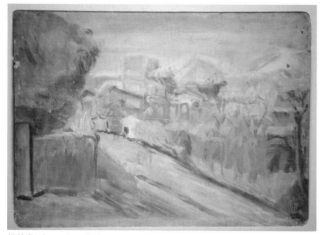

紅外光Infrared radiation
初步判斷畫作底層構圖有變動The original composition was changed

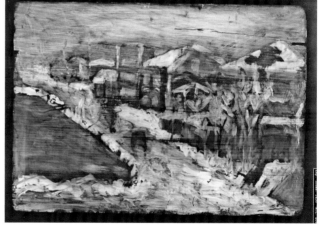

X光X-radiography
底層構圖已不同
Underlying composition is different

(normal, raking illumination) and non-visible radiation (infrared and UV radiation) photography, x-radiography, and x-ray fluorescence spectroscopy for the pigment identification. Comparison of these photographic and analytical results allowed the conservators to understand the work's materials and physical condition.

2. 狀況檢視登錄與修復計畫擬定 Condition report and treatment proposal

作品基本資料調查（尺寸、畫布經緯、凡尼斯保護層與損傷現狀等）、表面顏料溶劑測試。以此為基

礎，對作品現有損傷狀況提出合適的修復處理內容。

The work of art's basic information (dimensions, weft and weave of canvas support, damage) was recorded, and the paint layer underwent solvent testing. Based upon this information and the work's present condition, an appropriate treatment methodology was proposed.

3. 清潔與加固顏料層 Cleaning and paint consolidation

以沾有淨水的棉棒清潔表面附著物與裂痕內的灰塵。利用動物膠填入翹起的顏料層間，再以控溫熨斗使顏料層密合。

A cotton swab moistened with water was used to remove surface accretions and dust. Animal glue was applied to flaking paint and set down using gentle heat.

清潔畫作表面Surface cleaning

加固顏料層Paint consolidation

4. 清潔基底材 Cleaning the primary support

使用修復用海綿清潔木板背面並將附著物移除，再以棉棒沾淨水清潔表面的灰塵髒污。謹慎控制清潔水量避免木板吸收過多水分而潮濕變形。

Conservation-use sponges were used to clean the wood panel verso and remove surface accretions, and a cotton swab moistened with water was used to remove surface dirt. Water application was carefully controlled to avoid too much water absorption by the wood panel, causing warping.

乾式清潔木板表面灰塵
Dry cleaning the wood panel to remove surface dirt

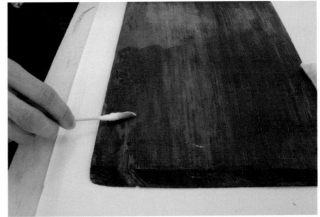

以濕棉棒輕移表面髒污
Moistened cotton swab is used to remove surface accretions

將木屑與無酸樹脂調和
Mixture of sawdust with neutral pH adhesive

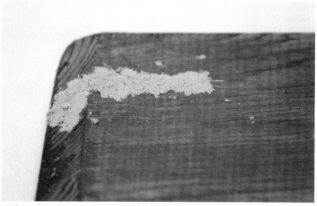
缺損處填補均勻
Filled losses

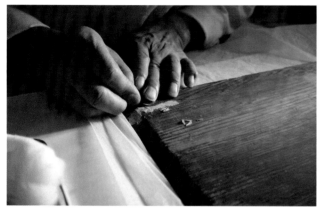
以刀片修整填補處
A blade is used to scrape the excess filling material

以溶劑型的壓克力顏料補彩
Acrylic paints are used to inpaint the fill

5. 填補缺損處 Filling losses

將木屑調和無酸樹脂作為填補木板缺損處的材料，待完全乾燥後再整平與補彩。

Sawdust is mixed with neutral pH adhesive to make the filling material. After the losses are infilled and fully dried, the surface is evened out and inpainted.

6. 填充整形 Filling losses

於顏料層剝落處填入水溶性補土（動物膠調和Gesso石膏），再按畫面肌里筆觸進行破損處的表面形體塑造。

Areas of paint loss were filled with a water-soluble material (animal glue and gesso) and textured.

正面缺損處亦以木屑充填後補土 Losses are filled with sawdust

補土的表面肌理塑造 Texturing the fill

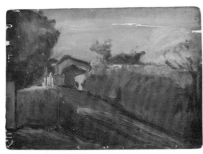
補土後、全色補彩前
After filling, before inpainting

塗佈凡尼斯隔離層
Applying barrier varnish layer

補彩中Inpainting

7. 全色補彩 Inpainting

先以水彩進行補彩作業,再將畫面全面性塗刷凡尼斯做為補彩前的隔離層。待乾燥後再以溶劑型的壓克力顏料進行色調整合。

First, watercolors are used to inpaint the fills, followed by applying the first varnish coating. After fully dried, acrylic paints are used to complete inpainting.

8. 凡尼斯保護層 Protective varnish layer

畫面修復完成後,再次噴塗達瑪凡尼斯保護層,全面性的整合畫面光澤以達均勻一致。

After the painting has completed treatment, a protective layer of damar varnish was sprayed on the painting for an even surface luster.

III. 修復前後對照 Before and after treatment

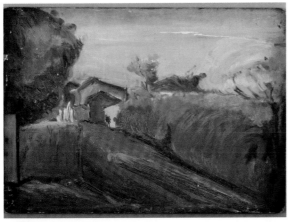

修復前Before treatment

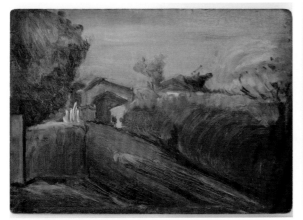

修復後After treatment

• 帆船A Sailboat

I. 修復前狀態 Before treatment condition

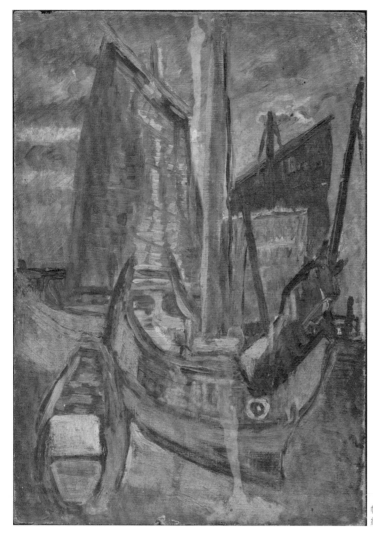

帆船A Sailboat 年代不詳Date unknown
紙板油彩Oil on paper board 32.9×23.4cm

修復紀錄 Conservation history
　　　■未曾修復Not treated □曾修復Previously treated

凡尼斯層 Varnish（■無None □有Yes）
　　　□黃化Yellowing □黴害Mold damage □塗佈不均Uneven □其他Other

繪畫層Paint layer
　　　■灰塵髒污Surface dirt ■黴害Mold damage ■水害Water damage
　　　■蟲害Insect damage（昆蟲排遺accretion、啃蝕破損loss）
　　　■龜裂Craquelure（乾燥drying cracks、經年age cracks、損傷damage）■起翹Lifting ■剝落Flaking □粉化Friable
　　　■擦傷Abrasion ■撞傷Compression damage □燒傷Fire damage □割傷Cuts
　　　■破洞Loss □舊補彩Inpaint □變形Distortion ■附著物Foreign accretion □其他Other

打底層 Canvas
　　　□既成畫布Commercial canvas □自製畫布Self-prepared canvas（□無None □有Yes）

基底材 Primary support

　　□木板Wood panel□畫布Canvas（麻布、平織Plain weave linen）■其他Other：紙板Paper board

內框 Inner frame

　　■無None □固定式內框Strainer □可調整式卡榫內框Stretcher（□楔子Keys）

　　1. 本件作品為繪製於畫布板上的油畫。紙板的單面黏貼畫布，稱為畫布板，提供畫家一種攜帶方便、堅固的油畫載體。作品的正反面沒有註明年代或標記落款。

This oil painting is painted on a canvas panel. A sheet of canvas is adhered to one side of the paper board, thus leading to the name 'canvas panel.' It is a portable, convenient, and sturdy oil painting support. There are no signatures nor inscriptions on the verso indicating the date painted.

　　2. 為初次修復，無後加的凡尼斯保護層。作基底材輕微彎曲，畫面佈滿灰塵與髒污，局部有黴斑。畫面有明顯的水漬痕跡且因無凡尼斯層的保護，水害濕氣直接致使顏料層霧白、變色。

Because this is the first time the painting has undergone conservation treatment, there was no previous varnish application. The primary support is slightly warped, and the painting has an overall coating of surface dirt and accretions, and localized foxing. There are visible tidelines, and due to the lack of a varnish, water penetrated directly into the paint layer causing a white surface haze and color change.

　　3. 顏料層的附著力尚好，但四邊的顏料與打底層皆有磨損剝落，局部已露出基底材，紙層有分離、空鼓的情形。背面有大面積缺損與顏料沾附。

The paint layer is very stable, but the painting suffers from physical problems including abrasion of both the paint and ground layers along the four edges, exposed primary support, delamination of the paper board. There is a large loss and non-image paint accretion on the panel verso.

II. 修復作業內容 Conservation treatments

1. 修復前攝影 Before treatment examination and documentation

　　作品修復前的整體狀況紀錄及調查。修復前進行可見光（正光、側光）、非可見光（紅外光與紫外

正光（背面）
Normal illumination (Verso)

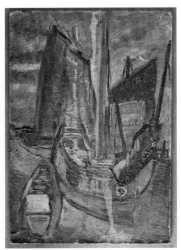

側光Raking illumination
許多摺痕、裂痕
Many creases and cracks

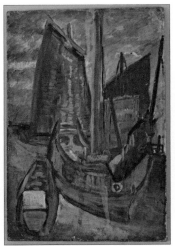

紫外光UV radiation
判斷無凡尼斯層與補彩
Evidence of varnish layer and inpaint

紅外光Infrared radiation
水害造成漬痕深入畫作內
Water damage has caused tidelines to affect the paint layer

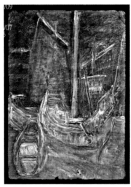

X光X-radiography
底層構圖無變動
The original composition
is the same as the final
composition

因水害導致顏料變色
Water damage has caused color changes

基底材撞傷，顏料層許多裂痕
Abrasion to primary support, and many cracks in the
paint layer

光）、X光攝影作業與非破壞性X螢光光譜儀（XRF）輔助分析顏料成份。透過上述不同特殊光源的攝影技術交互比對下，全面性了解畫作材質及損傷的狀態。

Before treatment examination and documentation of the work of art was carried out and included visible illumination (normal, raking illumination) and non-visible radiation (infrared and UV radiation) photography, x-radiography, and x-ray fluorescence spectroscopy for the pigment identification. Comparison of these photographic and analytical results allowed the conservators to understand the work's materials and physical condition.

2. 狀況檢視登錄與修復計畫擬定 Condition report and treatment proposal

作品基本資料調查（尺寸、畫布經緯、凡尼斯保護層與損傷現狀等）、表面顏料溶劑測試。以此為基礎，對作品現有損傷狀況提出合適的修復處理內容。

The work of art's basic information (dimensions, weft and weave of canvas support, damage) was recorded, and the paint layer underwent solvent testing. Based upon this information and the work's present condition, an appropriate treatment methodology was proposed.

3. 表面清潔與加固 Surface cleaning and consolidation

先清除背面沾的灰塵與髒汙，再將邊緣翹起與分離的紙層黏著固定。

After surface dirt and accretion was removed from the verso, flaking paint along the edges and delaminated paper layers were set down with adhesive.

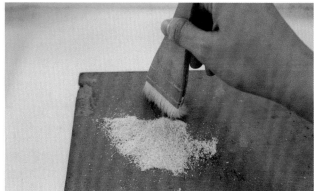
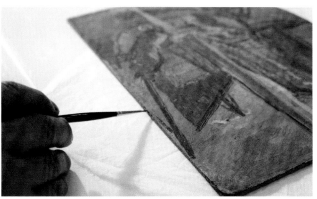

使用粉末橡皮擦與毛刷清潔髒污
Eraser crumbs and a soft sheep's hair brush are used to remove accretions

以甲基纖維素混合漿糊黏合分離的紙層
A mixture of methyl cellulose and wheat starch paste is used to readhere delaminated paper board

4. 基底材缺損填補 Filling support losses

因基底材是以紙張與畫布組合而成，評估後選用具有年代舊書的內部材料最為合適，材質與紙力結構等皆經過長時間自然老化性質已趨於穩定。

Because the primary support is a combination of paper and canvas, the conservators decided that the most appropriate filling material was from old books. These books' material, strength, and construction have naturally aged and stabilized over time.

以舊書作為填補缺損處的材料
Old books are used as the source filling materials

取書脊的寒冷紗和封面厚紙板
Mull fabric from the book spine and thick cover board are used as filling materials

5. 填補紙材製作與黏著劑調配 Making filling material and adhesive

把書皮厚紙板分層撕開至適合的厚度，將甲基纖維素與修復漿糊1:1調和作為黏著劑。謹慎控制水份避免濕氣影響作品基底材而引起紙板受潮變形。

The cover board was shaved down to an appropriate thickness, and methyl cellulose was mixed with wheat starch paste in a 1:1 ratio. Moisture was carefully controlled to avoid deformations of work of art.

取下書面具有厚度的紙材
182 Separated thick book cover

紙材沾取甲基纖維素與漿糊調勻的黏著劑
Paper is mixed with methyl cellulose and wheat starch paste adhesive

6. 填補背面缺損 Filling losses on support verso

　　取小塊紙張攪成泥狀，將細小的凹洞先填滿，再由小而大循序堆覆，僅需將缺損處填補到足夠支撐媒材即可，過多反而讓水氣乾燥緩慢，甚而影響作品的安全。

Small pieces of paper were made into a slurry and filled into losses starting from small to large. Just enough of the paper slurry was used to fill the losses and support the board, as filling too much would introduce too much moisture, causing structural harm to the work of art.

將填補紙材放入缺損處
Inserting the paper slurry into a loss

以紙鎮與吸水紙重壓填補處
The filled losses are pressed with blotting paper and weights

7. 填補與清潔畫面 Filling losses and surface cleaning

　　將寒冷紗剪切成合適於缺損處的尺寸，並使寒冷紗的纖維經緯與畫布板紋路對齊一致後填補。待填補處完成乾燥後，以棉棒沾淨水將畫面的灰塵與附著物清除。

The mull fabric was cut to an appropriate size, and after comparing the weave pattern of the mull with that of the painting's canvas support, it was inserted into the losses.

將寒冷紗貼於缺損處
Filling the loss with mull fabric

清潔畫面髒污
Removing surface accretions

8. 填充整形 Filling losses

於顏料層剝落處填入水溶性補土（動物膠調和Gesso石膏），再按畫面肌里筆觸進行破損處的表面形體塑造。

Areas of paint loss were filled with a water-soluble material (animal glue and gesso) and textured.

缺損處填入補土
Filling losses

補土的表面肌理塑造
Texturing the fills

9. 全色補彩 Inpainting

補土處先以水彩進行補彩作業，再將畫面全面性塗刷凡尼斯做為補彩前的隔離層。待乾燥後再以溶劑型的壓克力顏料進行色調整合。

After a base tone was applied to the filled areas with watercolors, an overall varnish coating was applied. After the varnish fully dried, acrylic paints were used to complete the inpainting.

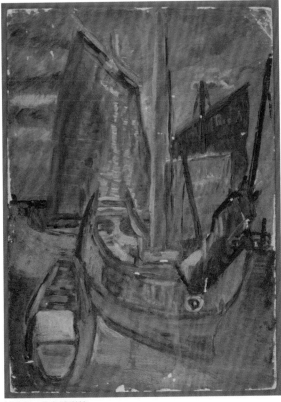

補土後，全色補彩前
After filling, before inpainting

塗佈凡尼斯作為隔離層
Applying barrier varnish layer

使用溶劑型壓克力顏料補彩
Inpainting with acrylic paints

10. 凡尼斯保護層 Protective varnish layer

畫面修復完成後，再次噴塗達瑪凡尼斯保護層，全面性的整合畫面光澤以達均勻一致。

After the painting has completed treatment, a protective layer of damar varnish was sprayed on the painting for an even surface luster.

III. 修復前後對照 Before and after treatment

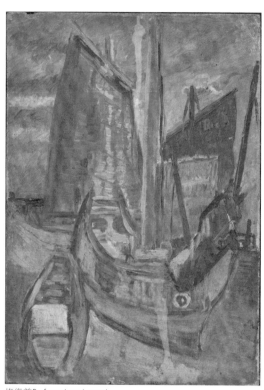

修復前Before treatment

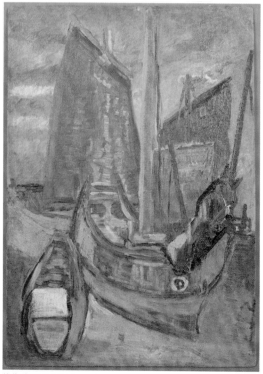

修復後After treatment

油畫作品
Oil Paintings

修復前後對照
Before and After Treatment

國立臺灣師範大學文物保存維護研究發展中心
National Taiwan Normal University Research Center for Conservation of Cultural Relics

第1類型修復：初次修復
Treatment category 1: First time treatment

每件作品以修復前和修復後做為對照，共四張圖。
修復前置於上方、修復後置於下方。

① 無凡尼斯層 No varnish

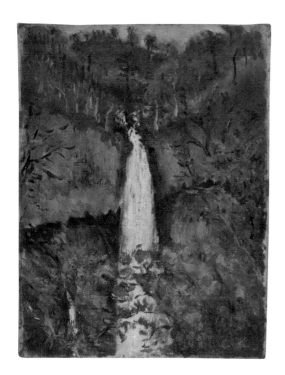

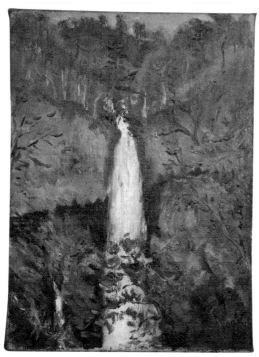

日光華嚴瀑布 Kegon Waterfall

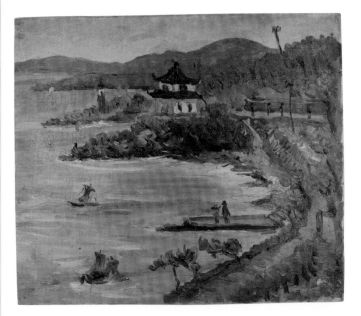

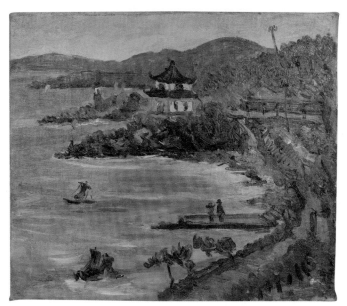

湖畔 Lakeside

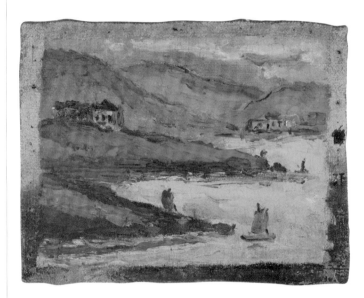

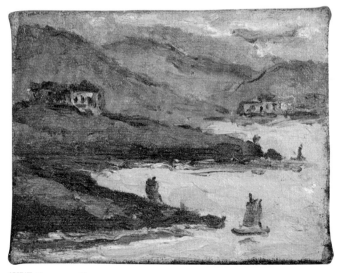

朝陽洞 Chaoyang Cave

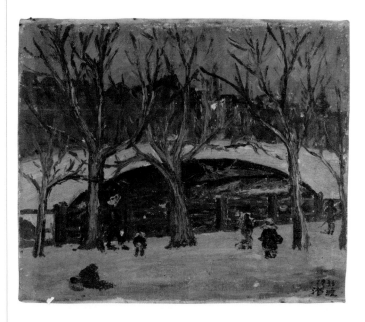

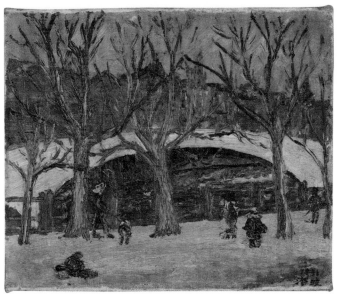

上海雪景 Shanghai in Snow

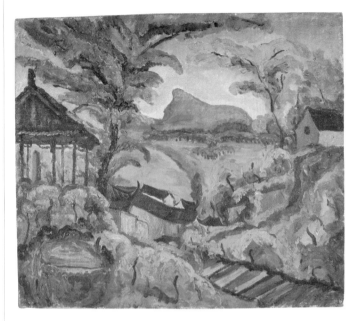

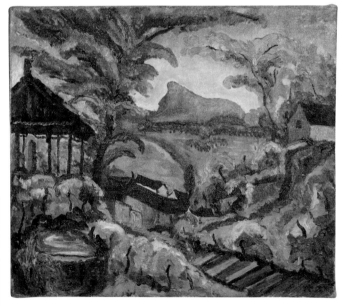

亭側眺望 Distant View from Side of Pavilion

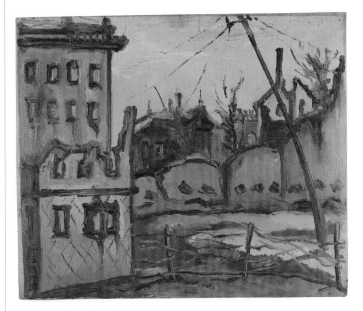

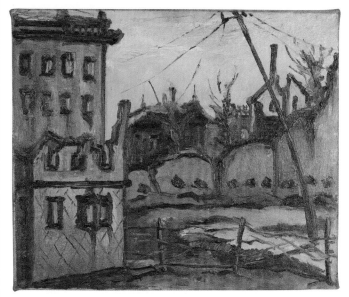

戰災（商務印書館側）War Devastation (Beside the Commercial Press Building)

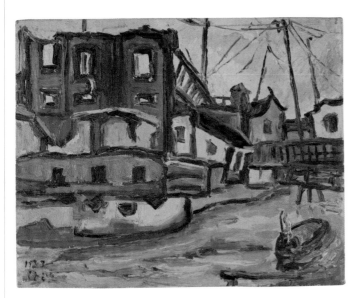

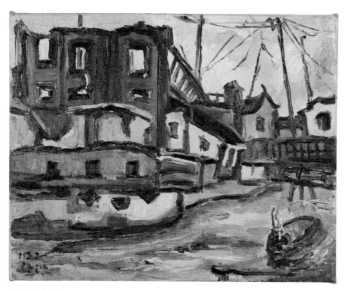

戰後（一）After a War (1)

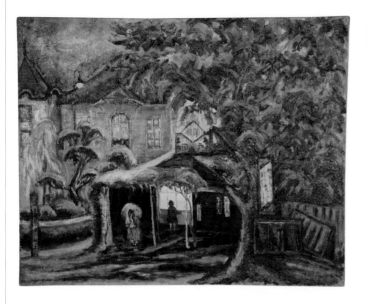

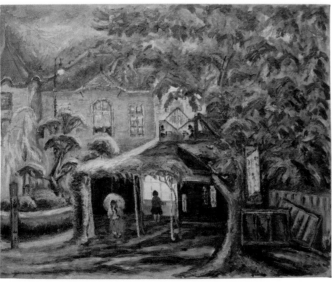

綠蔭 Foliage

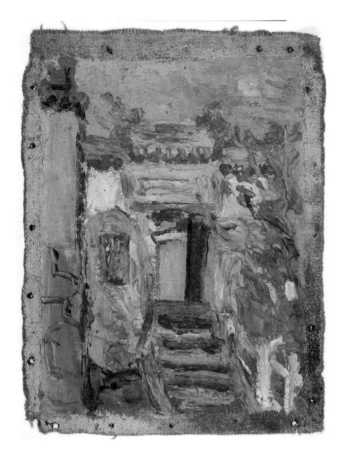

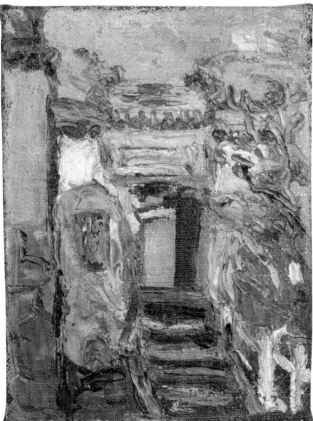

古門樓 Ancient Gate Tower

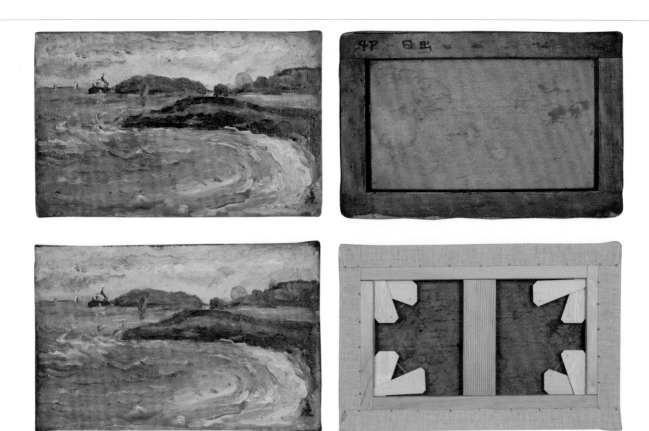

海灣 Bayside

② 後加凡尼斯或補彩 Varnish or inpainting

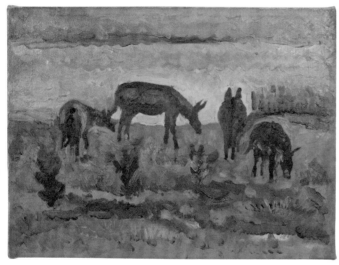

普陀山群驢 Donkeys at Putuo Mountain

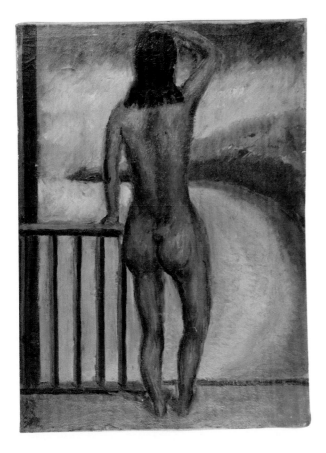

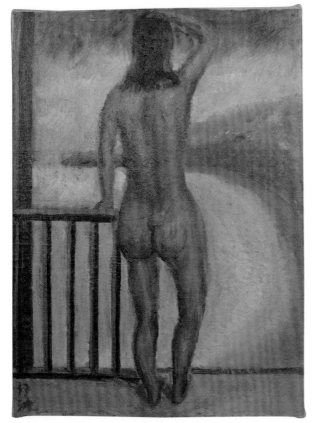

陽台遙望裸女 Nude Female Looking Out

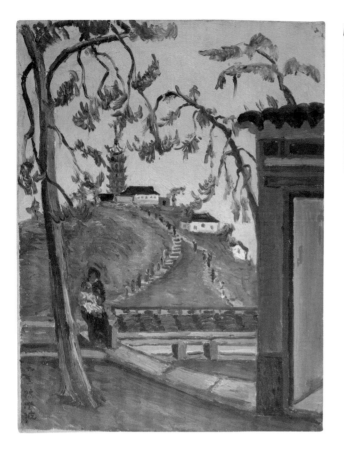

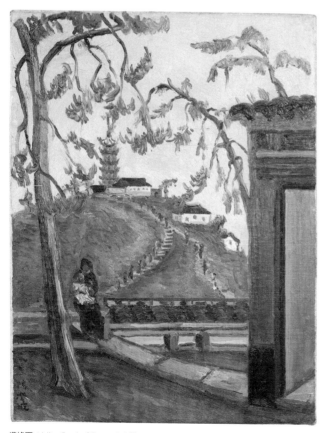

塔峰下 At the Foot of Pagoda Hill

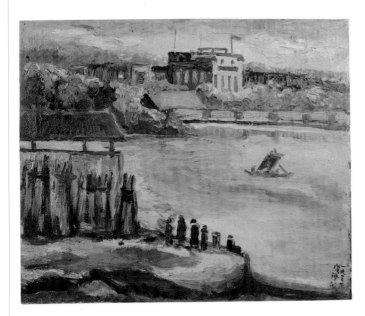

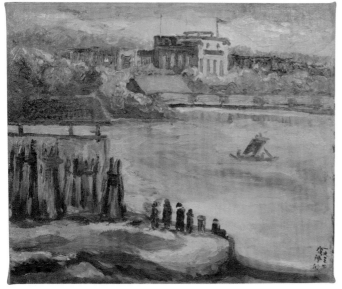

河岸 Riverside

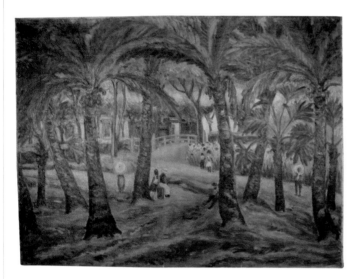

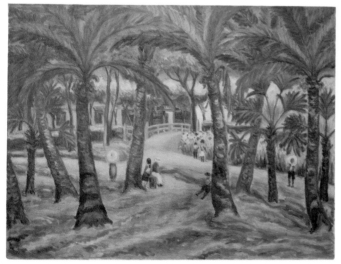

椰林 Coconut Grove

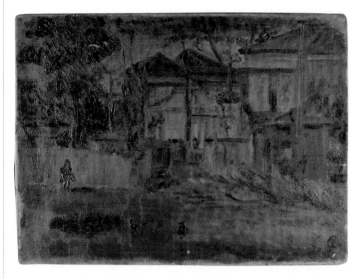

郊區風景 Rural Scene

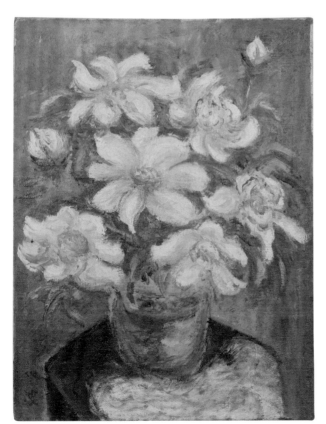

大白花 Big White Flowers

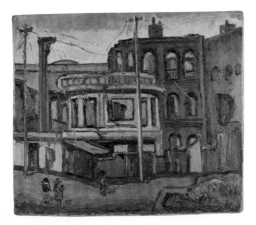

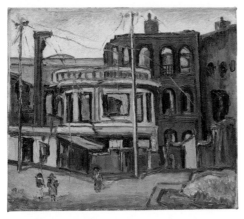

戰災（商務印書館正面）War Devastation (Front of the Commercial Press Building)

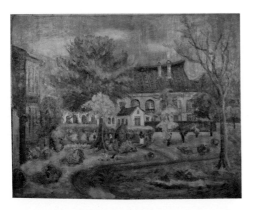

新樓庭院 Courtyard in Sin-Lau

第二類型修復：再修復
Treatment category 2: Previously treated

每件作品以修復前和修復後做為對照，共四張圖。
修復前置於上方、修復後置於下方。

屏椅立姿裸女 Standing Nude Female Leaning Against a Chair

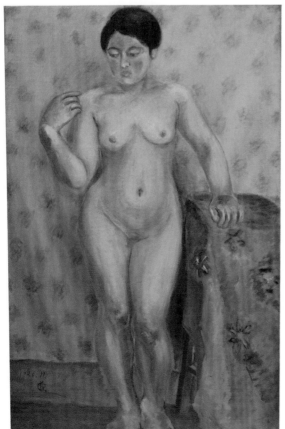

搭肩裸女 Nude Female with Hand on Shoulder

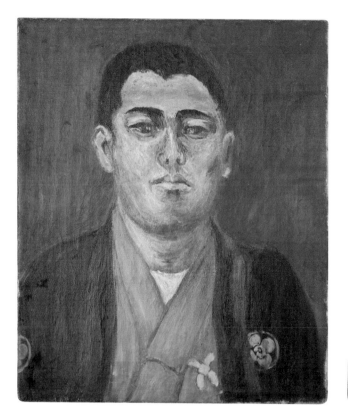

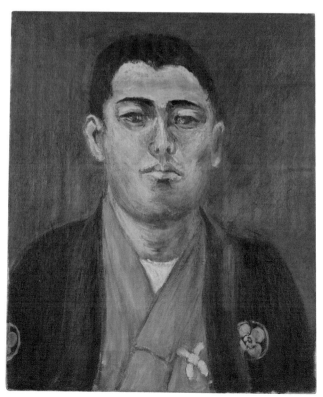

和服男子 Man in Kimono

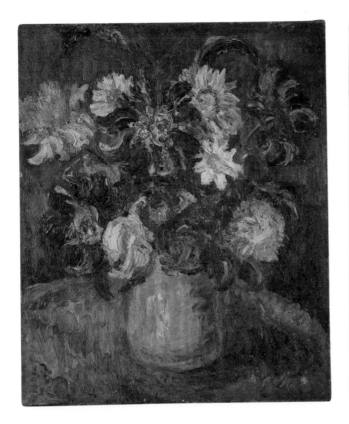

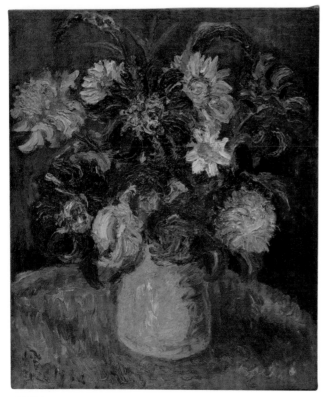

綠瓶花卉 Flowers in a Green Vase

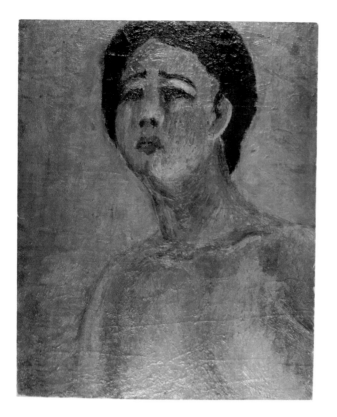

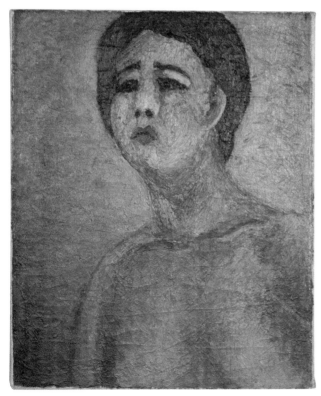

半身裸女 Half-length Portrait of Nude Female

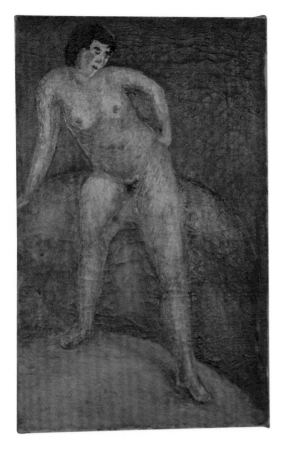

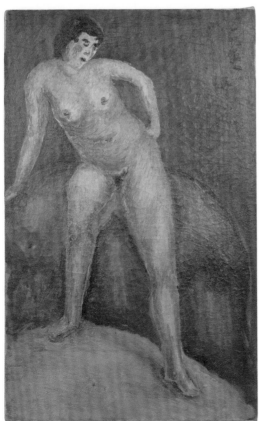

叉腰裸女 Nude Female with One Hand in Akimbo

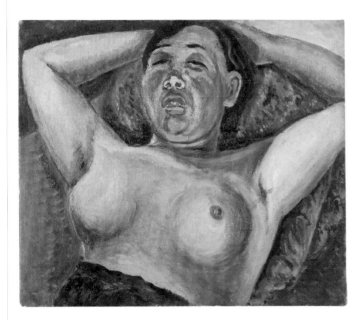

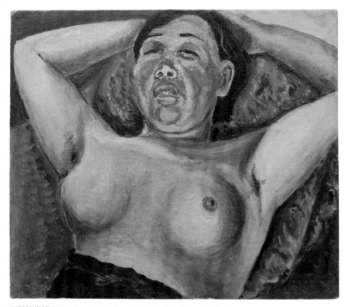

仰臥枕掌裸女 Supine Nude Female Pillowing Head on Palms

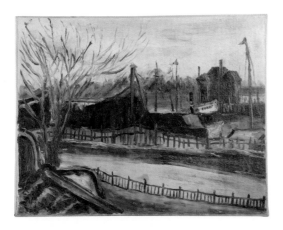

上海江南製船所 Shanghai Jiangnana Shipyard

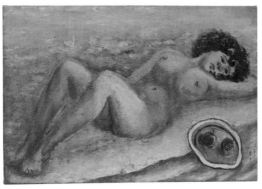

水畔臥姿裸女 Nude Female Lying on Waterside

第三類型修復：木板與紙板
Treatment category 3:
Oil paintings on wood panel and paper board

每件作品以修復前和修復後做為對照，共四張圖。
修復前置於上方、修復後置於下方。

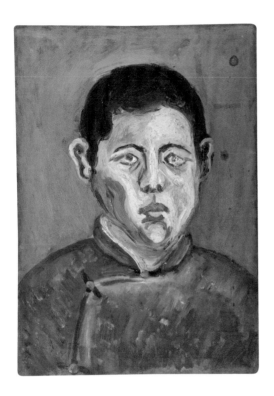

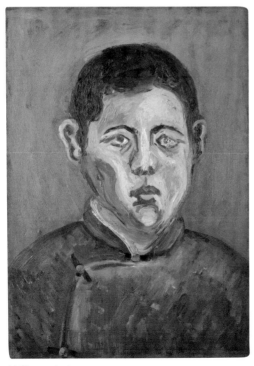

少年像 Portrait of a Teenage Boy

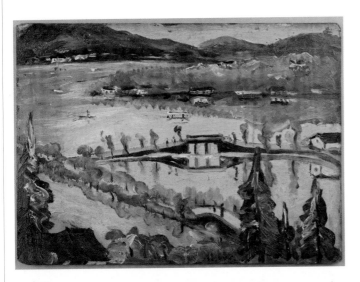

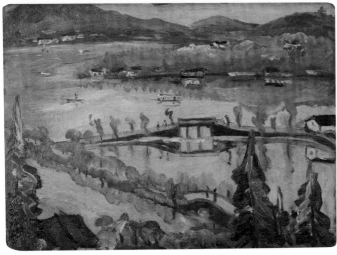

俯瞰西湖（一）Overlooking the West Lake (1)

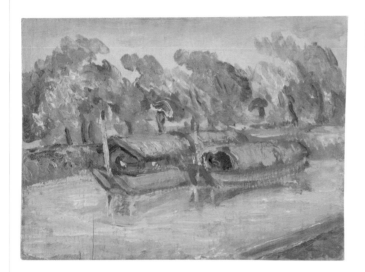

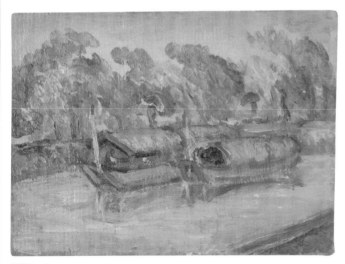

船屋 Boat Houses

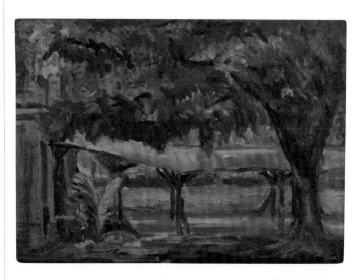

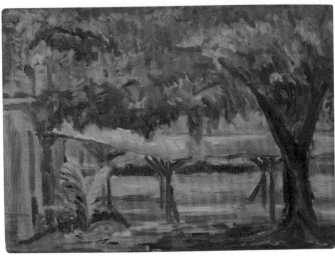

林中廊沿 Next to a Forest Corridor

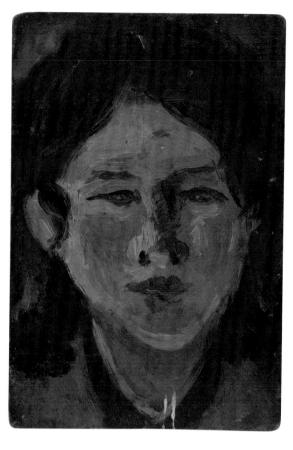

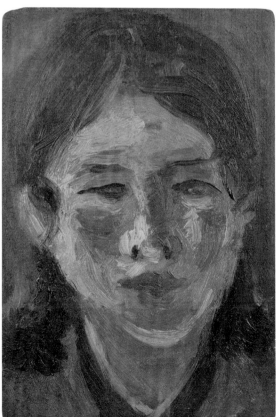

女孩 Girl

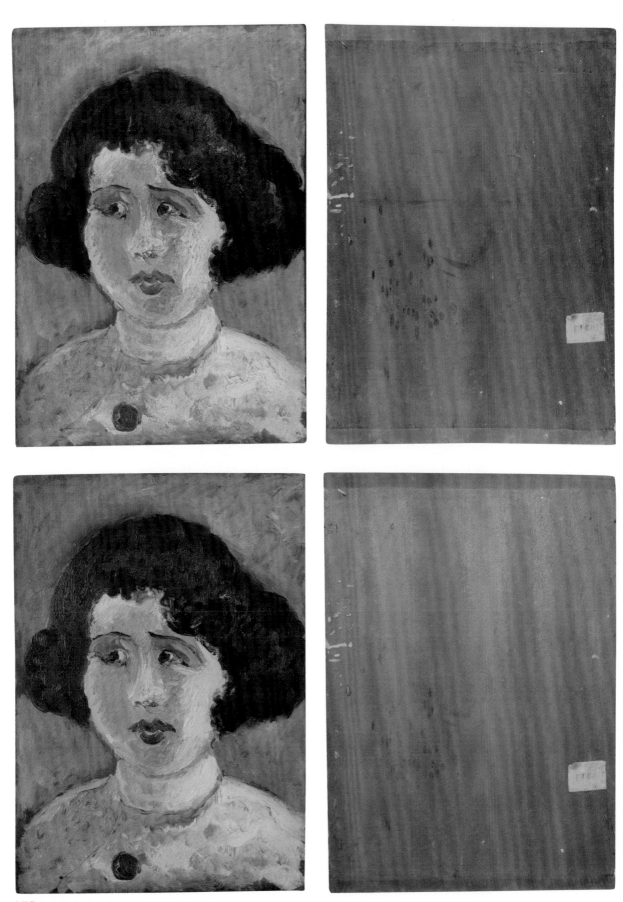

女子像 Portrait of a Female

街道Street

帆船A Sailboat

文　物
Cultural Relics

修復報告
Selected Treatment Reports

國立臺灣師範大學文物保存維護研究發展中心
National Taiwan Normal University Research Center for Conservation of Cultural Relics

受難著服
Final Garments

　　這兩件衣服是陳澄波在臨終時的著衣中，曾經染滿鮮血的衣物，是歷史上極具深遠意義的證物。就如同陳澄波的遺書，財團法人陳澄波文化基金會與臺灣師範大學文物保存維護研究發展中心皆認為修復後應盡可能地保留此兩件衣服的原貌與結構安全，並且給予妥善的保存為重點。修復作業由日本東京文化財保存研究所特聘織品修復家石井美惠博士規劃並指導。

These two shirts were worn by Chen Cheng-po upon his death, and having been stained with his blood, bear a great historical significance. Along with Chen Cheng-po's final will, the Judicial Person Chen Cheng-po Cultural Foundation and the National Taiwan Normal University Research Center for Conservation of Cultural Relics (RCCCR) decided that while these two shirts must be structurally stabilized, their original appearance must be preserved. This was the most important aspect of the conservation treatment. Following treatments was guided by Dr. Ishii Miei (Guest Conservator of Tokyo National Research Institute for Cultural Properties).

　　在送來文保中心之前，此兩件衣服已經過乾洗處理，肉眼看起來除了衣袖緣略有黃漬與從前的血跡洗除之後的淡褐色漬痕之外，並無嚴重的髒污，但是經過紫外光螢光反射反應，領口與衣服受損的地方發現有汗漬殘留與褐斑。

Prior to being sent to the RCCCR for treatment, these two shirts had been previously dry cleaned. Upon visual inspection, with the exception of yellow stains on the sleeves and residual light brown stains from washing out the blood, there is no severe dirt accumulation. However, UV-induced visible fluorescence reveals perspiration stains and foxing spots along the collar and damaged areas.

　　為使衣服整體狀態保持日後穩定，所以修復方針為清除殘留的乾洗清潔液，並以淨水清洗黃漬與殘留的洗劑，使整件更加明亮。在保存設計特製的緩衝襯墊加以支撐、固定，避免移動時的壓擠與晃動，使衣服可以保持其完整的樣貌並且可以直接展示。

In order to preserve the overall state of the shirts, treatment entailed removing residual dry cleaning soap and washing yellow stains and detergents to make the shirt brighter. A specially designed storage mount was made to prevent compression and swaying of the shirts during handling, thereby preserving its overall appearance and allowing it to be exhibited at any time.

I. 修復前狀態 Before treatment condition

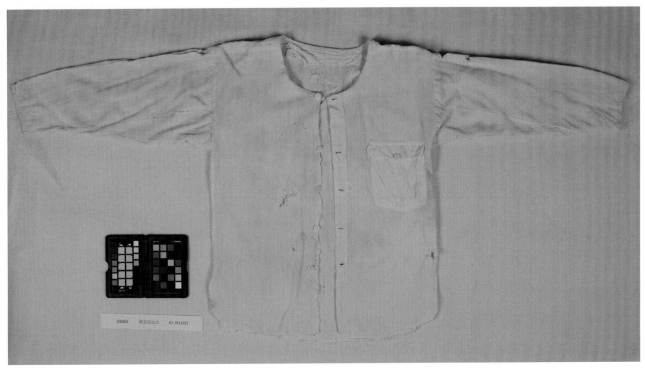

受難著服（一）Final Garment (1)　織品服裝 Shirt　60×126.5cm

·受難著服（一）Final Garment (1)

修復紀錄 Conservation history

□未修復Not treated before ■曾修復Previously treated：乾洗處理Dry cleaning

布料加工法 Fabrication method

□氈Felted □連環Looped □相互連環Knitted ■梭織Woven

	密度 Thread count	纖維顏色 Color	纖維類別 Fiber type	染色 Dye	紗撚 Weave
經 Warp	43	白 White	棉 Cotton	無 None	(2Z) S
緯 Weft	32	白 White	棉 Cotton	無 None	(2Z) S

裝飾 Decoration

□刺繡Embroidery □珠飾Bead work □印花Painted surface ■素面Plain

織品結構 Construction

■針線Sewing □其他Other

織品狀態 Textile support

■灰塵髒污Surface dirt ■黴害Mold damage □水害Tidelines

□蟲害（排泄物、啃食破損）Insect damage (accretions, losses) ■黃化Yellowing □燒傷Fire damage

■割傷Cuts ■破洞Losses □附著物Accretions □副料鬆脫Loose or missing elements

■縫線鬆脫Detached embroidery threads □硬化Stiffening □脆化Embrittlement ■纖維落屑Shedding □鉤紗Snagging

□滑紗Yarn slippage □起毬Pilling ■鬆邊Fraying □紗環滑脫Runs □收縮Shrinkage □糾結Entanglement

■皺摺Wrinkles ■縫合開裂Open seams □顏料汙染Colorant stain □展色劑汙染Adhesive stain □移染Dye migration

□褪色Fading □金屬腐蝕Metal corrosion

■其他Other：乾洗肥皂殘留、領口汗漬、血漬Dry cleaning soap residues, perspiration stains along collar, blood stains

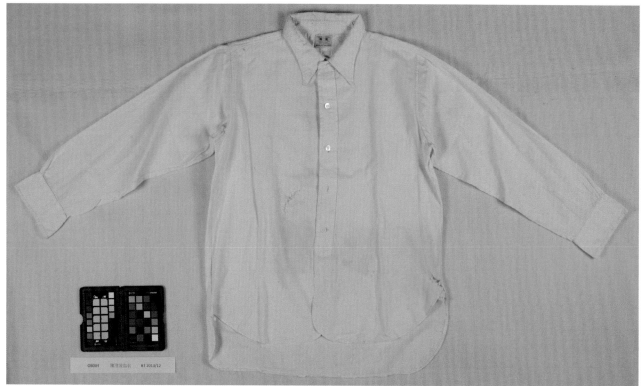

受難著服（二）Final Garment (2) 紡織服裝 Shirt 70.3×137.5cm

· 受難著服（二）**Final Garment (2)**

修復紀錄 Conservation history

　　□未修復Not treated before ■曾修復Previously treated：乾洗處理Dry cleaning

布料加工法 Fabrication method

　　□氈Felted □連環Looped □相互連環Knitted ■梭織Woven

	密度 Thread count	纖維顏色 Color	纖維類別 Fiber type	染色 Dye	紗撚 Weave
經 Warp	35	白 White	棉 Cotton	無 None	Z
緯 Weft	31	白 White	棉 Cotton	無 None	Z

裝飾 Decoration

　　□刺繡Embroidery □珠飾Bead work □印花Painted surface ■素面Plain

織品結構 Construction

　　■針線Sewing □其他Other

織品狀態 Textile support

　　■灰塵髒污Surface dirt ■黴害Mold damage □水害Tidelines

　　□蟲害（排泄物、啃食破損）Insect damage (accretions, losses) ■黃化Yellowing □燒傷Fire damage

　　■割傷Cuts ■破洞Losses □附著物Accretions □副料鬆脫Loose or missing elements

　　■縫線鬆脫Detached embroidery threads □硬化Stiffening □脆化Embrittlement ■纖維落屑Shedding □鉤紗Snagging

　　□滑紗Yarn slippage □起毬Pilling ■鬆邊Fraying □紗環滑脫Runs □收縮Shrinkage □糾結Entanglement

　　■皺摺Wrinkles ■縫合開裂Open seams □顏料汙染Colorant stain □展色劑汙染Adhesive stain □移染Dye migration

　　□褪色Fading □金屬腐蝕Metal corrosion

　　■其他Other：乾洗肥皂殘留、領口汗漬、血漬Dry cleaning soap residues, perspiration stains along collar, blood stains

II. 修復作業內容 Conservation treatments

這兩件衣服經過相同的修復處理與保存，並收納於無酸瓦楞紙盒裡。以下介紹兩件衣服清洗與固定的修復步驟：

These two shirts underwent the same conservation and preservation treatments, and were both stored in non-acidic corrugated board boxes. The cleaning and adding of a secondary support procedures are described below:

1. 修復前攝影 Before treatment examination and documentation

作品修復前的整體狀況紀錄及調查。修復前進行可見光（正光、側光）、非可見光（紫外光螢光反射與紅外光反射）檢測。透過上述不同特殊光源的攝影技術交互比對下，全面性了解文物材質及損傷的狀態。

The before treatment condition of the two shirts was examined and documented with normal and raking illumination, non-visible photographic methods (UV-induced visible fluorescence and infrared radiation reflectography). Comparison of these different photographic methods allowed the conservators to better understand the object's composition and physical condition.

受難著服（一）Final Garment (1)

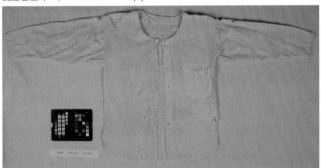
正光（正面）Normal illumination (Recto)

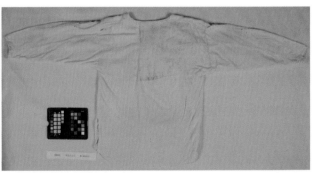
正光（背面）Normal illumination (Verso)

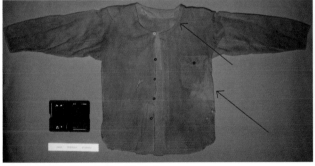
紫外光（正面）UV radiation (Recto)
紫外光下領口汗漬、槍擊破損區域血漬痕呈現較亮螢光反應
Under UV radiation, perspiration along the collar and blood around the bullet holes fluoresce brightly

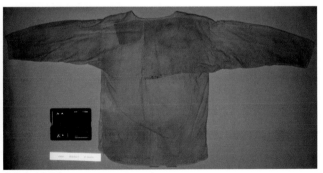
紫外光（背面）UV radiation (Verso)

紅外光（正面）Infrared radiation (Recto)
無特殊反應No unique characteristics are visible under infrared radiation

紅外光（背面）Infrared radiation (Verso)

受難著服（二）Final Garment (2)

正光（正面）Normal illumination (Recto)

正光（背面）Normal illumination (Verso)

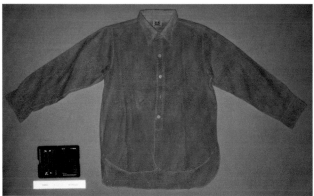

紫外光（正面）UV radiation (Recto)

紫外光下領口汗漬、槍擊破損區域血漬痕呈現較亮螢光反應
Under UV radiation, perspiration along the collar and blood around the bullet holes fluoresce brightly

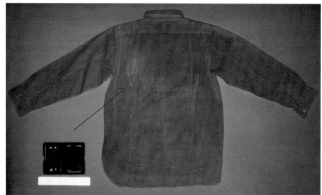

紫外光（背面）UV radiation (Verso)

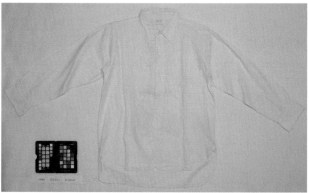

紅外光（正面）Infrared radiation (Recto)

無特殊反應No unique characteristics are visible under infrared radiation

紅外光（背面）Infrared radiation (Verso)

2. 狀況檢視登錄與修復計畫擬定 Condition report and treatment proposal

　　文物基本資料調查（尺寸、織品結構、布的加工法、織品狀態等）。以此基礎，對文物現有損傷狀況提適當的修復處理方式。

　　The object's physical condition and information is documented (size, textile construction, fabrication method, condition, etc.). An appropriate treatment proposal based on the condition report is prepared.

調查服裝的織法與密度
Documenting the shirt's fabric structure and thread count

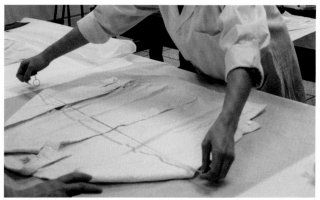
丈量服裝的尺寸
Measuring the shirt's dimensions

3. 清洗 Aqueous cleaning

進行清洗前，裂痕與脆弱區先以細聚酯網與不鏽鋼細針暫時固定。衣服正面朝上置於粗聚酯網墊子上，並放在托盤裡。用室溫（約25℃）的淨水將整件浸濕約3分鐘，再以大塊海綿輕壓吸出之前殘留的乾洗劑。吸出後，再將淨水放入托盤裡，重複加以清洗數次。背面也依上述步驟直到衣服完全洗淨（不再有泡沫洗出為止）。

Before aqueous cleaning, tears and weakened areas are supported on both sides with polyester netting and secured with stainless steel insect pins. The shirt is placed right-side up on a polyester netting, and then placed in the tray. The shirt was immersed in 25°C filtered water for three minutes, and then a large sponge was used to absorb the dissolved dry cleaning soap residue. After cleaning was finished, the dirty water was replaced with clean, filtered water and the process repeated. The shirt was flipped over and the process repeated until all soap residues were washed out (no soap was added during the cleaning process).

進行清洗前，裂痕、脆弱區先以細聚酯網與不鏽鋼細針暫時固定
Prior to aqueous cleaning, tears and weakened areas are supported with polyester netting and stainless steel insect pins

用25℃的淨水將整件衣服浸濕
The shirt is cleaned with 25°C filtered water

用海綿輕壓吸出之前乾洗肥皂殘留的汙濁水
A sponge is used to absorb dry cleaning soap residues

將衣服反面，清洗背面
The shirt is flipped over in order to clean the verso

4. 衣服風乾 Drying and pressing

　　將清洗後的衣服移至棉質布料上並使用吸水紙輕輕地將衣服吸乾，取出先前暫時固定的細聚酯網，接著將有裂縫及鬆邊的布料用不銹鋼細針暫時固定，放置一晚讓衣服自然風乾，再用設定低溫的熨斗整燙衣服。

　　After aqueous cleaning, the shirt was transferred to a cotton cloth and gently blotted from the top with large sheets of blotting paper. The temporary polyester netting and insect pins were removed. Loose and frayed edges were lightly held in place with insect pins, and the shirt was left to air dry overnight. The shirt was then gently ironed with low heat.

將有裂縫及鬆邊的布料用不銹鋼細針暫時固定
Loose and frayed edges were temporarily held in place with stainless steel insect pins

以低溫的熨斗整燙衣服
The shirt was gently ironed with low heat

5. 支撐模型 Inner mount

　　將衣服平放、鈕扣扣上定位，依照衣服的樣式，以填充棉製作手臂與胸部的支撐模型，再用聚酯纖維包覆並以平針針法予以固定。

　　The shirt was laid flat, buttoned and arranged into the final desired form for storage and display. The forms of each sleeve and chest section were cut out from polyester batting, covered on both sides with Hollytex, secured with plain stitches.

製作支撐模型
Making the internal mount

製作支撐模型
Making the internal mount

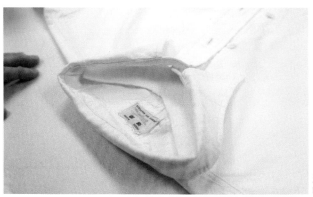

支撐模型裝進衣服後
Internal mount is inserted inside the shirt

6. 緩衝襯墊的基底卡紙板 Preparing the padded recessed mount base board

將衣服外圍輪廓以鉛筆描繪在一張80×80公分的8P無酸中性卡紙板上，每兩公分予以穿洞。

The shirt was outlined onto a 80x80cm sheet of 8ply non-acidic mat board. Holes were punched with an awl at 2cm intervals along the outline.

圖將衣服外圍輪廓描繪在卡紙板上
Tracing the shirt outline onto the mat board

圖每兩公分予以穿洞
Punching holes at 2cm intervals along the outline

7. 中性聚脂棉製作緩衝襯墊 Non-acidic polyester batting recessed mount

將0□公分厚的填充棉依照步驟□，把衣服的形狀裁剪出來，重覆製作五層填充棉並且置於卡紙板上，並依其穿孔的位置將卡紙板與中性聚脂棉對齊，完成放置衣服的緩衝襯墊。

The shirt form as outlined in step 6 was traced and cut out of five sheets of 0.5cm thick polyester batting. The outer forms were then aligned on the non-acidic mat board with the awl-punched holes.

中性聚脂棉固定於中性卡紙板
Polyester batting forms are placed on the non-acidic mat board

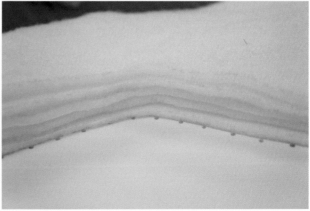

依穿孔的位置將卡紙板與中性聚脂棉對齊
The polyester batting layers are aligned with the awl-punched holes on the mat board

放置衣服於緩衝襯墊並定位
Shirt is positioned inside the padded recessed mount

8. 整合緩衝襯墊 Assembling the padded recessed mount

將蠶絲素絹平放在填充棉上，用針線把卡紙板的小孔與素絹縫合在一起。再把完成後的緩衝襯墊反過來放，並將素絹的四邊固定在卡紙板背面。

A non-patterned silk sheet was placed on top of the polyester batting, and secured to the mat board base by threading through the awl-punched holes. The recessed mount was then flipped over, and the four sides of the silk sheet secured onto the back of the mat board.

蠶絲素絹平放在填充棉上
A silk sheet is placed on top of the polyester batting

用針線把卡紙板的小孔與素絹縫合在一起
Thread is used to secure the silk sheet to the mat board by threading through the awl-punched holes

9. 完成緩衝襯墊 Completing the padded recessed mount

為了提高其結構強度，使用無酸雙面膠帶將無酸瓦愣紙緊貼在卡紙板的背面。把緩衝襯墊翻回正面，再將衣服及其支撐放入緩衝襯墊。最後，為了衣服保存的更為完整，在衣服上面多覆蓋上一層活動式緩衝襯墊，並存放於無酸瓦愣紙盒裡，維持其完整性。

In order to provide structural support to the mount, a sheet of non-acidic corrugated board was attached to the verso of the mat board with double-sided tape. The shirt was placed and aligned inside the recessed mount. To complete the storage mount, a removable cushion of polyester batting was placed on top of the shirt, followed by a non-acidic corrugated board cover.

製造上層活動式緩衝襯墊，以防止晃動
A removable cushion of polyester batting is made to reduce movement of the shirt during handling

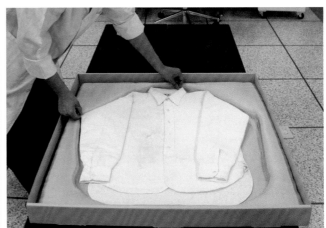

將衣服置入緩衝襯墊中
The shirt is placed and aligned inside the padded recessed mount

受難著服（一）修復後
After treatment of Final Garment (1)

受難著服（二）修復後
After treatment of Final Garment (2)

遺書
Chen Cheng-po's Wills

「史料文物類」的修復共計12件（包括遺書9件、受難著服2件、相片1件），大部份為資料、書信或創作用品等重要資料。此類文物的共同特徵是具有或佐證特殊時代意義（典範或事件）或行為特質的代表性意義，特別著重於具有歷史性的紀念物。

The category of Chen Cheng-po's 'historic cultural artifacts' includes twelve objects (9 sheets of Chen Cheng-po's will, 2 shirts from his final set of clothes, 1 photograph). Most of these objects are important records, letters and documentary items. All of these objects share a common characteristic - bearing evidence of, or being unique to a particularly time period (model example or event), or retaining significance as historical memorials.

因此，遺書是以「史料文物類」的方式整理，它是陳澄波在獄中倉促之間竭盡所能地找尋隻紙殘片以表達的心中牽掛、對家人訣別，具證明或代表重大歷史事件發生時，相關人、事、物的關鍵性意義。幾經思考後決定以歷史證物的整理方式完成，因此遺書上的皺摺、灰垢、黃化、斑漬都變成保存的對象之一，除了將可能造成斷裂的嚴重皺折稍加攤平與消毒之外，基本上是現狀保存。相對於繪畫作品的修復作業，遺書的作業相對性地刻意減少，這是對照「史料文物類」的方針執行。而由此也希望觀賞者、典藏管理者、布展者可以體會在修復作業中「不能」與「不為」的區別性。

Therefore, as one of these 'historic cultural artifacts,' Chen Cheng-po's will, written while he was imprisoned and on the only fragments of paper that he could find, expressing the concerns of his heart and biding a final farewell to his family, are proof of, and are an important symbol for a significant historical period, and the people, events, and objects involved. After careful consideration of how to treat these historical objects, it was decided that the creases, surface dirt, yellowing and stains must be preserved, and that with the exception of pressing severe creases that may lead to tears and disinfection, the original condition would be left as is. In comparison to the treated works of art, the conservation treatment of Chen Cheng-po's will is intentionally minimized; this is the guiding principle of treating 'historic cultural artifacts.' With this in mind, one hopes that those who look at these objects, collection managers and exhibition managers may more fully understand the difference of conservation treatment between 'cannot' and 'will not.'

保存修復陳澄波的遺書代表當時突發的悲痛與焦慮，如果將遺書維護到像作品般潔淨、完美的狀態反而會喪失遺書內含的情緒感與事件性的歷史背景，而減弱其歷史意義。因此將遺書以維持現狀處理（打開、消毒、輕壓折痕）為主要措施，讓它整潔地保存。

Chen Cheng-po's will represents the sudden onset of grief and anxiety of its time period; cleaning them until they are in immaculate condition is to deprive them of their emotional connotation and the historical background of these events, thus diminishing their historical significance. Therefore, in order to preserve their present condition the will was only opened, disinfection and gently pressed, thus preserving their record.

陳澄波的遺書寫在大小、種類不同的紙張，並有許多是雙面書寫。為了遺書的長久保存與展示效果，設計一款沒有人為干預的雙面「M型」夾裱，使遺書正反兩面能同時觀看。

Chen Cheng-po wrote his will on sheets of paper of varying size, several of which were double-sided. To ensure long-term preservation and allow for display, the conservators designed a double-sided M-style mat, allowing both sides of the will to be seen at the same time.

I. 修復前狀態 Before treatment condition

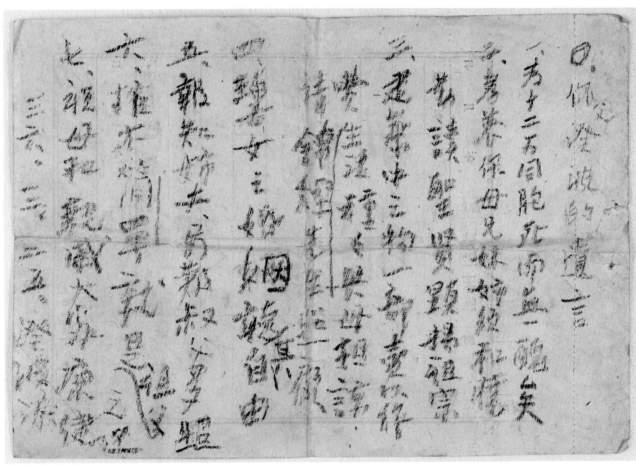

遺書（一）Will (1) 1947 12.9×18.6cm

· 遺書（一）Will (1)

修復紀錄 Conservation history

■未曾修復Not treated before □曾修復Previously treated

基底材 Primary support

■灰塵髒污Surface dirt □黴害Mold damage ■褐斑Foxing □水害Tidelines □油害Oil stains
□蟲害（排泄物、啃食破損）Insect damage (accretions, losses) ■黃化Yellowing □燒傷Fire damage
□割傷Cuts □破洞Losses □附著物Accretions ■折痕Creases □裂痕Tears □變色Discoloration
□磨損Abrasion ■變形Distortions □膠帶Tapes
■其他Other：紙纖維翹起、皺折Wrinkles, lifted fibers

媒材 Media

□脫離Friable ■磨損Abrasion ■褪色Fading □暈水Bleeding □透色Sinking □其他Other

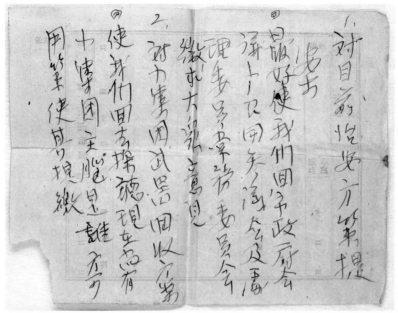

遺書（三）Will (3)　1947　12.8×17cm

遺書（四）Will (4)　1947　12.8×17cm

・遺書（三）**Will (3)**、遺書（四）**Will (4)**

修復紀錄 Conservation history

　　　　■未曾修復Not treated before □曾修復Previously treated

基底材 Primary support

　　　　■灰塵髒污Surface dirt □黴害Mold damage □褐斑Foxing □水害Tidelines □油害Oil stains

　　　　□蟲害（排泄物、啃食破損）Insect damage (accretions, losses) ■黃化Yellowing □燒傷Fire damage

　　　　□割傷Cuts ■破洞Losses ■附著物Accretions ■折痕Creases □裂痕Tears □變色Discoloration

　　　　■磨損Abrasion ■變形Distortions □膠帶Tapes ■其他Other：皺折Wrinkles

媒材 Media

　　　　□脫離Friable □磨損Abrasion ■褪色Fading □暈水Bleeding □透色Sinking □其他Other

遺書（五）Will (5)　1947　11.5×6.6cm　　遺書（七）Will (7)　1947　　　遺書（九）Will (9)　1947　11.5×6.6cm　　遺書（十一）Will (11)　1947　11.5×6.6cm
　　　　　　　　　　　　　　　　　　　　　　　11.5×4.4cm

・**遺書（五）Will (5)、遺書（七）Will (7)、遺書（九）Will (9)、遺書（十一）Will (11)**

修復紀錄 Conservation history

　　■未曾修復Not treated before □曾修復Previously treated

基底材 Primary support

　　■灰塵髒污Surface dirt □黴害Mold damage ■褐斑Foxing □水害Tidelines □油害Oil stains
　　□蟲害（排泄物、啃食破損）Insect damage (accretions, losses) ■黃化Yellowing □燒傷Fire damage
　　□割傷Cuts ■破洞Losses □附著物Accretions ■折痕Creases □裂痕Tears □變色Discoloration
　　■磨損Abrasion ■變形Distortions □膠帶Tapes □其他Other

媒材 Media

　　□脫離Friable ■磨損Abrasion ■褪色Fading □暈水Bleeding □透色Sinking □其他Other

遺書（十二）Will (12)　1947　15.8×10.8cm

・遺書（十二）**Will (12)**

修復紀錄 Conservation history

　　■未曾修復Not treated before □曾修復Previously treated

基底材 Primary support

　　■灰塵髒污Surface dirt □黴害Mold damage □褐斑Foxing □水害Tidelines □油害Oil stains

　　□蟲害（排泄物、啃食破損）Insect damage (accretions, losses) ■黃化Yellowing □燒傷Fire damage

　　□割傷Cuts □破洞Losses ■附著物Accretions ■折痕Creases □裂痕Tears □變色Discoloration

　　□磨損Abrasion ■變形Distortions □膠帶Tapes □其他Other

媒材 Media

　　□脫離Friable ■磨損Abrasion ■褪色Fading □暈水Bleeding □透色Sinking □其他Other

遺書（十四）Will (14)　1947　18.8×12.8cm

・遺書（十四）Will (14)

修復紀錄 Conservation history

　　　■未曾修復Not treated before □曾修復Previously treated

基底材 Primary support

　　　■灰塵髒污Surface dirt □黴害Mold damage ■褐斑Foxing ■水害Tidelines ■油害Oil stains
　　　□蟲害（排泄物、啃食破損）Insect damage (accretions, losses) ■黃化Yellowing □燒傷Fire damage
　　　□割傷Cuts □破洞Losses ■附著物Accretions □折痕Creases □裂痕Tears □變色Discoloration
　　　□磨損Abrasion ■變形Distortions □膠帶Tapes □其他Other

媒材 Media

　　　□脫離Friable □磨損Abrasion ■褪色Fading □暈水Bleeding □透色Sinking □其他Other

II. 修復作業內容 Conservation treatments

1. 折痕展開 Flattening creases

折痕打開後稍微以淨水加濕、展開，並以70%酒精水溶液多次局部處理，以避免變形，再以中性吸水紙、毛毯整張輕壓。重複數次後，確認沒有造成危險的皺摺或媒材脫落狀況。

Creases were flattened by applying a minimal amount of water to relax the paper and mechanically opening the paper, followed by local application of 70% ethanol. The papers were gently pressed with blotting paper and felts. This step was repeated several times, ensuring that no wrinkles or media loss were incurred.

2. 雙面夾裱 Double-sided window mat

陳澄波的遺書中有七件是雙面書寫，為了能夠雙面展示，文保中心設計了無酸聚酯（mylar）夾配雙面夾裱結構，其優點是可以安全拿取與容易解體。

Among the papers used for Chen Cheng-po's will, seven of the sheets were double-sided. In order to display both sides at the same time, the conservators developed a double-sided window mat construction that utilized the transparency of non-acidic mylar. Significantly, this structure allowed the sheet to be safely and easily removed.

▨	無酸開窗卡紙 / Window mat
▨	3P無酸聚酯片 / 3-ply mylar glazing
▨	無酸聚酯M型夾 / 'M-style' floating hinge
▨	2P無酸聚酯夾 / 2-ply mylar folder
■	文物 / Object

雙面夾裱結構Double-sided window mat

a. 卡紙板 Window mat

按照遺書的尺寸，各一邊再多0.5公分將開窗位置切出來，前後各一片。

Windows were cut into two identical sheets of 0.5cm thick mat board according to the dimensions of each sheet.

b. 無酸聚酯片 Mylar glazing

3P無酸聚酯片以雙面無酸膠帶黏在兩片開窗後的卡紙內面。

3-ply mylar sheets were adhered to the inside of each window with double-sided adhesive tape.

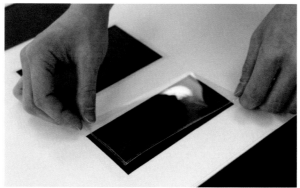

3P無酸聚酯片黏在卡紙板開窗內面
3-ply mylar sheets are adhered to the inside of each window

c. 無酸聚酯夾裱 Mylar folder

依照遺書的尺寸將遺書以2P無酸聚酯夾包覆以減少持拿的風險。

2-ply mylar folders, made to reduce handling-induced damage, were cut to the dimensions of each sheet.

d. M型固定式 M-style floating hinges

將無酸聚酯夾以無酸雙面膠帶固定在一面卡紙板上的開窗裡，讓全件遺書露出展示。

Mylar hinges were adhered to one side of the window mat, allowing the sheet to sit safely within the window.

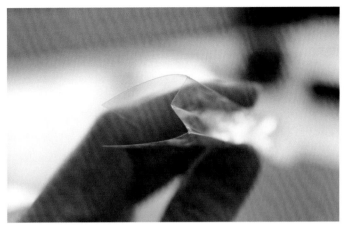
M型固定式的形狀
Structure of M-style floating hinges

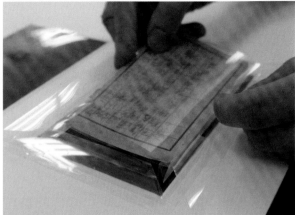
雙面可觀看的夾裱完成後
Completed double-sided mat

3. 標籤 Labels

以無酸標籤紙將遺書的內文黏在卡紙板上。

Translation of Chen Cheng-po's will was printed on-acidic paper labels and adhered to the front of the window mat.

遺書裝在夾裱裡
Placing will inside the window mat

相簿
Albums

　　三本相簿歷經數十載的傳承、翻閱，已出現結構鬆散、封面缺損、黑色內頁斷裂、照片脫落等情形，部分固定照片的護角因黏著劑老化、或是前人加強邊角黏固預防照片掉落，使得多數照片已無法取下；故此，因應委託者欲閱覽照片背面所記載之訊息，相本修復將著重於完整揭取照片、穩定照片結構性等部分。

These three albums were passed down from generation to generation, they suffered from loosened construction, torn covers, broken black pages, and loose photographs. Some of photographs were difficult to take off from the black text blocks caused by aging photo corners and reattaching photographs improperly. Therefore, according to the owner's request which is able to read information on the verso of the photographs, the treatment would be focused on removing all photographs appropriately and stabilizing their structure.

　　三本相簿內貼有明信片、照片等332張圖像紀錄作品，其中黑白明膠銀鹽照片約佔321張；332張作品皆進行攝影紀錄、乾式表面除塵與全面性攤平等處理，部分具破損、摺痕、裂痕、分層、明顯髒汙、等劣化狀況的照片，再分別進行補缺失、加固、局部濕式清潔等修復處理。相簿部分則執行了拆解結構、以無酸卡紙替換原酸性內頁與封面紙板、修補封面缺損處、依循原形式重新裝幀等修護步驟。與陳澄波文化基金會討論後，考量未來使用、捐贈、收藏等各面相需求，選擇個別收存照片與相簿，而非將修復後的照片回貼至原相簿內頁中；照片存放於無酸套夾，可安全持拿外，也便利瀏覽照片正、反面訊息；相簿則以無酸保護盒為保存措施。

There were 332 pieces of artworks, including three postcards and 321 black-and-white gelatin silver prints inside the albums. The 332 artworks were completed photo-documentation and dry surface cleaning and overall flattening. Some of them were repaired the losses, creases and tears, consolidated the delaminated areas, and wet-cleaned out the heavy dirt. The albums were disbinded and repaired the broken areas, and the acid text blocks were replaced by Rising Museum Board, then to reassemble the albums according to its original binding styles. After discussion with Judicial Person Chen Cheng-po Cultural Foundation, it was decided that repaired black and white gelatin silver prints and albums should be preserved individually, not combined together as the original condition. The black and white silver gelatin prints were stored in transparent acid-free photo pages, and the albums were housed in an archival storage box.

・照片Photographs

I. 修復前狀態 Before treatment condition

修復前 Before treatment

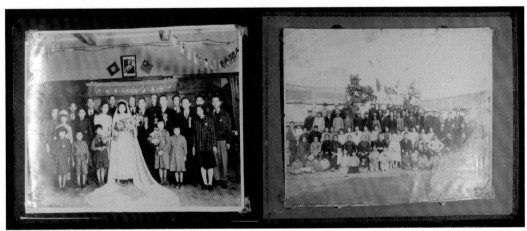

修復前 Before treatment

修復紀錄 Conservation history

■未曾修復Not treated before ■曾修復Previously treated：使用膠帶修補裂痕處Using tapes to repair tears

照片類別 Photographic process

■顯影型Gelatin DOP □曬出型Gelatin POP □其他Other

基底層 Primary support

■灰塵髒污Surface dirt □黴害Mold damage ■褐斑Foxing □水害Tidelines □油害Oil stains

■蟲害（排泄物、啃食破損）Insect damage (accretions, losses) ■黃化Yellowing □燒傷Fire damage

□割傷Cuts ■破洞Losses ■附著物Accretions ■折痕Creases ■裂痕Tears □變色Discoloration

■磨損Abrasion □變形Distortions ■膠帶Tapes ■其他Other：異物、分層、指紋Accretion, delaminate, finger prints

感光乳劑層 Emulsion layer

■灰塵髒污Surface dirt □黴害Mold damage ■裂痕Tears □變色Discoloration

■黃化Yellowing ■磨損Abrasion ■刮痕Scratch ■其他Other：分層、缺失、指紋Delaminatioion, losses, finger print

整體照片 Overall condition

■褪色Fading □氧化Oxidation ■磨損Abrasion ■其他Other：銀鏡反應Silver mirroring

II. 修復作業內容 Conservation treatment

1. 修復前攝影 Before treatment examination and documentation

照片修復前的整體狀況紀錄及調查。修復前進行攝影紀錄,可了解文物材質及損傷的狀態。

The photograph's before treatment condition was examined and documented with normal illumination. Conservators will understand the object's composition and physical condition.

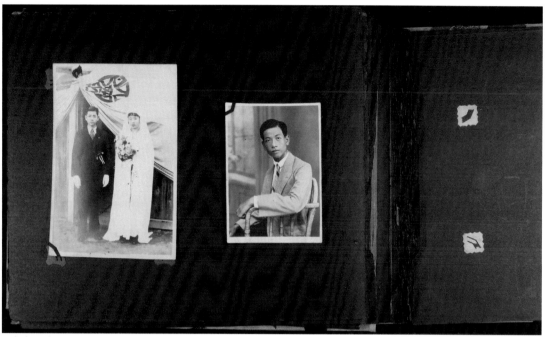

正光（正面）Normal illumination (Recto)
左邊照片已脫落且具銀鏡現象；右邊照片背面四周黏貼著黑色內頁、正面左上角見護腳殘留物
The left one had already tattered and revealed silver mirror reflection. The margin of the right strongly attached to the album's page and the remaining was on the upper corner on the right.

2. 標記照片位置 Mark the position of photos

在照片揭取下來前,先標記三本相簿各頁照片群的位置,並依順序將各張照片編號,以利後續整理建檔。

Before taking off the photos from text blocks, it was easier to organize all photographs by marking the original position of photos on the albums and assign numbers for each one.

利用黑色奇異筆依照片位置標記於透明塑膠片上
Marking the position of the photos on the transparent plastic sheet with a permanent marker

以鑷子將照片取下
Removing photo with the tweezers

使用抹刀將照片揭取下
Removing photo with the spatula

3. 揭取照片 Removing photos

利用鑷子或抹刀等修復工具，將相簿內的照片逐一揭下，各別編號並暫時存放於合適保存措施。部分照片四角或周圍黏貼於黑色內頁上，為避免破壞照片，揭取照片過程中會連同護角或黑色內頁一起揭下。揭下後，再為各張照片進行正、反面攝影紀錄。

Use tweezers or a spatula to separate the photos from the albums, and put them into the appropriate preservative materials according to the numbers. It would be take off photos with some remains of black pages and photo corners to avoid destroying the structure, while removing aging photo corners or reattaching photos.

4. 表面除塵 Surface cleaning

以聚氯乙烯粉末橡皮清潔作品正反兩面的灰塵髒污；若遇正面影像較脆弱者，使用軟毛刷或吹氣球輕柔地將表面灰塵掃除；部分照片正面黑色護角殘留則以鑷子小心移除，而明顯髒污則利用沾濕棉花棒清除。

Eraser crumbs were used to remove surface dirt on the recto and the verso of the work of art. If the images were fragile, soft brushes or air-blowers were used to clean the surface. The black mounting material was gently removed with tweezers, and the residual adhesive cleaned with a dampened cotton swab.

以無酸橡皮粉末清潔背面灰塵髒污
Cleaning the verso with eraser crumbs

沾濕棉花棒清除正面髒污
Cleaning the verso with a dampened cotton swab

移除表面髒污前Before cleaning surface

移除表面髒污後After cleaning surface

5. 移除異物、殘留物 Removing Solids and Residues

利用修復工具尖端挑除照片上的顆粒灰塵、昆蟲屍體、昆蟲排遺等異物。

將照片上殘留的黑色內頁或護角以水筆潤濕後，使用修復工具移除之，再以沾濕棉花棒將殘留黏著劑或紙渣完全清理乾淨；移除過程中，若遇背面有文字訊息書寫於紙質殘留物上，則剃除四周空白殘留物，保留字跡。

Insect accretions and solids were picked up with the tip of tools.

The black mounting materials or paper residues were moistened by water brush and gently removed with tools, and the residual adhesive cleaned with a dampened cotton swab. If the information was written on the residual paper, it should be kept and only cleaned surrounding paper residues.

移除昆蟲屍體 Removing insect accretions

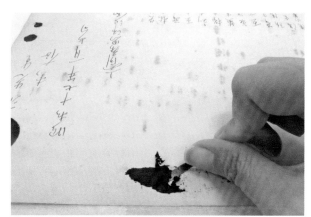

移除背面殘留紙渣Removing paper residues

6. 移除膠帶 Tape Removal

少數照片曾用膠帶黏貼破損位置，為了減緩未來膠帶黏著劑老化後對照片影像層或紙纖維造成劣化情形產生，因此利用加熱抹刀移除膠帶載體，再以豬皮橡皮擦清除殘餘黏著劑。

Few of photos had been repaired the torn areas by pressure sensitive tapes. The tapes break down over time, becoming brittle or oily. The adhesive layers might stain the paper bases or emulsion layer of photographs in the future, so using a heating spatula to remove the carrier and then using a crepe rubber square to pick up the rest of adhesive residues.

移除背面殘留物前
Before removing residues of the verso

移除背面殘留物後
After removing residues of the verso

移除膠帶前
Before removing tapes

移除膠帶後，呈現照片破損位置
The torn corners were shown up after removing tapes

7. 加固 Consolidation

部分影像層出現起翹、欲剝落的情形，或是摺痕較為嚴重的影像位置，使用5%明膠水溶液進行局部加固。而少數照片背面或邊角有紙張分層的狀況，則採用2.5%的甲基纖維素塗佈於分層處，再重壓該區位以達到重新黏合的效果。

The delaminated and crease emulsions were consolidated with 5% of gelatin. The damaged corners of few photos were applied with 2.5% of methyl cellulose and left to dry hard and reattach together.

加固正面分層處
Consolidating the rector

加固背面分層處
Consolidating the verso

加固影像層前
Before consolidating the emulsion

加固影像層後
After consolidating the emulsion

8. 頂條 Mending

摺痕、裂痕處以修復用皮料紙製成細長形頂條，塗刷2.5%甲基纖維素，再貼於摺痕處背面，藉此達到緩和摺痕處之起伏程度以及提升該區域之結構性。

The creases and tears were mended with narrow strips of Japanese papers and 2.5% of methyl cellulose, so that the damaged areas would be stabilized.

加固裂痕前
Before mending tears

加固裂痕後
After mending tears

9. 補缺失 Infilling losses

選用合適染色紙材裁剪成與缺失處周圍相同形狀，塗刷2.5%甲基纖維素，將補紙黏貼於缺失邊緣，待乾後，表面經瑪瑙刀輕撫推壓，使填補紙材表面產生平滑效果，再塗佈明膠或Klucel G等溶液於補紙表面，製造光亮感。

The losses were infilled with appropriated toned papers, trimmed the similar shape as missing area, and 2.5% of methyl cellulose. The infilled papers were burnished gently by an agate burnisher or applied with gelatin solution and Klucel G to create the smooth or glossy surfaces.

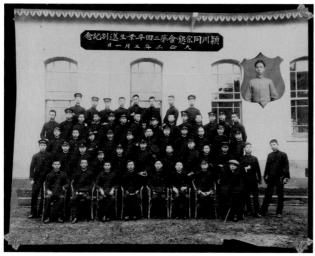

補缺失前
Before infilling losses

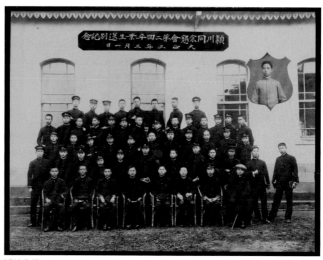

補缺失後
After infilling losses

10. 小托 Lining Backing Papers

少數照片背面紙基厚薄不勻的情形，故而在背面全面性托上一層修復用皮料紙，加強整體結構強度。另外，照片背面托裱卡紙亦見厚薄不均勻的狀況，且所用卡紙材料不佳，於未來可能出現更多劣化現象，因此將托裱卡紙移除，僅保留表面卡紙樣貌，再小托上與原卡紙厚度相仿的修復用皮料紙。

The uneven thicknesses of the verso sides of few photos were adhered a Japanese tissue to reinforce its structure. The original backing paper was acid and uneven, so it should be removed and replaced with the long-fabered paper which is closed to similar thickness as the original.

移除背面卡紙前
Before removing the backing paper

背面小托後
After lining the back

11. 全色補彩 Inpainting

針對少數照片裂痕處，以貓頭鷹水彩全相似背景景色，達視覺觀賞之連續性。

Schmincke water color was used to tone down creases on the recto of photos to match the surrounding background.

12. 全面性攤平 Humidification and flattening

以半濕潤水刷塗於照片背面，讓紙張纖維因水分而膨脹伸展，當整體紙纖維呈現放鬆狀態時，依續覆蓋不織布（光滑面朝向照片正面）、吸水紙於照片

局部全色前
Before inpainting locally

局部全色後
After inpainting locally

正、反面，最後重壓，等待乾燥、平整。

All photos were humidified overall by applying them with a dampened brush. When the photos were limp and relaxed, they were placed between blotters or sheets of Hollytex to dry and flatten.

13. 存放措施 Storage

依照委託者日後於使用、捐贈、收藏等方面考量，三本相簿內的332張影像作品修復後，將不回貼於原相簿，而是採取照片、相簿分開收存。因此，332張影像作品選用Print File®的照片套夾作為照片保存材料，不僅方便日後收納存放，亦可直接閱覽照片正、反面訊息；存放或取出照片時，須配戴手套，防止指紋留於照片上。

Instead of being reattached on the same position on these three albums, the 332 photos would be housed individually after the consideration in different perspectives. Therefore, useing transparent photo pages are made from Print File as hosing materials. It was not only good for storage but also convenient to read the message from the front and the back of photos. However, it was necessary to wear gloves when taking out.

先以吹氣球清除表面灰塵
Blooming out the dirt on the surface

裝入照片套夾內
Putting into the photo page

於套夾外貼上編號標籤
Labeling on the outside of the photo pages

將照片套夾收藏於無酸保護盒內
Housing all photo pages in the alkaline box.

透明套夾便利瀏覽正面影像
Transparent photo pages is easire to view the images

透明套夾便利瀏覽背面文字訊息
Transparent photo pages is easire to view the information

III. 修復前後對照 Before and after treatment

修復前 Before treatment	修復後 After treatment

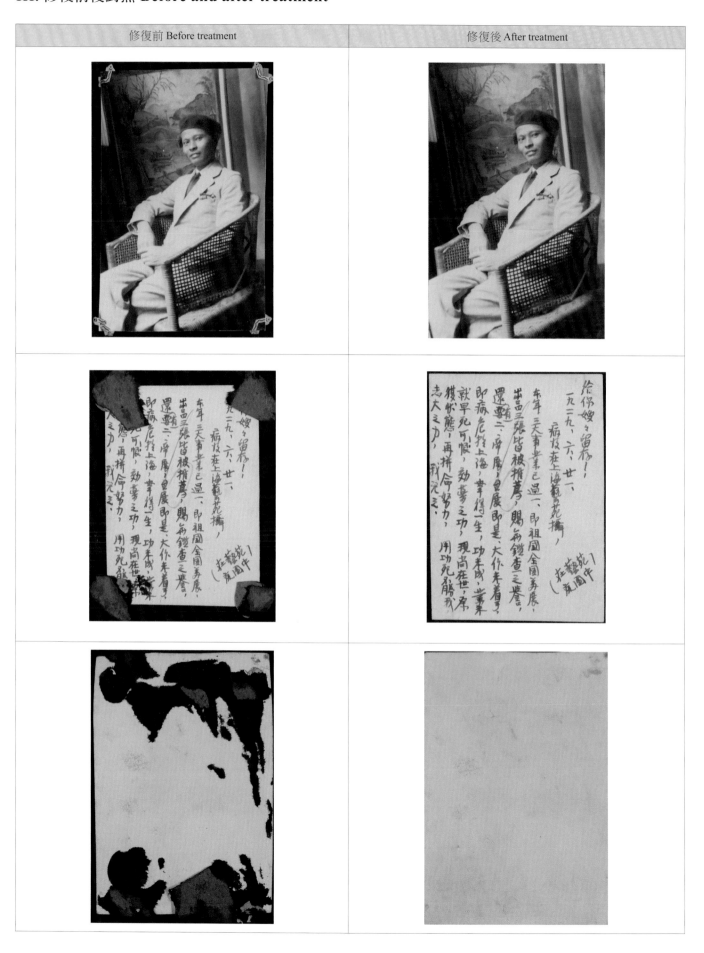

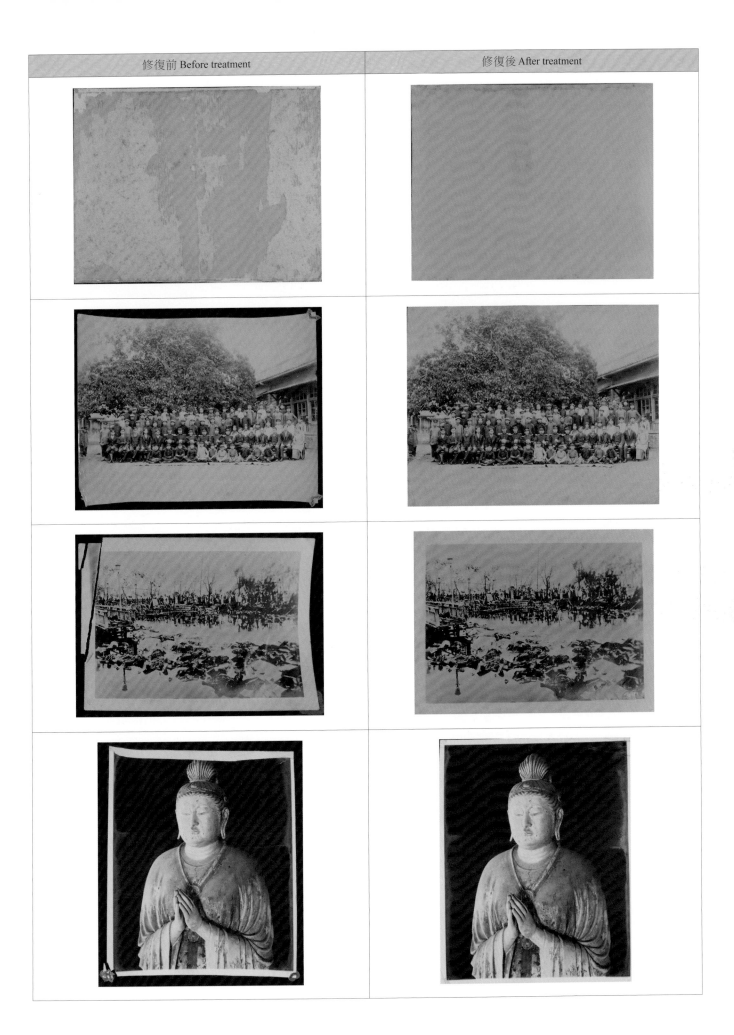

‧ 相簿 Albums

I. 修復前狀態 Before treatment condition

相簿（一）修復前（正面45度角）
Before treatment of Album(1) (45 degree on the recto)

相簿（三）修復前（正面45度角）
Before treatment of Album(3) (45 degree on the recto)

修復紀錄 Conservation history

■未曾修復Not treated before □曾修復Previously treated

內頁基底層 Text block

■灰塵髒污Surface dirt □黴害Mold damage □褐斑Foxing □水害Tidelines

□油害Oil stains □蟲害（排泄物、啃食破損）Insect damage (accretions, losses)

■黃化Yellowing □燒傷Fire damage □割傷Cuts ■破洞Losses

□附著物Accretions ■折痕Creases ■裂痕Tears ■變色Discoloration

■磨損Abrasion □變形Distortions ■膠帶Tapes

■其他Other：脫落、裝訂針與金屬環生鏽Detached, rusted metal nails and eyelets

封面基底層 Cover

■灰塵髒污Surface dirt □黴害Mold damage ■褐斑Foxing □水害Tidelines

□油害Oil stains □蟲害（排泄物、啃食破損）Insect damage (accretions, losses)

■黃化Yellowing □燒傷Fire damage □割傷Cuts ■破洞Losses

□附著物Accretions ■折痕Creases ■裂痕Tears □變色Discoloration

■磨損Abrasion □變形Distortions □膠帶Tapes

■其他Other

媒材層 Media

□脫離Friable ■磨損Abrasion ■褪色Fading □暈水Bleeding □透色Sinking

■其他Other：缺失Losses

II. 修復作業內容 Conservation treatments

1. 修復前攝影 Before treatment examination and documentation

相簿修復前的整體狀況紀錄及調查。修復前進行攝影紀錄，可了解文物材質及損傷的狀態。

The album's before treatment condition was examined and documented with normal illumination. Conservators will understand the object's composition and physical condition.

相簿（二）相本內頁斷裂
The broken text block of Album (2)

2. 表面除塵 Surface cleaning

選用聚氯乙烯粉末橡皮搭配軟毛刷清潔相簿封面表面髒污。相簿（一）封面上的明顯髒污，則利用沾濕棉花棒清除。

Eraser crumbs and soft brushes were used to remove surface dirt on the covers of the albums. The cover of Album (1) was cleaned with a dampened cotton swab.

3. 拆解相簿結構 Disbinding

三本相簿內的照片全數揭取下來後，即可進行分解結構，拆解成封面、內頁、封底等三大部分。後續修護處理僅針對封面與封底，內頁部分則因其測試後的酸鹼值呈現弱酸性（5至6之間）將更換成黑色2ply無酸卡紙。

移除相簿（一）裝幀綁繩
Removing the binding materials of Album (1)

使用抹刀分離相簿（一）封面與第一頁
Using a spatula to separate the cover and the first page of Album (1)

After taking off all photos from these three albums, the albums were separated to front covers, text blocks, and back covers. The following procedure would be focused on treating covers and replacing acid text blocks with 2ply black Museum Boards.

4. 清洗封面織物 Aqueous treatment

因相簿（二）與相簿（三）的封面、封底需更換卡紙底板，故需先將封面、封底潤濕，再一一分開封面上的織物、扉頁以及紙板。將揭下來的織物置於淨水中，清洗織物內的髒污與殘餘黏著劑，清洗次數和時間會依照織物狀況作調整。清洗過程中，可利用修護工具將封面織物或扉頁上的殘留黏著劑刮除乾淨。

Because the covers of Album (2) and Album (3) should need to replace by new mat board, the decision was made to aqueously clean the bookcloth. Prior to washing, the covers were moistened and separated into three parts: bookcloth, mat board, and pastedown. The bookcloth was immersed in water to washing out dirt and adhesive residues.

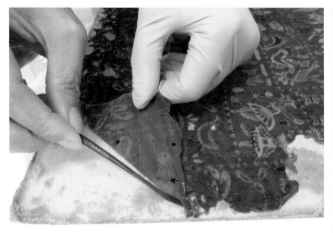

以抹刀分離相簿（三）封面織物與紙板
Using a spatula to remove the bookcloth from the cover of Album (3)

清洗相簿（三）織物中
Immersing the bookcloth of Album (3)

清洗相簿（二）織物中
Immersing the bookcloth of Album (2)

刮除相簿（二）扉頁背面上殘餘物
Removing the adhesive residues of the pastedown by tools

5. 小托 Lining

織物與扉頁皆於背面黏貼一層托紙，主要是為了固定織物尺寸大小以及提升整體結構強度。小托、待乾後，依修復前紀錄之紙板尺寸、厚度、與位置，準備背板材料與標注黏貼位置，最後將原織物、新卡紙板、原扉頁等循原順序一一包覆、黏合為原樣態。封面織物的小托紙選擇使用修復用皮料紙，扉頁小托紙則選用

小托相簿（二）面織物
Lining the textile of Album (2)

依原形式將織物與紙板黏貼結合
Reassembling the textile and new cardboard as the origilnal

典具帖，紙板為白色4ply無酸卡紙板，黏著劑為小麥澱粉糊。

In order to avoid changes in bookcloth size and to reinfoce bookcloth's structure, the bookcloth and the pastedown were lined with Japanese papers. The original bookclothes, new cardboards and original pastedowns were reassembled in accordance with the previous condition record, included the size, thickness, and position of the covers. The bookcloth extending over the board edges was wrapped to the inside of the board, replacing by 4ply white museum mat board, and pasted down with wheat starch paste.

6. 補缺失 Infilling losses

為考量相簿（三）封面紋樣之完整性和補紙的可辨識性，利用攝影、輸出技術，將織品圖樣列印於合適紙張（厚度相似之修護用皮料紙），裁剪成與缺失邊緣相近形狀的補紙，黏貼於缺失處邊緣。相簿（一）封面缺失處則是選擇已染色之修復用皮料紙作為填補材料。

In order to represent patterns which is on the bookcloth of Album (3) and to identify the difference between infilled paper and the original, the infill was duplicated by digitalizing the Album (3) bookcloth and printing out on appropriated Japanese paper. The outline of the loss was shaped using a scalpel. Wheat starch paste was used to paste the infill onto the verso of the bookcloth. The leather cover of Album (2) was infilled losses with Japanese paper toned with artist's acrylic paint.

填補相簿（三）封面缺失
Infilling losses of the cover of Album (3)

填補相簿（一）封面缺失
Infilling losses of the cover of Album (1)

7. 加固 Consolidation

　　相簿（一）封面磨損的皮革，以小號水彩筆塗上2%Klucel G溶液加固磨損處；另外，相簿（一）封面原有裝訂孔的生鏽金屬環以剉刀打磨移除鏽蝕後，塗佈上10%B72溶液。

　　The abrasion leather cover of Album (1) was applied with 2% of Klucel G using a fine brush. The eyelets on the Album (1) cover were cleaned out rust using metalworking tools, and then applied with 10% of B72.

Klucel G溶液加固皮革磨損處
Appling Klucel G on the abrasion areas of the leather cover

B72溶液塗佈於封面金屬環
Appling B72 on the eyelets of the leather cover

8. 重新裝幀 Rebinding

　　以黑色2Ply無酸卡紙替換三本相簿原有的酸性內頁，按照原裝幀孔洞位置於新內頁左側打洞，染色皮料紙撚成紙釘取代原金屬裝訂針，將內頁重新裝訂，再將舊有扉頁以小麥澱粉糊回貼於原位置。封面與內頁的裝訂側各塗上小麥澱粉糊相互黏合後，最後將已清潔的原綁繩穿入裝幀孔洞，繞結成原始形樣。

穿入紙釘裝訂相簿內頁
Gathering all pages by threading the paper staples

把相簿原有扉頁依原位置回貼
Pasting down the flyleaf on the original position

相簿（三）封面與內頁相黏
Adhering the Album (3) cover and the text block together

把相簿（一）原綁繩綁回
Threading the original rope back and tie with a knot

The text block was replaced by 2ply black Rising Museum Board. The text block was then punched holes on the left side by a single hole punch, following the original position of binding holes. The text block was assembled by threading paper staples into the holes, and then the flyleaf was adhered on the original position. The text block was rebound in the repaired covers with wheat starch paste, and then the cleaned rope was threaded into holes and tied with a knot as the original.

9. 數位輸出與存放措施 Duplication and Storage

因應委託者未來的使用、捐贈等用途，修復後的332張影像作品選擇不黏貼回修復後的原相簿內，而是照片和相簿各自依不同需求使用不同的保存措施。

但，為了能讓後人了解相簿內的原始樣貌，將委託者所提供之掃描圖檔，輸出列印於鏡銅紙上，沿照片框線裁剪，循修復前所記錄的位置，將複製的影像黏貼於該相簿內頁；希望透過數位掃描、輸出的方式將原相簿內的影像作品再次展現，保留相簿內原有的相貌。

最後，三本相簿選用側開式無酸保護盒為存放措施，由於三本相簿同置於一保護盒內，故在各相簿間隔以無酸瓦楞紙板，並於各相簿四周填以緩衝材料。

To accommodate for the owner's request to preserve 332 photos and three alums separately, the ways of storage would depend on the different demand. However, in order to represent and keep the original condition of albums, the duplicated photos were made of using owner's digitalized files and printing on coated papers. The printed photos were trimmed along the margin and adhered back to their original position. An archival box was provided to protect the repaired albums in storage.

裁切輸出影像
Trimming the margin of the deuplucated photo

依原紀錄位置黏貼相簿內頁
Adhering the duplicated photo on the black page

相簿內的複製影像
The duplicated image

相簿保存措施
The box for presveing albums

III. 修復前後對照 Before and after treatment

相簿（一）Album (1)

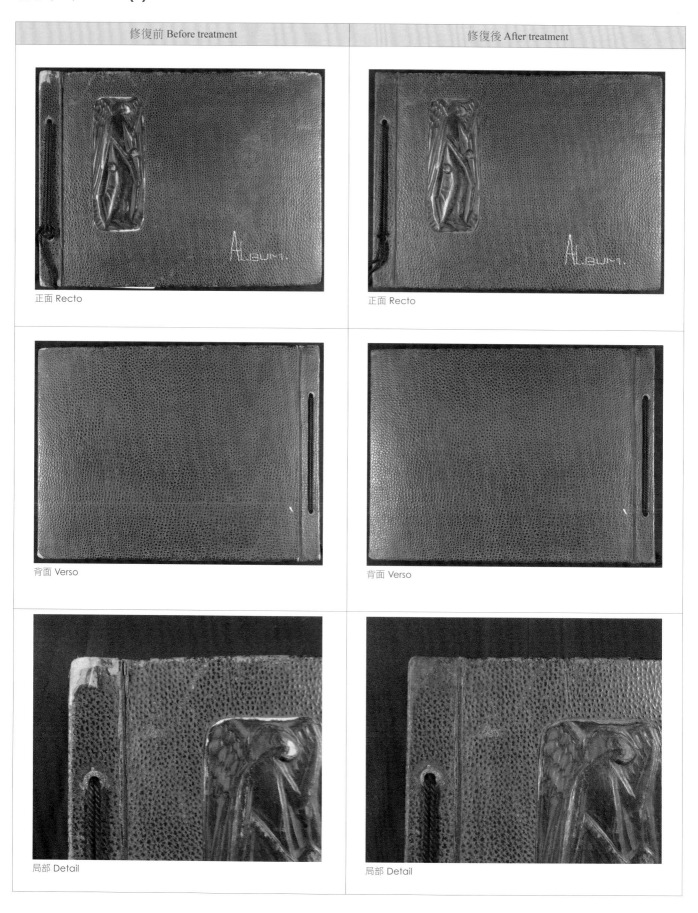

修復前 Before treatment	修復後 After treatment
正面 Recto	正面 Recto
背面 Verso	背面 Verso
局部 Detail	局部 Detail

相簿（二）Album (2)

修復前 Before treatment

修復後 After treatment

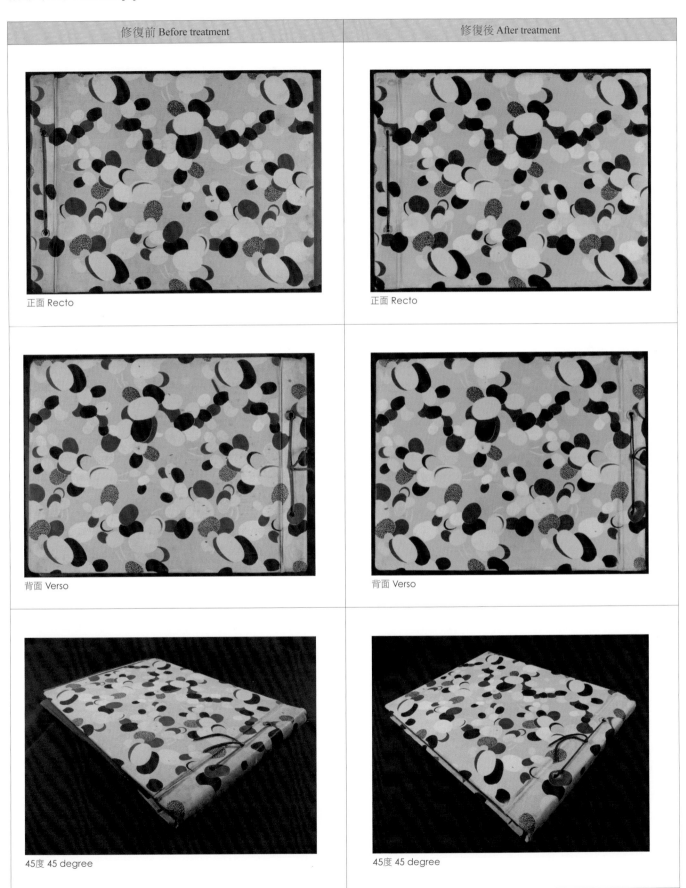

正面 Recto

正面 Recto

背面 Verso

背面 Verso

45度 45 degree

45度 45 degree

相簿（三）Album (3)

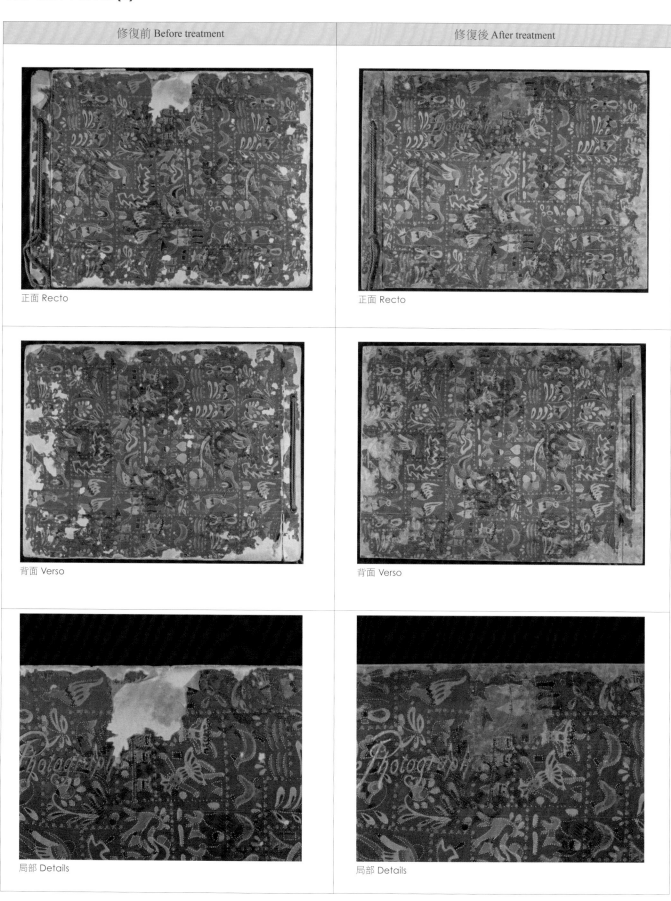

正面 Recto

正面 Recto

背面 Verso

背面 Verso

局部 Details

局部 Details

文　物
Cultural Relics

修復前後對照
Before and After Treatment

國立臺灣師範大學文物保存維護研究發展中心
National Taiwan Normal University Research Center for Conservation of Cultural Relics

受難著服 Final Garments

每件文物以修復前和修復後做為對照，共兩張圖。
修復前置於左側、修復後置於右側。

受難著服（一）Final Garment (1)

受難著服（二）Final Garment (2)

遺書 Wills

每件文物以修復前和修復後做為對照，共兩張圖。
修復前置於左側、修復後置於右側。

遺書（一）Will (1)

遺書（二）Will (2)

遺書（三）Will (3)

遺書（四）Will (4)

遺書（五）Will (5)

遺書（六）Will (6)

遺書（七）Will (7)

遺書（八）Will (8)

遺書（九）Will (9)

遺書（十）Will (10)

遺書（十一）Will (11)

遺書（十二）Will (12)

遺書（十三）Will (13)

遺書（十四）Will (14)

相簿 Album

每件文物以修復前和修復後做為對照，共兩張圖。
修復前置於左側（上方）、修復後置於右側（下方）。

相簿（一）Album (1)

相簿（二）Album (2)

相簿（三）Album (3)

紙絹類作品
Paintings on Paper/Silk

修復報告
Selected Treatment Reports

臺北文化財保存研究所
Taipei Conservation Center

前言
Introduction

2010年秋天，我受陳立栢的邀請到嘉義市垂楊路看陳澄波的作品。從斗六出發，每站都停靠的火車，像時光隧道般的，將我帶到了從日治時期使用至今的嘉義火車站。我花了一點時間，仔細的看了這個車站，歲月的痕跡，增添了我初訪陳澄波先生作品的歷史氛圍。看完作品，我被留下來晚餐，與陳重光、陳立栢同桌。餐桌在傳統的神案前，四周牆面掛滿陳澄波的作品。我們商討了修復作品相關的種種想法，結束時已晚。我搭著這個世代最新最快的高速鐵路，回到臺北。人，雖然被快速的帶離了重重的歷史影像，但修復陳澄波作品所面對的問題，才正要開始。

In the autumn of 2010, I was invited by Chen Li-po to go to Chuei Yang Road in Chiayi and take a look at Chen Cheng-po's art works. Like a time tunnel, the train from Douliu that stopped at every station brought me to Chiayi Railway Station which had been in use since the Japanese occupation years. I took some time to get a close look at the station, and, as a result, the trace of the years had added to the historical ambience of my first encounter of Chen Cheng-po's works. After seeing the works, I was invited to stay for dinner in the company of Chen Chung-kuang and Chen Li-po. The dining table was set in front of a traditional altar and was surrounded on all sides with Chen Cheng-po's works. We talked about ideas concerning the restoration of the works and it was already late when we finished. By way of one of the newest and fastest high-speed trains in this century, I returned to Taipei. Though physically I might have been speedily removed from layers after layers of historical images, the problems of restoring Chen Cheng-po's works just began.

陳立栢，作為臺灣前輩畫家第三代，是我見過最積極面對先人作品的後代。在他的推動下，環繞著陳澄波作品的相關活動，在這一年裡，鋪天蓋地（臺北市立美術館典藏組林育淳的說法）的展開來。他遍訪了臺灣的書畫修復師，詢問方法並委託處置。至今，我可以說臺灣前輩畫家的後代中，沒有人比他更熟知修復與保存相關的問題。

As a third-generation descendant of an early-day Taiwan painter, Chen Li-po is one who deals most enthusiastically with his ancestor's works. In that year, under his drive, activities related to Chen Cheng-po's works were carried out in spades (the description of Lin Yu-chun of the Taipei Fine Arts Museum collection team). He visited every art work restorer in Taiwan to ask about their methods and commission them jobs. Today, among the descendants of Taiwan's early-generation painters, I believe that no one is more familiar with restoration and conservation issues of art works then him.

我被委託的作品種類很多，損傷狀況與修復需求也各式各樣。我儘可能的對陳立栢說明自身的修復能力與限制，但他總是說自己是個商人，不懂修復。他的名言：「別怕失敗，把它拿出來討論，事情就會做的更好」。修復師的猶豫面對商人的明快，令我折服。他對專業的尊重，讓我的修復理念得以充分執行。

The works I have been commissioned to work on are varied in type while the damages and restoration requirements are also different from one to another. I have tried my best to explain to Chen Li-po about my own capability and

limitations in restoration. Yet he always says that he is a businessman and knows nothing about the restoration of art works. His famous saying is: "Don't be afraid of failure, bring any problem out for discussion and the job will be done better." I have to admit his superiority when my hesitation as a restorer is set against his assertiveness as a businessman. His respect for professionalism has allowed me to fully carry out my restoration concepts.

工作室承接的陳澄波及其周邊作品沒有裝裱的形態居多，後來少數為了展覽的需要，有過裝裱。

The works of Chen Cheng-po and other peripheral works assigned to my workshop were mostly in an unmounted state. At a later stage, we were assigned some that had been mounted for exhibition purposes.

因此，面對修復的問題，整理如下：

The problems of restoration to be dealt with were listed as follows:

（1）單張的作品盡量不托裱，保持原始樣態。從保存、持拿、搬運、展示等，設計出一套完整的方式，保留更完整的樣貌，提供日後需要做進一步研究時候的素材。

Single-sheet works would be kept at their original states and would not be lined as far as possible. A comprehensive set of procedures for preserving, holding, transporting, and displaying the works would have to be developed so that the works would retain a more intact appearance and could serve as materials for further studies at a later stage.

（2）沒有裝裱，而需要裝裱的作品，就要面對到現在這一代的人，附加上去的美感與價值的問題。當作品修復裝裱完成，也就是我們這一代的人對陳澄波作品的認識。

For unmounted works that had to be mounted, the problem of taking into account the esthetics and values of the current generation would have to be dealt with. Upon restoration and mounting, the final appearance should represent the current generation's perception of Chen Cheng-po's works.

（3）有裝裱的作品，就需要探討將裝裱與作品一起討論。裝裱與作品同屬一個時期的話，為了保留時代的資料性與歷史氛圍，就需要一併保留。裝裱為後加的，為了配合畫意，那就可以考慮新裝。留與不留，都具有不同意義。依據個人的工作經驗來看裝裱的問題，畫心與裝裱兩者都牽動著「美術文化資產」面臨修復時的諸多問題。目前在畫心的修復上，已有很明確的方法論，但裝裱還沒有受到關注，需要更多的考量與詮釋。

For mounted works, it would be necessary to consider the mounting together with the work in question. If the mounting and the work were of the same period, it would be necessary to preserve both in order to retain the

characteristics and historical ambience of the period. If the mount was added at a later period, remounting would be considered to achieve a better match with the sentiments expressed in the painting. In other words, to keep or not to keep an original mount would have quite different meanings. From my personal experience, both the painting proper and the mounting were related to all the problems concerned with restoring an artistic and cultural asset. Currently, the methodology in the restoration of the painting is very clear-cut. Whereas mounting has yet to receive much attention and more deliberations and interpretations are wanted.

經手修復處置的紙絹類繪畫作品中，單張的水彩速寫、素描簿與書信類，相對的容易進行修復處理；至於陳澄波的創作或與同時代友人交遊互贈的書畫作品，就面臨了如何修復及裝裱等等的問題。如果修復前作品的裝裱，確認是原來的，而被留下來，這當然是完整保留了歷史的一部份。但如果是在我們這代人手上，新加上去的裝裱，在修復完成的同時，就成了歷史的一部份；這是二十一世紀的我們，透過修復，詮釋陳澄波所做的「再現」及保存上所能提供最適宜的處置。

Among the paper/silk works for which restoration had been undertaken by the author, restoration treatment was easier to carry out for single-sheet watercolor sketches, drawing books and written communications. When it came to Chen Cheng-po's art works or calligraphy/paintings from his exchanges with his contemporaries, however, the problems of how to carry out restoration and mounting had been encountered. Before restoration, if the mount of a work was ascertained to be original, it would be preserved in the entirety as part of history. But if a mount was added by the current generation, on completion of the restoration, it would become part of the history. This was the most suitable treatment we could offer in "reproducing" and preserving Chen Cheng-po's works through restoration in the 21st century.

下表為工作室承接財團法人陳澄波文化基金會修復各類物件清單：

The following table lists the various items our workshop has undertaken to restore for Chen Cheng-po Cultural Foundation:

NO	日期 Date	修復畫作項目 Items for Restoration	備註 Remarks
1	2010.11	第一批淡彩速寫畫作 First batch of watercolor sketches	
2	2010.12	膠彩畫：〔仕女〕、〔枇杷樹〕 Glue color Paintings: *A Lady, Loquat Tree*	
3	2010.12	書畫掛軸類：張大千、張善孖、俞劍華、楊清磐、王濟遠〔五人合筆〕 Hanging scroll: A collaborative painting by Chang Dai-chien, Chang Shan-zi, Yu Jian-hua, Yang Qing-pan, and Wang Ji-Yuan	

4	2011.1	第二批淡彩速寫畫作 Second batch of watercolor sketches	
5	2011.3	書畫掛軸類：張聿光—紙本水墨畫作〔燭台與貓〕、曹秋圃—紙本書法〔挽瀾室〕、潘天壽—紙本水墨畫作〔凝寒〕、王濟遠—紙本書法〔陸游·夏日雜詠〕 Hanging scrolls: *Candlestick and Cat*—ink-wash painting on paper by Zhang Yu-guang; *Wan Lan Study*—ink-wash calligraphy on paper by Cao Qiu-pu; *Freezing Coldness*—ink-wash painting on paper by Pan Tian-shou; *Lu You's Summer-day Poem Written at Random*—ink-wash calligraphy on paper by Wang Ji-Yuan	
6	2011.4	第三批淡彩速寫畫作 Third batch of watercolor sketches	
7	2011.4	文物類：信封及明信片類、剪報資料及畫冊、石川欽一郎信件 Personal collected items: envelopes and postcards, newspaper cuttings and picture albums; letters from Ishikawa Kinichiro	
8	2011.5	鉛筆素描簿 Pencil drawing book	
9	2011.6	膠彩畫：〔竹〕、〔矢車菊〕、〔野生杜鵑〕 Glue color paintings: *Bamboo, Cornflower,* and *Wild Azalea*	師一習作 Painting exercises as first-year students at the Art Teacher Training Program of the Tokyo School of Fine Arts
10	2012.2	文物類：藏書、生活照、手稿、明信片、東京美術學校圖畫師範科畢業證書、美術圖片 Personal items: books; daily-life photos; manuscripts; postcards, graduation certificate from the Art Teacher Training Program, Tokyo School of Fine Arts; art pictures	創價學會「豔陽下的陳澄波」展覽 "Under the Searing Sun" exhibition of the Taiwan International Soka Association
11	2012.5	文物類：明信片、雜誌、藏書 Personal items: postcards, magazines, books	臺北市立美術館「行過江南」展覽 "Journey through Jiangnan" exhibition of the Fine Arts Museum
12	2012.7	文物類：明信片 Personal items: postcards	中央研究院臺史所 Institute of Taiwan History, Academia Sinica
13	2012.9	書畫掛軸類：收藏畫作 Hanging scrolls: artwork collection	
14	2013.4	膠彩畫：〔寒冬〕 Glue color painting: *Cold Winter*	

膠彩畫類修復處理
Conservation Treatment of Glue Color Paintings

· 枇杷樹Loquat Tree

I. 修復前狀態 Before treatment condition

枇杷樹 Loquat Tree 1924　絹上膠彩 Glue color on silk　61×51cm

II. 修復理念 Treament approach

1. 修復理念採取的是「最少的修復、最大的保護」。

 The Treament approach adopted was "minimal restoration, maximal protection".

2. 作品顏料層厚度偏厚，經檢視顏料層穩定狀況，發現顏料層相當穩定沒有剝離翹起的情形形成。

 Since the thickness of the paint layer was on the high side, inspection was carried out to determine its stability. It was found that the paint layer was quite stable and no peeling off or warping was found.

3. 作品曾經修復過，裝裱用的是白色中國傳統紋樣綾料。

Restoration had been carried out previously and white damask with traditional Chinese pattern was used in the mounting.

4. 畫心有大片褐色髒污。畫心托紙穩定，沒有空糊的現象。

A large area of brown dirt was found on the painting. The lining paper of the painting was stable and there were no pockets of area where paste was absent.

5. 畫作局部有破損情形產生，補彩處有接筆的痕跡。前次修復時沒有針對破損區域做補絹工序處理，採用的方法為直接在托紙上補彩，並在大面積的破損處，對缺損的畫意做接筆。這個畫面的印象，已經定型一段時間，如果在這次修復時，完全將它揭除，畫面的印象會劇烈變化，因而考慮保留。只將局部補彩調整的接近畫絹底色，減少破洞的印象，讓畫面更完整。

Damages were found on localized areas of the painting. Where paints had been applied for covering up, there were traces where brush strokes were extended. In the previous restoration, mending of the damask had not been carried out. Instead, paints were applied directly on the lining paper to fill up the damaged areas. If a damaged area was particularly large, broken-off brush strokes were touched up. The painting in such a state had already settled for some time and if all these filling up and touching up were removed entirely in the current restoration, the appearance of the painting would change drastically. So it was decided that reparation from the previous restoration would be kept, with the exception that the color of some of the filling up paint was adjusted to closer to the background color of the damask so that the broken areas were not so obvious and the painting appeared more intact.

6. 畫面基底材與背板，製作時考慮的重點如下；畫面平整不起伏變形，耐溼氣不易長霉，保護畫心不受碰撞。額裝作品在臺灣，長久以來大量運用三夾板。對應這個問題，我選用的是風扣板（Foam Board），加上兩層楮皮紙製作的空氣層袋，再將作品塗佈稀漿糊，整面貼附上去，乾燥後取得平整。背板則選用了塑膠材質的中空導流板，用防鏽處理的螺絲釘，固定在框條上。這些材質與做法可以減緩受潮、變形、酸化的影響。

In the production of substrate materials and base board, the key requirements were that the painting surface should remain even without any waviness or deformation; the painting should be moisture proofed and not easily susceptible to mold growing; and that the painting proper should be protected from being knocked. Plywood had long been used commonly in Taiwan for framed mounting. To deal with this situation, I had chosen to use foam board, added two air-layer bags made with Kozo paper, then applied dilute paste to the back of the whole painting before sticking it to the substrate material so that evenness could be achieved upon the drying of the paste. For base boards, plastic hollow baffle boards were used and were fixed to the framing borders with screws which had been rust proofed. These materials and treatment methods should help towards mitigating the impacts of moisture, deformation and acidification.

III. 修復前後損傷狀況處理對照 Before and after treatment comparisons

處理前 Before treatment	處理後 After treatment

畫心的大片褐色髒污用純水洗淨後，並沒有得到太好的改善。決定保持現狀，不強加清除。現階段的技術與材料無法解決的問題，保留下來，對作品不會造成傷害，而且說不定下一個世代的人會有更好的技術與材料，得以解決問題。這個修復理念看似消極，但卻是面對無法立即解決的問題時，最安全的作法。

The large area of brown dirt on the painting saw no big improvement after washing with purified water. It was decided that the status quo would be retained and no insistence on removal would be attempted. Retaining problems that could not be solved with existing technology and material would not cause any damage to the art work and leave the possibility that there would be better technology and materials in coming generations to solve the problem. This restoration approach may appear passive, but is the safest way to deal with problems that cannot be solved immediately.

清除突出異物。
Removal of jutted out foreign matters.

畫心破損區域補絹全色處理。
Inpainting treatment through damask mending of a damaged area of the painting proper.

IV. 修復工序 Conservation treatment procedures

處理前 Before treatment	處理後 After treatment
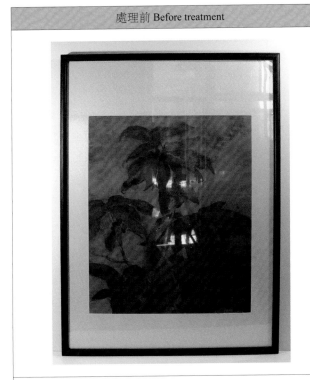	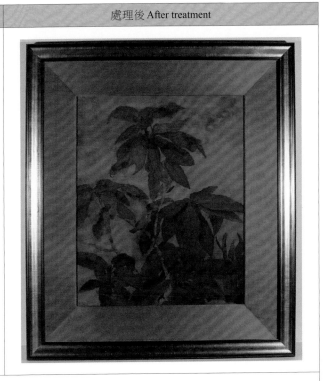

裝裱的純白色綾料不適合此幅膠彩畫作，改用雙色平織的緞面料子，外框選用金色系的框條。

Considering that the pure white damask used for mounting was not appropriate for this glue color painting, two-tone woven satin was used while frame borders of golden hue was used.

更換較為穩定的基底材，提供畫作安全的保存環境。

Changing to a more stable support offers a safer preservation environment for the painting.

265

V. 修復心得 Insights gained

修復過程中不單單只是面對畫作物件做出各項修復的決定，更需要與收藏對象充分溝通，多方聽取吸收各項看法及建議。對於修復過程中每個環節都要詳加說明，尤其是在鑲料及額裝畫作框條選用這個環節，更需要與收藏對象取得最終共識才能夠繼續進行下去。

During restoration, it is not enough just to make various restoration decisions regarding the art work in question. It is also necessary to maintain full communication with the collector concerned and to listen to and take in various points of view and suggestions. Each step of the restoration process should be explained in detail. In particular, in matters concerning the choice of material for bordering and painting frames, it is necessary to arrive at a consensus with the collector before proceeding.

〔枇杷樹〕畫作鑲料的選擇：

The choice of the bordering material used for *Loquat Tree*:

原裝裱使用的純白色綾料並不適合此幅膠彩畫作，因此改用雙色平織的緞面料子。第一次選用了接近畫心樹葉藍綠色系的料子，但陳立栢先生覺得顏色太重，與畫面色調對比太強，於是做了更換。再次選擇了與畫面底色相近的土黃色系的料子，完成了裝裱。

The pure white damask used in the original mounting was found not appropriate for this glue color painting, so two-tone woven satin was used instead. The color of the satin first chosen was a bluish-green hue close to the leave color on the painting. But Chen Li-po found the color contrast with the painting too great, so a replacement was made. In the replacement, a satin of yellowish brown color was chosen and mounting was carried out subsequently.

至於在畫框挑選方案，先行預選幾款條框，交由陳立栢先生決定，顏色則依陳重光先生的喜好，選用了金色系框條。

As to the choice of the painting frames, a selection of framing borders was presented to Chen Li-po for decision. The final choice was a golden hue one which was Chen Tsung-kuang's preference.

· 沉思 Meditation

I. 修復前狀態 Before treatment condition

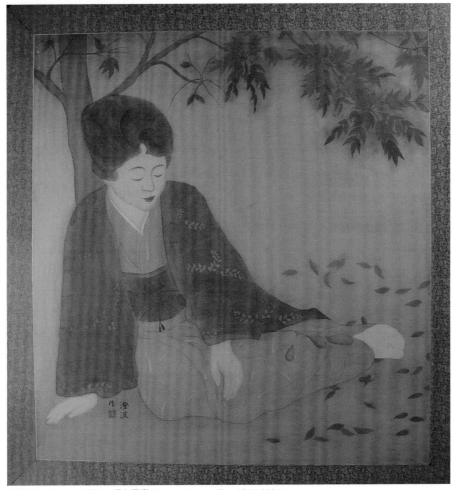

沉思 Meditation 1926 絹上膠彩 Glue color on silk 126×111cm

II. 修復理念 Treatment approaches

1. 同樣用「最少的修復、最大的保護」作為修復理念。

 Again, the treatment approach of "minimal restoration, maximal protection" was adopted.

2. 和服仕女的主題是很典型的日治時期東洋膠彩畫作品,因此在裝裱上企圖融入更適宜的日本元素材料。

 Human figures in kimono is a typical theme for Oriental glue color works during the Japanese occupation years, so Japanese elements which were more suitable were added to the mounting.

3. 畫面局部有小破損,因面積很小,只需略做全色,就可達到很好的完整性。

 Minor damages were found in localized areas of the painting surface. Because the affected areas were small, just minimum inpainting can achieve good intactness.

4. 畫心托紙穩定,沒有空糊的現象。在考量保護畫心顏料層與舊氣的前提下,決定不揭除舊托紙。

 The lining paper for the painting was stable and there was no empty pocket where paste was absent. With preserving the paint layers of the painting and maintaining a dated look as primary considerations, it was decided that the old lining paper would not be removed.

5. 畫心全面有褐色斑點，人物臉部、手部以及白色的足袋，特別明顯，妨礙作品的鑑賞。考慮以純水全面淋洗畫作，減緩褐斑視覺觀賞的干擾。

Brown spots were found all over the painting and were particularly evident on the face and hands of the figure as well as her tabi, so much so that they interfered with the appreciation of the painting. Consideration was made therefore to cleanse the work comprehensively with pure water to mitigate the interference of the brown spots on the viewing of the painting.

6. 畫面基底材與背板處理方式相同於〔枇杷樹〕畫作處理方法。

The methods used in treating the substrate materials and base board of the painting were the same as those used for Loquat Tree.

III. 修復前後損傷狀況處理對照 Before and after treatment comparisons

處理前 Before treatment	處理後 After treatment
	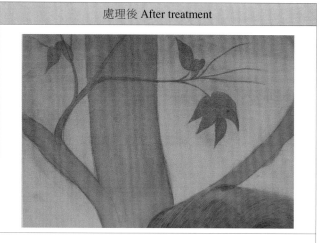

繪絹破損區域補絹全色處理
Inpainting treatment through mending damaged areas of the damask

繪絹破損區域補絹全色處理
Inpainting treatment through mending damaged areas of the damask

繪絹霉斑清洗處理
Rinsing treatment of mildew spots on the damask

IV. 修復工序 Conservation treatment procedures

清洗畫心
Cleansing the painting

檢查畫心底下吸水紙吸附髒污的情況
Checking how dirt was adsorbed by the blotting paper laid under the painting

內框架表面布料黏貼處理工序
Treatment procedures of pasting fabric on the surface of the inner frame

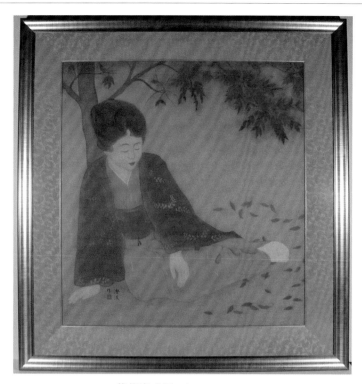

修復完成圖 After treatment

V. 修復心得 Insights gained

　　修復過程中不單單只是面對畫作物件做出各項修復的決定，更需要與收藏對象充分溝通，多方聽取吸收各項看法及建議。對於修復過程中每個環節都要詳加說明，尤其是在鑲料及額裝畫作框條選用這個環節，更需要與收藏對象取得最終共識才能夠繼續進行下去。

　　During restoration, it is not enough just to make various restoration decisions regarding the art work in question. It is also necessary to maintain full communication with the collector concerned and to listen to and take in various points of view and suggestions. Each step of the restoration process should be explained in detail. In particular, in matters concerning the choice of bordering material and painting frames, it is necessary to arrive at a consensus with the collector before proceeding.

〔沉思〕畫作鑲料的選擇：

The choice of bordering material used for *Meditation*:

　　裝裱料子的選擇方法，以畫意為準。原畫作採用褐綠色系唐草小團花紋樣的錦緞布料，無法襯托出畫意和服仕女的時代氛圍。改用日本織造的雙色緹花緞面料子，按著畫面上出現的顏色與圖案，選擇了一塊類似裙子圖案的緹花緞料。

　　The deciding factor for the choice of mounting material was the sentiments expressed by the painting. In its original form, the mounting material was a piece of satin embellished with small greenish brown arabesque patterns, which did not help in setting off the sentiments of the painting nor the ambience of the time represented by kimono wearing people. In the restoration, a two-tone jacquard satin made in Japan which matched well with the color and pattern of the dress depicted on the painting was chosen.

・師一習作

Painting exercises as first-year students at the Art Teacher Training Program of the Tokyo School of Fine Arts

I. 修復前狀態 Before treatment condition

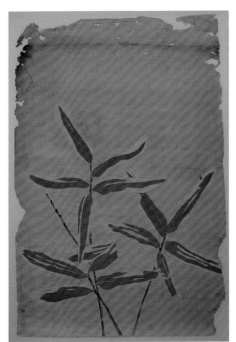

竹 Bamboo　1924
紙上膠彩 Glue color on paper
65.5×44cm

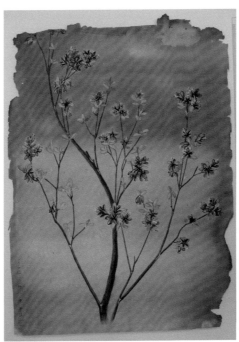

野生杜鵑 Wild Azalea　1924
紙上膠彩 Glue color on paper
63×45.5cm

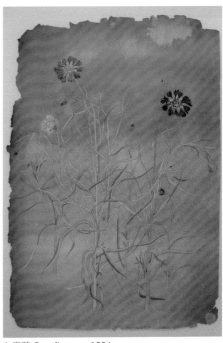

矢車菊 Cornflower　1924
紙上膠彩 Glue color on paper
63.5×44.2cm

II. 修復理念 Treatment approaches

1. 「師一」的三張習作。內容都是植物，藏家按內容取名為〔竹〕、〔野生杜鵑〕、〔矢車菊〕。根據畫作所使用的顏料及題材研判後的結果，推論作品特色是對單一顏料的練習，如綠色運用在竹葉與矢車菊的莖、而紅色與雲母是杜鵑花的花瓣與蕊、茶色則是用來表現枝幹。

 The paintings for restoration were three paintings carried out as exercises when Chen Cheng-po was a first-year student in the teacher training program of the Tokyo School of Fine Arts. All three paintings were about plants and the collector had named them according to the contents respectively as *Bamboo*, *Wild Azalea* and *Cornflower*. Judging from the use of pigments and the choice of theme, it was determined that these paintings were exercises in the use of single pigments. Thus, green was used for the bamboo leaves and the stalk of the cornflower, red/mica red was used for the petals and filaments of the azalea, and dark brown was used to depict branches and stems.

2. 紙張在保存過程中嚴重裂化，翻動觸摸隨即脆裂，四周因而有大面積的破損遺失，重度黃化也讓破損的四周有如燒焦的痕跡。同時也因受潮，而有大小不一的反白水漬與髒污。不僅保存不易也難鑑賞。

 The paper of the paintings had become extremely brittle during keeping, so much so that it cracked easily on turning or touching. As a result, there were large areas of damages and broken parts on all sides while severe yellowing had left the damaged sides looked charred. Also, because of moisture damages, there were reversed-out water stains and soiling. This had made preservation as well as viewing difficult.

3. 畫心有上過托紙，這很難判斷是陳澄波創作當時就托好的，還是畫好後才托上去的。空糊嚴重，需揭除舊托心紙。染製接近畫心底色的托心紙，但因為畫心四周破損嚴重，托心紙的大小與作品最後要決定尺寸息息相關。

The painting had been lined but it was difficult to say whether the lining was there when Chen Cheng-po made the paintings or afterwards. Since there were large areas with no paste, it was necessary to remove the old lining paper. A decision is made to use lining paper dyed to a color similar to that of the background color of the painting. However, because all sides of the paintings had been badly damaged, the dimensions of the lining paper would be closely related to the final dimensions of the art works.

4. 顏料層不穩定，特別是綠色（石綠）、紅色、以及雲母銀色。清洗畫心前需用動物膠溶液全面與局部加固。

The paint layers were not stable, particularly for the green (malachite green), red, and mica silver colors. Before cleansing the paintings, it was therefore necessary to use animal gelatin solution to give comprehensive or partial reinforcement.

5. 畫面基底材與背板處理方式相同於〔枇杷樹〕畫作處理方法。

The methods used in treating the substrate materials and base board of the painting were the same as those used for *Loquat Tree*.

III. 修復前後損傷狀況處理對照 Before and after treatment comparisons

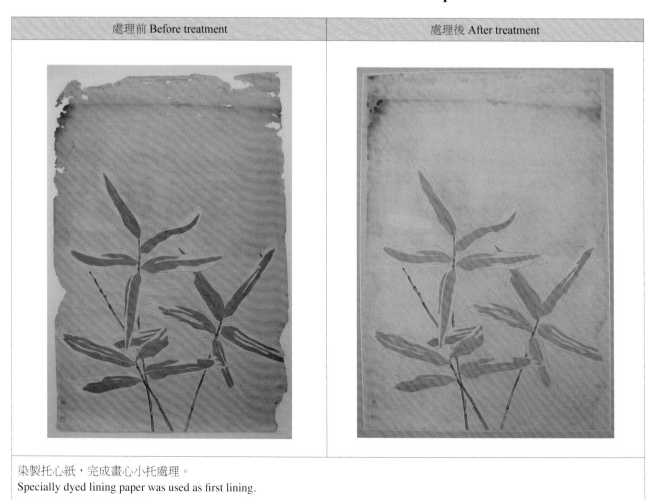

處理前 Before treatment	處理後 After treatment

染製托心紙，完成畫心小托處理。
Specially dyed lining paper was used as first lining.

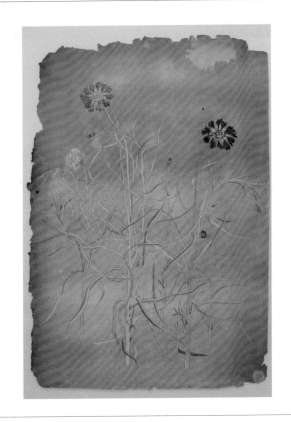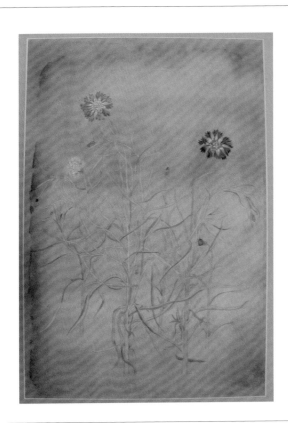

染製托心紙，完成畫心小托處理。
Specially dyed lining paper was used as first lining.

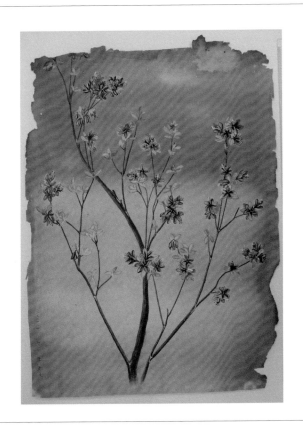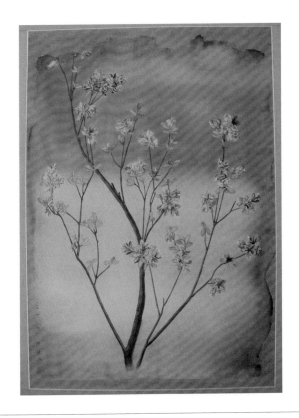

染製托心紙，完成畫心小托處理。
Specially dyed lining paper was used as first lining.

IV. 修復工序 Conservation treatment procedures

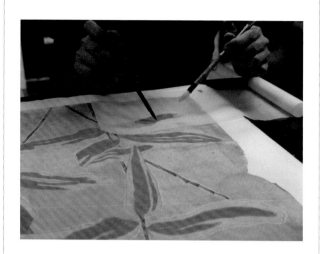

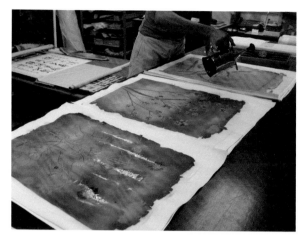

固色處理 Media consolidation
隔著化纖紙用毛筆沾動物膠溶液塗佈於顏料層不穩定區域，整幅畫心完成固色處理工序，放置 7 天等待動物膠溶液趨於穩定後再接著進行後續工序。

Animal glue solution was smeared with a writing brush through fiber paper to areas where the paint layer was not stable. On completion of this reinforcement treatment, the painting was set aside for seven days to allow the settlement of the animal glue solution before subsequent procedures were carried out.

清洗畫心 Cleansing of painting
畫心完成固色處理工序後，清洗畫心。以純水淋洗畫心，下方放置吸水紙吸附滲漏出來的髒污。

The painting was cleansed after media consolidation was completed. Pure water was used for cleansing while blotting paper was laid under the painting to adsorb any dirt leaching out.

小托畫心 First lining
畫心正面先以兩層化纖紙做全面的假托動作，提供畫心在一個穩定的狀態下進行畫心小托工序。

Two layers of fiber paper were put on top of the painting to provide a stable temporary lining for the placement of the first lining.

小托畫心 First lining
畫心完成正面假托工序，將畫心正面朝下排平於燈光桌上面，再逐一整理畫心破損殘缺區域。

After the front of the painting was provided with temporary lining, the painting was put face down on a light table for dealing with the damaged areas one by one.

上托心紙
Putting on lining paper

上完托心紙後，取下保護畫心用的化纖紙，上牆乾燥。
After lining, fiber paper used for protecting the painting was removed and the painting was allowed to dry on walls.

全色處理前先行量訂三幅畫作尺寸。〔竹〕畫作尺寸最為完整，因此，另兩幅畫作皆以其尺寸為準。
Before inpainting, the dimensions of the three paintings were measured. Because the dimensions of the painting Bamboo were most intact, they were used as reference for the dimensions of the other two paintings.

畫心進行全色處理。
Inpainting treatment

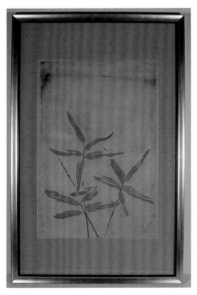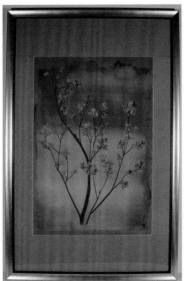

修復完成圖 After treatment

V. 修復心得 Insights gained

「師一習作」畫心尺寸大小抉擇：

Deciding on the dimensions of the painting propers:

三張作品同為陳澄波先生「師一」時期的作品；因為畫心四周破損嚴重，托心紙的大小與作品最後要決定尺寸息息相關。幸運的是〔竹〕還殘留了畫心料紙的部份裁邊，據此作為其他兩幅作品畫心料紙大小的依據，讓三張作品的料紙大小相同、趨於一致。

The three paintings were the works of Chen Cheng-po when he was a first-year student of the teacher training program of the Tokyo School of Fine Arts. Because all sides of the paintings had been badly damaged, the dimensions of the lining paper would be closely related to the final dimensions of the art works. Fortunately part of the trimmed edges of the paper for *Bamboo* still remained, so *Bamboo* was used as reference for the size of the paper of the other two works so that the sizes of the painting paper for all three pieces of work would be uniform.

面對此類尺寸大小不容易判斷而且可以確定是同一時期出於同一位創作者的畫作，這樣的訊息如果沒有同時也被藏家掌握的話，類似的作品一經修復，尺寸就會不一致，失去畫作材質的最原始基礎資料。作品所附加的歷史資料，在修復的過程被解讀出來的同時，藏家和修復師之間該如何建立資料網互通訊息，可以作為同類作品修復時的參考。

For paintings for which the sizes are not easy to determined but can be ascertained to be created by the same artist in the same period, if the collector is not able to get hold of such information, the sizes will not be uniform and the original basic information on the materials of the work will be lost after restoration work is carried out. The current restoration work provides an example on how historical information accompanying art works can be interpreted in the course of carrying out restoration and how collectors and restorers can establish channels to exchange information.

淡彩速寫類修復處理
Conservation Treatment of Watercolor Sketches

I. 修復前狀態 Before treatment condition

臥姿裸女-32.1（9）Lying Nude-32.1 (9)　1932
紙本淡彩鉛筆 Watercolor, pencil on paper　28.5×36.5cm

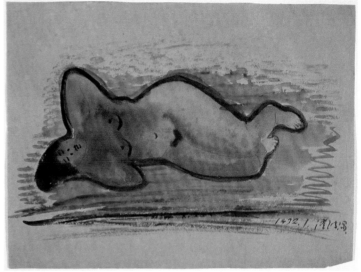

臥姿裸女-32.1（9）Lying Nude-32.1 (9)　1932
紙本淡彩鉛筆 Watercolor, pencil on paper　28.5×36.5cm

1. 紙張尺寸 Paper size

 使用的紙張尺寸相當一致，約略在 36×26.5cm之間，尺寸變動不大。

 The paper sheets used were quite uniform in size and were around 36×26.5cm with little variation in dimensions.

2. 紙張特色 Paper sheet characteristics

 沒有抄造紙張留下來的簾紋痕跡，紙張邊緣保留原本的形狀，沒有手工裁割的痕跡。據此推測有可能是當時最容易入手的量產機器紙，此類紙張較為適合畫家作大量的速寫時使用。

 There was no blind pattern characteristic of manually produced paper; the edges of the sheet had retained their original shape; and there was no trace of manual cutting. From these it was deduced that these were mass produced machine made sheets which were easiest to handle and were suitable for making a large number of sketches by artists.

II. 修復理念 Treatment approaches

1. 現狀保存。

 Status quo would be maintained.

2. 採取最少干預處理方式，不漂洗作品的褐色，減少對作品顏料層的損傷，也可以保留畫作的舊氣。

 A treatment approach of minimal interference was adopted. By not bleaching the brown color of the works, damages to the paint layers were minimized while a dated look of the works could be retained.

3. 保存作品紙張原有的樣貌與質感，盡可能的不托心。如果，畫作紙張強度相對變弱的作品，加托紙張才可以延續畫作保存需要，則以修復用傳統楮皮紙（樹火紀念紙文化基金會製作），進行染色。調整顏色跟欲托整的畫作顏色接近，進行托整畫作，以利後續的保存措施。

 Lining was not applied as far as possible to retain the original appearance and texture of the paper sheets. For works in which the paper strength had deteriorated and lining paper had to be added to extend its preservation, traditional Kozo paper for restoration purposes (produced by Suho Memorial Paper Culture Foundation) would be used. Dyeing would be carried out so that the color of the lining paper would be similar to that of the work to be lined. Lining with such paper would facilitate the implementation of subsequent preservation measures.

4. 曾經被托整過的畫作，用間接潮濕法，揭除舊托心紙。回復陳澄波先生創作當時，單張沒托心的樣貌。

 Works which had been lined previously would undergo an indirect moistening process for the removal of the old lining paper so as to revive the no-lining appearance just like it was when Chen Cheng-po was making the painting.

5. 少部份有褐色斑點的作品，現狀保留，不做漂洗。

 Brown spots were found on a minor portion of the works. To maintain the existing condition, no bleaching was carried out.

6. 四周略有折裂的作品，於折損處背後，加貼折條。

 For works where minor fold cracks were found on the sides, folding strips were added on the back of the cracks.

7. 四周有大面積破損的作品，挑選類似畫作料紙無簾紋的紙張，染製接近畫作料紙的顏色，從背後作局部的補紙。

 For works with large areas of damages on the sides, sheets with no blind pattern similar to the ones used in the paintings were chosen and dyed to a color close to that of the painting paper would be used for partial patching at the back of the painting.

III. 修復前後損傷狀況處理對照 Before and after treatment comparisons

處理前 Before treatment	處理後 After treatment
托心紙泛黃、霉斑 Yellowing and mildew spots found on lining paper	染製托心紙，揭除舊托心紙後再次上托心紙 Specially dyed lining paper was put on after old lining paper was removed
畫作邊緣區域破損狀況 Damages in areas near one edge of a sketch.	染製托心紙，小托畫作。提供畫作更周詳的保存環境，避免邊緣區域再次受到損傷。 Lining paper was specially dyed for use as first lining of the sketch. This provided a more comprehensive protective environment for the sketch to prevent further damages.

| 已托裱處理畫作。
A previously lined sketch. | 揭除舊托心紙，無加托托心紙，整平處理後畫作情形。
The appearance of the sketch after the old lining was removed and the sketch was smoothed out without adding a new lining. |

| 已托裱處理過畫作
A previously lined sketch. | 揭除舊托心紙，無加托托心紙，整平處理後畫作情形。
The appearance of the sketch after the old lining was removed and the sketch was smoothed out without adding a new lining. |

畫作邊緣區域大面積破損狀況。
Large areas of damages near the edge of a sketch.

畫作經過隱補工序後，放置於中性卡紙視窗內情形。
The appearance of a sketch in a neutral cardboard cut-out after concealed patching was carried out.

畫作邊緣區域破損狀況。
Damages in areas near the edges of a sketch.

完成隱補作業後畫作情形。
The appearance of the sketch after concealed patching had been carried out.

IV. 修復工序 Conservation treatment procedures

清洗畫作：畫作下方墊上多張吸水紙，吸附清洗出來的髒污。
Cleansing of sketch: absorbent paper was laid under the sketch to adsorb any dirt leached out.

已托裱之畫作：揭除舊托心紙。
Removal of old lining paper which had previously been lined.

已托裱之畫作：揭除舊托心紙。

Removal of old lining paper from a sketch which had previously been lined.

揭除舊托心紙。

Removal of old lining paper.

隱補用紙張描繪畫作邊緣區域破損形狀，裁切後上漿糊回貼畫作破損邊緣區域。

The shape of the damage area near one edge of a sketch was outlined on a piece of patching paper. After cutting out and applying paste, the piece of patching paper was adhered to the damaged area of the edge of the sketch.

完成隱補作業的畫作。隱補紙張跟原畫作邊緣區域略為重疊3mm左右。

The sketch after concealed patching was carried out. There was an overlapping of about 3mm between the piece of patching paper and the original edge of the sketch.

修復用傳統楮皮紙毛線邊區域刷上接著劑。

In the treatment, the feathered edge of pieces of traditional Kozo paper was applied with an adhesive.

畫作居中放置於中性卡紙視窗內，將作品浮貼於背板上。

The sketch was placed at the center of a neutral cardboard cut-out and loosely attached to a base board.

夾裱作業。
Matting operation.

中性保存盒。
Acid-free storage box.

製作提耳底板，方便持拿
Base board with carrying loops for convenient holding of mounts.

規格統一的保存盒，方便收藏
Storage boxes of uniform size for convenient keeping.

V. 修復心得 Insights gained

1. 現狀保存的重要性 The importance of maintaining status quo

現狀保存是為了保留畫作的原始風貌。將畫作料紙的尺寸、材質、質感、厚薄……等等相關資訊做為歷史資料的一部分，予以完整的保留下來。提供日後相關研究領域可以從中覓得所需要的線索。

The purpose of maintaining status quo was to retain the original style of art works. This involved the comprehensive retention of features of the painting paper including its dimensions, material, texture, and thickness as part of the historical data, which could serve as necessary clues for related studies in future.

2. 不托整畫作及不裝框的問題 The question of not mounting and not framing art works

針對此類畫作加上數量極為龐大，在面對保存、展示、持拿、搬運等等的問題需要通盤考慮。目前最常被使用的方式，是將作品浮貼夾裱在中性卡紙視窗中。這個好處是保存的方式就是展示的方式，大大的減少作品裝框的耗費，也減少了保存的空間。持拿時不會直接碰觸作品，搬運過程也因為有卡紙外框與保存盒，大大降低了碰撞，折損與摩擦的危險。

Because of the large quantity of sketches involved, it was necessary to devise an all-round solution to deal with the problems of save keeping, displaying, handling, and transporting. The method adopted was one most commonly adopted nowadays, which was to mount the works loosely in acid-free cardboard cut-outs. The advantages of this method of displaying were that it would substantially minimize expenses in mounting and framing and to reduce

the space used in safe keeping. With cardboard external frames and the storage boxes, direct touching of the art works during handling could be avoided and the dangers of collision, breakage and friction during transportation could be minimized.

3. 不托心與補紙的問題 The questions of no lining and paper patching:

不托心的前提下，補紙的材質就要非常接近作品。選用埔里長春紙廠抄造的無簾紋楮皮紙，染製接近畫作料紙的顏色。大面積的破洞還要考慮補彩的問題。面積較小的破洞，可以用顏料帶過，大面積時則以染色紙張取代用顏料全色處理方式，如此可減少補彩時塗佈膠礬水所造成的光澤，以及畫筆平塗時所產生的筆觸痕跡。

If no lining of an art work were to be carried out, the material used as patching paper will have to be very similar to the art work itself. In the treatment, Kozo paper with no blind pattern produced by Puli Changchun Paper Mill was used and dyeing was carried out to give a color close to that of the painting paper. For large holes it was necessary to carry out color retouching. For smaller holes, the use of pigment would suffice. But for large areas, dyed paper was used instead of carrying out inpainting treatment. This would reduce the luster resulting from coating gelatin alum water in color retouching and the traces of brushstrokes resulting from horizontal application of the painting brush.

4. 保存紙板的問題 The choice of safe-keeping cardboards

原本夾襯作品的卡紙，上面的視窗與下面的台紙都選用8P的中性卡紙。幾度與陳立栢先生討論的結果，考量到持拿時8P的中性卡紙會有彎曲的情況產生，因此改用0.5m的白色軟質風扣板。風扣板雖然質輕硬挺，廣為海報或照片直接貼付時使用，但它用來黏貼發泡材質與表面紙板的接著劑，是否足夠穩定還有待確實。

Originally, 8P acid-free cardboard was chosen both for the cardboard cut-outs and the base board below for mounting the art works. After several exchanges with Chen Li-po, considering that 8P acid-free cardboard may bend during handling, it was decided that white soft foam board of 0.5m would be used instead. Though foam boards are light in weight and firm in shape and are commonly used in direct pasting of posters and photos, its stability in gluing to foam materials and surface cardboards with adhesives remains to be ascertained.

5. 保存形式的問題 Problem of storage method

無酸保存盒內部另行製作一對提耳承板，將整疊完成夾裱的畫作整個拎起來。減少手部直接接觸畫作的頻率，提供方便、安全的取拿方式。

Inside the acid-free storage boxes, a pair of base boards with carrying loops was also made to help carry a whole stack of matted art works. This would reduce the frequency of direct touching by hands and offer a convenient and safe way of carrying the art works.

書畫掛軸類修復處理
Conservation Treatment of Hanging Scrolls of Calligraphy/Ink-wash Paintings

· 張大千、張善孖、俞劍華、楊清磐、王濟遠〔五人合筆〕

Collaborative painting by five artists: Chang Dai-chien, Chang Shan-zi, Yu Jian-hua, Yang Qing-pan, and Wang Ji-Yuan

I. 修復前狀態 Before treatment condition

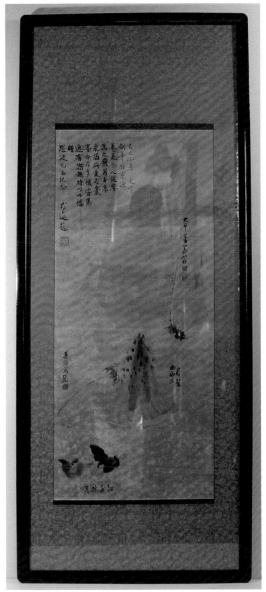

五人合筆 A Collaborative Painting by Five Artists 1929
紙本彩墨 Ink-colour on paper 81×36cm

II. 修復理念 Treatment approaches

1. 全色是本幅最需要被討論的問題。一般在補紙上全色，修復倫理上而言，日後在修復時可移除，但大面積色差及泛白，若不將之調整接近底色，則依然嚴重影響鑑賞，因而決定用直接在畫心上烘染的辦法，統一底色。這雖然有違修復倫理，不得在畫心上全色的原則，但卻能提高鑑賞畫意的辨識度。

For this scroll, inpainting was the top problem that needed to be addressed. According to restoration principle, inpainting should best be carried out on infill paper so that it can be removed if restoration is to be carried out at a later day. In the present case, because there were large areas of color differences and whitening, it would be necessary to adjust these irregularities to close to the background color, or else appreciation of the work would be badly hampered. It was decided to make the color uniform by setting off contrasts and adding touches directly onto the painting. Though this was in contradiction with the principle of restoration that inpainting should not be carried out on the painting, it could nevertheless help towards the appreciation of the painting.

2. 此幅畫作約略在1930年代完成，因此在鑲料的選擇年代相近的揉紙舊料來搭配，讓裱件整體凸顯時代氛圍。但裝裱用料上所要考量的是，1930年代在上海完成的作品，是否適合用當時臺灣流行的揉紙裝裱？另一個考慮是，這張畫被帶回臺灣後，如果要裝裱，很有可能就是用揉紙。因為揉紙裝裱一直到臺灣光復初期，仍是常被使用的方式，比方清大圖書館所藏的于右任、梁寒操等大陸遷臺書家的作品，就保留了當時的揉紙裝裱形式。

Since this scroll was completed in around 1930, the best choice of bordering material should be old crumpled paper from that period or thereabouts to highlight the ambience of that time of the whole mounted work. What needed to be considered, however, was whether it was really suitable to use crumbled paper mounting which was in rogue in Taiwan in those days to be used in an art work made in Shanghai in 1930. Another consideration was, after this painting was brought back to Taiwan, if it were to be mounted, crumpled paper would likely be used. This would be so because, up to the early days of the restitution of Taiwan, crumpled paper mounting had been commonly used. For example, for the works of calligraphers who had migrated to Taiwan from the mainland such as Yu Yu-jen and Liang Han-cao now curated in National Tsing Hua University, crumpled paper mounting of those days was retained.

III. 修復前後損傷狀況處理對照 Before and after treatment comparisons

處理前 Before treatment	處理後 After treatment

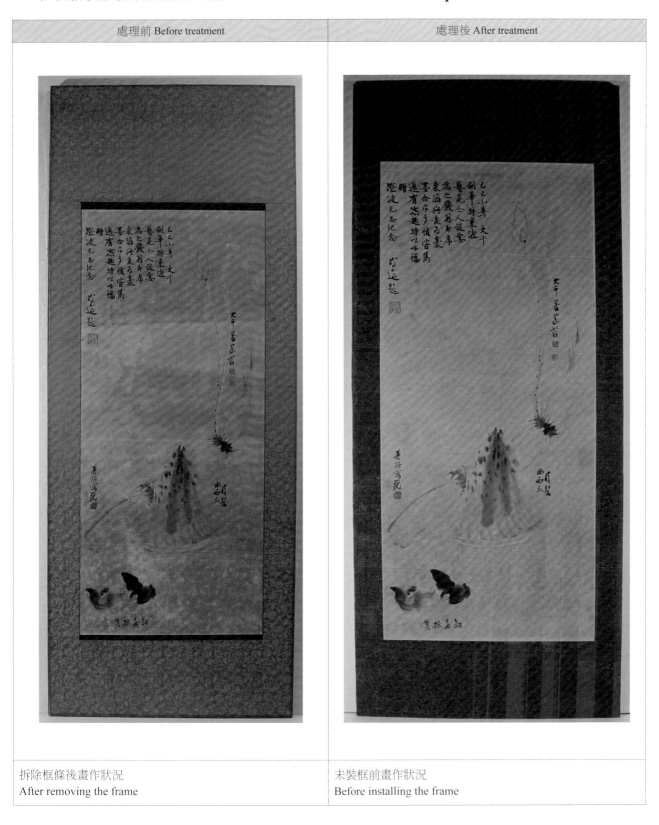

拆除框條後畫作狀況
After removing the frame

未裝框前畫作狀況
Before installing the frame

畫作框架結構
The structure of the painting frame.

基底材改用中性材料製作，加裝中空導流板，提供更妥善的保存條件
Acid-free material was used to make the support and hollow baffle board was added to provide better preservation conditions.

揭心前，畫心背面有補紙痕跡
Before removing the lining paper, there were infill papers at the back.

揭心後，將舊補紙一併清除
After removing the lining paper, old infill papers were also removed.

畫心全色處理前
Before inpainting

畫心全色處理後
After inpainting

畫心全色處理前
Before inpainting

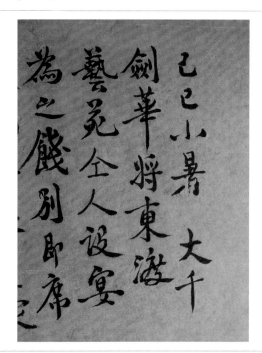

畫心全色處理後
After inpainting

IV. 修復工序 Conservation treatment procedures

以稀釋的酒精全面淋洗畫心。
Dilute alcohol was used to rinse the painting.

吸水紙吸附流出來的髒污情形。
Yellowed discoloration was washed out from the work of art onto blotting papper.

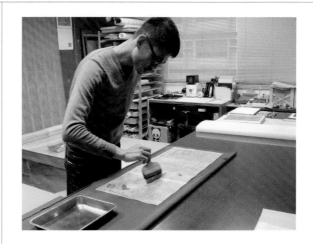

揭心前畫心正面先以化纖紙假托做為保護措施。
Before removing the lining paper, the front of the painting was temporarily lined with fiber paper as a protective measure.

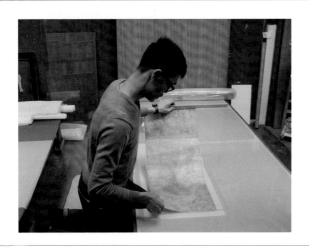
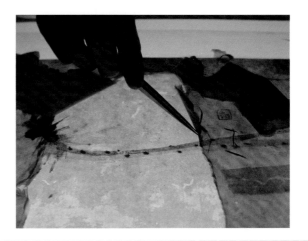

完成畫心正面假托保護措施後將畫心排平於燈光桌上面，準備接著進行揭除舊覆背紙及托心紙等等工序。
After the protective measure of temporarily lining the front of the painting had been carried out, the painting was laid flat on a light table in preparation for procedures including the removal of first and final lining papers.

揭除舊覆背紙及托心紙。圖片所顯示的內容為：畫心已揭除舊的覆背紙及托心紙。
Removal of first and final lining papers. In this photo, the first and final lining papers were removed.

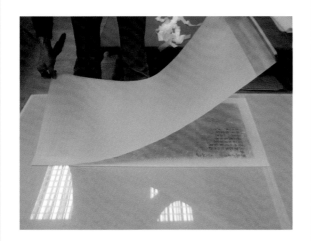
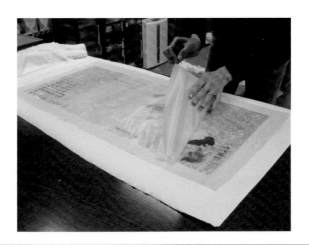

完成揭除舊覆背紙及托心紙後，上托心紙。
After removing first and final lining papers, new lining paper was applied.

完成上托心紙工序後，揭掉保護用化纖紙。
After lining, fiber paper for temporary protection was removed.

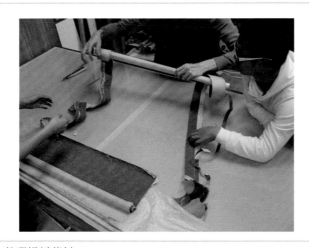

整理揉紙舊料。
Tidying up old crumpled paper.

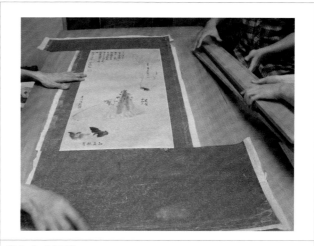

畫心完成四鑲。
Bordering of painting proper on all sides completed.

V. 修復心得 Insights gained

此件畫作的狀況比較複雜而且嚴重，畫心紙質已脆弱，並有多處嚴重的蟲蛀狀況。畫心顏色有明顯的落差，以及泛白斑點，嚴重影響觀賞。因此，在擬定修復計畫的時候更需要多方面的考量及安排才能夠加以進行。

The condition of this painting was rather complicated and serious as the paper of the painting proper had already turned brittle and severe moth damages were evident in many places. Also, the obvious color differences and whitening spots throughout the painting were distractions to the viewing of the painting. So, in devising the restoration plan, more considerations and arrangements had to be made before implementation.

清洗畫心作業方面，僅以微溫的純水全面清洗畫心，這一方式的考量是畫心並沒有霉斑附著在上面，因此不需要以藥劑清洗。然而前一方式對於畫心色差及泛白的狀況並沒有多大的助益，這兩種狀況只能夠以全色方面加以處理。

In the cleansing of the painting, it was decided that only lukewarm pure water would be used because no mildew was found and it was not necessary to use chemicals. This treatment, however, was not particularly helpful in dealing with the color differences and whitening of the painting, and these conditions could only be dealt with by inpainting.

鑲料部份：在考量畫作年代時間的氛圍取向，決定以畫作相對應的年代裡去挑選，恰好工作室留有舊式揉紙可以搭配。畫作修復裝裱在鑲料上面的選用方面是需要多方面加以考慮，而不是單純換個新的鑲料就可以。

For bordering, considering the period ambience of the painting, it was decided to choose materials from corresponding periods. It so happened that some old type crumbled paper was kept in our workshop. The lesson is that, in the choice of bordering material in the restoration and mounting of painting, there are many factors to be considered and it is never a simple case of replacing with new bordering material.

·挽瀾室 Wan Lan Study

I. 修復前狀態 Before treatment condition

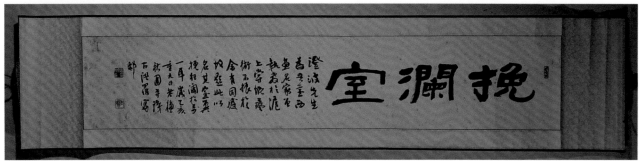

挽瀾室 Wan Lan Study 1935 紙本水墨 Ink on paper 22.5×121.2cm

II. 修復理念 Treatment approaches

1. 裝裱形式是要選擇橫批格式或者是額裝格式，是此一畫作最大的考量。橫批格式卷收起來的話比較省空間，但是不方便展示！額裝格式雖然較佔空間，相對於橫批格式比較方便展示。考慮該作品可能為書齋或畫室的題名，因而考慮將處理前橫批的形式，改為額裝。如此也方便日後的保存與展示。

 One main consideration in dealing with this piece of work was whether to use horizontal wall scroll or framed mounting. Horizontal scrolls would require less space for storage but would be less convenient for displaying. Frame mounting, though taking up more space, would be more convenient for displaying. Considering that this piece of work was meant to name a study or an art studio, it was decided to change the horizontal scroll before restoration to framed mounting for easier storage and display in future.

2. 裝裱用料為配合「挽瀾」一詞的意象，選擇了樹火紀念紙文化基金會近年研發的楮染紙，營造波瀾壯闊的氣氛。

 In the choice of mounting material, in order to match the imagery of the phrase "Wan Lan" (meaning stemming a [raging] tide), the Kozo paper developed by Suho Memorial Paper Culture Foundation in recent years was used so as to create a sense of surging waves and sweeping tides.

III. 修復前後損傷狀況處理比對圖版 Before and after treatment comparisons

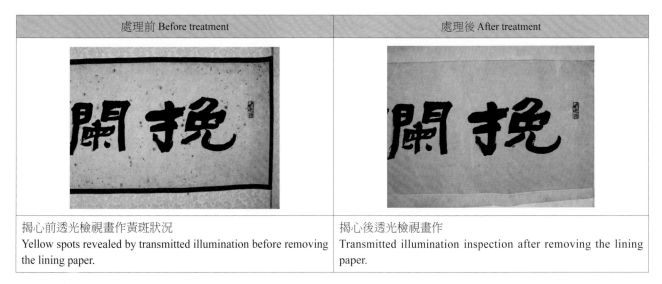

處理前 Before treatment	處理後 After treatment
揭心前透光檢視畫作黃斑狀況 Yellow spots revealed by transmitted illumination before removing the lining paper.	揭心後透光檢視畫作 Transmitted illumination inspection after removing the lining paper.

揭心前透光檢視畫作：有補紙痕跡
Transmitted illumination inspection before removing the lining paper: there were infill papers at the back.

揭心後透光檢視畫作：舊補紙已清除
Transmitted illumination inspection after removing the lining paper: old infill papers had been removed.

畫作多處區域黃斑狀況、破損
Yellow spots and damages were found all over the art work.

黃斑症狀已清除、破損區域已補紙處理
The yellow spots had been removed while the damaged parts had been treated with infill paper.

畫作多處區域黃斑狀況
Yellow spots were found all over the art work.

黃斑症狀已清除
The yellow spots had been removed.

IV. 修復工序 Conservation treatment procedures

清洗畫心
Cleaning the painting

清洗畫心處理後；揭心工序前以化纖紙在畫心正面做保護措施。
After cleaning, the painting was covered with fiber paper for protection before removing the lining paper.

於燈光桌上面，透光狀態下揭除畫心背面的覆背紙及托心紙
After the painting was put on a light table and back-lit, the first and final lining papers at the back were removed.

畫心上托心紙
Lining paper was being added to the painting.

排實托心紙
The lining paper was being pasted firmly.

完成揭心工序後，去除畫心正面保護用化纖紙。
After applying new lining paper, the protective fiber paper at the front of the painting was removed.

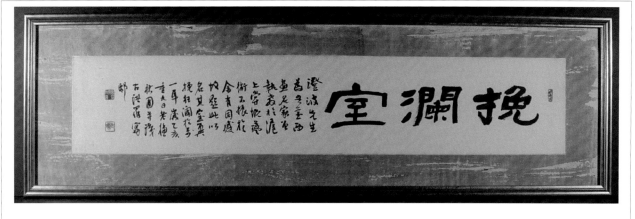

V. 修復心得 Insights gained

此幅畫作面臨到的問題是畫心多處霉斑清洗處理、決定裝裱形式、以及選擇裝裱用料等三項。

The problems to be dealt with in this case were the numerous mildew spots on the painting to be cleansed, the mounting method to be used, and the choice of mounting material.

維持原橫批樣式，在收藏方面的確可以省下許多空間，不過對於日後展示，比較不方便。若以展示用途做為考量議題，額裝款式比卷裝橫批形式更加便利。再以書寫內容方面加以考量，齋館號名稱，如同公司行號的招牌，就用途上面，懸掛展示是最常被使用的方式，這時候如果沒有框條及壓克力等等保護條件的話，日後的保存絕對是一個極為嚴苛的挑戰。因此，整個裝裱形式改由額裝形式取代先前舊有的橫批格式。

Maintaining the original horizontal scroll form would certainly save a lot of storage space but would be more inconvenient for displaying in future. From a display point of view, framed mounted paintings would be easier to handle than horizontal scrolls. From the viewpoint of the contents, the name plate of a study or a studio is like the signboard of a shop or a company—hanging is the most common form of display. If the painting in question was not protected by frames, acrylic plates, etc, conservation in future would definitely be a challenging task. For these reasons, frame mounting instead of the original horizontal scroll was adopted.

挑選鑲料部份如同II-2內容所述。

The reasoning for the choice of bordering material was as given in II-2 above.

紙絹類作品
Paintings on Paper/Silk

修復前後對照
Before and After Treatment

臺北文化財保存研究所
Taipei Conservation Center

膠彩 Glue Color Paintings

每件作品以修復前和修復後做為對照，共兩張圖。
修復前置於左側、修復後置於右側。

GC001
枇杷樹Loquat Tree

GC002
野生杜鵑Wild Azalea

GC003
竹Bamboo

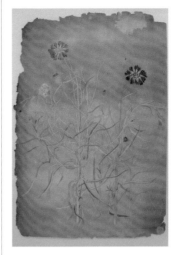

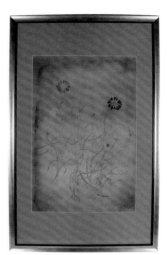

GC005
竹矢車菊Cornflower

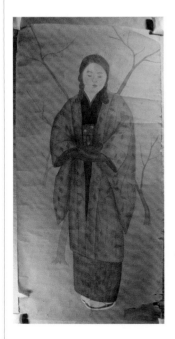

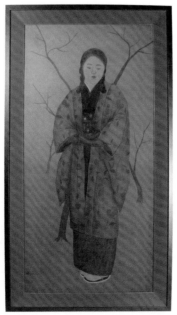

GC006
寒冬Wintry

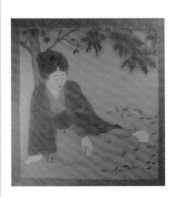

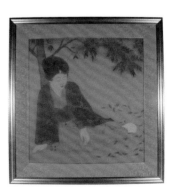

GC007
沉思Meditation

淡彩速寫 Watercolor Sketches

每件作品以修復前和修復後做為對照，共兩張圖。
修復前置於左側、修復後置於右側。

WS001
坐姿裸女-31.10.8（1）Seated Nude-31.10.8 (1)

WS002
坐姿裸女-31.11.18（2）Seated Nude-31.11.18 (2)

WS003
立姿裸女-31.11.18（1）Standing Nude-31.11.18 (1)

WS005
坐姿裸女-31.11.30（4）Seated Nude-31.11.30 (4)

WS006
立姿裸女-31.11.30（2）Standing Nude-31.11.30 (2)

WS007
人物-31.12.6（1）Figure-31.12.6 (1)

WS010
畫室-31.12.14（1）Studio-31.12.14 (1)

WS013
坐姿裸女-31.12（7）Seated Nude-31.12 (7)

WS014
坐姿裸女-31.12（8）Seated Nude-31.12 (8)

WS015
立姿裸女-31.12（5）Standing Nude-31.12 (5)

WS017
畫室-31.12（2）Studio-31.12 (2)

WS018
坐姿裸女-32.1.29（9）Seated Nude-32.1.29 (9)

WS019
坐姿裸女-32.1.29（10）Seated Nude-32.1.29 (10)

WS021
坐姿裸女-32.1.29（12）Seated Nude-32.1.29 (12)

WS022
畫室-32.1.29（3）Studio-32.1.29 (3)

WS024
臥姿裸女-32.1（2）Lying Nude-32.1 (2)

WS026
坐姿裸女-32.1（14）Seated Nude-32.1 (14)

WS027
坐姿裸女-32.1（15）Seated Nude-32.1 (15)

WS028
坐姿裸女-32.1（16）Seated Nude-32.1 (16)

WS029
坐姿裸女-32.1（17）Seated Nude-32.1 (17)

WS032
臥姿裸女-32.1（5）Lying Nude-32.1 (5)

WS033
臥姿裸女-32.1（6）Lying Nude-32.1 (6)

WS034
坐姿裸女-32.1（19）Seated Nude-32.1 (19)

WS035
坐姿裸女-32.1（20）Seated Nude-32.1 (20)

WS037
坐姿裸女-32.1（21）Seated Nude-32.1 (21)

WS038
立姿裸女-32.1（7）Standing Nude-32.1 (7)

WS039
臥姿裸女-32.1（8）Lying Nude-32.1 (8)

WS042
坐姿裸女-32.1（23）Seated Nude-32.1 (23)

WS043
臥姿裸女-32.1（9）Lying Nude-32.1 (9)

WS044
坐姿裸女-32.1（24）Seated Nude-32.1 (24)

WS045
臥姿裸女-32.1（10）Lying Nude-32.1 (10)

WS047
坐姿裸女-32.1（25）Seated Nude-32.1 (25)

WS048
臥姿裸女-32.1（12）Lying Nude-32.1 (12)

WS049
坐姿裸女-32.1（26）Seated Nude-32.1 (26)

WS050
坐姿裸女-32.1（27）Seated Nude-32.1 (27)

WS051
臥姿裸女-32.1（13）Lying Nude-32.1 (13)

WS052
坐姿裸女-32.1（28）Seated Nude-32.1 (28)

WS053
坐姿裸女-32.1（29）Seated Nude-32.1 (29)

WS054
坐姿裸女-32.1（30）Seated Nude-32.1 (30)

WS055
坐姿裸女-32.1（31）Seated Nude-32.1 (31)

WS057
臥姿裸女-32.1（14）Lying Nude-32.1 (14)

WS058
臥姿裸女-32.1（15）Lying Nude-32.1 (15)

WS059
坐姿裸女-32.1（33）Seated Nude-32.1 (33)

WS060
臥姿裸女-32.1（16）Lying Nude-32.1 (16)

WS062
臥姿裸女-32.1（17）Lying Nude-32.1 (17)

WS063
臥姿裸女-32.1（18）Lying Nude-32.1 (18)

WS064
臥姿裸女-32.1（19）Lying Nude-32.1 (19)

WS066
坐姿裸女-32.1（36）Seated Nude-32.1 (36)

WS067
坐姿裸女-32.1（37）Seated Nude-32.1 (37)

WS068
坐姿裸女-32.1（38）Seated Nude-32.1 (38)

WS069
坐姿裸女-32.1（39）Seated Nude-32.1 (39)

WS070
坐姿裸女-32.1（40）Seated Nude-32.1 (40)

WS072
臥姿裸女-32.1（20）Lying Nude-32.1 (20)

WS074
立姿裸女-32.1（10）Standing Nude-32.1 (10)

WS075
臥姿裸女-32.1（22）Lying Nude-32.1 (22)

WS077
臥姿裸女-32.1（23）Lying Nude-32.1 (23)

WS078
臥姿裸女-32.1（24）Lying Nude-32.1 (24)

WS079
立姿裸女-32.1（11）Standing Nude-32.1 (11)

WS080
立姿裸女-32.1（12）Standing Nude-32.1 (12)

WS081
臥姿裸女-32.1（25）Lying Nude-32.1 (25)

WS082
臥姿裸女-32.1（26）Lying Nude-32.1 (26)

WS083
立姿裸女-32.1（13）Standing Nude-32.1 (13)

WS084
立姿裸女-32.1（14）Standing Nude-32.1 (14)

WS085
坐姿裸女-32.1（43）Seated Nude-32.1 (43)

WS086
立姿裸女-32.1（15）Standing Nude-32.1 (15)

WS087
坐姿裸女-32.1（44）Seated Nude-32.1 (44)

WS088
坐姿裸女-32.1（45）Seated Nude-32.1 (45)

WS089
坐姿裸女-32.1（46）Seated Nude-32.1 (46)

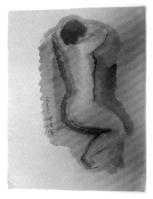
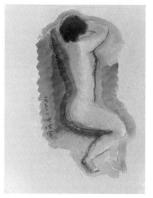
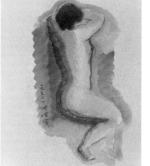
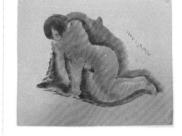

WS090
坐姿裸女-32.1（47）Seated Nude-32.1 (47)

WS091
臥姿裸女-32.1（27）Lying Nude-32.1 (27)

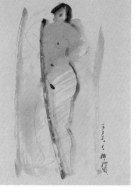

WS092
坐姿裸女-32.1（48）Seated Nude-32.1 (48)

WS093
立姿裸女-32.1（16）Standing Nude-32.1 (16)

WS094
立姿裸女-32.1（17）Standing Nude-32.1 (17)

WS095
立姿裸女-32.1（18）Standing Nude-32.1 (18)

WS096
立姿裸女-32.1（19）Standing Nude-32.1 (19)

WS097
臥姿裸女-32.1（28）Lying Nude-32.1 (28)

WS098
臥姿裸女-32.1（29）Lying Nude-32.1 (29)

WS099
立姿裸女-32.1（20）Standing Nude-32.1 (20)

WS100
坐姿裸女-32.1（49）Seated Nude-32.1 (49)

WS101
坐姿裸女-32.1（50）Seated Nude-32.1 (50)

WS102
坐姿裸女-32.1（51）Seated Nude-32.1 (51)

WS103
坐姿裸女-32.1（52）Seated Nude-32.1 (52)

WS104
立姿裸女-32.1（21）Standing Nude-32.1 (21)

WS105
臥姿裸女-32.1（30）Lying Nude-32.1 (30)

WS106
坐姿裸女-32.1（53）Seated Nude-32.1 (53)

WS107
臥姿裸女-32.1（31）Lying Nude-32.1 (31)

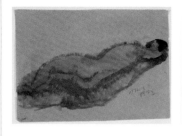
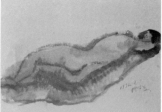
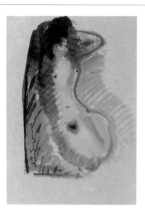

WS108
臥姿裸女-32.1（32）Lying Nude-32.1 (32)

WS109
坐姿裸女-32.1（54）Seated Nude-32.1 (54)

WS110
臥姿裸女-32.1（33）Lying Nude-32.1 (33)

WS111
臥姿裸女-32.1（34）Lying Nude-32.1 (34)

WS112
立姿裸女-32.1（22）Standing Nude-32.1 (22)

WS113
臥姿裸女-32.1（35）Lying Nude-32.1 (35)

WS114
臥姿裸女-32.1（36）Lying Nude-32.1 (36)

WS115
坐姿裸女-32.1（55）Seated Nude-32.1 (55)

WS116
坐姿裸女-32.1（56）Seated Nude-32.1 (56)

WS117
立姿裸女-32.1（23）Standing Nude-32.1 (23)

WS118
立姿裸女-32.1（24）Standing Nude-32.1 (24)

WS119
坐姿裸女-32.1（57）Seated Nude-32.1 (57)

WS120
坐姿裸女-32.1（58）Seated Nude-32.1 (58)

WS121
坐姿裸女-32.1（59）Seated Nude-32.1 (59)

WS122
臥姿裸女-32.1（37）Lying Nude-32.1 (37)

WS123
立姿裸女-32.1（25）Standing Nude-32.1 (25)

WS124
坐姿裸女-32.1（60）Seated Nude-32.1 (60)

WS125
臥姿裸女-32.1（38）Lying Nude-32.1 (38)

WS126
臥姿裸女-32.1（39）Lying Nude-32.1 (39)

WS127
臥姿裸女-32.1（40）Lying Nude-32.1 (40)

WS128
臥姿裸女-32.1（41）Lying Nude-32.1 (41)

WS129
臥姿裸女-32.1（42）Lying Nude-32.1 (42)

WS130
臥姿裸女-32.1（43）Lying Nude-32.1 (43)

WS131
臥姿裸女-32.1（44）Lying Nude-32.1 (44)

WS132
臥姿裸女-32.1（45）Lying Nude-32.1 (45)

WS133
坐姿裸女-32.1（61）Seated Nude-32.1 (61)

WS134
坐姿裸女-32.1（62）Seated Nude-32.1 (62)

WS135
臥姿裸女-32.1（46）Lying Nude-32.1 (46)

WS136
坐姿裸女-32.1（63）Seated Nude-32.1 (63)

WS137
坐姿裸女-32.1（64）Seated Nude-32.1 (64)

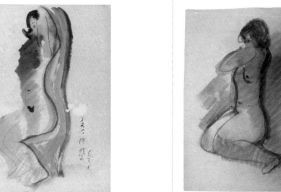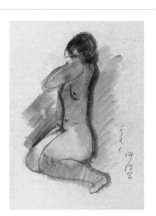

WS138
坐姿裸女-32.1（65）Seated Nude-32.1 (65)

WS139
坐姿裸女-32.1（66）Seated Nude-32.1 (66)

缺修復前照片

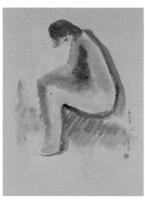

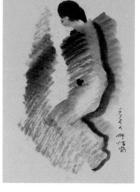

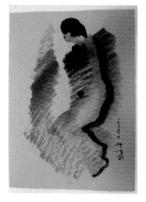

WS140
坐姿裸女-32.1（67）Seated Nude-32.1 (67)

WS141
坐姿裸女-32.1（68）Seated Nude-32.1 (68)

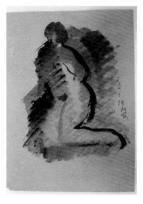

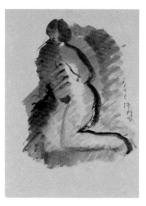

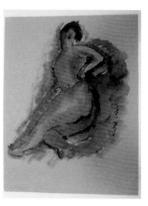

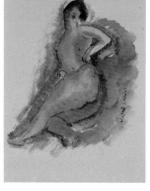

WS142
坐姿裸女-32.1（69）Seated Nude-32.1 (69)

WS143
坐姿裸女-32.1（70）Seated Nude-32.1 (70)

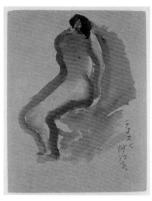

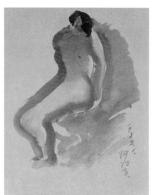

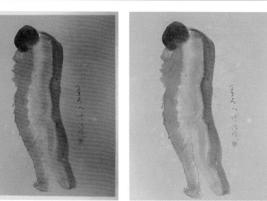

WS144
坐姿裸女-32.1（71）Seated Nude-32.1 (71)

WS145
立姿裸女-32.1（26）Standing Nude-32.1 (26)

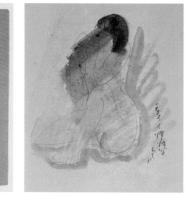

WS146
坐姿裸女-32.1（72）Seated Nude-32.1 (72)

WS147
坐姿裸女-32.1（73）Seated Nude-32.1 (73)

WS148
坐姿裸女-32.1（74）Seated Nude-32.1 (74)

WS149
坐姿裸女-32.1（75）Seated Nude-32.1 (75)

WS150
臥姿裸女-32.1（47）Lying Nude-32.1 (47)

WS152
立姿裸女-32.1（27）Standing Nude-32.1 (27)

WS153
臥姿裸女-32.1（48）Lying Nude-32.1 (48)

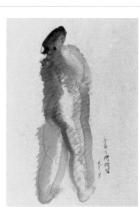

WS154
立姿裸女-32.1（28）Standing Nude-32.1 (28)

WS155
坐姿裸女-32.1（77）Seated Nude-32.1 (77)

WS156
坐姿裸女-32.1（78）Seated Nude-32.1 (78)

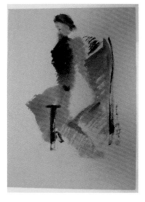

WS157
坐姿裸女-32.1（79）Seated Nude-32.1 (79)

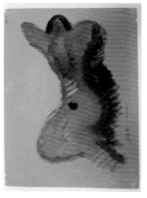
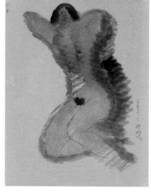

WS158
臥姿裸女-32.1（49）Lying Nude-32.1 (49)

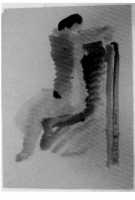
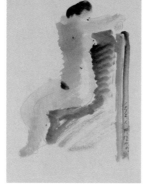

WS159
坐姿裸女-32.1（80）Seated Nude-32.1 (80)

WS160
坐姿裸女-32.1（81）Seated Nude-32.1 (81)

WS161
立姿裸女-32.1（29）Standing Nude-32.1 (29)

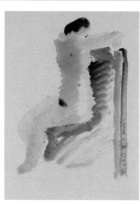

WS162
坐姿裸女-32.1（82）Seated Nude-32.1 (82)

WS163
立姿裸女-32.1（30）Standing Nude-32.1 (30)

WS164
立姿裸女-32.1（31）Standing Nude-32.1 (31)

 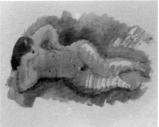

WS165
臥姿裸女-32.1（50）Lying Nude-32.1 (50)

WS166
立姿裸女-32.1（32）Standing Nude-32.1 (32)

WS167
立姿裸女-32.1（33）Standing Nude-32.1 (33)

WS168
立姿裸女-32.1（34）Standing Nude-32.1 (34)

WS169
立姿裸女-32.1（35）Standing Nude-32.1 (35)

WS170
坐姿裸女-32.1（83）Seated Nude-32.1 (83)

WS171
坐姿裸女-32.1（84）Seated Nude-32.1 (84)

WS172
臥姿裸女-32.1（51）Lying Nude-32.1 (51)

WS173
坐姿裸女-32.1（85）Seated Nude-32.1 (85)

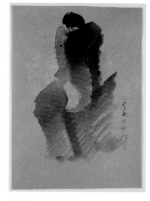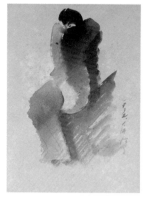

WS174
坐姿裸女-32.1（86）Seated Nude-32.1 (86)

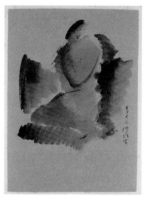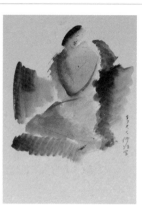

WS175
坐姿裸女-32.1（87）Seated Nude-32.1 (87)

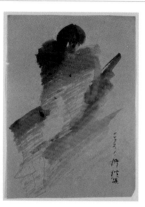

WS176
坐姿裸女-32.1（88）Seated Nude-32.1 (88)

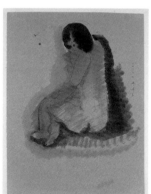

WS177
坐姿裸女-32.1（89）Seated Nude-32.1 (89)

WS178
坐姿裸女-32.1（90）Seated Nude-32.1 (90)

WS179
坐姿裸女-32.1（91）Seated Nude-32.1 (91)

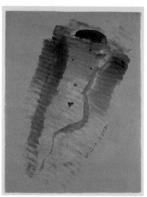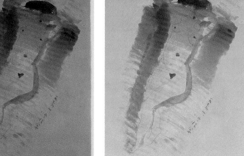

WS180
臥姿裸女-32.1（52）Lying Nude-32.1 (52)

319

WS181
臥姿裸女-32.1（53）Lying Nude-32.1 (53)

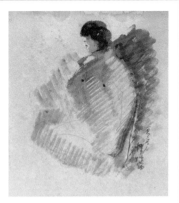

WS182
坐姿裸女-32.1（92）Seated Nude-32.1 (92)

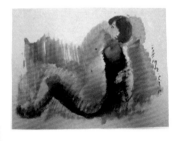 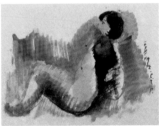

WS183
坐姿裸女-32.1（93）Seated Nude-32.1 (93)

 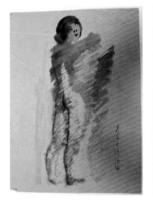

WS184
立姿裸女-32.1（36）Standing Nude-32.1 (36)

WS185
臥姿裸女-32.1（54）Lying Nude-32.1 (54)

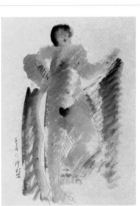

WS186
立姿裸女-32.1（37）Standing Nude-32.1 (37)

WS187
坐姿裸女-32.1（94）Seated Nude-32.1 (94)

WS188
臥姿裸女-32.1（55）Lying Nude-32.1 (55)

WS189
立姿裸女-32.1（38）Standing Nude-32.1 (38)

WS190
立姿裸女-32.1（39）Standing Nude-32.1 (39)

WS191
臥姿裸女-32.1（56）Lying Nude-32.1 (56)

WS192
坐姿裸女-32.1（95）Seated Nude-32.1 (95)

WS193
坐姿裸女-32.1（96）Seated Nude-32.1 (96)

WS194
坐姿裸女-32.1（97）Seated Nude-32.1 (97)

WS195
坐姿裸女-32.1（98）Seated Nude-32.1 (98)

WS196
坐姿裸女-32.1（99）Seated Nude-32.1 (99)

WS197
坐姿裸女-32.1（100）Seated Nude-32.1 (100)

WS198
坐姿裸女-32.1（101）Seated Nude-32.1 (101)

WS199
坐姿裸女-32.1（102）Seated Nude-32.1 (102)

WS200
立姿裸女-32.1（40）Standing Nude-32.1 (40)

WS201
立姿裸女-32.1（41）Standing Nude-32.1 (41)

WS202
立姿裸女-32.1（42）Standing Nude-32.1 (42)

WS203
立姿裸女-32.1（43）Standing Nude-32.1 (43)

WS204
立姿裸女-32.1（44）Standing Nude-32.1 (44)

WS205
立姿裸女-32.1（45）Standing Nude-32.1 (45)

WS206
立姿裸女-32.1（46）Standing Nude-32.1 (46)

WS207
立姿裸女-32.1（47）Standing Nude-32.1 (47)

WS208
立姿裸女-32.1（48）Standing Nude-32.1 (48)

WS209
坐姿裸女-32.1（103）Seated Nude-32.1 (103)

WS210
坐姿裸女-32.1（104）Seated Nude-32.1 (14)

WS211
畫室-32.1（4）Studio-32.1 (4)

WS212
畫室-32.1（5）Studio-32.1 (5)

WS213
畫室-32.1（6）Studio-32.1 (6)

WS214
人物-32.1（2）Figure-32.1 (2)

WS215
人物-32.1（3）Figure-32.1 (3)

WS216
人物-32.1（4）Figure-32.1 (4)

WS217
人物-32.1（5）Figure-32.1 (5)

WS218
人物-32.1（6）Figure-32.1 (6)

WS219
人物-32.1（7）Figure-32.1 (7)

WS220
人物-32.1（8）Figure-32.1 (8)

WS221
人物-32.1（9）Figure-32.1 (9)

WS222
人物-32.1（10）Figure-32.1 (10)

WS223
人物-32.1（11）Figure-32.1 (11)

WS224
群像-32.1（1）Group Portrait-32.1 (1)

WS225
群像-32.1（2）Group Portrait-32.1 (2)

WS226
群像-32.1（3）Group Portrait-32.1 (3)

WS227
貓-32.1 Cat-32.1

WS228
畫室-32.5.22（7）Studio-32.5.22 (7)

WS229
立姿裸女-32.2.14（49）Standing Nude-32.2.14 (49)

WS230
坐姿裸女-32.3.28（106）Seated Nude-32.3.28 (106)

WS231
立姿裸女-32.4.1（50）Standing Nude-32.4.1 (50)

WS232
頭像-32.4.1（1）Portrait-32.4.1 (1)

WS233
人物-32.4.9（12）Figure-32.4.9 (12)

WS234
坐姿裸女-32.4.16（107）Seated Nude-32.4.16 (107)

WS236
群像-32.4.16（4）Group Portrait-32.4.16 (4)

WS237
群像-32.4.26（5）Group Portrait-32.4.26 (5)

WS238
花-32.4 Flower-32.4

WS239
人物-32.4（14）Figure-32.4 (14)

WS240
街景-32.4 Street-32.4

WS241
人物-32.5.3（15）Figure-32.5.3 (15)

WS242
人物-32.5.3（16）Figure-32.5.3 (16)

WS244
立姿裸女-32.5.7（52）Standing Nude-32.5.7 (52)

WS245
立姿裸女-32.5.7（53）Standing Nude-32.5.7 (53)

WS246
人物-32.5.7（17）Figure-32.5.7 (17)

WS247
群像-32.5.7（6）Group Portrait-32.5.7 (6)

WS248
坐姿裸女-32.5.22（109）Seated Nude-32.5.22 (109)

WS249
坐姿裸女-32.5.22（110）Seated Nude-32.5.22 (110)

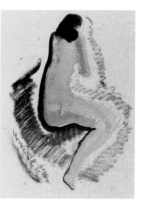

WS250
坐姿裸女-32.5.22（111）Seated Nude-32.5.22 (111)

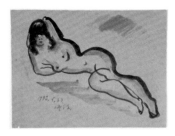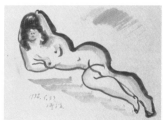

WS251
臥姿裸女-32.5.23（57）Lying Nude-32.5.23 (57)

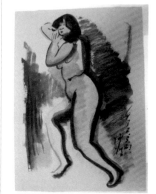

WS252
立姿裸女-32.5.23（54）Standing Nude-32.5.23 (54)

WS253
坐姿裸女-32.5.23（112）Seated Nude-32.5.23 (112)

WS254
臥姿裸女-32.5.23（58）Lying Nude-32.5.23 (58)

WS255
臥姿裸女-32.5.23（59）Lying Nude-32.5.23 (59)

WS256
臥姿裸女-32.5.23（60）Lying Nude-32.5.23 (60)

WS260
坐姿裸女-32.5.29（113）Seated Nude-32.5.29 (113)

WS261
立姿裸女-32.5.29（55）Standing Nude-32.5.29 (55)

WS262
臥姿裸女-32.5.29（63）Lying Nude-32.5.29 (63)

WS264
坐姿裸女-32.5.29（114）Seated Nude-32.5.29 (114)

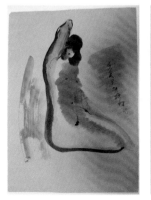
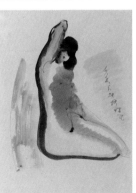

WS265
臥姿裸女-32.5.29（65）Lying Nude-32.5.29 (65)

WS266
坐姿裸女-32.5.29（115）Seated Nude-32.5.29 (115)

329

WS267
臥姿裸女-32.5.29（66）Lying Nude-32.5.29 (66)

WS270
臥姿裸女-32.5.29（67）Lying Nude-32.5.29 (67)

WS271
臥姿裸女-32.5.29（68）Lying Nude-32.5.29 (68)

WS272
坐姿裸女-32.5.29（118）Seated Nude-32.5.29 (118)

WS273
坐姿裸女-32.5.29（119）Seated Nude-32.5.29 (119)

WS274
人物-32.5.29（19）Figure-32.5.29 (19)

WS275
臥姿裸女-32.5.29（69）Lying Nude-32.5.29 (69)

WS277
頭像-32.7（2）Portrait-32.7 (2)

WS278
坐姿裸女-32（121）Seated Nude-32 (121)

WS279
城隍祭典餘興-33.9.22 City God Festival Entertainment-33.9.22

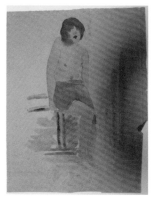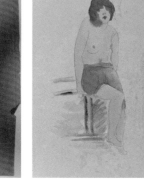

WS280
坐姿裸女（122）Seated Nude (122)

WS283
坐姿裸女（125）Seated Nude (125)

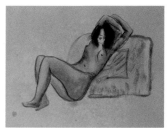

WS285
坐姿裸女（127）Seated Nude (127)

WS286
坐姿裸女（128）Seated Nude (128)

WS287
臥姿裸女（71）Lying Nude (71)

WS288
立姿裸女（56）Standing Nude (56)

WS290
坐姿裸女（129）Seated Nude (129)

WS291
立姿裸女（57）Standing Nude (57)

WS292
立姿裸女（58）Standing Nude (58)

WS293
臥姿裸女（73）Lying Nude (73)

WS294
臥姿裸女（74）Lying Nude (74)

WS295
立姿裸女（59）Standing Nude (59)

WS297
立姿裸女（60）Standing Nude (60)

WS298
立姿裸女（61）Standing Nude (61)

WS299
坐姿裸女（130）Seated Nude (130)

WS303
臥姿裸女（77）Lying Nude (77)

WS304
臥姿裸女（78）Lying Nude (78)

WS305
立姿裸女（62）Standing Nude (62)

WS306
立姿裸女（63）Standing Nude (63)

WS307
坐姿裸女（134）Seated Nude (134)

WS308
坐姿裸女（135）Seated Nude (135)

WS309
坐姿裸女（136）Seated Nude (136)

WS311
坐姿裸女（137）Seated Nude (137)

WS315
立姿裸女（67）Standing Nude (67)

WS316
立姿裸女（68）Standing Nude (68)

WS317
立姿裸女（69）Standing Nude (69)

WS319
立姿裸女（71）Standing Nude (71)

WS320
坐姿裸女（140）Seated Nude (140)

 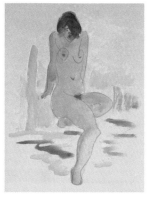

WS322
坐姿裸女（142）Seated Nude (142)

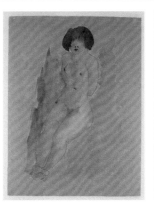 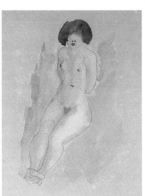

WS325
坐姿裸女（143）Seated Nude (143)

WS326
坐姿裸女（144）Seated Nude (144)

WS327
立姿裸女（73）Standing Nude (73)

WS328
立姿裸女（74）Standing Nude (74)

WS329
坐姿裸女（145）Seated Nude (145)

WS331
立姿裸女（76）Standing Nude (76)

WS332
坐姿裸女（146）Seated Nude (146)

WS333
坐姿裸女（147）Seated Nude (147)

WS334
立姿裸女（82）Standing Nude (82)

WS335
立姿裸女（77）Standing Nude (77)

WS336
臥姿裸女（81）Lying Nude (81)

WS338
臥姿裸女（83）Lying Nude (83)

WS339
坐姿裸女（149）Seated Nude (149)

WS340
坐姿裸女（150）Seated Nude (150)

WS341
坐姿裸女（151）Seated Nude (151)

WS342
坐姿裸女（152）Seated Nude (152)

WS343
坐姿裸女（153）Seated Nude (153)

WS344
立姿裸女（78）Standing Nude (78)

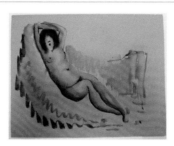

WS345
坐姿裸女（154）Seated Nude (154)

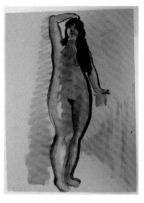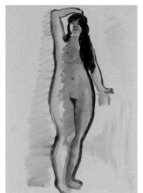

WS346
立姿裸女（79）Standing Nude (79)

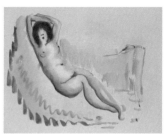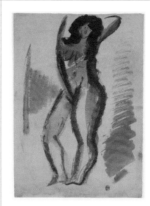

WS347
坐姿裸女（155）Seated Nude (155)

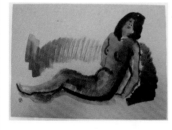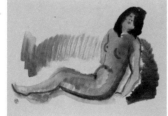

WS348
坐姿裸女（156）Seated Nude (156)

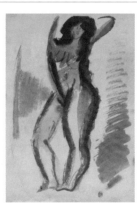

WS349
立姿裸女（80）Standing Nude (80)

WS350
立姿裸女（81）Standing Nude (81)

WS351
坐姿裸女（157）Seated Nude (157)

WS352
臥姿裸女（84）Lying Nude (84)

WS353
坐姿裸女（158）Seated Nude (158)

WS354
畫室（8）Studio (8)

WS356
畫室（9）Studio (9)

WS357
畫室（10）Studio (10)

WS358
畫室（11）Studio (11)

WS359
畫室（12）Studio (12)

WS360
畫室（13）Studio (13)

WS361
畫室（14）Studio (14)

WS362
畫室（15）Studio (15)

WS363
畫室（16）Studio (16)

WS364
畫室（17）Studio (17)

WS368
人物（24）Figure (24)

WS369
人物（25）Figure (25)

WS370
人物（27）Figure (27)

WS371
人物（28）Figure (28)

WS372
人物（29）Figure (29)

WS373
人物（30）Figure (30)

WS374
人物（31）Figure (31)

WS375
人物（32）Figure (32)

WS376
人物（33）Figure (33)

WS377
人物（34）Figure (34)

WS379
人物（36）Figure (36)

WS380
群像（7）Group Portrait (7)

WS381
群像（8）Group Portrait (8)

WS382
群像（9）Group Portrait (9)

WS383
群像（10）Group Portrait (10)

WS384
群像（11）Group Portrait (11)

WS385
群像（12）Group Portrait (12)

WS386
群像（13）Group Portrait (13)

WS387
群像（14）Group Portrait (14)

WS388
群像（15）Group Portrait (15)

WS389
群像（16）Group Portrait (16)

WS390
頭像（3）Portrait (3)

WS391
頭像（4）Portrait (4)

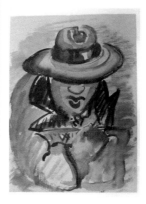 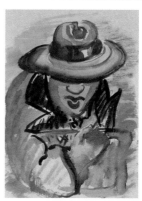

WS392
頭像（5）Portrait (5)

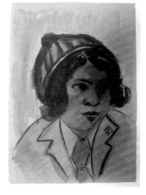 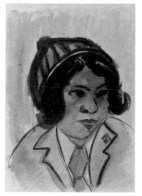

WS393
頭像（6）Portrait (6)

WS394
拖鞋 Slippers

WS395
掛在門板上的鍋子 Pot hanged on the door

WS396
兔子Rabbit

WS403
立姿裸女（70）Standing Nude（70）

WS405
坐姿裸女（133）Seated Nude（133）

友人贈送與自藏書畫 Art Collection
書法 Calligraphy

每件作品以修復前和修復後做為對照，共兩張圖。
修復前置於左側（上方）、修復後置於右側（下方）。

蔣式芬等人 Jiang Shi-fen et al.
格言（一）Motto (1)

吳樹梅等人 Wu Shu-mei et al.
格言（三）Motto (3)

王仁堪等人 Wang Ren-kan et al.
格言（四）Motto (4)

鄭貽林 Zheng Yi-lin
心曠神怡 Relaxed and Happy

羅峻明 Luo Jun-ming
朱柏廬先生治家格言 Master Chu's Homilies for Families

傅岩 Fu Yan
良用 Liangyong

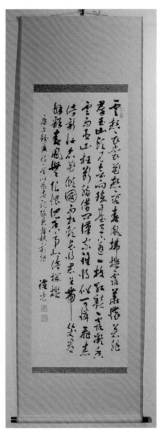

張守艮 Zhang Shu-gen
李白・清平調 Li Bai - A Song of Pure Happiness

林玉書 Lin Yu-shu
畫中八仙歌（一）A Song for Eight Artists (1)

曹秋圃 Cao qiu-pu
挽瀾室 Wan Lan Study

陳重光 Chen Tsung-kuang
川流不息 The Stream Flows without Stopping

渡邊竹亭 Watanabe Chikutei
趙孟頫・天冠山題詠詩帖-仙足巖
Zhao Meng-fu - Xianzuyan

渡邊竹亭 Watanabe Chikutei
李白・子夜吳歌-秋歌 Li Bai - A Song of an Autumn Midnight

張李德和 Zhang Li De-he
壽山福海 Shoushan Fuhai

李種玉 Li Zhong-yu
李白・春夜宴桃李園序（部分）Li Bai - Banquet at the Peach and Pear Blossom Garden on a Spring Evening (partial)

徐杰夫 Xu Jie-fu
孟子・公孫丑下（部分）Mencius - Gong Sun-chou II (partial)

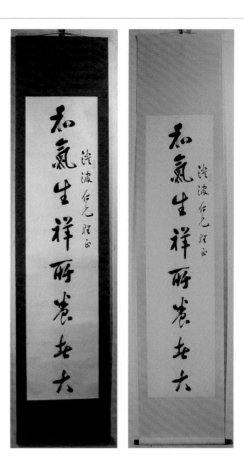

蘇孝德 Su Xiao-de
書法對聯之一 Calligraphy couplet (One of them)

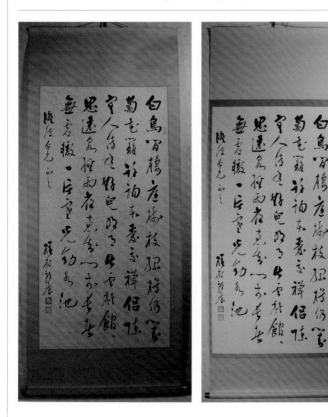

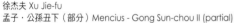

蘇孝德 Su Xiao-de
書法 Calligraphy

蘇友讓 Su You-rang
帝國艦隊臨高雄有感 Thought on Imperial Fleet's Coming to Kaohsiung

王濟遠 Wang Ji-yuan
陸游・夏日雜詠 Lu You's Summer-day Poem Written at Random

曹秋圃 Cao qiu-pu
水社海襟詠之一 Ode to the Shueishehai (Part)

黃開元 Huang Kai-yuan
藏頭對聯 Calligraphy couplet

友人贈送與自藏書畫 Art Collection
水墨 Ink Painting

每件作品以修復前和修復後做為對照，共兩張圖。
修復前置於左側（上方）、修復後置於右側（下方）。

陳存容 Chen Cun-rong
螃蟹四條屏 Crab Four Screen

潘天壽 Pan Tian-shou
凝寒 Freezing Coldness

李松坡 Li Song-po
歲寒三友圖 Three Durable Plants of Winter

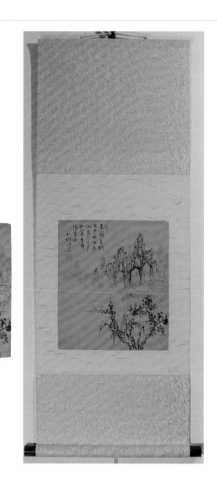

李松坡 Li Song-po
山水 Landscape

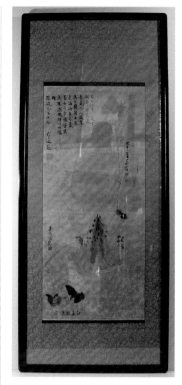
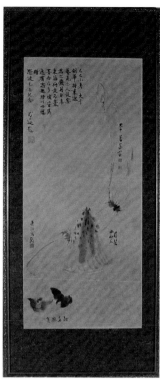

張大千、張善孖、俞劍華、楊清磐、王濟遠
Zhang Da-qian, Zhang Shan-zi, Yu Jian-hua, Yang Qing-pan, Wang Ji-yuan
五人合筆 A Collaborative Painting by Five

江小鶼 Jiang Xiao-jian
花卉 Flowers

劉渭 Liu Wei
採桑圖 Mulberry Leaf Picking

王賢 Wang Xian
梅石 Plum Blossom and Rock

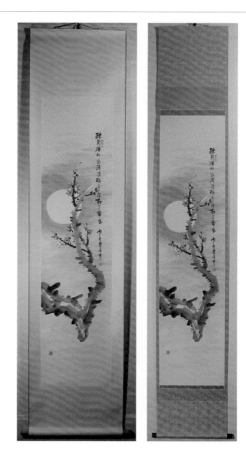

蔡麗邨 Tsai Li-tun
月梅圖 Moon and Plum Blossom

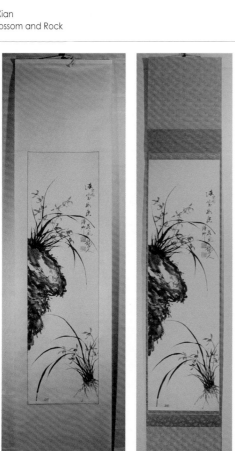

葉鏡鎔 Ye Jing-rong
幽蘭 Orchid

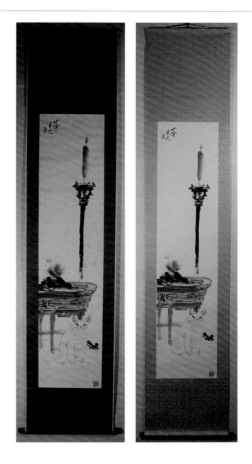

張聿光 Zhang Yu-guang
燭台與貓 Candlestick and Cat

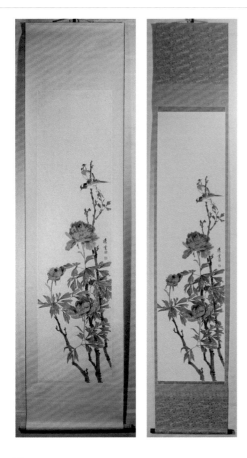

王逸雲 Wang Yi-yun
牡丹 Peony

張辰伯 Zhang Chen-bo
山水 Landscape

鄧芬 Deng Fen
山水 Landscape

元鳳 Yuan Feng
犬 Dog

竹心 Zhu Xin
墨竹 Ink bamboo

作者不詳 Author unknown
花卉 Flowers

友人贈送與自藏書畫 Art Collection
扇 Fan

每件作品以修復前和修復後做為對照,共兩張圖。
修復前置於左側、修復後置於右側。

韓慕儼 Han Mu-xian
山水書畫扇 Landscape and Calligraphy Fan

徐慶瀾 Xu Qing-lan
菊花書畫扇 Chrysanthemum and Calligraphy Fan

五峯 Wu Feng
牡丹書畫扇 Peony and Calligraphy Fan

林子白 Lin Zi-bai
荷花扇 Lotus Fan

林子白 Lin Zi-bai
花卉松枝扇 Flowers and Pine Branch Fan

余威丹、項保艾 Yu Wei-dan, Xiang Po-ai
飛蛾書法扇 Moths and Calligraphy Fan

犬養毅 Inukai Tsuyoshi
書法扇 Calligraphy Fan

友人贈送與自藏書畫 Art Collection
其他 Other

每件作品以修復前和修復後做為對照，共兩張圖。
修復前置於左側、修復後置於右側。

彭玉麟 Peng Yu-lin
紅梅 Red Plum Blossom

李石樵 Li Shi-qiao
蔬果圖 Fruits

編後語

陳澄波因二二八事件罹難，使得他的名字一度成為禁忌；其遺留下來的作品與文物，家屬為避免被政府單位查禁沒收，長期密藏在住家的閣樓裡，由於保存環境不佳，使得作品與文物遭受不同程度的嚴重損壞。因應2014年「陳澄波百二誕辰東亞巡迴大展」的展出，這些作品與文物需要被全面修復；由於數量龐大加上時間壓力，因此交付三個主要的單位同步進行，分別是：國立臺灣師範大學文物保存維護研究發展中心（簡稱文保中心）、正修科技大學文物修護中心，與臺北文化財保存研究所。

《陳澄波全集》第15-17卷，主要就是呈現這三個單位的修復成果。第15卷和第16卷前半部，為張元鳳老師領導的文保中心的紙質類作品、油畫和文物的修復報告，並搭配專文，深入簡出地介紹修復的理念與過程；第16卷下半部為林煥盛老師主持的臺北文化財保存研究所的紙絹類作品修復報告；第17卷則是收錄李益成老師領導的正修科技大學文物修護中心的油畫和紙質類作品修復報告，與修復期間所發表的文章。在每個類別的最後，並收入所有作品修復前後的對照圖，將修復作品做一完整之呈現，也讓讀者可以比對修復前後之差異。此外，15-17卷特以中英文對照呈現，以期能推廣國內優秀的修復技術。

由於修復前後對照圖有數千件，當初送修復時的編號也與後來《全集》的編號不同，因此耗費相當多的時間來重新整理圖檔；然而當作品能依序完整呈現，編者亦是感到十分欣慰。而修復前後對照圖大多是修復師所攝（除臺北文化財保存研究所的大部分淡彩，修復前為家屬所攝，修復後為攝影師所攝外），因為不是專業攝影或掃描，有些圖檔品質並不理想，圖檔顏色看起來也會與《全集》第1至5卷之作品圖錄有些許差異，然均為修復師工作中之紀錄，為完整呈現修復的全貌，編輯時選擇仍將其全部收錄。另有少部分素描簿圖檔，因修復後加強了騎縫處的黏合，導致攝影時靠近騎縫處會有陰影或不平整的狀況產生，實乃無法避免，尚請寬諒。

有人把修復師比喻為文物的醫生，而文物就是病人；在面對同一個病人，不同醫師所開的藥方也會不盡相同。同樣的，在面對各式各樣的文物和不一樣的修復需求時，三個單位的修復程序、方法與使用之材料，自然也會有所不同，甚至連修復報告的格式也有所差別。對於這些差異性，編輯者選擇如實保留，不強加統一，藉以呈顯各單位之修復特色。

此次陳澄波作品與文物的大量修復，應是國內創舉，目前在臺灣應還沒有其他畫家從事如此大規模的修復；這樣的工程，除需耗費龐大的金錢外，更考驗著三個單位的修復能力，不僅要在有限的時間內完成，以應付展出，最令人感動的是三個單位均嚴格遵循修復倫理，因為修復是為了延長文物的保存壽命，而非讓後人的修復介入反而毀壞了原作。

感謝三個單位的主持人與修復師，工作忙碌之餘，還抽空撰寫專文、規劃內容、整理資料，並協助校稿。若要瞭解作品與文物如何被修復，相信讀完這三卷報告書，就會有很清楚的概念。這是國內修復專業一次重大的成果；而美編處理幾千件圖檔的辛勞，在此也一併誌謝。

<div style="text-align:right">

財團法人陳澄波文化基金會
研究專員　賴鈴如

</div>

Editor's Afterword

The fact that Chen Cheng-po had fallen victim to the "228 Incident" had once made his name a taboo. For fear that his works and cultural objects might be searched for violation of ban and confiscated, his family members had them hidden for a long time in the household attic. Because of the poor conservation conditions, the works and cultural objects had undergone various degrees of serious damages. In order that they could be showcased in the 2014 "Chen Cheng-po's 120th Birthday Touring Exhibition in East Asia", there was a need to conserve these works and cultural objects comprehensively. Considering the large quantity involved and the limited time available, three institutions were charged with carrying out the conservation simultaneously, namely, Research Center for Conservation of Cultural Relics (RCCR), National Taiwan Normal University; Cheng Shiu University Conservation Center; and Taipei Conservation Center.

Volumes 15 to 17 of *Chen Cheng-po Corpus* mainly present the conservation results of these three institutions. Volume 15 and the first half of Volume 16 consist of the reports of conserving respectively paper-based works, oil paintings, and cultural objects by an RCCR team led by Chang Yuan-feng. Also included is a monograph that succinctly presents the concepts and processes of the conservation in depth. The second half of Volume 16 is a report on the conservation of paper or silk based paintings by Taipei Conservation Center run by Lin Huan-sheng. Included in Volume 17 are reports on the conservation of oil paintings and paper-based works carried out by Cheng Shiu University Conservation Center under the leadership of Li I-cheng. It also consists of a number of papers published in the course of the conservation. At the end of each category section, there are comparison photos showing the works before and after treatment. Such a complete presentation of the conserved works allows readers the chance of comparing the differences before and after treatment. Also, Volumes 15 to 17 are published in a Chinese-English bilingual format to better promote the superb conservation techniques available in Taiwan.

Since there are thousands of before and after treatment photos and that the serial numbers at the time of sending out for conservation are different than those given in the *Corpus*, considerable amount of time has been engaged in reorganizing the photo files. Yet, when all the works are finally presented in their sequential order, this editor cannot help but thrilled with satisfaction. Most of the before and after treatment photos have been taken by the conservators concerned (except in the case of most of the watercolor sketches conserved by Taipei Conservation Center in which the before treatment photos have been taken by members of the artist's family, while the after treatment ones have been taken by photographer). Since no professional photography or scanning is involved, the quality of some of the photo files is less than desirable, with the colors of the files somewhat different than those included in Volumes 1 to 5 of the *Corpus*. Nevertheless, as the entire photo files are the work records of the conservators, in compiling these three volumes, it has been decided to include all of them in order to present a full picture of the conservation efforts. In addition, in some of the sketchbook photo files, since the bonds of the sketchbook seams have been reinforced during conservation, shadows or unevenness may show up near the seams in the photos. This is unavoidable and we hope readers will understand.

Conservators have been likened to doctors of cultural objects and the cultural objects are the patients. When dealing with the same patient, the prescriptions given out by different doctors are not all the same. Likewise, in dealing with a whole range of cultural objects and different conservation needs, the procedures, methods, and materials adopted by the three conservation institutions are naturally not the same; in fact, even the formats of their conservation reports are also different. Faced with these differences, this editor has chosen to retain them as they were and has not enforced uniformity so as to present the conservation features of these institutions.

The current wholesale conservation of Chen Cheng-po's works and cultural objects is a first of its type in Taiwan. As yet, there is no other artist in Taiwan whose works have undergone conservation of such a large scale. Such an undertaking not only incurs a lot of money, it is also very taxing on the conservation capabilities of the three institutions. In addition to having to complete their respective tasks within limited time to be ready for the exhibition, what is touching is that all three of them had to abide by stringent conservation ethics. This is so because, after all, the purpose of conservation is to extend the retention life of the works of art and cultural objects, and is not to allow the intrusion of conservation to damage them.

We extend our gratitude to the directors and conservators of the three institutions for sparing time in their busy schedules to write the papers, plan the contents, and organize the materials as well as to help proofreading. If one wants to understand how art works and cultural objects are conserved, reading these three volumes would be a sure way to get a clear idea. This project is a major achievement on the part of Taiwan's conservation profession. Our thanks is also due to our art editor who had to laboriously handle thousands of photo files.

Researcher,
Judicial Person Chen Cheng-po Cultural Foundation
Lai Ling-ju

Lai Ling-ju

國家圖書館出版品預行編目資料

陳澄波全集. 第十六卷, 修復報告. II / 蕭瓊瑞總主編. --
初版. -- 臺北市：藝術家出版；嘉義市：陳澄波文化基金會；
[臺北市]：中研院臺史所發行, 2018.3
360面；22×28.5公分
ISBN 978-986-282-206-7(精裝)

1.書畫 2.文物修復

941.5 106016442

陳澄波全集
CHEN CHENG-PO CORPUS

第十六卷・修復報告（II）
Volume 16・Selected Treatment Reports（II）

發　　　行：財團法人陳澄波文化基金會
　　　　　　中央研究院臺灣史研究所
出　　　版：藝術家出版社
發 行 人：陳重光、翁啟惠、何政廣
策　　　劃：財團法人陳澄波文化基金會
總 策 劃：陳立栢
總 主 編：蕭瓊瑞
編輯顧問：王秀雄、吉田千鶴子、李鴻禧、李賢文、林柏亭、林保堯、林釗、張義雄
　　　　　張炎憲、陳重光、黃才郎、黃光男、潘元石、謝里法、謝國興、顏娟英
編輯委員：文貞姬、白適銘、林育淳、邱函妮、許雪姬、陳麗涓、陳水財、張元鳳、張炎憲
　　　　　黃冬富、廖瑾瑗、蔡獻友、蔣伯欣、黃姍姍、謝慧玲、蕭瓊瑞
執行編輯：賴鈴如、何冠儀
美術編輯：廖婉君
翻　　　譯：日文／潘襎（序文）、陳芳婷、英文／陳彥名（序文）、陳詩薇、盧藹芹

出 版 者：藝術家出版社
　　　　　台北市金山南路（藝術家路）二段165號6樓
　　　　　TEL：（02）23886715
　　　　　FAX：（02）23965708
　　　　　郵政劃撥：50035145 藝術家出版社帳戶

總 經 銷：時報文化出版企業股份有限公司
　　　　　桃園市龜山區萬壽路二段351號
　　　　　TEL：（02）2306-6842
南區代理：台南市西門路一段223巷10弄26號
　　　　　TEL：（06）261-7268
　　　　　FAX：（06）263-7698

製版印刷：欣佑彩色製版印刷股份有限公司
初　　　版：2018年3月
定　　　價：新臺幣1800元

ISBN　978-986-282-206-7（軟皮精裝）